A History of Video Art

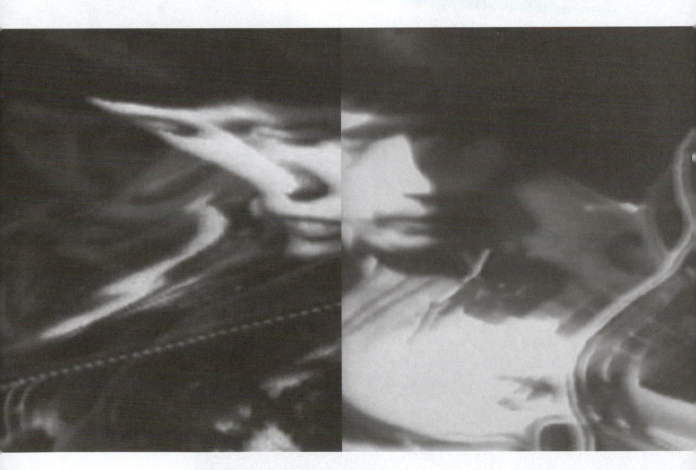

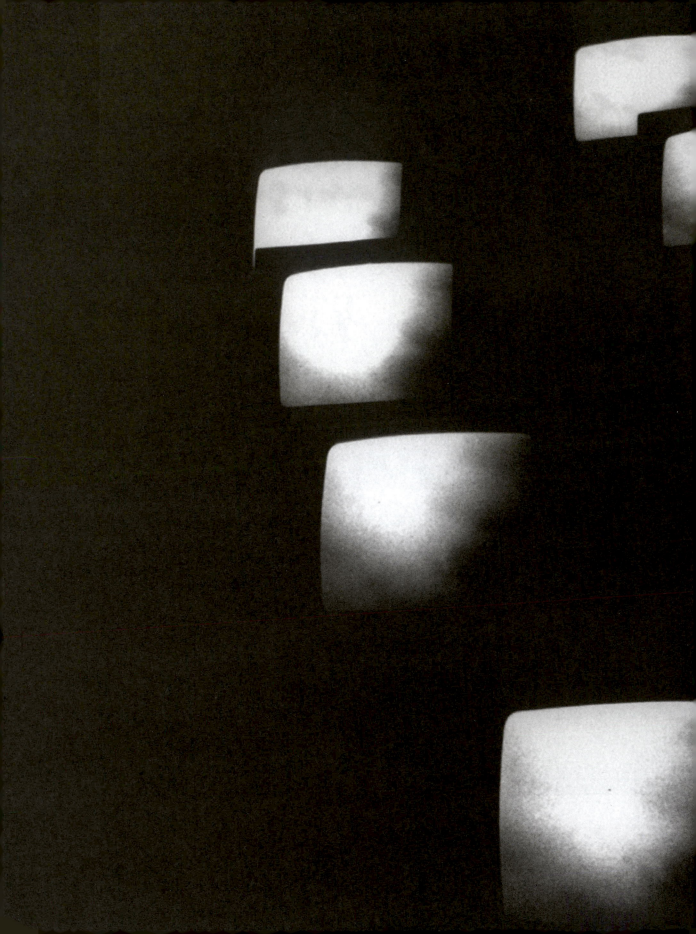

Chris Meigh-Andrews

A History of Video Art

2nd Edition

BLOOMSBURY

NEW YORK • LONDON • NEW DELHI • SYDNEY

Bloomsbury Academic

An imprint of Bloomsbury Publishing Inc

1385 Broadway	50 Bedford Square
New York	London
NY 10018	WC1B 3DP
USA	UK

www.bloomsbury.com

Bloomsbury is a registered trade mark of Bloomsbury Publishing Plc

First published 2006 by Berg Publishers

This 2nd edition © Chris Meigh-Andrews, 2014

Library of Congress Cataloging-in-Publication Data
A catalog record for this book is available from the Library of Congress.

ISBN:	HB:	978-0-8578-5177-2
	PB:	978-0-8578-5178-9
	ePDF:	978-0-8578-5188-8
	ePub:	978-0-8578-5189-5

Typeset by Fakenham Prepress Solutions, Fakenham, Norfolk NR21 8NN
Printed and bound in the United States of America

CONTENTS

Monitor, Steve Partridge, UK, 1975; *Television Delivers People*, Richard Serra and Carlotta Fay Schoolman, USA,1973; *This is a Television Receiver*, David Hall, UK, 1974; *Vertical Roll*, Joan Jonas, USA, 1972; *The Video Touch*,Wojciech Bruszewski, Poland, 1977; *Marca Registrada* [*Trademark*], Leticia Parente, Brazil, 1975

PART III. THE DEVELOPMENT OF ARTISTS' VIDEO AND VIDEO INSTALLATION IN RESPONSE TO TECHNOLOGICAL CHANGE AND ACCESSIBILITY

PART IV. REFERENCES

LIST OF BLACK AND WHITE ILLUSTRATIONS

George Barber, *Tilt,* 1984, Courtesy of the artist.

Steven Beck, *Illuminated Music,* 1972–3. Courtesy of Electronic Arts Intermix (EIA), New York. http://www.eia.org

Guy Ben-Ner, *Wild Boy,* 2004. Courtesy of the artist.

Vince Briffa, *Playing God,* 2008. Courtesy of the artist.

Robert Cahen, *Juste le Temps,* 1983. Courtesy of the artist.

Peter Campus, *Passage at Bellport Harbor,* 2010 and *Fishing Boats at Shinnecock Bay,* 2010. Courtesy of the artist.

Peter Donebauer, *Merging-Emerging,* 1978. Courtesy of the artist.

Duvet Brothers, *Blue Monday,* 1984, Courtesy of the artists.

Terry Flaxton, *In Re Ansel Adams,* 2008. Courtesy of the artist.

Clive Gilllman, *NLV1,* 1990. Courtesy of the artist.

Judith Goddard, *Television Circle,* 1987. Courtesy of the artist.

David Hall, *A Situation Envisaged, the Rite 2,* 1988–90. Courtesy of the artist.

Steve Hawley, *Trout Descending a Staircase,* 1990. Courtesy of the artist.

Takahiko Iimura, *Interactive AIUEONN,* installation at Harris Museum & Art Gallery, Preston for Digital Aesthetic 2012. Courtesy of the artist. Photograph © Simon Critchley.

Stephen Jones, *Stonehenge,* 1978. Courtesy of the artist.

Malcolm le Grice, *Even Cyclops Pays the Ferryman,* 1998. Courtesy of the artist.

Mary Lucier, *Four Mandalas,* 2009. Courtesy of the artist.

Churchill Madikida, *Virus,* 2005. Courtesy of the artist.

Chris Meigh-Andrews, *For William Henry Fox Talbot (the Pencil of Nature),* 2002. Courtesy of the artist.

Chris Meigh-Andrews, *SunBeam,* 2011. Courtesy of the artist.

Richard Monkhouse, *Images produced by the EMS Spectron,* 1977. Courtesy of the artist.

Tony Oursler, *Escort,* 1997. Courtesy of the artist and the Lisson Gallery, London.

Nam June Paik, *Zen for TV,* 1961. Courtesy of Carl Solway Gallery, Cincinnati, OH

Jacques Perconte, *Impressions-Infinite,* 2010. Courtesy of the artist.

Peter Callas, *Night's High Noon,* 1988. Courtesy of the artist.

Dan Reeves, *Obsessive Becoming,* 1995. Courtesy of the artist.

Dan Sandin: *Live performance at Electronic Visualization Event 3,* 1978. Courtesy of the artist.

Eric Siegel, *Einstine,* 1968. Courtesy of Electronic Arts Intermix (EIA), New York. http://www.eia.org

Steina, *Summer Salt,* 1982, Courtesy of the artist.

Marty St James and Anne Wilson, *The Swimmer, Duncan Goodhew,* 1990. Courtesy of the artists.

Studio Azzurro, *Il Natatore,* 1984. Courtesy of the artists.

Woody Vasulka, *Art of Memory,* 1987. Courtesy of the artist.

This edition of A History of Video Art has developed directly out of the original edition, first published in 2006. In writing the original, I had wanted to try to provide a guide to the background and genesis of artists' video as I had experienced it, and this is still the primary purpose of the book. Encountering artists' video in the early 1970s I became captivated and enthralled by the swiftly developing technology and the challenging theoretical, cultural and political context, and inspired by the passionate commitment of many artists to the communicative power and creative potential of the medium.

In the early days video was perceived as a medium on the 'outside' – technically inferior to film, not suitable for broadcast, difficult to show in the gallery and yet so clearly offering something that other media did not – or could not. Video had a unique and compelling immediacy – and with the introduction of the Portapak, it's instantly 'replayable' image and sound made it ideal for personal experimentation. For artists seeking new possibilities, video offered something equivalent to an audio-visual sketchbook, and additionally could be operated by a single person in just about any location or situation. As portable video recorders and cameras become less expensive and more reliable and as the image and sound quality improved and presentation methods become more practical, it's advantages and strengths become increasingly obvious to those who had initially been sceptical – even hostile to its potential.

The first edition of this book had grown out of my own experience with all of this – as a practicing artist and as one who was seeking to make sense of its complex trajectory; both personally and as a teacher attempting to communicate these ideas to other developing artists. My own early experience with artists' video had been very much a transatlantic one; meeting artists who worked with the medium in the 1970s in the USA and Canada before coming to the UK to study and become involved in the London video art community. I became aware of the personal networks of artists, curators and activists involved and how these were crucial to the development of the art form.

The book began as PhD research into the context and background of my own art practice and was completed in 2001 under the watchful and patient eye of AL Rees at the Royal College of Art, with additional input, advice and encouragement from Prof. Malcolm Le Grice. The thesis was not in any sense suitable for publication and developing it into something that might be of use to others took me nearly five years. (Although not all of that time was spent writing, as I was determined not to stop making and exhibiting my own work!)

My own experience as an artist working with the medium across this period was that the limitations and capabilities of the technology that I was able to access had

had an impact on the ideas, content and form of the work I was able to make, as well as on how it was perceived, and this was something I also observed in the work of my colleagues and peers. These insights and observations have had an impact on my approach to writing and structuring this book.

A History of Video Art is divided into three main sections: a discussion of the historical and critical context in which artists' video developed and evolved; an examination of some representative works in relation to both technical and critical context, and a final section which attempts to examine artists' video in relation to a period of rapid technological change. I have retained this structure in the new edition because it still seemed to offer a way to organize a very complex and diverse set of concerns, and I felt that this was still the best way to try to communicate and to initiate other alternative approaches and investigations. I remain convinced that there is a need for many parallel historical narratives in the history of any subject, and hence the title remains 'A History of Video Art'. This is simply one of many possible historical surveys, and should be seen in this light. I wanted to encourage readers to engage in the development of their own research and to form and develop their own understanding and perceptions, perhaps as a direct result of reading this book,

This new edition includes changes and corrections to errors and omissions present in the first edition and I would like to thank those artists and readers who have made suggestions and pointed out mistakes and inaccuracies. This edition has been expanded to include brief summaries of the development of the genre in a number of countries – Japan, Australia, China, India and Brazil as well as discussions of new works by artists working in countries not previously covered, such as South Africa, Brazil, Japan, Pakistan and Israel. These are of course simply examples, as there are now many countries in which artists' video is made and shown. I wanted, within the limitations of the book to give a sense of the truly international scope of artists' video, and the way in which influences and ideas have spread and interacted.

Writing this book has been a challenging, rewarding and enriching experience, giving me greater insight into a medium that has fascinated me from the first time I picked up a Portapak in 1972. More importantly, it has given me the opportunity to meet and engage with some of the most significant and insightful artists working in the last part of the twentieth century and into the beginning of the new millennium. Video as a medium has evolved and transformed – some would argue that it has been re-absorbed into a new rejuvenated notion of 'cinema', with a brief flowering as a separate art form with its own unique trajectory. This may well be the case, but however things unfold, I hope that this book will in some way help to inspire a new generation of artists to explore and challenge creative frontiers and to develop moving image culture into the next decade and beyond. As always it is crucial to know and understand what has gone before, and to have a sense how what you are doing now connects and builds upon it.

As with the first edition, I would like to acknowledge the help and support of many friends, artists and colleagues. In addition to those named in the first edition they include Michael Goldberg, André Parente, Peter Callas, Takahiko Iimura, Stephen Jones, Shinsuke Ina, Warren Burt, Terry Flaxton, Peter Angelo Simon, Robert Cahen, Peter Kennedy, Jozef Rabakowski, Beryl Korot, Jacques Perconte, Churchill Songezile Madikida, Guy Ben-Ner, Andrew Demirjian, John Gillies, Dan Sandin, Steve Beck,

Gary Willis, Vince Briffa, Itsuo Sakane, Lori Zippay, Sei Kazama, Hatsune Ohtsu and Bani Abidi.

I would also like to thank Tristan Palmer, the editor of the first edition at Berg and Katie Gallof, the editor of the 2nd edition at Bloomsbury for their support, guidance and advice at every key stage in the development of this book.

As ever, I would like to thank my wife Cinzia, whose love, support, advice and encouragement have continued unabated, despite the increasing demands of her own projects and commitments. The second edition of this book is dedicated with affection to my friends Steina and Woody Vasulka – video pioneers and visionaries.

Chris Meigh-Andrews, Colchester, February 2013.

PART I

THE ORIGINS OF VIDEO ART: THE HISTORICAL AND CULTURAL CONTEXT

As a result of the tool's unprecedented usefulness, video conveys far too much information to be counted among the traditional plastic arts. It supports characteristics that would connect it more appropriately to the temporal arts of music, dance, theater, literature or cinema. Nor is it a tangible object, and fine art almost invariably is, but rather the ethereal emanation of a whole set of complicated electro-magnetic devices. In fact, video is more an end than any one specific means; it is a series of electronic variations on an audio-visual theme that has been in continual progressive flux since its inception. For the purposes of art, video's theoretical and practical possibilities are so inconceivably vast, its versatility so immeasurably profound and of such perplexing unorthodoxy, that even after a quarter of a century, the medium's defenders are still struck with vertiginous awe as if glimpsing the sublime.

Marc Meyer, *Being & Time*

INTRODUCTION

Towards the end of the middle decade of the twentieth century, a perplexing and complex art form emerged in Europe and the United States. Variously called video art, artists' video, experimental video, artists' television, 'the new television' – even 'Guerrilla TV'. The genre drew on a diverse range of art movements, theoretical ideas, and technological advances, as well as political and social activism. In this period of dynamic social, economical and cultural change, much new art was formally and politically radical – artists who took up working with video in this period were highly influenced by movements and ideas from Fluxism, Performance art, Body art, Arte Povera, Pop Art, Minimalist sculpture, Conceptual Art, avant-garde music, experimental film, contemporary dance and theatre, and a diverse range of other cross-disciplinary cultural activities and theoretical discourses.

Video art was also clearly an international phenomenon. From the outset artists working with video have not only drawn from diverse cultural influences, but they have also imported ideas and attitudes across national boundaries, enriching and nourishing the wider fine art practice as well as re-appropriating ideas and approaches from other disciplines and media. Distinctive practices from one country have been grafted onto another, so that in order to grasp the complex history of artists' video one must have an overview of the approaches and attitudes that have contributed to the genre.

It will be seen that video art can itself be divided into a number of sub-genres which reveal something of the hybrid nature of the art form, and where relevant, this book will discuss and explore the numerous strands of this complex phenomenon. Video art's relationship to broadcast television is especially problematic, since many artists took up a position against it, and sought to change it, or to challenge the cultural stereotypes and representations it depicted. Since both share a common technology, especially in terms of how the final images and sounds are presented and experienced, the relationship between artists' video and broadcast TV is complex and varied, and it is one of the central issues of this book.

In tracing a history of video art, I have chosen to examine the relationship between developing and accessible video imaging technology and video as an art medium and to discuss a representative selection of influential and seminal works produced by artists working in a number of different countries. This analysis does inevitably involve both a historical and chronological approach, as the influences and cross-references of artists' activities are cumulative, especially in relation to developing technology and access to the production facilities and equipment. I have chosen to trace the development of video art in relation to changes in technology because this reflects my own experience and involvement in the evolution of video art practice

during the period under discussion. Clearly this approach is not without its problems, but it is undeniable that video as a medium is technology-dependent, and I believe that any history of artists' video must acknowledge the part played by issues of access to the technological means of production on the development of its form and in relation to the cultural context. It seems important to stress however that I do not use these technological developments as a system or method of analyzing content, but as a method of structuring a chronology and categorizing approaches and themes explored by artists that helped to shape and unlock issues relating to content, representation and meaning.

During the period under discussion (from about 1960) there has been an extraordinarily rapid development in electronic and digital imaging technology. Advances in the field have transformed video from an expensive specialist tool exclusively in the hands of broadcasters, large corporations and institutions into a ubiquitous and commonplace consumer product. In this period video art has emerged from a marginal activity to become arguably the most influential medium in contemporary art.

Video recording equipment generally available to the artist in the late 1960s and early 1970s was cumbersome, expensive and unreliable. These early 'low-gauge' videotape recordings were grainy, low-contrast black-and-white. Editing was crude and inaccurate, with an end result that was considered by many, especially broadcasters, entirely unsuitable for television. This situation had completely changed by the mid to late 1980s – artists had regular access to lightweight and portable colour video camera/recorders capable of producing near broadcast-quality images and frame-accurate multi-machine non-linear editing with 'real-time' digital effects. This technological transformation, fuelled by the demands of the consumer market and converging computer technology, has had a considerable impact on the visual culture generally, as well as on broadcast television and particularly on contemporary art and culture. This period of rapid technological change has also naturally had a marked effect on the kind of screen-based works and installations produced by artists. In identifying the crucial relationship between this technological change and video art, American writer and critic Marita Sturken puts it succinctly:

> In a medium heavily dependent on technology, these changes ultimately become aesthetic changes. Artists can only express something visually according to the limits of a given medium's technology. With every new technique or effect, such as slow motion or frame-accurate editing, attempts have been made to use these effects for specific aesthetic results. The aesthetic changes in video, irrevocably tied to changes in its technology, consequently evolved at an equally accelerated

pace. For instance, within a short period of time, digital imaging and frame-accurate rapid editing have replaced real time as the most prevalent aesthetic styles. Whereas in 1975 it was still standard fare to produce a tape in real time, by 1982 it had become (when rarely used) a formal statement.[1]

This approach to an understanding of the evolution of video art via the development of technology is potentially contentious. Indeed, the very notion of a history of video art is itself problematic. Artists' video is a comparatively new activity – the first video works to be clearly identified and labelled as 'art' were produced in the late 1960s, and artists and curators anxious to identify the new cultural form have tried to define a canon with little success. The art form itself seems paradoxically to defy the activity of classification whilst simultaneously requiring it.

The terms 'artists' video' and 'video art' are both themselves increasingly troublesome, and with the phenomenon of converging electronic media with the rise and spread of digital technology, these labels are often ascribed to any kind of moving image art practice, regardless of the original format or source material. Video Art is now often used as a way to describe and identify any moving image work presented within an art gallery context and this is particularly the case when the work in question is displayed on multiple screens. During the 1990s the term began to be used interchangeably with artists' film, and this was at least partly because of the improvements in the quality and availability of video projection equipment, and even more recently, the development of large, flat screen LCD (Liquid Crystal Display) and plasma screens, and the accessibility of high-definition recording and playback formats. Within the contemporary context, there is a tendency for all types of artists' film and video to be considered a sub-genre of cinema, although curiously, the label 'video artist' is not uncommon, even preferred by gallerists, curators and the public.

Art works recorded onto videotape (or, more recently, disc and computer hard drives) are by nature ephemeral – many early video formats are either no longer playable, or are obsolete – pioneering and historically significant videotapes are deteriorating rapidly and many are already lost or irretrievable. This is not only a problem limited to recorded works – once a video installation has been exhibited and disassembled, only the documentation remains to attest to the work's former existence. The rapid introduction of new and more sophisticated formats and recording and display systems also present the artist and curator (and potential collectors and archivists) with considerable dilemmas relating to the presentation and exhibition of historical work designed to operate with obsolete and defunct technological hardware, and this is an especially acute issue with much medium-specific work in the so-called 'post-medium' period.

This book also contains chapters devoted to developments in experimental music and avant-garde film practice as these fields overlap with the development of video art, and since both also precede the development of video, offer important insights into the relationship and influences between developing technology and cultural form. It is also undeniable that artists often chose to work across and between conventional media and genre boundaries, many deliberately refusing to be categorized or typecast as filmmakers, photographers, sculptors, painters or composers – and especially not as video artists!

1. IN THE BEGINNING
THE ORIGINS OF VIDEO ART

The impermanent and ephemeral nature of the video medium was considered a virtue by many early practitioners: artists who wished to avoid the influences and commercialism of the art market were attracted to this temporary and transient nature – working 'live' could in itself be a political and artistic statement. But the impermanent nature of the video medium demands some kind of record, and it seems likely that written histories such as this one will eventually be all that remains. This of course means that many important works will inevitably be 'written out' of history; lost, marginalized or ignored – especially those works which do not fit with current notions or definitions. The history of video art, unlike the history of painting and sculpture, cannot be rewritten with reference to 'seminal' or canonical works – especially once those works have disappeared. It is also obvious that videotapes not considered 'significant' are unlikely to be preserved, archived or restored.

The development of video as a medium of communication has been, and remains, heavily dependent on technology, and the activity of artists' video is inevitably as dependent on the same technological advances. Parallel to this development is the question and issue of accessibility. In general, as video technology has advanced, relative production costs have decreased. The equipment itself has also become increasingly reliable, more compact, less costly and more readily available. It is also important to point out that the design and function of that equipment is not without its own 'bias', in the sense that electronic engineers are rarely themselves 'end-users'. This bias may well include (or certainly extends towards) the ideological, and in this sense we get the 'tools' that we are given, rather, than necessarily, the tools we might want, even supposing we knew what they were or might be. This book includes material on artist/engineers – innovators who sought to build technological tools to suit their own particular aesthetic and creative requirements.

Technological developments in the related fields of broadcast television, consumer electronics, computer hardware and software, mobile telephones, video surveillance, the Internet, and more specialized imaging technologies such as thermal imaging, magnetic resonance imaging (MRI), etc. have all had an influence on the developing aesthetics of video art. Changes in technology, reliability, miniaturization

and advances in electronic imaging systems, synchronization and computer control devices have also influenced the potential for video installation and image display. Video projection is now commonplace, computer-controlled systems for multi-machine synchronization during playback, Digital Versatile Disk (DVD) players and hard drives have made multi-screen and interactive presentations and continuous replay reliable and practicable.

In the last decade the widespread use of mobile phones with the incorporation video-imaging devices has had an increasingly profound impact on moving image culture, particularly in tandem with the rise of the Internet, video streaming and social networking. It has become commonplace to be able to 'post' images and video clips on-line, or connect a web cam – sharing and downloading picture and sound anywhere, and at any time. Editing and image-processing software has also become much more available and easier to use. This sea change in the way that moving image culture can be produced, accessed, experienced and disseminated has had a powerful impact on the public perception of artists' video, and on the way artists themselves use and communicate with the medium.

Clearly, this technology-dependent relationship is especially problematic in relation to any art historical analysis, not least because of the confusions that arise from issues of 'modernism' and 'modernity' in fine art discourse. A discussion of video's inherent properties has been the predominant method of tracing the medium's history and this is revealing of a fundamental problem in any analysis of the relationship between Western cultural creativity and technology. American writer and critic Marita Sturken points out that early video artists explored the specific properties of video not only in order to distinguish it from other fine art media such as film, painting and sculpture, but because these properties also had much in common with other concerns of the period – especially those of Conceptual Art, minimal sculpture and performance.[1]

Video artist and writer Stuart Marshall (1949–93, UK) claimed there was nothing inevitable about (British) video art practice's 'entanglement with late modernism'. The availability of portable video technology was co-incidental with a period when radical strategies such as alternative exhibition spaces and hybrid practices had become a significant aspect of avant-garde activity. The influence of experimental and avant-garde cinema on video art practice is especially significant, and Marshall identified the role played by experimental filmmakers as a model for early video artists with respect to production funding, distribution and organizational issues. He also linked the development of video art in the UK to its association with the art school.[2]

As a direct consequence of this institutional dependency on funding from agencies such as the Arts Council of Great Britain and regional arts associations, and for access to equipment and facilities from art school media departments, video art in the UK

was brought into direct competition with the more established media of painting and sculpture. Thus Marshall linked the development of a modernist video art practice to a strategy for survival:

> If, therefore, video were to develop a modernist practice it would stand on equal footing with other traditional art practices. At the same time, however, it would have the advantage of being recognised in its specificity as a result of the modernist concern with the foregrounding of the 'inherent' properties of the medium.[3]

David Hall (1937, UK) was one of the first video artists in the UK to identify his practice with this approach. In his influential essay 'Towards an Autonomous Practice', Hall set out his position. Trained as a sculptor, he worked with photography and film before taking up video. He was not interested in work which used video, but rather works which foregrounded video as the artwork, and in his writings he was most concerned to distinguish video art practice from television:

> Video as art seeks to explore perceptual thresholds, to expand and in part to decipher the conditioned expectations of those narrow conventions understood as television. In this context it is pertinent to recognize certain fundamental properties and characteristics which constitute the form. Notably those peculiar to the functions (and 'malfunctions') of the constituent hardware – camera, recorder and monitor – and the artist's accountability to them.[4]

Hall's position as the pre-eminent artist working in video in the UK during the mid-1970s was considerable, with an influence that was exerted not only because of his own rigorous and uncompromising video work, but also via his critical writing and his campaigning for the acceptance of video as a medium for art. Hall's own work sought to explore notions about the relationship of video technology to the institution of broadcast television, and he acknowledged the role of developing technology on video art in a short essay for the 1989 *Video Positive* festival catalogue:

> … developing technology has undoubtedly influenced the nature of the product at all levels and wherever it is made. These developments have inevitably affected aesthetic criteria as well as making life easier. In the early days of basic black and white Portapaks, extremely limited editing facilities, and no special effects, the tendency was towards fairly minimal but nevertheless profound pioneering work. This was necessary and appropriate at a time when concerns were generated in part by reductive and "cerebral" preoccupations. If it can be said that now, in this so-called post-modernist phase, an inclination

has developed towards more visually complex, even baroque artwork, then the timely expansion of technical possibilities in video allows for greater image manipulation. The dangers are that as the gap has gradually closed between the technology available to the artist and that used by for instance TV companies, temptations inevitably arise to indulge in what is often only slick and superficial electronic wizardry. The medium here indeed becomes the message. Conversely the current availability of complex studio mixers, time-base correctors, multi-machine editing, "paint boxes"and other dedicated computers can provide (with due caution for their many seductions) a very sophisticated palette inconceivable twenty years ago.[5]

Although an approach to working with video through an examination of the medium's unique qualities was the dominant position of artists during the early period, the attraction of the establishment of these inherent properties as significant was not limited to practitioners. It was also especially attractive to those curators and historians who wished to validate the medium in a fine art context. For Marita Sturken this problematic relationship between technology and art is one of the principal causes for both the comparatively immature state of video theory and the troublesome relationship to an historical context.[6]

Broadcasters with an interest in innovative television took note of video artists' examination of the medium, but only insofar as these activities could be seen to form an experimental 'advance guard' for new techniques to be plundered by the media. British TV producer John Wyver is critical of any treatment of video art as a separate category and argues for a history of convergence, based on a notion of the digital. He points out that the period when it was necessary to argue a special case for video art because of its lack of broadcast airtime, poor funding and gallery exposure has long passed: '… concentration on video as video cuts the forms of video creation off from the rest of an increasingly dynamic and richly varied moving image culture'.[7]

But questions of context and definitions of video art often seem more of a problem for the critic than for the artist. Many artists who took up video in the early 1970s were attracted to the medium precisely because it did not have either a history or an identifiable critical discourse as an art medium. American writer David A Ross saw this lack of a critical position as a 'Pure delight…' . Video was the solution because it had no tradition. It was the precise opposite of painting. It had no formal burdens at all.[8]

Feminist artists were attracted to the medium for similar reasons. Shigeko Kubota (1937, Japan) Japanese/American video artist (and wife of video pioneer Nam June

Paik – see below) claimed in the mid-1970s 'Video is Vengeance of Vagina. Video is Victory of Vagina', championing video and claiming the new medium for women:

> I travel alone with my Portapak on my back, as Vietnamese women do with their babies
> I like video because it is heavy.
> Portapak and I travelled over Europe, Navajo land, and Japan without male accompany [sic]
> Portapak tears down my shoulder, backbone and waist.
> I feel like a Soviet woman, working on the Siberian Railway.[9]

These statements identified Kubota's claim for video as a medium empowering women and enabling them to attain recognition that many felt would not be possible via the more traditional and male-dominated disciplines of painting and sculpture.[10]

Whilst it is clearly the case that many feminist artists were initially attracted to video because of its lack of a history, by its immediacy, and by its less commodifiable nature, these same attributes were also appealing to male artists with comparable counter-cultural, subversive and radical agendas. By the mid-1970s video artists had developed a variety of strategies and approaches to video bound up with the particularities of a new and developing medium. The short history of video art, which began in the early 1960s with work by two artists working in Germany, has its early roots in a radical anti-art movement called 'Fluxus'.

FLUXUS, NAM JUNE PAIK AND WOLF VOSTELL

American writer and curator John Hanhardt argues that video art in the United States has been formed by two issues: its opposition to commercial television and the intertextual fine art practices of the late 1950s and early 1960s. Hanhardt also identifies the introduction of the Sony 'Portapak' in 1967–8, as a key event, 'placing the tools of the medium in the hands of the artist', but also indicates that the pre-1965 activities of artists Nam June Paik (1932, Korea to 2006, USA) and Wolf Vostell (1932–98, Germany) in appropriating the television apparatus and presenting the domestic TV set as iconic, were crucial to the establishing of video art as discourse, and influential on subsequent generations of video artists.[11]

Both Paik and Vostell were connected to the Fluxus movement, a loosely defined international group of artists interested in debunking the art establishment and other cultural institutions. Drawing on earlier so-called 'anti-art' movements including Dadaism, the ready-mades of Marcel Duchamp (1887–1968, France), and highly influenced by the chance operations employed by the American composer John Cage (1912–92, USA), Fluxism flourished from the late 1950s into the early 1970s, and

was influential on the development of Conceptual Art. Fluxus artists produced ironic and subversive work that was deliberately difficult to assimilate, often organizing live events or 'happenings' critical of materialism and consumerism (see Chapter 5 for further discussion of Fluxus and its relationship to experimental music).

John Hanhardt argues that through the adopting of collage techniques Vostell and Paik overlapped media technologies and strategies, engaging in a blurring of categories that established a dialogue between artists. The Paik-Vostell strategy of removing the domestic television from its usual setting and incorporating it into performances and installations subverted it as an institution and underlined its role in shaping opinion and producing cultural stereotypes. For Hanhardt, Paik and Vostell's activities 'broke frame', violating the social and cultural frame of reference.[12]

In *Television dé-Collage* (1961) Wolf Vostell suggested distorting the TV image using random interference to the broadcast images of television receivers installed in a Paris department store. Thus Vostell's 'dé-Collage' techniques employed the use of public spaces. Traditionally dé-Collage employed a reversal of the more conventional collage technique by erasing, removing and tearing off elements of texts, images and information to reveal and create new combinations. Vostell described dé-Collage TV as:

> TV Picture De-Formation
> with
> magnetic zones
> DO IT YOURSELF.

Hanhardt posits that all forms of video art – screen-based work and installation, can be understood as collage because of the way in which the electronic processing, layering and mixing of images and sounds is an inherent aspect of video technology, including the image display and viewing condition:

> Strategies of image processing and recombination evoke a new visual language from the multi-textual resources of international culture. The spectacular history of the expanded forms of video installation can be seen as an extension of the techniques of collage into the temporal and spatial dimensions provided by video monitors placed in an inter-textual dialogue with other materials.[13]

NAM JUNE PAIK AND THE INFLUENCE OF JOHN CAGE

Nam June Paik is considered by many to be the seminal figure in the emergence of video art. The range of his work with video covers most of the categories within

the genre: installation, live performance and broadcast, as well as single and multi-channel works. It is instructive to trace the development of his approach to working with the apparatus of television, drawing most significantly from the ideas and pioneering attitudes of John Cage.

Prior to working with the television set as a cultural object, Paik's activities were within the field of avant-garde music. After studying aesthetics, music and art history at the University of Tokyo, Paik went to Germany. Initially enrolling on a music history course in Munich, Paik soon switched to the study of musical composition under Wolfgang Fortner (1907–87, Germany) at the Academy of Music in Freiburg. During this period Paik's fascination with sound collage techniques and the use of audio recordings as a basis for musical composition emerged. On advice from Fortner, Paik went to work in the electronic sound studio of WDR, the West German Radio station in Cologne in 1959. By this time, The WDR studio had become a major centre for contemporary music, producing and broadcasting works by new international composers such as Cornelius Cardew, Karlheinz Stockhausen and Gyorgy Ligeti (see Chapter 4). Whilst working there, Paik came into contact with a number of these composers, himself becoming part of the German avant-garde music scene. Even more significantly, it was during this formative period that Paik encountered the ideas and music of John Cage.[14]

Initially, Paik was attracted to Cage because of his acknowledgement of the Zen Buddhist influence through the teachings of D. T. Suzuki, but it was Cage's attitude to musical composition and his notions about the liberation of 'pure sound' from musical convention that helped to free Paik from his veneration of the traditions of Western music:

> I went to see the music (of Cage) with a very cynical mind, to see what Americans would do with oriental heritage. In the middle of the concert slowly, slowly I got turned on. At the end of the concert I was a completely different man.[15]

In relation to Cage's agenda for the liberation of sound, Paik's avowed intention became to go a stage further, with musical performances calculated to irritate and shock his audience. Describing one particular Paik performance of the time, composer and writer Michael Nyman quotes Fluxus artist Al Hansen:

> [Paik would]… move through the intermission lobby of a theatre, cutting men's neckties off with scissors, slicing coats down the back with a razor blade and squirting shaving cream on top of their heads.[16]

In *Homage to John Cage* (1959) Paik even performed these anarchistic and provocative

actions on Cage himself.[17] Cage describes one particularly harrowing performance that took place in the Cologne apartment of Mary Bauermeister (music student and later, second wife of Stockhausen):

> Nam June Paik suddenly approached me, cut off my tie and began to shred my clothes, as if to rip them off. [Paik then poured a bottle of shampoo over Cage's head] Just behind him, there was an open window with a drop of perhaps six floors to the street, and everyone suddenly had the impression that he was going to throw himself out.

Instead Paik strode from the room, leaving all present frozen and speechless with terror. A few minutes later the telephone rang; it was Paik announcing that the performance of the *Homage to John Cage* was over.[18]

By 1959 Paik's compositions were built of a combination of audio tape collage and live action performance activities such as smashing eggs or glass, and most significantly, overturning a piano. Paik's symbolic destructive acts were a way of signifying a break with convention and a rebellion against the representatives of the musical status quo.[19] The piano, symbolic of traditional values in Western music, was the ideal technological object:

> … Paik's musical education bore the imprint of a wholehearted admiration for European music. Therefore one can assume that he had a stronger awareness of the cultural significance of the piano than the European who, more often than not, is indifferent to his own traditions.[20]

EXPOSITION OF MUSIC-ELECTRONIC TELEVISION

Paik's first solo exhibition was at Rolf Jahrling's Galerie Parnass, in Wuppertal, Germany during March 1963. For several months prior to this exhibition Paik had been secretly experimenting with television sets in an attic space rented separately from his main studio. Paik felt this secrecy necessary because he was particularly wary of criticism, and nervous that other artists would prematurely take up his ideas. Working occasionally with an electronics engineer, Paik set to work modifying the circuitry of a number of television receivers – literally making 'prepared' televisions, perhaps drawing on the idea of Cage's prepared pianos.

In an interview with American video artist and writer Douglas Davis, Paik explained how this came about, sketching out the background and describing some of the modifications he made:

> If you work every day in a radio station, as I did in Cologne, the same place where television people are working, if you work with all kinds of electronic equipment

producing sound, it's natural that you think that the same thing might apply to video... . I developed the horizontal modulation, that stretches the faces, and also vertical modulation, which I've never been able to reproduce on American television sets for some reason. I hadn't thought of the magnet at that time, but I was working with sync pulses that warped the picture with sound waves. I also made negative TV, a set in which the blacks and whites were reversed; the picture was without sync too, so that it just floated across the screen, always in motion. I made a set with a microphone so that when you talked, the TV line moved... . A number of the sets you could change by playing with the dials.[21]

For his exhibition at Galerie Parnass Paik extended an idea previously explored for his 1961 exhibition 'Symphony for 20 Rooms'. In 'Exposition of Music-Electronic Television' Paik exhibited a range of musical and visual objects throughout the rooms and gardens of the gallery. Among the objects on display, which ranged from prepared pianos to modified record players and tape recorders (all of which demonstrated the influence of John Cage) were the modified television sets.[22]

Scattered across the floor in one room within the gallery, all the televisions were tuned to the same frequency. Although displaying the same broadcast, the TV pictures had been electronically modified in different ways – two were not working properly, presumably damaged in transit,[23] and the remaining ten were arranged into three groups. The TV broadcast pictures were distorted to present abstract image forms, in some cases by introducing audio signals into the modified picture display either from a radio or microphone as described above.[24]

Paik's notion of 'random access', drawn from computer terminology, was important both to the overall concept of the exhibition and to his appropriation of television sets in this context. Themes of randomness and arbitrariness were important at this time to avant-garde composers such as Cage and Stockhausen, and to the Fluxus group of which Paik was a founder member and a major force. In his exhibition at Galerie Parnass Paik was concerned to create participatory works, with images and effects produced directly through the engagement and actions of the audience. His use of the television sets in this context was intended to reverse the usually passive mode of the viewer-television relationship:

> Paik was exploring the technical possibilities of the medium with the goal of cancelling out its one-directional character and creating further possibilities of intervention. He provoked the creation of a new aesthetic of the distorted picture by transforming the normal process of recorded images, the aim of which was to be distortion free. As with most of his other exhibits involving various media, he tried to involve televisions in his concept of audience participation.[25]

Paik's prepared televisions had clearly drawn inspiration from Cage's prepared pianos, but Cage's 1951 composition *Imaginary Landscape No. 4* (which co-incidentally used twelve 'live' radios), was also a direct and significant influence.

Imaginary Landscape No. 4, a four-minute piece for twelve radios, featured two 'players' at each – one to control the tuning, the other to adjust the tone and volume. Cage's intention had been to further liberate the compositional process from aspects of personal taste after a challenge from Henry Cowell who claimed that *Music of Changes* was not free of personal preferences.[26] In 1949, Cage had written: 'a piece for radios as instruments would give up the matter of method to accident'.[27]

Although the influence of Cage is clear, Paik's appropriation of the domestic television set as cultural icon could be seen to extend Cage's use of the radio in works such as *Imaginary Landscape No. 4* because of the participatory aspects outlined

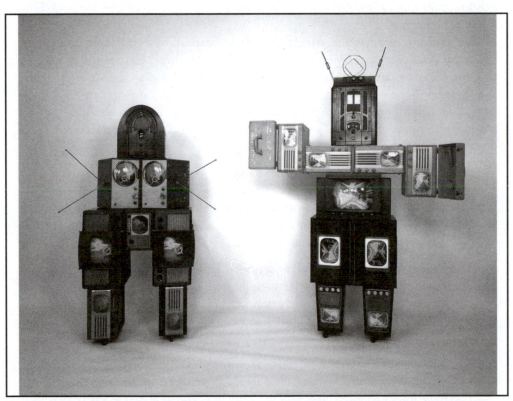

1:1 Nam June Paik, *Family of Robot: Grandmother and Grandfather*, 1986. Courtesy of the artist and Carl Solway Gallery, Cincinnati, Ohio. Photo by Carl Kowal.

above.[28] Whilst the potential of musical experiences beyond the concert hall were important to Cage, in *Imaginary Landscape No. 4* the audience experience is still predominately passive. Paik extended this participatory aspect through his appropriation of the television set: '[building] on the active personal experience of the non-initiated'.[29]

Nam June Paik's 'Exposition of Music-Electronic Television' is an important event in any history of the genre and is widely acknowledged as the first exhibition to present television as a medium for art. Paik's work is significant in that it engaged directly with the available (and accessible) technology, challenging the established 'one-way' process of broadcast television via a series of individual technical manipulations. Drawing on influences from experimental sound collage and electronic music, and directly from the example of John Cage, Paik's prepared TV sets paved the way for a new electronically based art form, simultaneously critiquing and subverting existing communication technology. (For further discussion of the work of John Cage, see Chapter 5.)

In a critique of what she termed the 'sanctification' of Nam June Paik as the father of video art, the American video artist and writer Martha Rosler suggests that his Fluxus strategy of the importation of the television set into the art world anesthetized its domestic function simply producing an 'anti-art art'. Rosler is critical of Paik's position as a mythical figure, claiming that his activities did not advance the cause of a radical video art but simply reinforced the dominant social discourse of the day:

> He neither analyzed TV messages or effects, nor provided a counter discourse based on rational exchange, nor made its technology available to others. He gave us an upscale symphony of the most pervasive cultural entity of everyday life, without giving us any conceptual or other means of coming to grips with it in anything other than a symbolically displaced form.[30]

American video artist Woody Vasulka identified Paik's ambition for video art as one dedicated to elevating the genre to be of equal status to painting or sculpture, and it became a crusade that was increasingly tied in to his own ambitions as an artist.

> (Paik) would always take famous people if he could – the more famous, the more desirable. He was the shadow of everybody: McLuhan or Cage, or Nixon. You actually could see the effort of taking the established codes, putting them on television, destroying or altering them by the prescription of, let's say, Fluxus. So there was this anti-bourgeois effort ... Paik was caught in the middle of this transition because as he says openly: as music became electronic, and then "art"

and eventually "high art" – in the same way television – the electronic image, will eventually become material for high art. This was his struggle – to achieve high art at any price. This meant that he would violate any of the rules – the rejection of the popular, of the bourgeois, of the successful. But I think he had no strategy for this. As a man coming from the Orient, success is a condition for the definition of your significance. He fought it at times, but eventually settled to this notion that if he was not famous, or at least a famous Korean or Asian, then he had failed. So he carried this huge baggage of playing this specific role – and he became the first internationalist.[31]

Paik is not only significant because of his position as one of the first artists to seriously address crucial issues about the relationship between television and video, but also for his pioneering explorations of the potential of video as an art form via a wide range of approaches which include installation, broadcasting, live events and gallery screenings, as well his championing of the cause for the funding of video art in the United States. He was also instrumental in the setting up of artists' access to advanced production facilities such as the television workshop at WNET in New York. The development of his video synthesizer with electronic engineer Shuya Abe in 1969 is also a considerable achievement (see Chapter 7), as was his well-documented early use of the Sony Portapak.

PAIK AND THE DEBUT OF THE SONY PORTAPAK

Mythology surrounding the origins of video art present the apocryphal story of Nam June Paik's purchase of the first commercially available ½-inch portable video recorder – a Sony 'Portapak' at the Liberty Music shop on Madison Ave for $1,000 and his first use of it to record images of the Pope's visit to New York City, recorded from the back of a taxi, and shown that very evening at the Cafe Au Go-Go at 152 Bleecker Street in Greenwich Village, 4 October 1965.[32] This event, combined with Paik's 1963 exhibition at Galeri Parnass, has cemented Paik's reputation as the 'founding father' of video art. What is clear is that Paik, with a grant from the John D. Rockefeller III fund, purchased one of the earliest Sony Portapaks available in the United States and made and showed his first recording that evening.[33]

In a statement produced for the screenings (4 October and 11 October) presented as a preview to his November exhibition at Gallery Bonnino, Paik presented a brief manifesto of predictions for the new video medium:

> In my videotaped electric vision, not only you see your picture instantaneously and find out what kind of bad habits you have, but see yourself deformed in 12 ways, which only electronic ways can do.

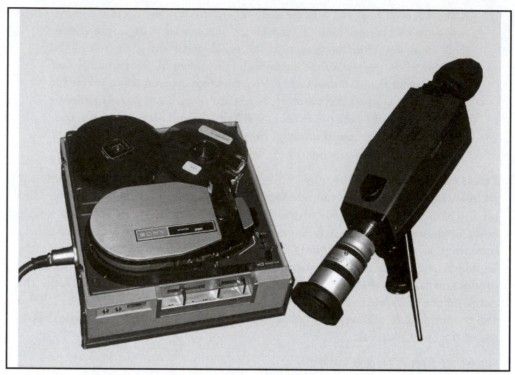

1.2: Sony AV 3400 'Portapak', 1986. Courtesy of Richard Diehl, http://www.labguysworld.com

*It is the historical necessity, if there is a historical necessity in history, that a new decade of electronic television should follow the past decade of electronic music.
** Variability & Indeterminism is underdeveloped in optical art as parameter Sex is underdeveloped in music.
*** As collage technic [sic] replaced oil paint, the cathode ray tube will replace the canvas.
****Someday artists will work with capacitors, resistors & semi-conductors as they work today with brushes, violins & junk.[34]

For many critics and video art historians, these events were critical 'utopian' moments. The newly available and relatively inexpensive portable video recorder clearly empowered artists, politically active individuals and groups to fight back against the corporate monopoly 'one-way' broadcast television system.

Nam June Paik's frequently quoted slogan 'TV has been attacking us all our lives – now we can attack it back' has an important place in all this. Artists found the

Portapak's accessibility, its instantaneity, the 'available light' capabilities of the camera, and the grainy, low-resolution grittiness of the monochrome image it produced very appealing. But there were a number of other significant factors besides the introduction of cheap portable video recording equipment and the state of broadcast TV to the genesis of video art.

2. CROSSING BOUNDARIES
INTERNATIONAL TENDENCIES AND INFLUENCES IN EARLY ARTISTS' VIDEO

GERRY SCHUM'S TV GALLERY AND *LAND ART*

The earliest examples of so-called 'television art' were produced in Germany by Gerry Schum's pioneering Fernsehgalerie (Television Gallery) in a specially commissioned TV programme entitled *Land Art* broadcast nationally from Berlin on 15 April 1969 at 10.40 p.m. *Land Art* comprised eight specially commissioned works by international conceptual artists including Richard Long, Jan Dibbets, and Robert Smithson. This innovative first broadcast was followed on 18 November in the same year when Schum's TV Gallery transmitted Keith Arnatt's *TV Project – Self Burial*, as a 'television intervention' on WDR II (Westdeutscher Rundfunk) Cologne.

Gerry Schum (1938–73, Germany) studied filmmaking at the Deutsche Film und Fernsehakademie in Berlin 1966–7. Whilst in the second year of his studies he was commissioned to make a five-minute report of *Schaustucke Ereignissei Feur, Luft, Wasser und Erde aus Kunstof,* a Fluxus 'Happening' staged by artist Bernhard Hoke at the Berlin Academy of Fine Arts (Akademie der Kunste). Schum's intention with his film of this event, subsequently broadcast on SFB – Sender Freies Berlin (Broadcaster of Free Berlin) 30 March 1967, was not merely documentation, but the creation of a televisual equivalent to parallel this complex art event.[1] This approach to Hoke's event was characteristic of Schum's film work with artists on subsequent broadcast projects such as a feature on the 6th San Marino Art Biennale and *Konsumkunst-Kunstkonsum* (*Consumption Art-Art Consumption*) both made for WDR, Cologne.[2]

In partnership with the artist Bernhard Hoke and his first wife Hannah Weitemeier, Schum developed a collaborative approach in which the interaction between the subject of the broadcast and the filmmaking process was a crucial element in the final product. This approach was very much in line with the prevailing attitude of the most progressive contemporary artists of the period – the very work that Schum and his collaborators were presenting. New industrial processes and techniques were being adopted by contemporary artists in a desire to challenge conventional notions about art which were bound up with issues of authorship and originality. New ideas about the making and experiencing of art which were current at the time included

the making and selling of low-cost art multiples, Fluxus and multi-disciplinary events, process art, Arte Povera, minimalism and Conceptual Art. Unique static object-based artworks had given way to transitory and ephemeral works, which could be site-specific and/or performance based. Many progressive artists were concerned to explore venues for art outside of the conventional 'neutral' gallery environment, using techniques and materials which had not traditionally been used to make art. Schum's work at this time began to explore the notion and potential of television as a medium for the direct experience of art, rather than simply for the presentation of documentaries about art. For example in *Konsumkunst-Kunstkonsum* Schum presented the German artist Heinz Mack describing his idea for a series of works exclusively for television:

> I intend to do an exhibition that is no longer held in a museum, that is no longer
> held in a gallery, but appears only once exclusively on television. All objects that
> I will be showing in this exhibition can only be made known to the public via
> the television and then will be destroyed by me.[3]

Following the production of *Konsumkunst-Kunstkonsum* Schum established Fersehgalerie Gerry Schum (Television Gallery Gerry Schum) and began working with a new partner, Ursula Wevers, who would soon become his second wife. Developing ideas from his previous broadcasts, Schum and Wevers conceived *Land Art*, a series of short films of works by eight international conceptual artists who worked directly in the landscape – Richard Long, Barry Flanagan, Dennis Oppenhiem, Robert Smithson, Marinus Boezem, Jan Dibbets, Walter De Maria and Michael Heizer. Schum had conceived of the broadcasting of these works as autonomous art events: his intention was to show 'only art objects', with no explanation, committed to the idea that artists should develop an approach in which a new kind of art object would be directly communicable via broadcast TV.

Schum had understood the unexplored potential of the works that these artists were making and their suitability for an entirely new approach to the experience of art. He sought out artists who could 'make art especially for TV', realizing that television broadcasting could provide the missing temporal element to process-based art, removing the material 'art object' and freeing up the spectator to a direct encounter with the work. Schum's clearly stated his aim and purpose in a letter to Gene Youngblood: '… all objects transmitted during the show of the Fernsehgalerie are specially created for the reproduction by the medium of TV. The only way of communication is the transmission by the TV station'.[4]

One of the most innovative artworks in *Land Art* was Richard Long's (1945, UK) *Walking a Straight Ten Mile Line*. Schum believed Long's contribution:

> ... created the most consequent object in the *Land Art* show. To mark his ten mile line he used neither chalk nor digged [sic] a trench. Only the camera filmed every half mile six seconds of landscape shooting in the direction he walked. Long himself was out of the camera frame.[5]

Long's work is portrayed in a six-minute film in which the spectator is presented with a direct experience of the making of the work within the landscape, via series of discontinuous zooming sequences each lasting 6 seconds, filmed at half-mile intervals. Although the work was shot on 16mm film: for Schum it was the broadcasting of this work that was the significant act. *Land Art* was conceived of as a 'live' transmission of the art object, in which the spectator's perceptual experience of the work is in the 'here-and-now' of the present. Schum sought to enable the viewer to engage in a critical detachment in which the television set itself could be simultaneously perceived as both a support structure for the image and as a manifestation of the work itself. The television was thus alternately both present and absent. Because of the minimal interventions of the filmmaking process that Schum imposed in the production of the works in *Land Art*, the spectator's attention could be focused directly on the functioning of the conceptions and actions of the artist and his/her engagement with the art activity.

The *Land Art* programme was also screened in a number of conventional gallery venues. In 1968 it was exhibited at the Institute of Contemporary Art in London as part of an important touring exhibition *When Attitudes Become Form*, and it was whilst there that Gerry Schum met the British artist Keith Arnatt (1930–2008, UK).

Keith Arnatt's *Self Burial* was originally constituted as a sequence of nine photographs called *The Disappearance of the Artist*. In discussions with the artist John Latham (1921, Rhodesia–2006, UK), Arnatt subsequently developed the idea into a TV project in which each of the nine images would appear very briefly in the middle of a normal TV broadcast. Arnatt and Latham had previously approached the BBC, who though interested, had declined the project. Following discussions between Arnatt and Schum at the ICA it was arranged to have the work broadcast on WDR in Cologne.

Self Burial was broadcast over eight consecutive nights at 8:15 p.m. and 9:15 p.m., when normal programmes were briefly interrupted and two images from the series were flashed onto the screen without any prior warning or introduction. Initially the interventions were for a duration of 2.5 seconds, but from 13 October they were increased to 4 seconds. On the final day of the project Arnatt was interviewed on a live television broadcast from the Cologne Arts Fair, his explanation of the work interrupted by his own images.[6]

Between Christmas Eve and New Year's Eve, 1969, WDR 3 broadcast another Television Gallery Gerry Schum intervention project when *TV as a Fireplace*, by Jan Dibbets (1941, the Netherlands) was screened at the end of each evening's transmission. Images of an open fire, in a sequence which develops from a small flame into a blazing fire and finally dwindles to glowing embers, were shown for 2:45 minutes each evening over eight consecutive nights for a total of 23 minutes. Although only broadcast locally, *TV as a Fireplace* was influential, widely copied and often cited as representative of Schum's overall project.

Schum began developing ideas for a new TV gallery broadcast to be called 'Artscapes' intending to extend the scope of the ideas behind the notion of gallery spaces or environments available via conventional exhibition venues. 'Artscapes' were to be seen as 'spaces totally dedicated to art, going beyond the concrete space … with the media of photography, film and television contributing decisively to their design'. The notion behind 'Artscapes' was to exploit the various technical processes available via the broadcast medium in order to transform the natural and cultural landscapes (the 'actual environment') creating 'art landscapes'. These transformations would be accomplished with a combination of film production techniques including slow and fast motion, the combining of real objects and models, and the use of macro photography. Schum sought to 'remove the separation of the art event and the medium of TV', seeking to create a similar situation for the visual arts to that of literature or music, believing that this approach would have the potential to reach a wider public.[7]

Although the 'Artscapes' project was never realized, a second television exhibition entitled *Identifications* was broadcast on Sudwestfunk Baden-Baden (SWF) in November 1970, featuring the work of 20 contemporary artists including Joseph Beuys, Klaus Rinke, Hamish Fulton, Gilbert and George, Alighiero Boetti, Mario Merz and Richard Serra.

The artworks broadcast on *Identifications* were all shot on 16 mm film, but soon afterwards Schum abandoned the medium, selling his film equipment and switching production to video, considering the potential of instant playback and review as a powerful asset for artists.

The following year Schum and Wevers established Video Galerie Schum in Düsseldorf, to produce, exhibit and market video art with an inaugural exhibition of three new video works by the sculptor Ulrich Ruckriem (1938, Germany): *Teilungen, Kreise* and *Diagonalen* (*Partitions, Circles and Diagonals*).

Despite his commitment and enthusiasm for video, Schum was plagued by difficulties with the medium in the early days, as it was expensive and bulky and required a considerable level of technical knowledge. Initially Schum recommended the Sony ½-inch system for making copies for distribution to museums and galleries, although

for production the TV gallery he used the industry standard 1-inch video format. Schum actively promoted the Phillips video cassette format when it was introduced in 1972, because he felt it would ease the logistical problems associated with the of distribution of artists' video work, but for some time the cassette tape stock was in very short supply. There was also the additional problem of international TV standards, the European system being incompatible with those in use in the United States and Japan, a factor which further hampered the distribution and sales of video artworks.

Gerry Schum was directly involved with the early video work of the British performance artists Gilbert Proesch (1943, Italy) and George Passmore (1942, UK). *The Nature of Our Looking* (1970), although originally shot on 16 mm film, was also available from the Videogalerie Schum on ½-inch video tape, and produced in an edition of four. More significantly, *Gordon's Makes Us Drunk* (1972) was produced at the 'Art for All' premises in East London directly onto 1-inch videotape. The eleven-minute tape was issued in an edition of 25 and labelled 'Sculpture on Video Tape'. Two more video works followed in the same year – *In the Bush* and *A Portrait of the Artists as Young Men*. These works were very much in line with Gerry Schum's understanding of the suitability of the video medium for the creation of 'art objects', comparing the instantaneity of the electronic image to that of paint and canvas:

> With the video system today it is possible for the artist to monitor his work as soon as an object has been realized for the video camera. This means you have the opportunity to take control of the medium in the same way as you do, for instance, with the canvas or paint medium where there is a learning process. I believe this learning process has very decisively contributed to making the video system as popular as it already is amongst avant-garde artists.[8]

Gerry Schum made a major contribution to the foundation of video as a medium for art through his visionary ideas about the potential of televisual space for the exhibition of time-based art and via his commitment to video as a production and distribution medium. The establishment of Videogalerie Schum anticipated the emergence of video as a significant art form and paved the way for the wider acceptance of artists' video alongside other more established art media.

EARLY VIDEO ART IN GERMANY

Video art in Germany was comparatively slow to develop in the early years, given the significance of the early contributions of Wolf Vostell, Nam June Paik's pioneering experiments with manipulations of the television display and the pioneering work of Gerry Schum. Early works such as Jochen Hiltmann's (1935, Germany) *Video*

Tape II (1972) and Harald Ortlieb's *Television 1* (1973) echoed Vostell's notion of the television set as a physical object and an integral part of the domestic setting in which the viewing habits and rituals associated with TV viewing were referenced. This attitude to the relationship between the viewer and the television was explored in a number of ways by foreign artists working in Germany in the early period, including the previously mentioned broadcast intervention by Keith Arnatt, as well as the Canadian artist Robin Page (1932, UK) who, in a project entitled *Standing on My Own Head* (1972), challenged the usually passive home audience to make a drawing of him and post it to the television studio. Nearly 3,000 responded to his challenge!

There were a number of important media activists working in Germany by the mid-1970s including Telewissen (Teleknowledge), a group based in Darmstadt and the Berlin-based Video-Audio-Medien. These and similar groups in Munich and Hamburg rejected narrow definitions of the art-making process, preferring to embrace a wider philosophy of social activism, recognizing the potential of the new portable video as a medium for social and political change:

> The spontaneous improvisation of trivial and fictional roles means a frame for social and communicative creativity which, by going beyond mere art production, understands itself as an emancipated contribution towards the development of newer and more time-appropriate behaviour forms and a growth of consciousness.[9]

Despite Germany's pre-eminence in the field of electronic music (as discussed in Chapter 5) electronic manipulations of the video image did not flourish in the early period except in the areas of televised music broadcasts and brief sequences in the intervals between regular programming on the WDR in Cologne. An example of this approach was *Black Gate Cologne* produced in 1968 by Otto Piene (1928, Germany) and Aldo Tambellini (1930, USA) for WDR, a 30-minute work made from the documentation of an installation which presented superimposed film projections and the interactions of polyethylene tubing with electronically coloured shapes.

The most prolific area of activity in early German video art was in the relationship between the recording process, physical action and the body in which artists such as Ulrike Rosenbach (1943, Germany), Jochen Gerz (1940, Germany), Christina Kubisch (1948, Germany) and Rebecca Horn (1944, Germany) took up the medium's potential as a tool for the documentation of live performance. For example in *Call Until Exhaustion* (1972) Gerz documented his efforts to shout 'hello' at a video camera 60 yards away.

Wolf Kahlen (1940, Germany) worked extensively with video in both installations and tapes in the 1970s, exhibiting a collection of 25 video works in Berlin in 1975 in which he explored the medium's potential to represent spatial relationships in relation

to his own body and the problems of human communication. Kahlen also made a number of significant sculptural video installations using simple natural objects. In works such as *Video Object I, II and III*, for example, he juxtaposed live video images of chunks of granite with the real material. Kahlen and Wolf Vostell initiated the earliest and most important collection of German video art at the Neuer Berliner Kunstverein in 1972.

Valie Export (1940, Germany) produced *Raumsehen und Raumhören Projekt 74* (*Spatial Seeing and Spatial Hearing*) a video installation featuring a live performance to multiple cameras at the Cologne Kunstverein in 1974. Also attracted by the potential of the new medium, Ulriche Rosenbach (Germany, 1943) also began experimenting with video in the early 1970s (see Chapter 14).

Maria Vedder (1948, Germany) has produced a number of significant works both as a solo artist and in collaboration with Bettina Gruber including *On Culture* (1978) *A Glance at the Video Shop* (1986) and *Der Herzschlag des Anubis* (*The Heartbeat of Anubis*) (1988).

Since the late 1970s there have been a number of important exhibitions of artists' video in Germany. Wulf Herzogenrath (1944, Germany) has been particularly active, curating the first video section at 'Documenta 6' in 1977, as well as the first major historical survey of video installation *Videoskulptur, Retrospectiv und Aktuel. 1963–89*, which toured Europe in 1989. In addition to these important showcase exhibitions, a number of important international video festivals such as the Videonale Bonn, the European Media Art Festival Osnabrück, and the International Media Art Festival transmediale in Berlin were set up in the 1980s.

Many of the most significant video artists in Germany have taught at art academies influencing the ideas and output of new generations. These include Marcel Odenbach (1953, Germany) and Klaus von Bruch (1952, Germany) at the College of Art and Design in Karlsruhe, Birgit Hein at the Brunswick College of Fine Arts, Maria Vedder and Heinz Emigholz (1948, Germany) at the Institute for Time-Based Media at the Berlin University of the Arts, and Peter Weibel (1944, USSR) who taught at the Institute for New Media in Frankfurt am Main before becoming director of the ZKM (Zentrum fur Kunst und Medientechnologie) in Karlsruhe.

THE BEGINNINGS OF ARTISTS' VIDEO IN THE NETHERLANDS

Video in the Netherlands had its tentative early beginnings around the end of the 1960s when a group in Eindhoven, led by Rene Coelho (1936, the Netherlands), formed 'The New Electric TV' to experiment with video and television. In 1970 Livinus van de Bundt (1909–79, the Netherlands) produced a series of synthesized tapes including *Moiree*, an early abstract tape in which colour and form were made

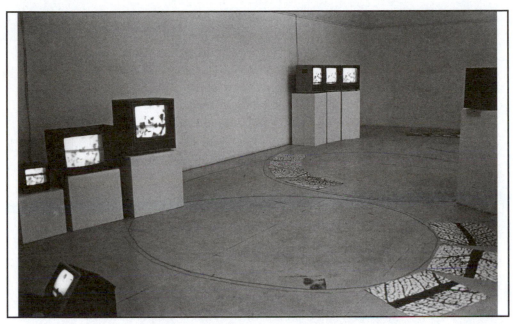

2.1: Madelon Hooykaas and Elsa Stansfield, *Finding*, 1983. Courtesy of the artists.

to correspond to changes on the soundtrack. The same year, Jack Moore founded 'Video Heads', a production studio in Amsterdam and video production activities were initiated in Rotterdam at the Lijnbaanscentrum. Although these facilities were initially only used to make supporting materials for exhibitions of work in other media, in the mid-1970s American artists such as Dennis Oppenheim and Terry Fox were invited to use the studios to produce new works.

In 1971 Openbaar Kunstbezit commissioned video work from Dutch artists Marinus Boezem (1934, the Netherlands), Stanley Brouwn (1935, Suriname), Ger van Elk (1931, the Netherlands), Peter Struycken (1939, the Netherlands), and the American artist Bruce Nauman that were broadcast on Nederlandse Omroep Stichting (NOP) on a programme called 'Visual Artists Make Video' (Beeldende Kunstenaars Maken Video). Theo van der Aa and Ger van Dijk founded the Galerie Agora in Mastricht in 1972 supporting artists working with video such as Elsa Stansfield (1945, UK – 2004, Netherlands) and Madelon Hooykaas (1942, the Netherlands).

Meatball, founded in 1972 in The Hague, was one of the most important centres for video art in the Netherlands. In 1975 it was renamed Het Kijkhuis and was regularly presenting work by international video artists, establishing the World Wide

Video Festival in the early 1980s. Montevideo, a video production facility and centre for media art, was also set up in Amsterdam in the late 1970s.

The De Appel Foundation, an organization initially set up in 1975 to present and promote new and radical art forms including live work and body art, began supporting and distributing new video work by artists working in the Netherlands such as Raul Marroquin (1948, Colombia), Stansfield and Hooykaas and Nan Hoover (1931, USA – 2008, Germany) and Michel Cardena (1934, Colombia). De Appel, along with the artists Stansfield and Hooykaas was instrumental in establishing the Association of Video Artists that led to the formation of Time-Based Arts, an organization dedicated to the promotion, distribution and exhibition of video art in the Netherlands in 1983.

Some of the video organizations that had flourished in the 1970s and early 1980s in the Netherlands were affected by the Dutch government's decision in 1986 to abolish the generous subsidies that artists had been enjoying up till then. This change in the fortunes of Montevideo and Het Kijkhuis, for example, whose subsidies were withdrawn by the Ministry of Culture, had the effect of directing public attention to the art form and resulted in the provision of special funding for Time-Based Arts, who assumed the role of representing Dutch video art at a national level.

Although art schools did not have the impact and influence on the development of video art as in the UK (see below), art academies in the Netherlands such as the Jan van Eyck and the AKI in Enschede were offering opportunities to study video at post-graduate and undergraduate level by the early 1980s.

EARLY VIDEO IN FRANCE

In France a number of radical filmmakers including Jean Luc Godard (1930, France), Chris Marker (1921–2012, France) and Alain Jacquier were involved in early video experiments working with the newly available Sony AV 2100 ½-inch deck and portable recorders in 1967–8 interested in using the medium as a catalyst for social change. The recent social and political unrest during the Paris events of May 1968 (see Chapter 3) had united many radical filmmakers and political activists, and this led directly to the formation of a number of collectives along similar lines to the New York-based Raindance Corporation (see Chapter 3). Chris Marker and André Delvaux established the film and video group SLON (Service of Launching of New Works), as 'a co-operative at the disposal of all those which want to make documentaries which share certain common concerns'.[10] Similar groups formed in France around the same time include Immedia, Les Cents Fleurs and Video OO.

Fred Forest (1933, Algeria) who worked with a Sony CV-2400 Portapak video recorder in 1967 was one of the first artists to experiment with video. His earliest

works, *The Telephone Booth* and *The Wall of Arles* were both made during 1967 and he produced an interactive video installation *Interrogation 69*, which was exhibited in Tours in 1969.[11] During the 1970s Forest continued to work with video, producing a number of important tapes and installations including *Gestures in Work and Social Life* (1972–4), *Electronic Investigation of Rue Guénégaud* (1973), *Senior Citizen Video* (1973), *Video Portrait of a Collector in Real Time* (1974), *Restany Dines at La Coupole* (1974), *TV Shock, TV Exchange* (1975), *Madame Soleil Exhibited in the Flesh* (1975), and *The Video Family* (1976).[12]

As in other countries, French performance artists were among the first to work with video, primarily using the new medium as an element within their live work or for documentation purposes. The earliest example of this in France was Gina Pane's *Nourriture,* Feu, Actualités produced in 1971.

As discussed elsewhere in this book, a number of filmmakers and musicians working at ORTF in Paris produced experimental video for broadcast television in the late 1960s and early 1970s using François Coupigny's 'Truquer Universel', an early video synthesizer (see Chapter 7) including Martial Raysse (1936, France), Jean-Christophe Averty (1928, France), and Olivier Debre (1920–99, France). The most significant video artist to emerge from this period at the OFTF was Robert Cahen (1945, France) (discussed in more detail in Chapters 5 and 10).

The first important video exhibition in France was 'Art-Video Confrontation' at the Musée d'Art Moderne and Centre d'Activités Audio-Visuales in Paris in 1974, which presented a mix of French and European video art.

Other important video artists to emerge in France during the late 1970s and early 1980s include several who were also writers and theorists for the medium such as Dominique Belloir (1948, France), who produced *Memory Foldes* (1977) using the 'Truquer Universel' and *Digital Opera* (1980), Thierry Kuntzel (1948, France) who made works such as *Nostos* (1979), and *Time Smoking a Picture* (1980) and Jean-Paul Fargier (1944, France), who produced *Carnet d'un magnétoscope* (1980) and *L'arche de Nam June Paik* (1981).

A number of major exhibitions in Paris in the early 1980s featured video installation work. French artists, including Catherine Ikam (1945, France) (*Fragments of an Archetype*, 1980); Thierry Kuntzel (1948–2007, France); Michel Jaffrennou (1944, France) (*Videoflashes, Totalogiques, 1982* and *The Sweet Babble of Electrons in the Video Wall,* 1983); and Nil Yalter (1938, Turkey) (*The Rituals,* 1980); were featured at the Centre Pompidou, the Biennales de Paris (1980) and the ARC (1981–3).

In 1981, the American artist, curator and writer Don Foresta (1939, USA) organized the earliest exhibition of video work by French artists to tour in the USA. This exhibition, which featured work produced in France during the 1970s, included

works by Roland Baldi (1942, Egypt); Robert Cahen, Collette Debre (1944, France); Catherine Ikam, Chris Marker, Olivier Debre, Francois Pain (1945, France); Partick Prado (1940, France); Claude Torey (1939, France); Nil Yalter and Nicole Croiset (1950, France).[13]

VIDEO ART IN POLAND

Video art in Poland first emerged in the early 1970s, as artists beginning to explore the potential of the new medium gained access to it via the *Film Form* Workshops. Drawing on the experience of experimental film, Polish artists sought to examine the formal properties and functioning of broadcast television, including its central role in domestic life and the nature of the live image of the closed-circuit television system (CCTV), as well as the television set as sculpture.

The art historian and curator Lukasz Ronduda identified the four most important artists working with video in Poland during the 1970s and 1980s as Wojciech

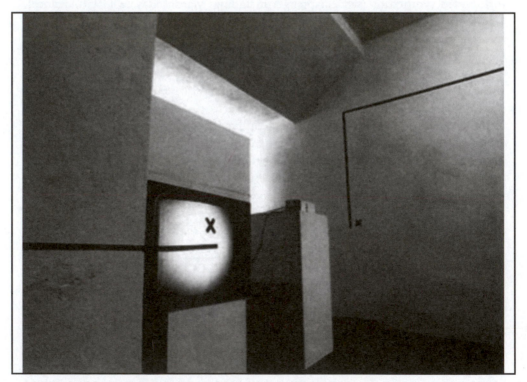

2.2: Wojciech Bruszewski, *From X to X*, 1976. Courtesy of the artist.

Bruszewski (1947–2009, Poland), Janusz Szczerek (1953, Poland), Jozef Rabakowski (1939, Poland) and Zbigniew Libera (1959, Poland). For Ronduda, the work of these four artists is significant because it established and determined the most significant trends and approaches to artists' video in Poland.[14]

Wojciech Bruszewski, who co-founded the Film Form workshop, explored the potential of video to explore the complex relationships between the representations of reality mediated via the electronic image. This was particularly apparent in both videotapes and installations in his series *The Video Touch* (1976–7), *Outside* (1975) and *Input/Output* (1977) (see Chapter 8).

Other artists from this early formative period include Andrzej Rozycki (1942, Poland) and Pawel Kwiek (1951, Poland) who both made their first video installations in 1973. The same year, Bruszewski and Piotr Bernacki (1954, Poland) made *Picture Language,* a videotape which explored the relationship between visual images and abstract signs. Bruszewski and Kweik (*Video A*) both produced works in 1974 focusing on the articulation and contradictions of image space.

The most significant theme in much of this work, as with Polish experimental film of the period, was the exploration of the relationship between reality (tele)visual representation and the viewer's perceptions. This theme was tied into an examination of the nature of the medium and its potential for the communication of abstract ideas.

Beginning with *An Objective Transmission*, considered to be the first Polish video installation (1973), Jozef Robakowski began to explore the potential of live video performance work, a genre that became one of the most prevalent forms of video art in Poland during the 1970s. In his single-screen videotapes Robakowski was particularly concerned to distance himself from broadcast television, in *Video Art: A Chance to Approach Reality*, written in 1976, he claimed:

> Video art is entirely incompatible with the utilitarian character of television; it is
> the artistic movement, which through its dependence denounces the mechanism
> of the manipulation of other people.[15]

Robakowski's videotapes such as *Memory of L. Brezhnev* (1982), and *Art is Power* (1985) (discussed in more detail in Chapter 9), can be seen as examples of his ideas about the complex relationship between artists' video and broadcast television.

By the mid-1970s a new generation of artists, many of whom had previously worked with film, had begun to explore the potential of video, including Jolanta Marcolla, Zbigniew Rybczynski, Janusz Kolodrubiec and Anna Kutera.

At the height of the Solidarity Movement in Poland during the beginning of the 1980s, there was a number of large-scale surveys of avant-garde work including

'Konstrukcja w procesie' (the Construction in Process) in Lodz and 'Nowe zjawiska w sztuce lat siedemdziesiatych' (New Phenomena in the Polish Art of the Seventies) in Sopot, both of which featured work by artists exploring the potential of the video medium.

After the imposition of martial law in 1981, there was inevitably a radical change to the lives of most Polish artists. Many went 'underground', exhibiting and presenting their work in alternative venues that had the positive effect of bringing critics, artists and the public into much closer contact with each other. With state patronage withdrawn, the film workshops, once the mainstay of experimental film production, ceased to function and access to filmmaking equipment and facilities became very restricted. Equipment such as video cameras had to be smuggled into the country and were often shared and passed between artists clandestinely, as possession was illegal for private citizens. However, after the lifting of martial law in 1983 video equipment became much more freely available (and as a direct result of technological developments it was also much easier to use) and video inevitably became the more prevalent medium for moving image work.

THE EMERGENCE OF ARTISTS' VIDEO IN ITALY

In 1952 Lucio Fontana (1899, Argentina; 1968, Italy) and his 'gruppo spazialista' formulated the 'Manifesto del Movimento spaziale per la televisione'. In an experimental television programme broadcast on RAI (Radio Audizioni Italiane), Italian state television, Fontana first applied his notion of the 'concetto spaziale' to the television image.

The earliest Italian video work was produced by artists known for their work in other media such as Fontana: Mario Merz (1925–2003, Italy); Franco Vaccari (1936, Italy); Eliseo Mattiacci (1940, Italy); Vettor Pisani (1934, Italy); Antonio Trotta (1937, Italy); Francesco Clemente (1952, Italy); and Mimmo Germana (1944–92, Italy).

A number of the artists associated with Arte Povera initially experimented with the formulation of a linguistic analysis of video with works that made use of 'narrative' or literary structures such as analogy and metaphor. Many of these early works presented a series of intricate, almost rhetorical structures, which contrasted with the early video work produced in the USA, for example, which often focused on single units of signification, as in the work of Nam June Paik.

In 1969 two kinetic artists, Vincenzo Agnetti (1926–81, Italy) and Gianni Colombo (1937–93, Italy) produced *Vobulazione e bieloquenza negativa*, based on the distortion of the video signal.

As in many other countries under discussion, there was a sudden flurry of

video activity in Italy at the beginning of the 1970s. The very first exhibition to include video work by Renato Barilli (1935, Italy), Maurizio Calvesi (1927, Italy) and Tommaso Trini (1937, Italy), was 'Gennaio 70, III Biannale Internationale della Giovane Pittura' at Museo Civico in Bologna. Following this, the first 'videosaletta' (video salon) was established in Milan in 1971 at Galleria Diagramma.

'TV mezzo aperto' ('TV Open Medium') is the inaugural exhibition at Galleria d'Arte Moderna e Contemporanea Palazzo dei Diamanti in Ferrara where the 'Centro Video Arte' was established in 1972. The same year the Venice Biennale presented Joseph Beuys' *Filz-tv*, a live performance in which the artist performs various actions in front of a TV screen that he had covered with felt.

In 1973, Maria Grazia Bicocchi established Art/Tapes/22 in Florence, with American video artist Bill Viola as technical director. Between 1973 and 1976, this pioneering centre produced an astonishing number of videotapes by major American and European artists. The list of artists who visited Art/Tapes/22 and produced new works reads like a 'Who's Who' of the contemporary art scene: John Baldessari, Daniel Buren, Chris Burden, Joan Jonas, Richard Landry, Douglas Davis, Allan Kaprow, Jannis Kounellis, Nina Sobell, Simone Forti, Jean Otth, Terry Fox, Simone Forti, Christian Boltansky, Alighiero Boetti, Takahiko Iimura, Frank Gillette, Vito Acconci, Les Levine, Paolo Patelli, Willoughby Sharp, Marco Del Re, Charlemagne Palestine, Sandro Chia, Maurizio Nannucci, Gino de Dominicis, Guido Paolini and Lucio Pozzi. In 2008, this important contribution to the development of artists' video as an international phenomenon was documented in a major exhibition at the University Art Museum at the College of the Arts in Long Beach California. A number of the videotapes produced at Art/Tapes/22 were relatively unknown and have been now been restored by the Venice Biennale Foundation's Historic Archives of Contemporary Arts.[16]

Prior to this, as early as 1967, Luciano Giaccari presented artists' videotapes at 'Studio 971' in Varese. The following year he established the 'Videoteca Giaccari' focusing on video documentation of artists' performances and events as part of a major project entitled 'Televisione come memoria' ['Television as Memory'].

In 1973 Giaccari wrote the 'Classificazione dei metodi d'impiego del video in arte' ['Classifications of the Methods and Uses of Video in Art'] based on his broad experience of a wide range of video related activities including the production of some of the earliest video-documents of artists' work, the establishment of 'videosalette' in various locations, the use of video for 'real-time' documentation of music, dance and theatre events, the production of video-catalogues, a video-magazine entitled *Video-critica* and the establishment of a video lab of the history of art. Giaccari's

'Classification' became the basis for a precise theoretical formulation and functioned as a bridge between these diverse experiences and the establishment of the Videoteca, which had a profound influence on other later initiatives in artists' video in Italy and elsewhere in Europe.

The establishment of the Videoteca Giaccari was significant, and constituted a major presence, contributing to the most important Italian and international festivals, surveys and institutions. The Videoteca was also the production centre for most of the video works in two major exhibitions surveying Italian contemporary art of the 1970s: 'Identité Italienne' in Paris (1981) and 'Italian Art' in London (1982).

From the earliest years of artists' video, and in parallel with the European and North American context, Giaccari supported and encouraged Italian artists to experiment with a wide variety of forms and approaches, but in comparison to the developments in artists' video in countries such as the United States and Germany, the experiments of Italian artists in the early period were tentative and sporadic. Nevertheless, these experiments took place and have been collected, archived and catalogued by Giaccari, constituting a valuable record of Italy's contribution to the development of video art.

Giaccari also encouraged other galleries to promote and exhibit artists' video. For example, the Venice-based Galleria del Cavallino became an important centre for the distribution of Italian artists' video to international venues.

Centro Video Arte Palazzo dei Diamanti in Ferrara was the other significant centre of activity for video art in Italy. For example it was here that Fabrizio Plessi (1940, Italy) produced his first videotapes *Acquabiografico* (1973) and *Travel* (1974), and in the following year he collaborated with the German artist Christina Kubisch (1948, Germany) to produce *Liquid Piece*. Other artists active at the Centro Video Arte include Maurizio Bonora (1940, Italy), Maurizio Camerani (1951, Italy) and Giorgio Cattani (1949, Italy).

As the 1970s progressed other institutions and galleries such as Galleria Civica in Turin and Centro Internazionale di Brera in Milan began to exhibit and feature video work by artists such as Piero Gilardi (1942, Italy), Mario Sasso (1934, Italy), Gianni Toti (1924–2007, Italy), Claudio Ambrosini (1948, Italy), Luigi Viola (1949, Italy), Michele Sambin (1951, Italy).

VIDEO ART IN CANADA IN THE EARLY YEARS

Being the northern neighbour to the United States has advantages and disadvantages – former Canadian Prime Minister Pierre Trudeau once famously remarked that it was like sharing a bed with an elephant! The cultural, political and economic influences from the USA were (and still are) significant, but nevertheless Canada has made a distinctive contribution to the development of artists' video. It is a large and

sparsely populated country, with a complex cultural heritage and this has produced a number of distinctly unique approaches to video. As Canadian curator and writer Peggy Gale points out, Canada is 'too spread out, too diverse, to present a united front'.[17] Gale identified four major centres in which video began to have an impact on the arts at the beginning of the 1970s in Canada: Vancouver on the west coast, Halifax on the east coast, and in the two major cities of Toronto and Montreal. It is important to note that these regional centres have remained influential and that they forged distinctive identities in terms of their theoretical, aesthetic and political approaches to the medium.

In Ontario activity was initially centred on 'A Space' in Toronto, a gallery, production facility and distribution centre for artists' video, which was established in 1971. Toronto-based artists working in this period included the artist's collective 'General Idea' (A. A. Bronson, born Michael Tims, 1946, Canada; Felix Partz, born Ronald Gabe, 1945–94, Canada; and Jorge Zontal, born Slobodan Saia-Levy,

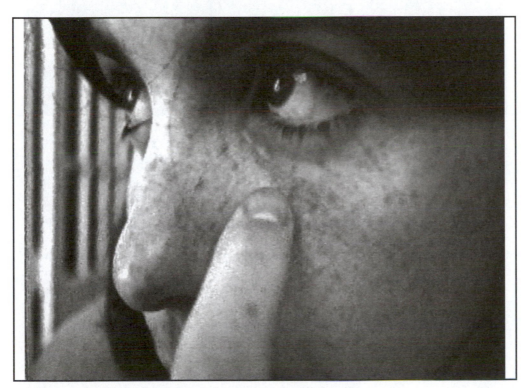

2.3: Lisa Steele, *Birthday Suit*, 1974, Courtesy of V-tape and the artist.

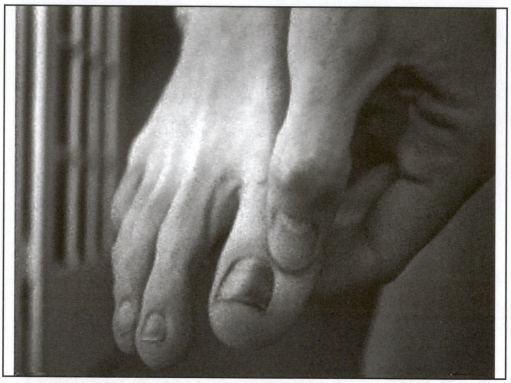

2.4: Lisa Steele, *Birthday Suit*, 1974, Courtesy of V-tape and the artist.

1994–9, Canada) who founded Art Metropole, a video distribution centre and gallery in 1974. Video works by this group include *Light On* (1970–4) *Blocking* (1974), *Pilot* (1977) and *Press Conference* (1977). Other significant artists working out of Toronto included Colin Campbell (1942–2001, Canada) and Lisa Steele (1947, USA). The predominant approach of artists such as Campbell and Steele has been characterized as highly personal and intimate, often working with video in a one-to-one setting using their own bodies to present and explore self-reflexive and often intimate issues of the personal and the formal. Early works by Steele include *Birthday Suit* (1974), *A Very Personal Story* (1975) and *Internal Pornography* (1975) a three-monitor installation. Previously a sculptor, Colin Campbell began working exclusively with video in 1972, producing tapes such as *Sackville I'm Yours* (1972), *Real Split, Janus* (1973) and *Hindsight* (1975).

Outside of the metropolis of Toronto, other Ontario-based artists who worked

consistently with video, included Eric Cameron (1935, UK), *Contact* (1973), *Sto/ol* (1974), *Numb Bares I and II* (1976) (see Chapter 9); Noel Harding (1945, UK), who made many tapes including *Untitled Using Barbara* (1973), *Birth's Child* (1973), *Clouds* (1974) at the University of Guelph; Murray Favro (1940, Canada) and Gregory Curnoe (1936–92, Canada) based in London, Ontario.

In Montreal, Quebec, the emphasis in early video work was more social than personal, and this cultural activity was focused by the foundation of Videographe by Robert Forget in 1971. Forget, one of the founders of the influential 'Challenge for Change' project at the National Film Board of Canada, was instrumental in researching the use and application of the Portapak, established Videographe as a production and distribution centre with substantial funding from both the Quebec provincial and Canadian central government. Forget perceived the Portapak as the ultimate democratic medium, a tool that was ideally suited both to personal expression and as a tool for the empowerment of others. His ideas were influential, both in Canada and abroad (see for example, a discussion about the work of John Hopkins and Sue Hall in the UK below). This approach to video was by far the most dominant in Montreal, as Videographe provided the support and technical resources for many projects both within the region and well beyond. Individuals working with video during this period include Lise Belanger, Jean-Pierre Boyer (1950, Canada), Pierre Falardeau (1946–2009, Canada) and Julien Poulin (1946, Canada), who produced *Continuons le Combat* (1971) and *La Magra* (1974).

Vancouver was the epicentre of video activity on the Canadian west coast. Initially centred on Intermedia, an artists' group formed at the end of the 1960s, activity soon splintered into a number of artists' co-operatives and studios, the best known

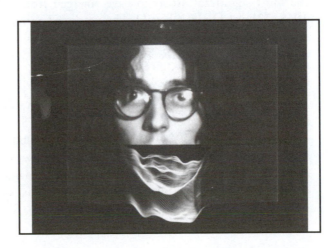

2:5 Jean-Pierre Boyer, *Inedit*, 1975.
Courtesy of the artist.

of which were The Satellite Video Exchange Society (initially known as Video Inn – now Video In) established in 1972; the Western Front; and Women in Focus, set up a year later. Video Inn, a co-operatively run video library and screening facility, whose founder members included Renee Baert, Michael Goldberg (see Early video in Japan, below), Patricia Hardman, Charles Keast, Ann McDonald, Janet Miller, Shawn Preus, Paula Wainberg, Richard Ward, and Paul Wong, published *The International Exchange Directory*, a listing of video work that covered the entire spectrum of video activity from community and social action to experimental image-processing, conceptual and performance work, with Video Out as a distribution channel. The Western Front's activities however, were centred on the creative input of its individual members, which included Kate Craig; *Still Life* (1976) and *Back Up* (1978), Vincent Trasov (a.k.a. Mr. Peanut); *Civic Election in Vancouver: Mr. Peanut for Mayor* (1974) and *My Five Years in a Nutshell* (1975).

Aside from the artists' co-ops, individual artists based in Vancouver included Don Druick, a composer and performer who began working with video in 1970, producing for example, *Van de Graff* (1971–4) and *(AE) ONE* (1975); and Al Razutis, who worked in film, poetry and sound, as well as videotape, and who produced *Waveform* (1975).

The Nova Scotia College of Art and Design (NSCAD) in Halifax on the Atlantic coast was another important Canadian centre for early video art activity. The institution made a decision at the beginning of the 1970s to encourage artists to work with video, and this was accentuated by an earlier decision to invite a number of important international artists for periods as artists-in-residence, many of whom worked with video, including Vito Acconci, Dan Graham and Steve Reich. One of the most significant artists to have emerged from NSCAD (he taught there from 1968–73) was David Askevold, who produced narrative videotapes of works that had originated in other media, such as *Green Willow for Delaware* (1974) and *My Recall of an Imprint from a Hypothetical Jungle* (1973) and *Very Soon You Will* (1977).

EARLY VIDEO IN JAPAN

Despite Japan's pre-eminence in the manufacture and design of early portable video and electronic equipment, there were surprisingly few pioneering video and televisual experiments before 1970. However, some notable works from this first period include Toshio Matsumoto's (1932, Japan) *Magnetic Scramble*, which was included in his 1968 film *Funeral of Roses;* Katsuhiro Yamaguchi and Yoshiaki Tono's video event *I Am Looking for Something to Say* as well as some early video experiments by filmmakers such as Kohei Ando, Rokuro Miyai, Keigo Yamamoto and Takahiko Iimura.

Expo '70 in Osaka was an important turning point for the development of artists' video in Japan; with its focus on the integration of art and technology, artists were encouraged to experiment with the new medium with the support of business and industry.

As in the West, many Japanese artists who began to work with video had previously worked with more established media such as painting, printmaking, sculpture or music, but some who were attracted to the new medium also had experience of working with film, photography and performance, and so ideas and approaches from these media were influential. Many of the artists who became interested in the potential of video were members of one of the two influential groups engaged in the so-called 'anti-art' activities of the 1960s – the 'Gutai' and the 'Mono-ha' groups, which had grown up in opposition to the more traditional and formal art of the previous generation.[18] All or most of these artists had previously exhibited work in both national and international art exhibitions, and so were aware of new ideas and approaches to exploring new mediums and materials.[19]

The 'Tenth Tokyo Biennial', subtitled 'Between Man and Matter', was an influential event that laid the foundation for future experimental art activity in Japan. Organized by the art critic Yusuki Nakahara, the exhibition showcased contemporary experimental art activity, presenting the work of a number of important conceptual artists from the United States and Europe including Donald Judd, Carl Andre, Richard Serra, Sol Lewitt, Keith Sonnier and Klaus Rinke.

Takahiko Iimura (1937, Japan) extended his earliest video experiments with a live closed-circuit video projection event entitled *Inside/Outside* presented at the Ashai Lecture Hall in Tokyo in February 1971, followed by his video work *Man and Woman* exhibited at the 10th Contemporary Japanese Art Exhibition in May of the same year. One of the most important and prolific Japanese artists to work with video, Iimura first encountered the medium in New York, where he met the Korean video artist Nam June Paik, and saw the work of the pioneering American artist Les Levine.[20]

A visit to Japan in November 1971 by the Canadian video activist Michael Goldberg (1945, Canada) also had a significant impact on the development of artists' video in Japan. Initially staying for four months in Tokyo, Goldberg, a member of the Vancouver artists' group Video Inn (see above, 'Video art in Canada in the early years'), presented videotapes by Canadian artists including Don Druik, Eric Metcalfe and General Idea, to promote his ideas about the power and potential of video as a radical communication tool within a decentralized distribution network.[21]

Goldberg's ideas and enthusiasm for the new medium and its potential struck a chord, and was the catalyst for the development of the first video exhibition in Japan, 'Video Communication Do-it-Yourself Kit', which was presented at the Sony

2.6: Takahiko Iimura, *Man and Woman*, 1971. Courtesy of the artist.

showroom in the Ginza district of Tokyo and initiated in collaboration with Japanese artists Katsuhiro Yamaguchi and Fujiko Nakaya in February 1972. This event, for which many artists made their first videotapes under the direct guidance and tutelage of Goldberg, featured screenings of these tapes as well as five separate live events using video feedback and time delay. Japanese artists featured in this inaugural exhibition include Toshio Matsumoto, Hakudo Kobyashi, Nobuhiro Kawanaka, Yoshiaki Tono, Tetsuo Matsushita, Michitaka Nakahara, Rikuro Miyai, Masao Komura, Sakumi Hagiwara, Keigo Yamamoto and Shoko Matsushita.

Most importantly this seminal event led directly to the formation of 'Video Hiroba'[22] in March 1972, marking a key moment in the history of artists' video in Japan. The Video Hiroba group jointly purchased a portable video camera and recorder and rented an office in Tokyo, aiming to provide facilities and opportunities to make and exhibit new video work. The same year, the group followed up their inaugural exhibition with a second event, 'Video Week: Open Retina-Grab Your Image' in collaboration with the American Center, Tokyo. This event featured

the work of 28 Japanese artists including Shuya Abe, Takahiko Iimura and Shigeko Kubota from the USA.

Two other artists' video groups were also active from this period – Video Earth, established by film-animator Ko Nakajima in 1971, and the Video Information Center, founded in 1974 by Ichiro Tezuka, initially to produce and distribute video-tapes of theatrical and cultural events. Toshio Matsumoto presented three colour videotapes at Video Earth – *Metastasis, Autonomy and Expansion* in June 1972. These works explored the potential of a video process called 'Data Color System', which provided Matsumoto with the potential for subtle control over the colour changes. Following on from this work he collaborated with electronics engineer Shuya Abe, also an active member of Video Hiroba, towards the development of a computer video system.

In January 1973 Fujiko Nakaya presented a selection of work by the Video Hiroba group at the 'Matrix International Video Conference', organized by Michael Goldberg in Vancouver.[23] The influence and exchange of ideas between artists working with video in North America is a significant factor in the early years, and in addition to the pioneering initiatives of Michael Goldberg in the instigation of Video Hiroba there were a number of important lectures, screenings and exhibition events by pioneering American artists including John Reiley, Rudi Stern, Joan Jonas, John Sturgeon, Arthur Ginsberg and Michael Shamberg. During Shamberg's visit to Tokyo in September 1971 he distributed copies of *Radical Software* to a number of artists, and according to Fujiko Nakaya, the ideas and approach of the publication were influential. (The following year Nakaya's translation of Shamberg's book *Guerrilla Television* was published by Bijutsu-Shuppan-Sha, Tokyo.)[24]

In addition to being one of the founding members of Video Hiroba, Fujiko Nakaya is an important figure in the development of artists' video in Japan. Studying fine art in the USA, she was based in New York in the mid-1960s becoming a member of the Experiments in Art and Technology Group (EAT) founded by Billy Kluver and Robert Rauschenberg. Although perhaps now better known for the innovative fog sculptures that she has exhibited internationally since the early 1970s, Nakaya has continued to work with video throughout her career. In 1980 she founded the only specialist video gallery in Japan, Video Gallery Scan, based in the Harajuku area of Tokyo.

In 1974 New York-based artist Shigeko Kubota organized 'Tokyo-New York Video Express', exhibiting 30 American videotapes alongside tapes and live performances by artists from Video Hiroba including works by Shuntaro Tanigawa, Kyoko Michishita and Mako Idemitsu at the Tenjosajikikan Theatre.

Japanese artists were also exhibiting new video work internationally in 1974. Toshio Matsumoto presented a selection of tapes by members of Video Hiroba and other artists as part of his lecture on 'Video Art in Japan' at the international video conference 'Open Circuits' at the Museum of Modern Art in New York. That same year Japanese artists were also featured in the newly introduced video section at the 11th International Contemporary Art Exhibition, which presented tapes by Fujiko Nakaya, Katsuhiro Yamaguchi, Hakudo Kabayashi, Shoji Matsamoto, Morihiro Wada and Masao Komura.[25]

By the mid-1970s, artists' video in Japan had begun to flourish, with screenings, exhibitions and events in a wide variety of venues and institutions using a range of media and formats. Some of the work in this early period had a distinctly political dimension, exhibiting the influence of approaches to the medium from activists such as Goldberg, Shamberg and others, providing a model for alternative communication networks, local cable TV systems and community action initiatives.

According to the writer and translator Alfred Birnbaum, who was actively involved in the early days, with one or two exceptions, artists' video in Japan lacked a viable 'second generation', and during the late 1970s and early 1980s video art in Japan was dominated by two major foreign artists – Nam June Paik and Bill Viola. Students studying video in art schools and university art departments were highly influenced by the work of these two artists to the extent that early 80s artists' video in Japan can

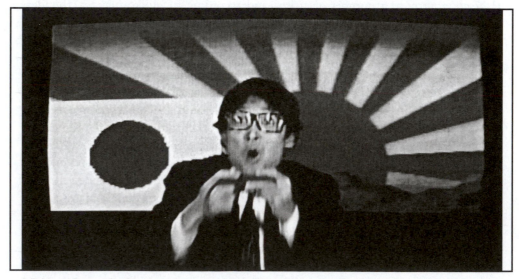

2.7: Visual Brains, *De Sign 2*, 1991. Courtesy of the artists.

be divided into two distinct camps: 'The Emotive Viola School of fixed framing, slow zooms and subtle distortions of the visual field' or the 'Playful Paik School of slapdash pop and irreverent media trickery, translated into fast frame editing, processed imagery and synthetic techno-colours'.[26]

However, among the more notable second-generation video artists to emerge in the 1980s was the duo 'Visual Brains' (Hatsune Ohtsu and Sei Kazama, both 1956, Japan), who produced a number of significant videotapes and performances, including *Mold* (1983) and *Soko* (1985) and the *De Sign* series during the early 1990s and Shinsuke Ina (1953, Japan) who began to explore the capabilities of the video image at the end of the 1970s with videotapes and closed-circuit video performances such as *Watching/Drawing/Zooming* (1979), *Flow* (1983) and *Sha* (1986).

VIDEO ART IN BRAZIL IN THE 1970S AND EARLY 1980S

Although artists' video emerged in Brazil in the late 1960s, it was not initially as an autonomous practice, but as part of a search for new structures and forms which artists developed alongside their previous work in more established art forms – particularly painting.[27] In Brazil the earliest video work was made by previously established artists such as Jose Roberto Aguilar, Sonia Andrade, Paulo Bruscky, Fernando Cocchiarale, Antonio Dias, Mary Dritschel, Anna Bella Geiger, Roberto Sandoval, Ivens Machado, Leticia Parente, Regina Silveira, Paulo Herkenhoff and Regina Vater. These artists and others began working with video as one among many alternative media such as photography, film and installation, and therefore opportunities to experience video art in Brazil were initially limited to art galleries and museums, and it was not seen either by artists or potential audiences as a radical alternative to television, although it was to some extent perceived as distinct from cinema. For the most part artists working with video in Brazil used the medium as an extension to their existing and emerging practice in other media, and did not seek to explore the medium in order to develop a new and unique language in ways comparable to artists in the USA, Europe or Japan.

Letícia Parente (1930–91), one of the most influential artists of this early group, produced an extended series of short video pieces centered on actions and performances using her own body. Works in this series include *Preparation I* (1975); *Preparation II* (1975); *In* (1975); *Trademark* (1975); *Who blinked first* (1978), *Specular* (1978) and *The man's arm and the arm of man* (1978). Other important early video works by pioneering Brazilian artists working in the 1970s include *Lua Oriental* (José Roberto Aguilar), 1978; *M3X3* (Analívia Cordeiro), 1973; *A Situação* (Geraldo Anhaia Mello), 1978 and *Temporada de caça* (Rita Moreira).

Although the first generation of Brazilian artists working with video explored the potential of video as a method of performance documentation of their own bodily actions rather than as an alternative communication medium with its own aesthetic language, this situation changed radically in the 1980s when a new generation of university and college educated individuals took up the medium. Two groups originating in Sao Paulo exemplify this approach: TVDO (Tadeu Jungle, Walter Silveira, Ney Marcondes, Paulo and Pedro Vieira Priolli), formed in 1980 by former students at the School of Television Arts and Communication; and Olhar Eletrônico, created in 1981 by graduates of the College of Architecture and Urbanism at the University of São Paulo (Fernando Meirelles, Marcelo Machado, Jose Roberto and Paulo Morelli Salatini. Renato Barbieri and Ernesto Varela).[28]

Although initially none of the new work these artists produced was broadcast, this generation of artists saw their work as an extension and development of television, initiating and establishing alternative methods of presentation such as video festivals

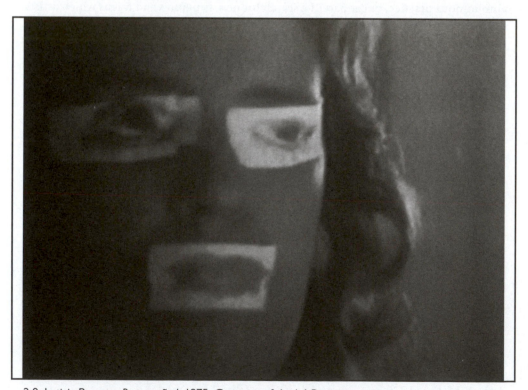

2.8: Leticia Parente, *Preparação I*, 1975. Courtesy of André Parente.

and independent screening rooms. This new breed of artist/ video maker often adopted an approach related to documentary and social /political themes, rejecting the illusion of the impartiality and 'balance' of conventional broadcast TV, and opting for an approach to the medium that incorporated their own doubts and uncertainties and foregrounding the position and bias of the maker(s) and the medium within the work. This second generation of Brazilian artists working with video include Rafael França (*Du Vain Combat*, 1984); *Reencontro* (1984); *Getting Out* (1985); Alfredo Nagib (*Eletricidade*, 1982); Pedro Vieira and Walter Silveira (*VT Preparado AC/JC*, 1986); Fernando Meirelles (*Brasília*, 1983); and Olhar Eletrônico, which comprised Renato Barbieri, Paulo Morelli and Marcelo Machado (*Do outro lado da sua casa*, 1985); Marina Abs (*Mergulho*, 1986); and Tadeu Jungle (*Non Plus Ultra*, 1985).[29]

VIDEO ART IN AUSTRALIA IN THE 1970S AND 80S

Although for the most part Australian artists perhaps inevitably looked to North America and Europe for inspiration, they have drawn upon these influences to develop an independent approach and sensibility. As elsewhere, artists in Australia began experimenting with video in the early 1970s and work in the medium emerged out of Conceptual Art practices of the late 1960s and early 1970s that were characterized by a shift away from more traditional art media and materials.

Among the earliest artists in Australia to experiment with video were performance artists. Peter Kennedy and Mike Parr (both 1945, Australia) first began using the medium to document their performances and events using the Akai ¼-inch video format and showed a series of works in 1971 at Inhibodress, an artists' co-operative and alternative exhibition space they founded in Sydney the previous year.[30] Other works from these two artists include Parr's *Cathartic Action/Social Gestus No. 5* (1977) and Kennedy's *November Eleven* (1979) made in collaboration with John Hughes and Andrew Scollo.

Two other performance artists, Tim Johnson (1947, Australia) and Tim Burns (1947, Australia) were also early pioneers in the new medium. Johnson's *Disclosures Series* (1971–72) presented at the Tin Sheds at Sydney University and Burns' installation *Fences to Climb*, which made extensive use of CCTV as a central element. Both were featured in the exhibition 'Recent Australian Art' at the Art Gallery of New South Wales in 1973.[31]

An important strand of early video experimentation in Australia involved the electronic manipulation and transformation of the image which began with work by filmmaker and artist Michael Glasheen (1942, Australia) with his work *Teleological Telecast from Spaceship Earth* (1970). This work, influenced by the ideas from Information Theory (Shannon and Weaver), and cybernetics (Norbert Weiner et

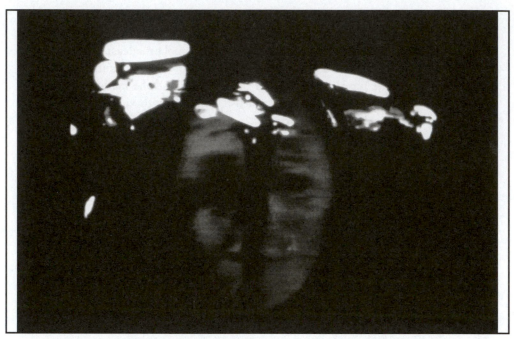

2.9: Peter Kennedy, John Hughes and Andrew Scollo, *November Eleven* 1979. Courtesy of the artists.

al.), was perhaps the earliest video work made by an Australian artist. Later in the decade Glasheen also made *Uluru* (1977), a blend of time-lapse photography, video mixing and electronic superimpositions relating to Aboriginal myths and legends of the Australian landscape.

Glasheen co-founded Bush Video with Joseph El Khourey, Jon Lewis, Anne Kelly, 'Fat Jack' Jacobson and Melinda Brown, after being approached by the organizers of the Aquarius Festival, held in the town of Nimbin, New South Wales, to set up a video resource centre and workshop to document the festival.[32] With funding from the Australian government to purchase equipment and transport, the project resulted in the first experiment in cable television in Australia. The project attracted a cluster of sympathetic artists and technologists forming a collective of enthusiasts who continued and extended their work once relocated to Glasheen's studio in Ultimo, a suburb of Sydney, following the festival.

The Bush Video group produced many hours of abstract experimental video work mostly created in live mix-down sessions recorded onto videotape. According to video artist and writer Stephen Jones (see below), who was himself part of the

group once it established itself in Sydney, Bush Video produced hundreds of hours of recordings which explored and investigated the abstract potentials of vision-mixing and electronic image college using a complex blend of video feedback, image synthesis and live and recorded video sources.[33]

> Using wipes and luminance keys the mixer could take layers of images – oscil-loscope displays, Lissajous figures, animated wire-frame geometric drawings done on Doug Richardson's computer, and the streaming echoes of visual feedback – and combine them into collections of images redolent with ideas about the geometry of space and consciousness. They were searching for a new language for the new ideas that came with cybernetics, geodesic domes, Buckminster Fuller and Marshall McLuhan, and of course, the newly accessible electronic technologies.[34]

As in the UK, many Australian artists were interested in working with the medium in opposition to broadcast television, and this approach was fostered in part by the establishment of twelve Video Access Centres around Australia by the Labour government under Prime Minister Gough Whitlam in 1974, drawing on ideas and approaches from the National Film Board of Canada's 'Challenge for Change' programme[35] (see above). As part of this network, two main resource centres were set up – 'City Video' at Paddington and Melbourne Access Video and Media Co-operative (MAVAM) at Carlton. These two centres became the main access for artists and independent producers throughout the 1970s, in addition to supporting major art galleries such as the Art Gallery of New South Wales (AGNSW) in Sydney.

The AGNSW presented some of the first examples of video work by US and international artists working with video; for example in 1976, Nam June Paik and Charlotte Moorman presented *TV Cello*, Les Levine showed a selection of recent political works and the video collective Ant Farm presented *Media Burn*. However, as Peter Callas (1952, Australia) has written, these events were not common and most of his experience of artists' video was more indirect:

> Nearly all of my earliest exposure to video art was through books. Installation work incorporating video fared somewhat better under these circumstances than videotape work did in its distorted "transmission" via printed black and white photographs. Nam June Paik's humour and irreverence in his performance works like *TV Bra* and *TV Penis* and in his installations like *Fish TV*, *TV Chair* and *Rembrandt Automatic* were never difficult to understand in print.[36]

Warren Burt (1949, USA) studied electronic music and video in New York and California, collaborating with American video imaging pioneers Tom De Witt and Ed Emshwiller (see Chapter 7) before becoming Senior Tutor in Music at La Troube

University in Melbourne. An aspect of Burt's role in the department was to develop a new video and sound studio at La Troube. Newly acquired video equipment in the studio included an Electronic Music Studios (EMS) Spectre, which along with the Hern Video Lab, Burt was able to access to develop and refine his own experimental video work (see Chapter 7 for further information about the Spectre/Spectron and Hearn Videolab). In both live performance collaborations with dancers and musicians and videotaped works which included *Nocturnal B* (1978) and *Five Moods* (1979), Burt's innovative early colour video work drew directly on what he called the 'Cageian and Xenakisian traditions' of electronic music applied to the generation and manipulation of video imagery:

> … with the electronic generation of images; the most simple and direct way to record those images was with video … making electronic images, which are controlled by the same, sort of – at first analogue and later digital, electronic processes … and this means that we're constantly thinking about what sort of processes we can assemble. For example, the old Moog had 6 or 10 low frequency oscillators and so if you mixed those together you get a complex fairly non-predictable pattern that you could apply to sound or to colour. If you have 3 of those going, you could have incredible changing colour things. If you apply another one of those to shape pretty soon you are algorithmically generating images. What today would be called "generative imagery".[37]

Influential through his work and teaching on the subsequent generation of artists working with video in Australia, Burt was also a founder member of important alternative venues for the presentation of experimental video and sound events such as the Clifton Hill Community Music Centre (1976) and as a curator of early video exhibitions in Australia such as 'Video Spectrum' (1977), which included American video artist Bill Viola, in his first visit to Australia.[38]

Stephen Jones (1951, Sydney) also included in 'Video Spectrum', has been an influential and important artist, engineer, activist, curator, writer and historian of artists' video in Australia since the mid-1970s. Examples of his early solo work include *Stonehenge* and *TV Buddha (Homage to Nam June Paik)* (both 1978), and he has collaborated with numerous artists and performers, most notably between 1983 and 1992 with Tom Ellard (1962, Australia), as one of the main members of Severed Heads, an electronic music group based in Sydney. In 1976, Jones worked with Nam June Paik and Charlotte Moorman to construct the Perspex video cello used during their performance at the AGNSW (see above). In 1977 Jones organized 'Open Processes' at the Watters Gallery in Sydney, an open format event to explore

the potential for video and associated electronic technologies within the gallery environment: 'a space for working, in public ways, with games, performance, playback, videotaping, real-time audio/video synthesis activities, theatre, dance music, hardware, installations'.[39]

In 1979, Jones co-curated the touring exhibition 'Videotapes from Australia', with Bernice Murphy, that included works by 25 artists and was shown at The Kitchen in New York, the Los Angeles Institute for Contemporary Art, Video Free America in San Francisco and Video Inn, Vancouver. It was subsequently shown at the Art Gallery of New South Wales and the Venice Biennale in 1980.

Robert Randall and Frank Bendinelli (both 1948, Australia), collectively known as the Rendellis, were particularly prolific during the 1980s, producing a body of short, visually graphic works working with so-called 'high-end' video production facilities. Single-screen works such as *Spaces 1–6'*, *Fantales*, *Leash Control* and Love *Me, Buy Me, Envy Me* (all 1981) were widely exhibited both in Australia and abroad.

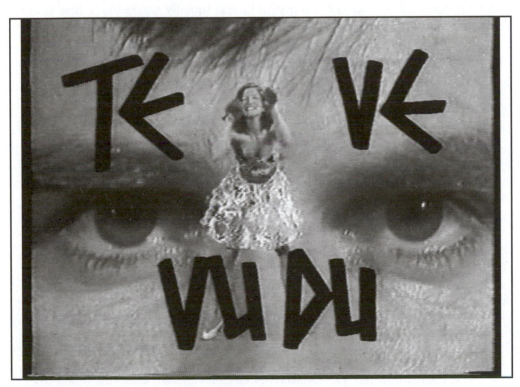

2.10: Gary Willis, *Te Ve Vu Du*, 1982. Courtesy of the artist.

Gary Willis (1949, Australia) working in collaboration with Eve Schramm (1956, Germany) has produced a number of important works including *Strategies for Goodbye* (1981) and *Te Ve Vu Du* (1982) also made with Chris Mearing (1947, UK).

Since the early 1980s John Gillies (1960, Australia) has produced a series of multi-layered and complex videotapes and installations including *Hymn* (1983), *Techno/Dumb/Show* (1991), *My Sister's Room* (2000) and *Divide* (2004). He has also curated a number of important video screening programmes – 'Mixed Bodies: Recent Australian Video' (Brazil, 1998) and 'Landscape/Mediascape' for the Sydney Film Festival in 2001.

Peter Callas (1952, Australia), a prolific and influential video artist with an international profile, has produced a distinctive body of single-screen videotapes and installations via an extensive exploration of the capabilities of the Fairlight Computer Video Instrument (CVI) (see Chapter 7). Callas has worked as video Artist in Residence both in Japan and the USA, and has developed a distinctive graphic approach combined with a sharply critical and satirical view of both Australian and international politics and cultural attitudes. Initially trained as a film editor on Australian broadcast television, Callas began to work with video in 1980 after attending a workshop with the American video artist and writer Douglas Davis. Key works of the 1980s include *Our Potential Allies* (1980), *Double Trouble* (1986), *Night's High Noon: An Anti-Terrain* (1988), *Neo Geo; An American Purchase* (1989) (see Chapter 10).

Other artists who began working with video in this early period include Phillip Brophy (1959, Australia), *ADS* (1982); Ken Unsworth (1931, Australia), *Five Secular Settings for Sculpture as Ritual and Burial place* (1975) and *A Different Drummer* (1976); Sam Schoenbaum (1947, Australia), *Still Life: Breakfast Piece* (1976) and *Peelin an Oran e* (1976); Bob Ramsay (1950, Australia), *Of Voice to Sand* (1979); and Sue Richter (1949, Australia), *A Historical Tale About the Art Object* (1978).

EARLY CHINESE VIDEO ART: 1980S AND 1990S

Chinese artists did not begin to work with video as an art medium until the late 1980s. This relatively late start when compared with countries in the West and Japan, is partly due to the rigid guidelines for the arts as set down by Chairman Mao in 1942 at the Yenan Forum on Art and Literature. At these talks, Mao compared and discussed his vision of the political and cultural purposes of art, allying them with the aims and purposes of revolutionary work in general and to the task of the military in particular:

> Our aim is to ensure that revolutionary literature and art follow the correct path of development and provide better help to other revolutionary work in

facilitating the overthrow of our national enemy and the accomplishment of the task of national liberation… . We must also have a cultural army, which is absolutely indispensable for uniting our own ranks and defeating the enemy. Since the May 4th Movement such a cultural army has taken shape in China, and it has helped the Chinese revolution, gradually reduced the domain of China's feudal culture and of the comprador culture which serves imperialist aggression, and weakened their influence.[40]

However, by the 1980s Chinese artists began to react against the 'socialist realist' style championed by the communist regime that had been the dominant and authorized form during the previous 40 years, in favour of more radical approaches. Established and traditional media such as painting and drawing were rejected in favour of photography, installation, performance and video. These new mediums were embraced for their potential to challenge the authority of the socialist realist style and it was in the latter part of this decade that the first video works by artists began to appear in China.[41]

Zhang Peili (1957, China) is considered by many to be the 'father' of Chinese video art. His seminal video tape *30x30* (1988–9), generally acknowledged to be the first video artwork produced in China, (discussed in more detail in Chapter 12), presents a continuous unbroken recording of the artist's own gloved hands breaking a mirror and laboriously gluing it back together again. This work, perhaps inspired by the fixed-camera, 'single take' film and video work of North American artists such as Michael Snow, Martha Rosler, Andy Warhol and Bruce Nauman (see Chapters 4 and 12), was Peili's response to an invitation to produce a new work for the Huangshan Conference on Modern Art in 1988.[42] *30x30* initiated an extended body of videotapes and installations during the 1990s, cementing Peili's international reputation and influencing subsequent generations of Chinese artists working with video such as Zhu Jia (China, 1963), *Forever* (1994) and *Continuous Landscape* (1999–2000), and Yang Zhenzhong (China, 1968) *Fishbowl* (1996) and *I Will Die* (2000–5).[43]

By the mid-1990s China was opening up to the Western markets. As part of this inevitable phenomenon, galleries and collectors were keen to acquire and sell Chinese contemporary art abroad – particularly politically inspired paintings, and this caused a reaction among more radical young Chinese artists who were wary of being drawn into the Western Art market, perceiving it as a form of post-colonialism. Seeking alternatives, a new generation of Chinese artists including Qiu Zhijie (China, 1969), *Writing 'The Orchid Pavilion Preface' One Thousand Times* (1986–87), *Railway from Lhasa to Kathmandu* (2007), Song Dong (China,1966), *Broken Mirror* (1999) and *Floating* (2004), began to explore the potential of video – a medium which was, as

we have seen in other countries, more resistant to the art gallery system and less easily marketed and sold to collectors. Because of this, video had an advantage for Chinese artists because it was seen to have an 'inherent defence mechanism against Western commercial interests' with the added advantage of being radically different in form and content to the aesthetic of the officially sanctioned socialist realist style of visual art in China.[44] Also, as we have seen elsewhere, accessible, relatively inexpensive and easy to operate, with the capacity to be used to make explorations of the private and personal, video was an attractive prospect for new and emerging artists and these factors, combined with the medium's ability to be freely copied and distributed, made it a natural and obvious choice.

The first exhibition to be devoted to video art in China was 'Image and Phenomenon' (1996), curated by artist and curator Qiu Zhijie and his partner Wu Meichun. In his own practice Zhijie had rejected some of the key ideas of Peili, who had been heavily influenced by the approach of American video artists of the 1970s – Gary Hill in particular. For Zhijie, this earlier work constituted what he termed an 'insipid tradition' because of its belief in the utopian notion of the potential of video to offer alternatives to broadcast television and for the way that it ignored the creative and aesthetic possibilities of more recent technological developments.[45]

In 1997, following 'Image and Phenomenon' Meichun and Zhijie published a set of documents about early video works by European and American artists alongside a commentary by contemporary Chinese artists who had begun to work with the medium, and this became a significant source of information for artists exploring the potential of video in China. Concurrently the couple organized 'Demonstration of Video Art China '97' at the Central Academy of Fine Art in Beijing.[46]

Following this second exhibition of Chinese video art, it was clear that the reaction to Zhijie's 'insipid tradition' had spawned a number of new directions drawing on the potential of developing video technology such as interactivity and an exploration of moving image alternative genres such as narrative and documentary. Wu Meichun identified the key issue for artists' video in China in the catalogue for 'Demonstration of Chinese Video Art '97':

> The problem we are facing is not what video art is, rather what we can do with video. It is still too early to define video art. Though it appears that a standard video art is coming into being, but it is destined to weary itself during its shaping. Video with an innate media is full of challenges, which is powerful and inexpensive. It is private and easy to duplicate and spread: it is both intuitive and imaginative.[47]

Wang Jianwei (1958, China) abandoned painting to work with video and theatre

after reading the essays of Joseph Beuys translated by Wu Mali (1957, Taiwan). Jianwei's feature length videotape *Living Elsewhere* (1998) documents the day-to-day existence of a group of people living in some abandoned dwellings on the edge of a city in Sichuan.[48]

The influence of Jianwei and Zhang Peili can be seen in the video works of Zhu Jia (China, 1963), Li Yongbin (China, 1963) and Wang Gongxin (China, 1960). Work by these artists is often a mix of sculptural elements and video installation featuring a documentary aspect, highlighting the changes and shifts in Chinese society as a result of recent government economic policy and reform.[49]

Wang Gongxin spent seven years in New York during the 1990s and although his work shows the influence of video installations by Bill Viola and Gary Hill, it also questions Chinese perceptions and responses to Western culture and attitudes. His video installation *The Sky of Brooklyn* (1997) comprises an upturned video monitor displaying images of the New York sky at the bottom of a deep well. The soundtrack is a looped voice-over in Chinese: 'What are you looking at – is there something worth looking at?', spoken by Gongxin himself.[50]

At the beginning of the millennium, two major exhibitions of Chinese video art had a significant effect on the reputation of the art form both within and outside the country. 'Compound Eyes: Contemporary Video Art From China' (2001) toured galleries and venues in New South Wales, Brisbane, Singapore, Hong Kong and China. Curated by Huang Zhuan, Binghui Huangfu and Johan Pijnappel, the exhibition featured works by Li Yongbin, Wang Gongxin, Wang Jianwei, Zhang Peili and Zhu Jia. 'Synthetic Reality' (2002) presented at the East Modern Art Centre in Beijing included works by Chen Shaoxiong (China, 1962), Geng Jianyl (1962, China), Ni Haifeng (China, 1964) and Shi Yong (China, 1963), in addition to Yongbin, Gongxin, Jianwel, Peili and Jia, and had a comprehensive bilingual on-line catalogue.[51]

In China artists' video was not perceived as a practice in opposition to more traditional media such as painting, sculpture and printmaking, nor was it engaged with a mission to have the medium recognized as legitimate for art practice. In his essay for the 'Compound Eyes' exhibition catalogue, curator Huang Zhuan describes video art in China during the first few decades as a 'forlorn player', without the 'opportunity for commercial success … nor the status of performance art in assuming a symbolic role of a "pioneering" art form'.[52]

THE EMERGENCE OF VIDEO ART IN INDIA

According to the Dutch curator Johan Pijnappel, India has never had a close relationship with new technology, despite the country's growing significance in the development of computer software. Contemporary art is still perceived as marginal,

with the established media of painting and sculpture remaining a dominant force in Indian cultural life. Because of this artists in India did not begin to work with video until the early 1990s, and even then video was initially employed as a component or element in a wider or more diverse approach.[53] For example, Nalini Malani (1946, Pakistan) produced a single channel documentary of her site-specific installation *City of Desires* (1992), and Vivan Sundaram (1943, India) incorporated video screens into his sculpture and installation *House from House/Boat* (1994).

However, since the mid-1990s there has been an increasing number of younger Indian artists working with video. Many of them first encountered the medium whilst studying abroad – mostly in the USA, the UK and Australia, and on their return from their studies continued to work with the medium despite the lack of exhibition venues and funding. This group includes Ranbir Kaleka (1953, India); *Man with a Cockerel* (2002), Subba Ghosh (India, 1961) *Remains of a Breath*, 2001, Sonia Khurana (1968, India) *Bird* (1999), Tejal Shah (1967, India*), I Love My India*, 2003, and *What Are You?* (2006), Eleena Banik (1968, India) *An Urban Scape*, 2004 and Umesh Maddanahalli (1968), *Between Myth and History*, 2001.

Recently a few specialized galleries devoted to the medium have emerged, such as the Apeejay Media Gallery set up in 2000 in New Dehli and run by curator Pooja Sood (who was also responsible for the Khoj International Artists' Association, see below) and the Chemould Contemporary Art Gallery, Mumbai, established in 2007. Although there is currently no commercial market for video and very few specialized galleries, there is increasing interest in work from India overseas, and there have been several significant international exhibitions profiling the work of Indian artists: 'SELF', at the Institute of Modern Art in Brisbane 2002; 'Indian Video Art: History in Motion' (2004), Fukuoka Asian Art Museum, Fukuoka, Japan curated by Johan Pijnappel; and 'Indian Highway – Contemporary Indian Video Art', a major touring exhibition curated by Julia Peyton-Jones, Hans-Ulrich Obrist and Gunnar Kvranand, featuring the work of 24 artists (Serpentine Gallery, London (2008), the Astrup Fearnley Museum of Modern Art, Oslo (2009) and the Reykjavik Art Museum, Iceland (2010).

Shilpa Gupta (India, 1976) has been active as both a maker and a curator, selecting works for 'Transformations', an exhibition within an exhibition (an integral element of the 'Indian Highway' touring exhibition) showcasing video work by eight emerging artists working with the medium including Nikhil Chopra (*Yog Raj Chitrakar*, 2008), Baptist Coelho (*Corporal Dis(Connect)-Standard Mode & Intoxicated Mode no. 1, 2007*), Sunil Gupta (*Love Undetectable Nos 12, 11 and 13*, 2009), Tushar Joag (*Jataka Trilogy*, 2004) alongside works by Sundram, Malni and Khurana.

Gupta's work is both personal and political, addressing issues relating to HIV/

AIDS, desire, love and alienation. As with many of the most significant artists working with video and new media in India, issues of politics, race, gender and class are central, as experimental work here has sought to express a desire for social and political change. As Johan Pijnappel points out, many of this new generation of Indian artists were female (as is Gupta) and for many of this group of artists it seemed video was the most appropriate medium to state their case:

> ... video combined with installation and performance was the appropriate way to collapse the frame, to shake things up. Apart from going on protest marches this was another means of cultural resistance. In addition, it provided access to new audiences and not only those accustomed to entering the white cube.[54]

The gallery 'Nature Morte', founded in New Dehli by Peter Nagy in 2007 has championed lens-based and video work and has had an impact on the Indian art scene both in terms of introducing international artists and their work to India, and bringing Indian artists to the attention of the wider art world. Nature Morte also developed an important programme of collaborating with cultural institutions based in India and abroad including the British Council, the Alliance Francais, the Sanskriti Foundation, the India International Centre and the National Gallery of Modern Art, and this policy has enriched and enhanced the standing of Indian contemporary artists both abroad and within the country itself.[55]

Another important factor in the opening up of artists' video in India was the Khoj International Artist's Association in New Delhi, a member of the Triangle Arts Trust (TAT), an international network of artists, visual art organizations, and artist-led workshops.[56] Khoj was instrumental in providing opportunities for artists to experiment with new media and perhaps most significantly, it opened up the potential of art production free from the commodity-oriented commercial gallery system. According to Mumbai-based writer and critic Nancy Adajania, the Khoj workshop's:

> ... lively laboratory atmosphere brought Indian cultural producers into close communion with their colleagues from other countries, breaking down the nation-centric self-discourse then in force. Khoj emphasised the importance of process over product: sculptors could work with installations, painters with performance art and the rudiments of video art and public art were put into place here.[57]

THE BEGINNINGS OF VIDEO ART IN THE UK

British video art mythology has its own parallel to the Paik Portapak story. In 1969 John Hopkins (1937, UK) (known to the alternative video community as 'Hoppy') on his way home from a visit to Italy made a side trip to Sony UK headquarters near Heathrow airport and convinced them to loan him a Portapak and playback unit in exchange for a written report on the new video format's value to alternative and community users.[58]

Hopkins used this loaned equipment as part of an initiative to equip a new radical video group called TVX, a counter-cultural organization to use electronic media in relation to broadcast TV as a parallel to the activities of the London filmmaker's co-op. Writing in the 1976 edition of *Studio International* dedicated to Video Art, Hopkins and his collaborator Sue Hall (1948, UK) began their article 'The Metasoftware of Video' with a direct and fundamental question: 'Video exists. Therefore the next thing to ask is what can one do with it?'[59]

In this short article discussing the potential of video for social and political change, using concepts drawn largely from communications theory, the Portapak was identified as 'the basic means of the individual decentralization of TV technology'. For Hopkins and Hall, video represented a field of largely unexplored potential. Their article identified some significant characteristics and potential for change inherent in the technology:

> Decentralization, flexibility, immediacy of playback, speed of light transmission, global transmission pathways, input to two of the senses – these are characteristics not yet shared by any other medium.[60]

Although neither Hall nor Hopkins considered themselves artists, they had a clear view of the value and significance of video made by artists within a broader cultural context. Quoting from the selected works of Mao Tse Tung, their article ends with a direct challenge to artists who aspired to experiment with video technology:

> Why should art be the domain of the few and not the many? Shouldn't democratization of culture, and in our case the liberation of communications technology for public access, be an integral part of our actual art activity? We demand the unity of technology, art and politics; the unity of information, meaning and effect.[61]

The video co-operative TVX was founded in 1969 as part of the 'Institute for Research into Art and Technology' (IRAT), to attract funding. The same year IRAT/TVX founded the New Arts Lab in collaboration with the London Filmmakers Co-op, where there were regular screenings of videotapes by artists and video groups from the

UK and the United States. Around this time Hopkins also published a column in *The International Times*, the style and tone of which sums up his attitude to broadcast TV, and his enthusiasm for the potentially liberating power of portable video:

> Tonight's topic is VIDEO… . Here it is at last: you can make your own TV and it's so easy to operate anyone can do it. All that crap about directors, producers, camera crews – forget it.[62]

During 1969 Hopkins had visited the United States and made a survey of the American experimental video scene, returning to the UK with renewed enthusiasm for the broadcast potential of low-gauge video. The following year TVX was commissioned by BBC TV to produce some pilot experimental video programmes, two of which were broadcast. In the years that followed, Hopkins continued to campaign for the broadcast of low-gauge video, initially achieving some success. For Hopkins, the issue of low-gauge broadcasting was linked to editorial and creative control and this relationship between accessible formats and radical content was central to his interest in video as a tool for cultural and social change.

In that early period the link between video art and television was crucial, as there was no viable alternative means of disseminating video images. Reporting on the state of video art in Britain in 1974, the writer and broadcaster Edward Lucie-Smith presented a gloomy and parochial picture in comparison with the American situation:

> … the technical sophistication of "official" television, by which I mean the product of the big networks, has tended to discourage personal experiment in a number of subtle ways. For example, whilst the artist still hoped to gain access to the BBC or one of the independent television companies, it hardly seemed worth it to use the comparatively crude equipment available to him outside. In addition, he soon discovered that, if he offered material he had made himself, on ¼-inch or ½-inch tape, this would almost inevitably be rejected as "technically unacceptable" for transmission.[62]

This technical impasse was certainly encountered by Hopkins' group TVX and by numerous other video artists, but it was also a problem that had dogged some of the more progressive individuals working from within broadcast television. BBC Producer Mark Kidel, responsible for some of the earliest broadcasting of British video art, reported on the conflict between broadcast television and video art:

> When "Arena: Art and Design", BBC 2's visual arts programme, recently transmitted a selection of work by British and American video artists, a special

2.11: TVX, *Area Code 613*, 1969. Photographer, John 'Hoppy' Hopkins.

directive had to be sent to every single transmitter in the country, preparing them for "irregularities" in the material. Without this warning, transmission would have been interrupted, as the machinery is programmed to reject anything "sub-standard". A case of censorship, or just a case of technological indigestion? The incident is symptomatic of a situation where, although the content and style of video art are intimately related to the substance of broadcast TV, the two are split by an almost unbridgeable estrangement.[63]

For many British (and other) video artists, television became the cultural and institutional opponent. Technically superior, and with access to mass audiences, it was also seen as monopolistic and unimaginative. For the most part artists saw the broadcast television of the day as the purveyor of visual experiences that were the antitheses of art. Broadcast TV and video art were seen by many as antagonistic, or at best, incompatible with each other.

Writer and video artist Mick Hartney's assertion is that TV 'seduces rather than assaults'. In an attempt to outline the early British context, Hartney (1946, UK)

examined the implied 'symmetry of empowerment' implicit in Paik's previously quoted slogan ('TV has been attacking us ... now we can attack it back'.) to one which suggests that with the advent of low-cost accessible video technology it would be possible to mount a counter-attack to broadcast TV. In Hartney's view the appeal of Paik's declaration was more emotional than logical. Paraphrasing Paik, Hartney proceeded to sketch out the UK television broadcast situation.

Since the broadcast monopoly had effectively ceased in 1955 with the advent of commercial television, British television in the 1960s was 'a seething arena of contending attitudes and cultures'. Moreover, Hartney pointed out that access for potential innovators was not impossible:

> Ironically those who had the determination to force an entry, or the opportunity
> to apply or who had something original to say or show, soon found that they
> were heaving against an open door.[64]

Hartney identified artists and independent video makers working outside television as a diverse but 'specialized interest group' – the 'we' of Paik's implied united retaliatory – artists and independents were in fact often blatantly opposed to each other's intentions and viewpoints. There was a clearly identifiable discursive tension between artists interested in the development of formal concerns and socio-political activists, despite their superficially united front in the fight for recognition and broadcast airtime.

Although this tense relationship between video art and broadcast television was significant, it was by no means the only issue, but one of a number of interrelated factors to be taken into account in relation to the development of artists' video. As in the United States, and elsewhere, the British video art scene arose out of a combination of events that included the development of accessible video technology, the concerns of minimal and Conceptual Art, the sensibilities and preoccupations of the so-called 'underground' political movement and the model of independent/experimental cinema.

Reviewing the situation from the 1990s, video artist David Hall identified early video art in the UK with a conceptualist rather than formalist approach, which he claimed separated it from much of the filmmaking of the late 1960s and early 1970s:

> In the early work, processes of deconstruction were evident from the outset
> ... unique video reflexivity was sometimes a component utilized as part
> of the formal matrix but rarely the prime objective of the work. Equally,
> whilst occasionally echoing contemporary formal devices, concern only for a
> foregrounding of the signifier was rare... . Nevertheless some artists initially

sought to detach themselves from dominant modes of expression, primarily in the use of the signifier and its technology, necessitating investigation into not only the medium's technological properties but also (by evident implication if not direct engagement) the political structures employed in television.[65]

DAVID HALL: 'VIDEO *AS* ART'

In 1971 David Hall broadcast *TV Pieces* on Scottish television (STV) during the Edinburgh Festival. Screened unannounced between regular evening programming, these pioneering works were intended to create a break in the flow of the viewer's potential relationship to his/her television receiver.[66]

Hall was staking a claim for video art as an autonomous art form, and indicating that previous critical writing had either been simply descriptive or attempted to define video solely in relation to broadcast television. Hall felt the reasons for this were twofold: 1) In contrast to painting, sculpture and film, there was no historical precedence and/or established practice for video art from which it could develop a theoretical and critical base, and 2) a reluctance on the part of the art establishment to embrace the discourse of 'electronic media'.[67]

As his contribution to *Locations Edinburgh*, part of the Edinburgh Festival, Hall produced ten short television pieces. From these original works, broadcast two or three times per day over a period of ten days during August and September 1971, seven were later selected for tape distribution under the title *7 TV Pieces* (1971). In their compiled videotape form these works can now be read very differently, and to understand their original context one must refer back to Hall's original interventionist intentions:

> The idea of inserting them as interruptions to regular programmes was crucial and a major influence on their content... . These transmissions were a surprise, a mystery, no explanations, no excuses.[68]

Although these television interventions were shot on 16 mm film, they were made specifically for the TV context, to be shown on 'the box', and take account of the specific properties of television as an object in the domestic environment. Hall's earlier film work, primarily designed for projection, such as *Vertical* (1970), had been an extension of his previous concerns with contradictory visual perspective. Funded by the Arts Council of Great Britain as one of a series of documentaries featuring contemporary artists' work, *Vertical* extended Hall's sculptural ideas into filmic space. Abandoning physical structure altogether, the film itself became the work. Hall's interest in video initially sprang from an interest in reaching a different kind of audience from the gallery-going public.

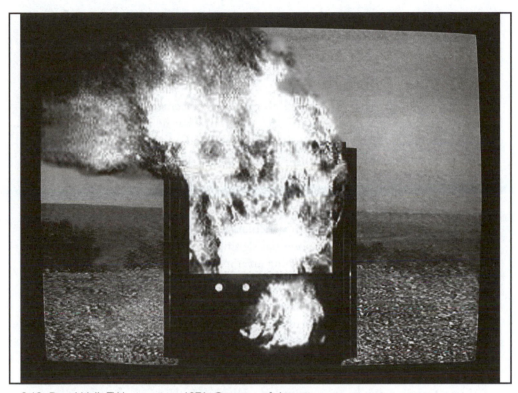

2.12: David Hall, *TV Interruptions*, 1971. Courtesy of the artist.

> ... it seemed to me that using film. i.e. like cinema, and using video, like
> television, or better still on television, seemed to me to be a much more appro-
> priate place to be as an artist.[69]

TV Pieces further developed and extended Hall's notions of the 'film as artwork' and
filmic perspective to include the illusory space 'behind' the TV screen. In an entirely
consistent manner the TV pieces adopt a formal approach that was specific to the
medium of television. *TV Pieces* were clearly intended for the broadcast context, and
Hall claimed that they were not works of art, but an attempt to draw the viewer's
attention to the nature of the broadcast experience.

David Hall's *This is a Video Monitor* (1974) is built from a systematically degen-
erated repeating sequence of a close-up of a woman's face and voice as she describes
the technical functions and principles of the television display on which she appears.
The tape was remade for the 1976 BBC 'Arena Art & Design' broadcast as *This is*

a Television Receiver, when the face and voice of the woman was replaced by the familiar and iconic representation of newscaster Richard Baker. Shot in colour in a BBC TV studio, this tape has become perhaps Hall's best-known work, symbolic of a whole generation of video artworks made in the UK in the mid-1970s (see Chapter 8).

In the period between 1971 and 1978, Hall was concerned to define his aesthetic practice – to distinguish authentic 'Video Art' from what he termed 'Artists' Video'; the documentation of art activities primarily manifested on video. In his practice and through his writing and teaching in this period, Hall advocated a rigorous, reflexive and often didactic approach, working to define a practice for video art as distinct from film.

In an essay in *Art & Artists* magazine about *The Video Show* (1975), Serpentine Gallery, London, Hall discusses the particularities of the video medium in relation to those of film. He suggests the potential significant relationship between a consideration of duration as object, establishing an important link with Conceptual Art:

> It is the fact that a video signal is transferred as an invisible stream along the length of the tape, compared to being a series of very apparent separate frames, which precludes the process conscious tape-maker from considering it in segmented plastic terms. It can only be regarded in total as a plastic equivalent to its duration.... . The developing involvement with the medium has a historical rationality when considering recent moves from object-orientated art to "process" art where time-span becomes an intrinsic substance.[70]

In 'Towards an Autonomous Practice' Hall's purpose is clearly stated: 'not to elaborate on the position of artwork *using* video, but rather to tentatively examine video *as* the artwork'.[71] In this important essay Hall set out his ideas and principles, indicating that video should be understood with reference to its fundamental inherent properties and specific technical characteristics. For Hall, 'video as art' was work that acknowledged the crucial presence of the television monitor display as 'an irrevocable presence which in itself contributed from the outset to the dissolution of the image'.[72]

In his essay 'Materialism and Meaning' John Byrne contrasts the differences of approach between Stuart Marshall's examinations of the shift in development of British experimental video from modernist to postmodernist concerns, with David Hall's view of the theoretical intentions of early British work. Marshall maintains that there was a convergence between a Greenbergian 'modernist' project which explored and foregrounded the specificity of the medium, and later documentary and narrative-based concerns, further strengthened by the influence of feminist art practice.[73] For

Marshall, postmodernist video was primarily concerned with the deconstruction of narrativity as the dominant social discourse in television.

Byrne emphasized Hall's contention that Marshall's view was an over-simplification, both in terms of the development of video practice, and significantly, of the concerns and intentions of earlier video work. Hall claimed that the most significant early work sought to challenge the viewer's expectations by foregrounding the underlying properties of the illusion. Thus formal experimentation in video was in the service of anti-illusion. In Hall's view the early video work was more firmly linked to this kind of conceptualist practice, in contrast to British 'Structural-Materialist' film of the 1970s, which sought to present 'film-as-film', seeking what could be understood as 'pure cinema' (see Chapter 4) offering the potential of a 'relative freedom from the formalist object'.[74]

In Hall's view the relationship of early modernist video to an examination of its inherent properties was first and foremost 'political' in that it constituted a questioning of the televisual message and a critique of the structures of broadcast television.

This attitude is not only apparent in David Hall's video tape work, it is also a crucial aspect of his installations, as Sean Cubitt points out in his analysis of Hall's installation *A Situation Envisaged: The Rite II* (1988). Cubitt identifies the ambitious nature of Hall's installation, which sought 'a purification of television through the medium of video sculpture', attempting to produce an awareness of the potential for television as a 'medium without content'.

A Situation Envisaged comprises fifteen television sets stacked in a monolithic formation in which the screens are all turned towards the wall with the exception of a single monitor that displays a low-resolution image of the moon.[75] The stacked monitors are tuned to receive broadcast images that can only be seen in reflection to 'form an aurora of moving changing light around the stack'.[76] The sculpture also has a soundtrack derived from broadcast television programmes that have been composed as a musical score.

For Cubitt, *Rite II* deconstructs TV's rigidly structured organization of time into schedules, time-slots and narratives etc., in favour of a fluid subjectivity. The installation presents TV in perpetual change, as opposed to endless repetition. In this sense Hall's installation can be perceived as 'utopian' – attempting to free the spectator from established ideological representation:

> At once focusing on and undermining the nature of TV as flow, as a medium without content, he makes us aware of the processes in which TV produces itself as content, and us as its subjects, whilst simultaneously removing the chains of

2.13: David Hall, *A Situation Envisaged: The Rite,* 1980. Courtesy of the artist.

subject formation, subjection, that normally binds us to the administration of time, the time-budget of T.V.[77]

David Hall's use of the sculptural installation format in *Rite II* can also be understood as a strategy to critique the problematic of the broadcasting of video art. The installation seems to address broadcast television as a phenomenon, and as problematic simultaneously avoiding the issue of content *within* the screen, and identifying the role of the artist as, in some significant sense, transcendent.

Compared with the potential for video art as installation, Hall is less satisfied with the single-screen format of video art, identifying the form as problematic with reference to its context. For Hall, video art intended to be shown on a single screen is inevitably understood or interpreted in relation to broadcast television:

I'm less enthusiastic about single-screen video works, because they seem to have no place. They are peculiar hybrids. The point is when you are looking at a

videotape, as far as I'm concerned, there is inevitably this influence of television on your reading of it. It's not a pure form. But what is a pure form? Painting of course has grown out of painting – but the thing about video is that it's come out of television. The reading of it is incredibly dependent upon, whether the viewer likes it or not, the phenomenology of TV.[78]

THE BRITISH ART SCHOOL, LONDON VIDEO ARTS AND ALTERNATIVES

David Hall also identified the significance and crucial role of the art school in terms of access to technical facilities and resources on the development of British video art in the 1989 *Video Positive* Catalogue:

> Video art emerged out of, and has been sustained by art colleges in this country not only because of an emphatic and progressive context ... but also out of necessity, since colleges of art have been the main providers of the essential and expensive hardware. Many artists in Britain have been dependent on their connections with these facilities in one way or another since the early seventies. Occasional excursions into the use of commercial equipment are attractive but economically prohibitive especially if considerable time is required for experimentation... . A video artist, unlike a painter cannot function without considerable support.[79]

Hall founded the audio-visual workshop at Maidstone College of Art in 1972. This was the first of a growing number of educational institutions with fine art departments in the UK that established areas to encourage experimentation with video media in the early to mid-1970s. By 1975 a significant number of art schools had thriving video and film cultures, with facilities used not only by students but also by the practicing artists who taught them, both as part-time and permanent staff. Among these were Newcastle and Sheffield Polytechnics, St. Martins School of Art in London, as well as fine art departments at Coventry, Brighton, Hull, Cardiff and Wolverhampton as well as the Environmental Media department at the Royal College of Art.

The Arts Council of Great Britain funded a series of residencies at a number of art school video departments including Maidstone College of Art, Brighton, Newcastle and Sheffield Polytechnics during the 1970s and early 1980s which gave artists access to facilities, and provided students with an increased awareness of the potential of video as an art form. Artists doing residences during this period included Elsa Stansfield, and Judith Goddard (Maidstone); Steve Hawley, Richard Layzell, Neil Armstrong, and Steve Littman (Brighton); Ian Bourne (Sheffield) and Andrew Stones (Newcastle).[80]

2.14: Stephen Partridge, *Monitor*, 1975. Courtesy of the artist.

This fertile ground nurtured a new generation of artists committed to video as an art form. In 1972 Clive Richardson (1944, UK) produced a series of video sketches whilst a student at the Royal College of Art in London. This series of short works presented investigations into the illusionistic conventions of the TV monitor, in which the scale of the video image and the scale of the original subject were an important and crucial aspect. For example, in *Balloon* (1972) the artist slowly inflates a toy balloon as the camera zooms out, maintaining the relative size of the object in question, whilst the artist's head reduces in size, only to be 're-inflated' as the air is slowly released from the balloon, and the camera zooms back in.

Steve Partridge (1953, UK) who studied at Maidstone and at the Royal College of Art in the early mid-1970s produced *Monitor* (1975) a videotape that in many ways epitomized the approach of tape-based work by British artists at the time. Partridge described *Monitor* as: 'A careful reorganization of time scales and images of a revolving monitor which produces a disorienting temporal and spatial collage' (see Chapter 8).[81]

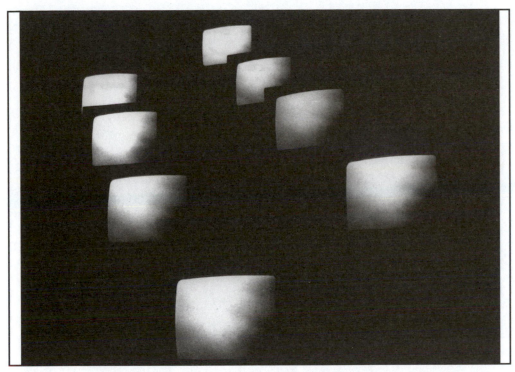

2.15: Tamara Krikorian, *Disintegrating Forms*, Video Installation, 1976. Courtesy of the artist.

Tamara Krikorian (1944–2009, UK) produced a number of important works during the 1970s including multi-screen installations such as *Breeze* (1975) a four-channel videotape installation of images of flowing water exploiting the extreme image contrast fluctuations of the monochrome video camera which both evoked the landscape tradition in British art and asserted the video medium's presence in the representation of the subject. *Disintegrating Forms* (1976) featured video sequences of dissipating clouds displayed on monitors perched atop tall plinths above the heads of gallery visitors. The monochromatic images became almost indistinguishable from the blank television screens as the low-resolution images gradually failed to resolve an overcast sky. Krikorian's videotape *Vanitas* (1976) draws on traditions derived from French painting, but the work also refers to and comments on the ephemeral nature of the broadcast TV image, which incidentally features images of the BBC newscaster Richard Baker, the presenter who appears in David Hall's 1976 BBC remake of *This is a Television Monitor*.

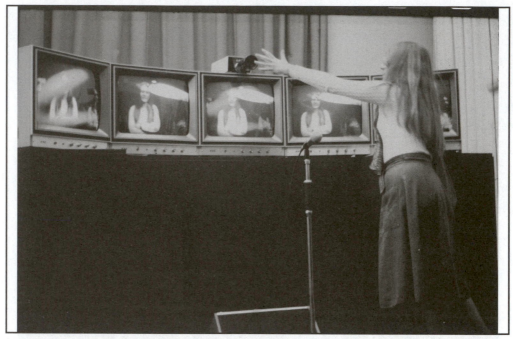

2.16: Brian Hoey, *Videvent*, 1975–6. Courtesy of the artist.

EARLY VIDEO INSTALLATIONS AND 'LIVE' EVENTS IN THE UK

Artists working with video in this period did not restrict themselves to pre-recorded works. Brian Hoey (1950, UK) presented *Videvent* (1973–5) a series of 'live' installation presentations at art schools and other venues including The Slade School of Art, Exeter College of Art, University College, London and The Serpentine Gallery. Hoey had become interested in experimenting with the interaction between imaging systems and participant observers.

Videvent employed two video recorders to create a tape-loop feedback system; it made use of the time delay created between the record head of one machine and the playback head of the second. A video camera was focused on the participant and connected to the first recorder; the delayed image from the second recorder was then mixed with the first to build a gradually accumulating image sequence displayed on a single monitor. Hoey saw this directly interactive and 'live' approach to art as crucial to maintaining contact with his audience:

> For a system in which the spectator is participating with aspects of his own appearance or behaviour the most suitable medium appeared to be video, as

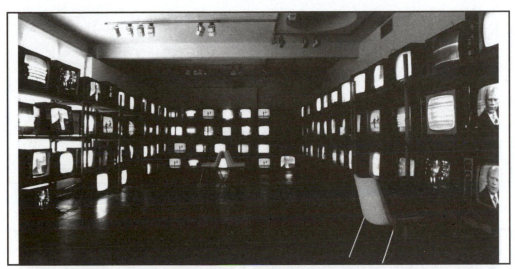

2.17: David Hall and Tony Sinden, *101 TV Sets*. 1975. Courtesy of the artists.

it provides the basis for a real-time relation of events coupled with the ability to modify images in a fluid organic manner. Practical possibilities include the manipulation of the participant in time: he may be seeing himself in the past with his actions over a period of time built up as a composite picture.[82]

Roger Barnard's *Corridor* (1973–4) also made use of a mix of 'live' and pre-recorded video images displayed on a single monitor. Placed at the end of a specially constructed corridor, pre-recorded images of spectators from the past were superimposed onto spectators from the present. In Barnard's installation only the time-image was changed, whereas images of static objects such as walls and floor and objects within the space remained the same. The installation was concerned with the contrast and interplay between the 'real' and the televisual, with the video image presented as way of expressing ideas related to consciousness and perception:

> We and the environment in which we live consist of matter at different densities and in different states and stages of becoming. You exist in all spatial planes between your physical being and my mind in forms other than that of your own physical being.[83]

Steve Partridge's *Installation No. 1* (1976) also explored and manipulated space-time configurations, this time using a custom-made 'Automatic Video Switcher' (AVS), which he designed with a colleague at the Royal College of Art. This programmable

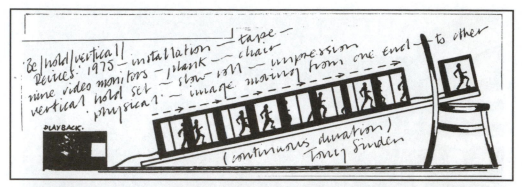

2.18: Tony Sinden, *Behold Vertical Devices*, sketch, 1975. Courtesy of the artist.

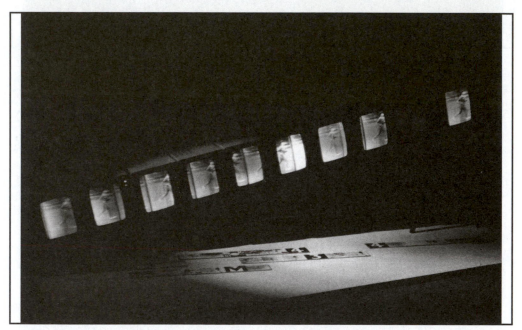

2.19: Tony Sinden, *Behold Vertical Devices*, 1975. Courtesy of the artist.

switcher enabled Partridge to produce a four-camera / four-monitor installation in which 'time and space can be altered within a structural and programmed format'.[84]

In collaboration with film and video artist Tony Sinden (1946–2009, UK), David Hall produced an influential multi-screen installation entitled *60 TV Sets* in 1972, later restaged at the Serpentine video show as *101 TV Sets*. Although this work

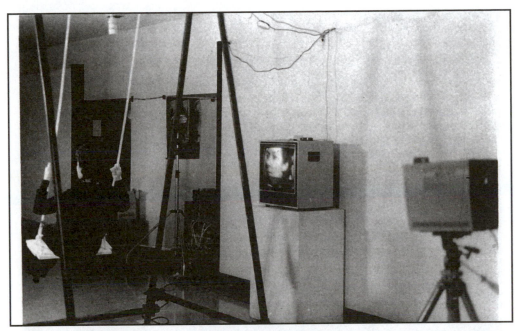

2.20: Tina Keane, *The Swing*, 1978. Courtesy of the artist.

involved no video recording or 'live' camera images, instead consisting of mis-tuned broadcast television signals, it was an important precursor to video installation work produced later in the decade.

Tony Sinden produced a number of sculptural video installations himself, including *Be/Hold/Vertical/Devices* (1975) and *Step Sequence* (1976–7). These works were significant and influential because of the playful and innovative deployment of the TV monitor and repeating image display as the principle building block within a larger sculptural construction.

A number of important feminist artists including Rose Garrard (1946, UK) and Tina Keane (1948, UK) began working with videotape and installation in the latter half of the 1970s, drawing on earlier work based in performance and live art. Garrard, who first used video to document her live work, made *Tumbled Frame* (1984) as part of 'Artist's Works for Television' produced by Anna Ridley for Channel 4. Tina Keane made sculptural installations such as *Playpen* (1979) and *The Swing* (1978), using a combination of 'live' video camera display, installation and performance. These works drew on the complex relationship between personal and private spaces that the

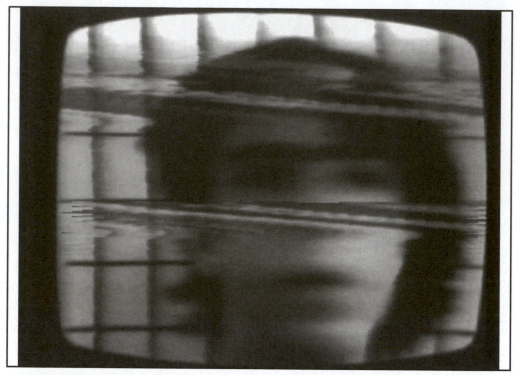

2.21: David Critchley, *Static Acceleration*, 1976. Courtesy of the artist.

closed-circuit video system enabled, and corresponded to issues of the 'personal as political' which many feminist artists of the period sought to explore.

David Critchley produced a number of works which explored the relationship between live performance and videotaped presentation including *Static Acceleration* (1976) and *Pieces I Never Did* (1979), which chronicles a series of short works he had planned but never previously got around to making. Critchley (1953, UK) addresses his audience directly, explaining and then restaging the works especially for the camera.[85]

Mick Hartney's (1946, UK) *State of Division* (1979) draws on the performance tradition using the image of the artist directly addressing his audience too, but here the message is directly related to the video medium, with states of alienation and isolation presented using aspects associated with television technology – including multiple images, grainy low-resolution, and loss of focus.

2.22: David Critchley, *Pieces I Never Did*, 1979. Courtesy of the artist.

Whilst all of these works demonstrated the potential for video installation as a sculptural medium, with the television 'box' as a building block or component, many also explored the creative potential of the live camera/ monitor configuration in a way that involved and encouraged an interaction between the spectator, the performer and the work. The spectator could be seen as simultaneously a participant and the subject of the work, involved and implicated directly in the decoding and functioning of the installation. These works also challenged conventional notions about the relationship between the artist and the spectator, and paved the way for the acceptance of video installations as an art gallery phenomenon.

David Hall's curatorial influence included the first major exhibition of video art in the UK at the Serpentine Gallery in London in 1975. Organized by Sue Grayson, this exhibition drew on the expertise of a committee of advisors that included Hall along with art critic William Feaver, broadcaster Stuart Hood and cultural consultant Clive Scollay. This month-long show was a mixed collection of independent work including

single-screen tapes, installations, lectures, presentations, events and performances by artists and video activists from the UK and a number of other countries, including the USA, Canada and the Netherlands. Many of these individuals had previously been working in near isolation, and much of the work presented, as well as the optimistic catalogue statements, demonstrated an idealistic enthusiasm fuelled by a sense that the new medium of video would herald a technological and socio-cultural revolution. There was a strong sense that artists and video activists alike perceived their work as being in opposition to broadcast television. Stuart Marshall (1949–93, UK), himself among those early video artists and an influential writer and commentator on video art practice, observed that many early video artists' statements read 'like political diatribes against the television institution', and that these same artists were surprised to discover a common purpose in seeking a language and context in which to critique conventional broadcast TV.[86]

As a direct consequence of 'The Video Show', a number of these artists (including Roger Barnard, David Critchley, Tamara Krikorian, Stuart Marshall, Steven Partridge, and Brian Hoey) formed a pressure group under the leadership of David Hall, which led to the establishing of London Video Arts in the summer of 1976. Although London Video Arts (LVA), as it was more generally known, was formed initially as an organization to distribute and screen video artwork, it was also keen to promote the issue of artists' video, to lobby for funding, bursaries and eventually for the establishment of production and post-production facilities. Initially set up in Hall's flat in Brixton, South London, premises were soon moved to Little Newport Street in London's West End.[87]

In 'From Art to Independence' Stuart Marshall stresses the significance of the relationship between LVA, the development of video art in the UK and the art school network:

> An aspect of the early membership of LVA which was specific to video was that almost all of the first steering committee members were, or were to become, in some way related to colleges and schools of art. At this time many art colleges were setting up media departments and investing in video technology. This came as a response to both the new developments in the cross-fertilization in the arts and the increasing institutional fascination with new information technology which was making its presence felt in the form of audio-visual aids in media-dependent teaching practices. Early British video therefore became inextricably linked with undergraduate and post-graduate education, both in terms of its means of production and the development of its aesthetic.[88]

The launch of the first LVA distribution catalogue was timed to correspond with the inaugural screening at the Air Gallery in London's Covent Garden in October 1978.

This was a significant event, and it marked a realization of the first two of LVA's declared goals.

David Hall's presence at this event was conspicuous; his influence over the development of video art in the UK was at its peak. Through a combination of polemical writing, teaching, the promotion of video art and his own video work, Hall established a tradition of video that was pure, formal and rigorous. Mick Hartney points out that Hall's extreme position commanded respect, producing a body of work of consistent purity – a rarity in the diversity of contemporary video culture, but it also produced work that could be extremely restrictive and predictable:

> Much of the work embraced by this prescription had many virtues: it could be intelligent, serious and often very elegant. It was capable of bearing the weight of complex theoretical exegeses. ... some of the single-screen work on the other hand could be extremely boring, even for other video artists. Adherence to a predetermined process in the production of a tape often meant that the viewer knew precisely what was going to happen long before it did.[89]

During this early period, the artists associated with LVA were almost exclusively associated with aesthetic concerns derived from modernism. Avant-garde art practice was at this time dominated by a refusal of representation. In painting and sculpture this had resulted in 'the play of signifiers emancipated from the tyranny of the signifier'[90] and in video and film (and to some extent, photographic practice), it gave rise to an exploration of the inherent properties of these respective media. Video artists sought to explore their medium by examining the image making mechanisms that were specific to video, and this placed them in an oppositional stance to the institution of television, as well as to the broader history of fine art. Video artists of the period saw themselves as seeking to define a grammar or language that was specific to video – a syntax that was inherent to the medium and free from the conventions of broadcast TV.

In the UK this group of artists had a considerable impact on video practice in the period between 1976 and the early 1980s and beyond. Through LVA they initiated and organized a number of important and influential exhibitions – notably at the Tate Gallery, London (1976), the Third Eye Centre, Glasgow (1976), the Herbert Art Gallery, Coventry (1978), as well as regular screenings at the Acme and Air Galleries in London.

Peter Donebauer's (1947, UK) work with abstract colour video imagery was distinctly different in approach and concept to the practice and ideas championed by David Hall and others associated with LVA. In 1979 Donebauer formed VAMP (Video and Music Performances) with musician Simon Desorgher and conducted

a national tour of live video and music works following the development of his Videokalos Image Processor. Donebauer's work gained some significant early attention, and he was the first UK video artist to attract funding from both the Arts Council of Great Britain and the British Film Institute and to have his work broadcast on national television on the BBC arts programme 'Second House' in 1974 (see Chapters 7 and 10 for a more detailed discussion of Donebauer's work and ideas).

Brian Hoey and Wendy Brown, joint artists-in-residence in Washington New Town in the north of England, organized 'Artist's Video: An Alternative Use of the Medium' in 1976. This exhibition became an important annual event for the next five years, showcasing new video work by a number of important British and international video artists including Tom Dewitt and Vibeke Sorenson (USA), Dan Sandin (USA), Tom Defanti (USA), Peter Donebauer (UK), Jean Brisson (France), Kit Fitzgerald and John Sanborn (USA), Sanja Ivekovic and Dalibor Martinis (Yugoslavia), Elsa Stansfield and Madelon Hooykaas (Netherlands/UK), Steve Partridge (UK), Tamara Krikorian (UK), David Critchley (UK), Ed Emshwiller (USA), Sue Hall and John Hopkins (UK), David Hall (UK), Stuart Marshall (UK), Ronald Nameth (USA), Ira Schneider (USA), Ture Sjölander (Sweden), Tony Sinden (UK), the Vasulkas (USA), Mick Hartney (UK), Richard Monkhouse (UK), Bill Viola (USA), Rene Bauermeister (Switzerland), Steven Beck (USA), Peter Campus (USA), Marceline Mori (France/UK), Marianne Heske (Norway), Nan Hoover (Netherlands) and Claudio Ambrosini (Italy).

During this early formative period LVA also established a distribution network, publishing a catalogue to promote their work, and were responsible for the publication of most of the written criticism and theoretical writing on video art practice in the UK. Through this activity of self-validation the modernist practice established a foundation for later artists, but also restricted and divided the independent video community in the UK, alienating and marginalizing alternative approaches to video within a fine art context.

3. TECHNOLOGY, ACCESS AND CONTEXT
SOCIAL AND POLITICAL ACTIVISTS AND THEIR ROLE IN THE DEVELOPMENT OF VIDEO ART

THE SOCIO-POLITICAL CONTEXT IN WESTERN EUROPE AND THE USA

In the latter part of the 1960s the spectre of war was once again the dominant issue. The United States was deeply involved in the conflict in Vietnam, and as with the Korean War in the 1950s, this fact was impossible for the people and governments of Western Europe to ignore. The French, who had experienced and lost similar protracted guerrilla conflicts in Algeria and Indochina, advised the USA to withdraw. The Scandinavians and the Dutch were deeply opposed to the war on humanitarian grounds, and those countries with governments who had significant economic relationships with the US; the UK, West Germany and Italy gave the USA at least a qualified support, although public opinion was mixed.

In Europe the so-called 'Cold War' – the conflict between the Western democracies and the USSR, which had emerged during the 1950s, continued throughout this period, but compared with the tensions of the previous decade, the issues raised by the Vietnam War gave a sense that a new era of uncertainty and political change was about to emerge.

In France an alliance between the communists and the socialists threatened to destabilize an eleven-year domination of the government by Charles De Gaulle. Just as it seemed that the Left would wrest power from De Gaulle, a wave of student protests and violence during May 1968 disrupted the Left and enabled the Gaullists to re-establish order.

In April 1968 there had been a number of violent student protests in West German Universities similar to those that had occurred in Paris. These students, many born after the end of World War II, felt remote from the events which had torn Europe apart. This new generation wanted to see an end to the stigma of guilt and a restoration of the status of Germany as a nation within Europe.

In parallel with this pressure for changes to the governing of the country, students in France, West Germany, Italy and the UK demanded changes to the way in which universities were organized and administered, as well as changes to the curriculum. In the 1960s many new universities were created, with a subsequent and inevitable

increase in teaching posts and student numbers. Across Western Europe a new generation of academics sought to expand and transform the curriculum and to develop new courses and disciplines. Throughout Western Europe generally the structures of government and society remained, but underlying attitudes had been transformed which set the stage for sweeping changes in the late 1960s and early 1970s.

GUY DEBORD AND THE SITUATIONISTS

The influence of the Situationists and the political critique of Guy Debord (1931–94, France), one of its principle founders, on the student activists in Paris and elsewhere during the 1968 demonstrations was significant. Set up in 1957 from an amalgamation of a number of European radical artists' groups including the London Psychogeographical Association (LPA), CoBrA, and the Letterist International (LI), the Situationist International (SI) sought to build a new society in which traditional art was abandoned in favour of an enriched urban existence. As Asger Jorn (1914–73, Denmark) one of the main protagonists of the group wrote of Situationism:

> Visual art was a useless medium for creativity and thinking. It was the radiation of art into pure existence, into social life, into urbanism, into action, and into thinking, which was regarded as the important thing.[1]

A number of the Situationists were directly involved in the Paris uprisings during the Nanterre occupation, fomenting unrest and organizing student protesters. Posters produced by art students during the riots and demonstrations took up ideas and slogans directly influenced by Situationist rhetoric: 'Are You Consumers or Participants?' 'Art Does not Exist – Art is You', and 'Propaganda Comes into Your Home', the caption for a poster depicting a forest of television aerials among urban rooftops. The perception of television as a major tool in the state apparatus, a force of control and manipulation propagated by the selective presentation of information and the presentation of false and distorted images of reality, was part of a growing public awareness. In *The Society of Spectacle* (1967) Guy Debord identified a crises of alienation in a society of conspicuous consumption, that struck a chord with many artists and political activists in Western Europe and North America:

> … the individual's gestures are no longer his own, but rather those of someone who represents them to him. The spectator feels at home nowhere, for the spectacle is everywhere.[2]

NEW TECHNOLOGICAL DEVELOPMENTS – 'LOW-COST' PORTABLE VIDEO

It is clear that industrial/military technological research and development during the 1960s was directly responsible for the introduction of the first relatively inexpensive

portable non-broadcast video equipment. Demand for compact, inexpensive machines for airborne surveillance operations during the war in Viet Nam opened the way for more peaceful, though certainly subversive cultural projects.

> A lot of people think that Sony developed the "Portapak" for artists and community groups, but nothing could be further from the truth! They were actually developed for the American military to use in their planes during the Vietnam War. The first Portapaks were entirely in the hands of the military and they were basically to check where their napalm or bombs had gone. Like virtually everything in our society, the driving force is actually conquest. Whether it's successful, or as in this case, happily unsuccessful.[3]

As in Western Europe, the 1960s had been a decade of social, cultural and political change in the USA. This period saw the rise of a new youth culture (in 1968, 50 per cent of the population in the United States was under the age of 25). Experienced at civil rights confrontations and highly critical of American military involvement in Viet Nam, they were politically active and fuelled with a desire for a greater participation in the democratic process and with a growing awareness of the power of cultural production. This cultural imperative swelled into a 'movement', and increasingly viewed accessible video and computer technology as major components in an arsenal of radical cultural tools. The formation of media collectives such as the New York-based Raindance Corporation grew as much out of a shared cultural imperative as from a pragmatic need to pool and share equipment. This combination of political theorists, artists and activists believed that radical social change was possible. Artists and activists alike saw accessible low-cost video as a radical alternative to commercial television. The first issue of *Radical Software*, published by the Raindance Corporation in 1970 stated:

> Unless we design and implement alternate information structures which transcend and reconfigure the existing ones, our alternate systems and life styles will be no more than products of the existing process.[4]

During this early period of innocence, the newly accessible 'low-cost' video recording equipment gave rise to an optimistic and enthusiastic wave of experimentation which inspired and united artists, video activists and groups of individuals committed to social and political reform. All of these groups saw a potential in portable video technology to challenge the status quo in a wide range of areas which included broadcast television, the art gallery structure and social and political inequality. Although this enthusiasm for new video technology can be seen to have begun in the United States in the mid-1960s, it soon spread to other countries, including the

United Kingdom, West Germany, France, the Netherlands, Poland, Canada and Australia.

RAINDANCE CORPORATION AND *RADICAL SOFTWARE*

During the winter of 1967–8 abstract painter turned media activist Frank Gillette (1941, USA) was engaged to run a seminar on the ideas and theories of Marshall McLuhan (1911–80, Canada) at the Free University in New York City. Gillette's fascination with McLuhan's ideas had led him to meet Paul Ryan, McLuhan's research assistant in the Centre for Media Understanding at Fordham University, who arranged for the loan of video equipment during the spring and summer of 1968, including Portapaks, cameras and playback equipment, which Gillette experimented with at his 6th St. studio. During this period Gillette met other video enthusiasts including David Cort, Howard Gutstadt, Victor Gioscia and together they formed Commediation, a discussion group with irregular meetings attended by Nam June Paik, Eric Siegal and Les Levine. Gillette and Gioscia had much in common, including an interest in the potential of video as a vehicle for social and political change influenced by the ideas of Gregory Bateson, McLuhan and Warren McCullough.

Working with Ira Schneider (1939, USA), a close colleague and a filmmaker with a scientific background, Gillette proposed the construction of a complex multi-screen installation entitled *Wipe Cycle* (1969) for 'TV As a Creative Medium', the first gallery exhibition to be devoted entirely to video art in the USA, at the Howard Wise Gallery in New York in 1969.[5]

Wipe Cycle combined the interests and ideas of Schneider and Gillette, drawing on Gillette's experiments with the new medium the previous summer and Schneiders' fascination for the potential of live interaction and video delay. *Wipe Cycle,* which required the building of customized electronics to mix the multiple images, consisted of a bank of nine monitors in a 3 x 3 configuration, with four screens displaying pre-recorded 'off-air' material and the other five showing 'live' and delayed video sequences of gallery viewers. With this influential and innovative installation Gillette and Schneider were concerned to present an experience that would break the conventional single-screen TV perspective, by providing a complex mix of live images and multiple viewpoints, in real time.

Michael Shamberg (1945, USA) who met Gillette whilst working on an article about 'TV as a Creative Medium' and *Wipe Cycle* for *Time Magazine*, was also interested in the potential of video as a journalistic medium and had been inspired by the writings of McLuhan. In October 1969 Gillette and Shamberg founded the Raindance Corporation with funds of US$70,000 provided by Louis Jaffe, as an

alternative media 'think-tank', in an ironic reference to the mainstream organization the Rand Corporation. Raindance was conceived of by Gillette and its co-founders as an umbrella organization to promote and disseminate ideas about video as a radical alternative to centralized television broadcasting through the activities of production, publication and distribution of alternative video work. Based in a loft at 24 East 22nd Street in New York, Raindance was joined by Phyllis Gershuny and Beryl Korot (1945, USA) who set to work producing *Radical Software*, a publication dedicated to the needs of the alternative video community. The first editorial, jointly penned by Shamberg, Gershuny and Korot outlined a range of counter-cultural ideas about the control of information and the necessity of liberating the television medium from the grips of large corporations. Drawing on ideas from Gregory Bateson (1904, UK – 1980, USA) Buckminster Fuller (1895–1983, USA), and others, the editorial outlined an ecological approach to an understanding of the power of technology as a cultural force.

Radical Software continued publishing until 1974, a total of eleven issues with eventual press runs of upwards of 10,000. During that period the magazine covered and publicized radical alternative approaches to video and detailed technical information championing the use of the video medium for social, political and aesthetic change. Although Raindance, constituted as a non-profit foundation in 1971, ceased to publish *Radical Software*, it also published two important and influential books. *Guerrilla Television*, written by Michael Shamberg, attempted to distil the message of *Radical Software* into book form, reaching a wider audience than the periodical as well as publicizing the activities and philosophy of Raindance and giving them a more permanent legacy. Published by Holt, Rinehart and Winston in 1971, *Guerrilla Television* was designed by the Californian video group Ant Farm. The book was divided into two sections – a manual which contained practical and technical information about video and a 'meta-manual' which presented the Raindance philosophy, distilled from the ideas of Frank Gillette and Paul Ryan drawing on the work of their mentors McLuhan, Bateson and McCullough.

In 1975, Schneider and Korot edited *Video Art: An Anthology*, the last of the Raindance publications, a survey of 73 practicing video artists with contextualizing essays by Douglas Davis, Frank Gillette, David A Ross, John Hanhardt and others. Although the Raindance foundation was interested in a wider approach to video than gallery art, many of the most important individuals at the centre of Raindance, Gillette, Schneider and Korot among them, were artists committed to the notion that the new low-gauge medium of video could challenge the status quo of broadcast TV in the United States, and build the foundation of a new approach to communication that extended well beyond the art gallery and museum system.

Frank Gillette's contribution to *Video Art: An Anthology*, 'Masque in Real Time' gives an insight into his thinking and ideas at the time about video as a medium and its relationship to human communication, demonstrating his affinity to the ideas and writings of Marshall McLuhan in particular:

> The video network, in this sense, is the extension of a neurophysiological channel, the connection between the world and the visual-perceptual system terminating in the prefrontal neocortex. Video can thus become a record of the resonance between that channel – eye/ear/prefrontal neocortex – and natural process in time. The first criteria for a video aesthetic, then, is the economy of movement in the use of the camera as a record of mediation between the "eye-body" taken as the symbol and substance of the entire viscero-somatic system in video art, and the processes being recorded. Through a kinaesthetic signature which individuates the "loop" – eye-.body, the technology itself, and the process being recorded – the artist transmutes random information into an aesthetic pattern.[6]

The later distinction between video artists and video activists was still blurred at this time, and many artists who began using video were politically and socially motivated and made what came to be called 'street tapes' – direct documentation of ordinary people going about their day-to-day lives, often edited 'in camera', using the pause control of the Portapak. The artist Les Levine (1935, Ireland), for example made *Bum* in 1965, one of the earliest videotapes of this genre, containing a series of interviews of winos and derelicts on the streets of New York. Frank Gillette made a five-hour documentary on the street life of the hippy community in St. Marks Place during the summer of 1968, whilst experimenting with the portable video he borrowed from Fordham University.

NEW YORK AND OTHER AMERICAN VIDEO GROUPS

By the end of the 1960s, the New York video scene had flourished, and numerous cooperative groups were formed. The members of Commediation, one of the earliest, were united in the belief that video could be used as a tool for social and political change. Individually and collectively, members of Commediation went on to form a number of other important video groups, including Videofreex, Top Value Television, the People's Video Theater and Global Village (see below). Shamberg, Cort, Gutstadt, Gioscia and their colleagues realized that video had the potential for a very different mode of communication to that offered by broadcast television at that time, and these ideas were subsequently developed by other New York-based video groups. David Cort, a key member of the Commediation, saw the new lightweight, portable video

camera could offer activists the potential for a more direct connection between the subject and the viewer: 'The camera was like a funnel through which you could work. You could move in, and be intimate and close.'[7]

The Videofreex, founded in 1969 and initially based in New York City with members including Skip Blumberg, Nancy Cain, David Cort, Davidson Gigliotti, Chuck Kennedy, Curtis Ratcliff, Carol Vontobel, Tunie Wall and Ann Woodward, eventually relocated as Media Bus to Maple Tree Farm in Lanesville, up-state New York. It developed a considerable knowledge base in the application and use of video equipment and techniques and published *The Spaghetti City Video Manual: A Guide to Use, Repair and Maintenance* (1973), which was a comprehensive guide to the operation, use and maintenance of low-gauge video. The group operated a touring media bus programme, visiting communities and institutions throughout New York State and beyond, making and showing their community-based work, and establishing links with environmental groups and experts involved with computer information systems.

The People's Video Theater, founded by Ken Marsh and Elliot Glass, were mainly involved with community video, working with live and recorded video feedback of community issues, using techniques developed with low-cost video and Portapacks in order to present alternative views and attitudes not available via the network news. Their techniques, which included recording responses to their tape screenings, were influential on other community-based video groups, including the UK-based Graft-On (see below).

Top Value Television (TVTV) was formed in 1972 by Michael Shamberg with members of other video groups, including Ant Farm (see below), Videofreex and Raindance in order to cover political conventions using Portapacks for cable TV. *Four More Years* (1972), an hour-long tape documenting the Republican convention of that year, was produced with a crew of 19, and presented material covering a range of activities connected with the convention, including rallies, demonstrations and interviews. This project led to the broadcast of their work on PBS, the American national public broadcasting network.

According to Davidson Gogliotti, one of the original members of Videofreex, and Media Bus, the New York State Council for the Arts made an important contribution to the development of video art in New York. Peter Bradley, director of film, TV media and literature at NYSCA during the early 1970s, funded a wide variety of innovative projects, including media centres, video groups, collectives and individual artists. It is clear that many of the activities of groups such as Videofreex, TVTV and The People's Video Theater would not have been possible without the enlightened attitude of Bradley and his colleagues at NYSCA during this early period.[8]

Chip Lord and Doug Michels founded Ant Farm, a radical architectural and video group In San Francisco in 1968. The group, which at various times included Doug Hurr, Hudson Marquez, Joe Hall, Andy Shapiro, Kelly Gloger, Curtis Schreier and Michael Wright, began exploring the potential of video as an element of their installation and performance work, making use of the Portapack as an improvisational and communication tool and as a method for archiving their projects and live events. In 1971, Ant Farm designed a studio and video screening room for San Francisco art collector Jim Newman, an early example of 'telematics' – a fusion of media technology and architecture. The group produced a number of significant videotapes from documentation of their performance work, including *The Eternal Frame* (1975), with TR Uthco (Doug Hall, Diane Hall, and Jody Procter), *Cadillac Ranch* (1974) and *Media Burn* (1975).

SUE HALL, JOHN HOPKINS, IRAT AND GRAFT-ON

In England, photographer, journalist and political activist John 'Hoppy' Hopkins (1937, UK) was part of a radical counter-cultural group calling themselves the Institute for Research in Art & Technology (IRAT) established during 1969–70 and operating out of a disused factory in Camden, North London. They considered themselves to be artists and media activists with activities and interests spanning a wide range of disciplines which included cinema, electronics, cybernetics, exhibitions, music, photography, printing, music, theatre, video, words and semiotics.

> We were all doing stuff and took the wider view of what an artist is and in some ways pushing at the envelope in some direction – whether the aesthetic or technical or semantic – living on the edge in some way. So, if you think of yourself as an artist in that sense, the activity that you do is art, so if you're doing recording which turns out later to fall into the category of documentary, in my view that would still qualify as art.[9]

The video group TVX was a sub-set of IRAT, an umbrella organization with charity status. There were six original members of TVX including Hopkins, Jo Bear Webb, Cliff Evans, Steve Herman, John Kirk 'and a whole lot of other people who plugged in from time to time, contributing ideas, energy and money'.[10]

The other face of IRAT was 'The Centre for Advanced TV Studies' – the more formal part of the operation, which attempted to make an interface with mainstream organizations such as the International Association for Mass Communications Research, as well as with academic institutions and was involved with the importing and selling of video and communication publications. Hopkins and his group also conducted research on the potential of non-broadcast video as a communication tool

and were commissioned by the British Home Office to write a report about the use of video in community development, which was to become a standard work.

Hopkins met Sue Hall in the early 1970s when IRAT was re-housed by Camden Council after their first premises were demolished. Hall and Hopkins formed a partnership called 'Graft-on' and began to use video in support of a campaign to stop the demolition of the rows of Victorian terraced housing by the local council as part of a plan to rebuild a large section of north London with tower blocks.

Hopkins and Hall worked systematically and methodically, using video techniques and practices that had been developed by George Stoney (1916, USA) who had worked with the 'Challenge for Change' video project at the National Film Board of Canada and on similar projects at New York University. Stoney's methods used video to engage people in issues that concerned them but which they had not been able to articulate or vocalize. Sue Hall described the basic procedure they adopted:

> Basically you go and shoot video in a community where they would raise issues and concerns fairly randomly. Then you'd play bits of it back to them – because there was no way to edit the tape, and then you asked people questions about those bits, and from that usually you would find people who would focus: "what we want to do is this, or what we want to do about that". You would then video them saying that and then you would try to get them to outline how it was going to work, so for example they might say "we'd like to paint all the houses, so they'd look nice, we'd like to clean up the streets".[11]

As video activists, Hall and Hopkins explored the use of video as a catalyst for social action, exploiting the instantaneous playback and combined sound and picture, recording sessions and playing them back selectively, maximizing the flexibility of the Portapak as well as making a virtue of the relatively low running costs of the medium and the re-usability of the tape. The concepts derived from their study of communication theory were fundamental to their approach with video. Hopkins outlined the distinctions between the three levels of meaning as described by Shannon and Weaver (see Chapter 6) in communication systems, and how they were applied to the video work that Hall and Hopkins made during the early 1970s:

> Level A is the technical level. In answer to the question: How well are the symbols of transmission being communicated and received? (Which we were concerned with quite a lot.) So, doing a technical fix to improve the inadequacies in order to achieve better communication.
>
> Level B is semantic, which is characterized by the question: How well is the message getting across? This is the content level and includes aesthetic considerations.

> Level C is where it joins up with the social aspects. To answer the question: How well are the objectives being achieved in the external world? Or, if you like, in terms of social change: What is the effectiveness of the product (or the activity) we've made in achieving the external objectives?[12]

The process of making these tapes was the crucial activity and this process included the entire cycle of engaging with the subject, recording the material and selectively playing it back to the intended audience. The most common screening situation for Hopkins and Hall was to present their resultant video work back to the people directly involved with the activities and events they had documented, or to groups associated with the particular cause or issue they were engaged with. This feedback loop was a fundamental part of their working process, as described above by Sue Hall, a concept clearly drawn from their interest in applying ideas drawn from cybernetics. Often for Hall and Hopkins the process of feedback was the most rewarding part of the activity – playing back the tapes to audiences outside those for whom the tape was originally intended provided them with the greatest learning experiences.

EARLY VIDEO TAPE FORMATS AND BASIC EDITING

In the early days of video the technology was very unreliable, and different machines and models were incompatible – tapes recorded on a machine manufactured by one company were unlikely to play back using machines made by another. The first Portapak available in the UK in 1969 was the Sony CV2000, which had a resolution of 405 lines. In 1970 Sony introduced the CV2100, which although it had 625 lines, had no 'capstan servo', which meant that a tape made on one had to be re-engineered in order to get it to play back on another. The Sony 'Rover', introduced in 1973, finally provided a machine that recorded tapes to a standard format. However the Portapak, manufactured for the North American and Japanese markets (see Glossary: videotape formats) was made to conform to the US 525 line standard, which was incompatible with the UK and European versions, producing further complications and hampering the transatlantic exchange of tapes. As the recorders became standardized and increasingly reliable, video editing became feasible, although initially this was quite a 'hit and miss' operation – either you tried to edit 'in camera', which basically meant pausing the tape between shots, and if you were recording a live event, trying to guess when to start and stop the tape.

THE FANTASY FACTORY

By 1974 Hall and Hopkins had set up an open-access video facility consisting of a ½-inch mains operated video recorder (a Sony AV 3670) and a sound mixer. Visitors to the facility had to supply their own Portapak, and using a time-consuming and

3.1: Sony CV2600. Courtesy of Richard Diehl, http://www.labguysworld.com

rather inaccurate method, it was possible to reorganize the sequences of the original video recording, shorten scenes and eliminate unwanted sections of picture and/or sound, as well as add additional sound sources and music. The technique required a user to roll back both the source tape (the original material) and the master tape (the tape onto which the new recording was to be made) for at least ten seconds (called the 'pre-roll'). Then, using a stopwatch and the mechanical tape counter on the video recorder, punch or hit the 'record' button at the precise moment at which the new recording was intended to begin – a haphazard and tedious process which often yielded disappointing or indifferent results.

By the following year, after research into the operation and availability of various video editing systems, Hall and Hopkins secured grant funding from the Greater London Arts Association (GLAA) to set up an open-access automatic video editing facility, which they called the Fantasy Factory. Sony had recently introduced the 'U-matic' format – a more robust ¾-inch colour video cassette system for the

industrial (non-broadcast) market, and Hall and Hopkins, working with video artist and electronics engineer Richard Monkhouse (see Chapter 7) designed an interface which enabled accurate editing directly from a ½-inch source machine.[13] The U-matic system soon became the standard preferred format of non-broadcast and independent users and remained so well into the 1980s (see Glossary: videotape formats, for further details). The Fantasy Factory continued to be one of the few open-access video post-production facilities in London, but with the advent of computer-based video editing in the 1990s, their client base has gradually eroded, and they have recently ceased operation. Hall and Hopkins have continued to work with video, still working together closely and engaged in various freelance projects and productions.

4. EXPANDED CINEMA
THE INFLUENCE AND RELATIONSHIP OF EXPERIMENTAL AVANT-GARDE AND UNDERGROUND FILM TO ARTISTS' VIDEO

As was seen in the first chapter, video art had its beginnings in the late 1950s and early 1960s. However, artists have been experimenting with moving images using film since the beginning of the twentieth century, and this creative output has been very influential on the development of video art in a number of significant ways. Artists who began to use video in the early days had often themselves also experimented with and/or worked in film. Video pioneers such as the Vasulkas, David Hall, Robert Cahen, Richard Serra, Vito Acconci, Wojciech Bruszewski and many others, often explored and contrasted these two moving image media.

The influence of experimental film on video art is a complex and varied topic, and to treat it properly would require a book of its own. In this chapter I have restricted my discussion to some broad examples of the direct influence of avant-garde/experimental filmmaking on the development of video art (i.e. work by filmmakers who worked within a fine art context, or artists who drew on or reacted against experimental filmmaking traditions). In recent years (since the late 1980s) computer technology has facilitated a convergence between the previously very distinctly separate moving image technologies of film and video in a number of important and significant ways. Increasingly the distinctions between the two media, so crucial in the early days of video, are no longer important or relevant to the experience of viewing and engaging with work by video artists, and for many practitioners the distinctions between the two media have little or no aesthetic or cultural significance.

LOOP STRUCTURES IN EXPERIMENTAL FILM

An important formal structuring device commonly used by experimental filmmakers is the loop – a strip of film joined from beginning to end and used as the basis of a repeating image sequence. One of the earliest known repeated loop sequences occurs in Fernand Leger's (1881–1955, France) *Ballet Mécanique* (1924), an experimental film which includes a multiple repeat action of a single film sequence of a woman climbing a series of steps. *Ballet Mécanique* is Leger's only film, and he was interested in extending ideas developed from his paintings by imposing a machine action to

human movement. He was also interested in producing a film based on what he called a 'new realism' which drew on Futurist principles. In 1926 Leger wrote:

> To get the right plastic effect, the usual cinematic methods must be entirely forgotten.... . The different degrees of mobility must be regulated by the rhythms controlling the different speeds of projection.... . I have purposedly [sic] included parts of the human body in order to emphasize the fact that in the new realism the human being, the personality, is very interesting only in these fragments and that these fragments should not be considered of any more importance than any of the objects listed.[1]

P. ADAMS SITNEY: THE 'STRUCTURAL' FILM

Repeating loop structures were adopted as a formal strategy by a number of American experimental filmmakers who began working in the early- to mid-1960s. Filmmakers including Michael Snow (1929, Canada), Hollis Frampton (1936–84, USA), Ken Jacobs (1933, USA), Paul Sharits (1943–93), Tony Conrad (1940, USA) and Ernie Gehr (1943, USA) produced a number of films which were grouped together by film critic P. Adams Sitney in *Visionary Film*, his classic study of American avant-garde film, under the heading of the 'Structural Film'. According to Sitney's definition, the 'structural' film is cinema in which 'the shape of the whole film is predetermined and simplified'. Within the films made by this group of artists, Sitney identified an awareness and foregrounding of filmmaking's technical processes as crucial:

> ... the formal film is a tight nexus of content, the shape designed to explore the facets of the material.... . The structural film insists on its shape, and what content it has is minimal and subsidiary to the outline.[2]

Sitney identified four main formal techniques that characterized the structural film:

1 The fixed-camera position
2 'Flicker' effect
3 Re-photography off the screen
4 Loop printing.

According to Sitney three of these four defining characteristics of the Structural Film were derived from the work of Andy Warhol (1928–1987, USA), who in a rejection of Abstract Expressionism, produced 'anti-romantic cinema', an attitude that was also in direct contrast to the lyrical and poetic film work of Stan Brakhage (1933, USA–2003, Canada) who passionately believed that every frame was crucial. In contrast, according to Sitney, Warhol 'simply turned the camera on and walked away'.

In Warhol's *Sleep* (1963) for example, a film which has a duration of over six hours, long sequences of film were produced by loop printing entire 100-ft fixed-camera takes, and freeze-printing a static close-up image of the sleeper.

For Sitney, the fundamental challenge of Warhol's films for the structuralist filmmakers was in the orchestration of duration: 'How to permit the wandering attention that triggered ontological awareness ... and at the same time, guide that awareness to a goal'. These new Structural films evoked meditational states through the mediation of the camera.[3]

BRAKHAGE AND 'METAPHORS ON VISION'

According to Sitney's formulation, the Structural Film also grew out of (through an opposition to) the lyrical filmmaking practice of Stan Brakhage, where the cinematic metaphor was tied into eyesight and body movement, and was extended to embrace consciousness. In the works of Brakhage, perception was presented as a condition of vision, almost an imposition of the eye, most clearly stated in *Metaphors on Vision*, a collection of writings about his film work and theories. Brakhage's vision is complex. Poetic and heroic, it celebrates the potential of the camera to break from the confines of 'realism'. In a key section of his book, Brakhage catalogues and identifies the camera's multiplicity of viewpoints in a celebration of its technical prowess:

> Consider this prodigy for its virtually untapped talents, viewpoints it possesses more readily recognizable as visually non-human yet within the realm of the humanly imaginable. I am speaking of its speed for receptivity which can slow the fastest motion for detailed study, or its ability to create a continuity for time compression, increasing the slowest motion to a comprehensibility. I am praising its cyclopaedian penetration of haze, its infra-red visual ability in darkness, its just developed 360 degree view, its prismatic revelation of rainbows, its zooming potential for exploding space and its telephotic compression of same to flatten perspective, its micro and macro-scopic revelations. I am marvelling at its Schlaeran self capable of representing heat waves and the most invisible air pressures, and appraising its other still camera developments which may grow into motion, its rendering visible the illumination of bodily heat, its transformation of ultra-violets to human cognizance, its penetrating x-ray.[4]

In Brakhage's film work the camera and its associated technologies take on a poetic and metaphoric significance in relation to vision and an experience of the world through the eye. In Sitney's interpretation, Structural film is a 'cinema of the mind rather than the eye'.[5] For many, this distinction is rather academic, as it is clear

from Brakhage's writing that his discussion of the 'eye' as the organ of sight is itself metaphoric. For example, in a section subtitled 'My Eye' Brakhage begins:

> My eye, tuning toward the imaginary, will go to any wavelengths for its sights.
> I'm writing of cognizance, mind's eye awareness of all addressing vibrations.
> What rays still pass thorough this retina still unrestrained by mind?[6]

For Brakhage, the mechanism of the eye is in some significant way constrained by the thinking mind. By extension, conventional ('dominant' Hollywood narrative) cinema is constrained by conditioning and linguistic models of rational thought. His notion of the human eye as capable of recovering a wider and more profound vision was influenced by his cinematic experiments. This approach to 'subjective' camera techniques can be seen for example, in *Anticipation of the Night* (1958), a film that presents the viewer with a 'first-person' and highly subjective 'narrative', the representation of a conscious experience.

MICHAEL SNOW AND *WAVELENGTH*

Sitney's identification of the structural film's meditational qualities is illustrated with a discussion of *Wavelength* (1967) an influential film by Canadian artist Michael Snow (1929, Canada).

In her essay 'Towards Snow', Annette Michelson argues that *Wavelength* is a metaphor for consciousness, drawing on ideas from phenomenology in support of her thesis. Michelson discusses *Wavelength* as the film which 'reintroduced expectation as the core of film form' after Brakhage and Warhol, redefining space as an 'essentially a temporal notion'.[7] For Michelson, *Wavelength* transcends distinctions between the two polarities of experimental film form – the 'realist' (prose) of Warhol on the one hand, and the 'poetic' (montage) of Brakhage on the other, through an investigation into the filmic modes of presentation.

Snow himself outlined his original intentions for the film in a statement written to accompany the film on its release:

> I wanted to make a summation of my nervous system, religious inklings, and aesthetic ideas. I was thinking of planning for a time-monument in which the beauty and sadness of equivalence would be celebrated, thinking of trying to make a definitive statement of pure film space and time, a balancing of "illusion"and "fact", all about seeing. The space starts at the camera's (spectator's) eye, is in the air, then is on the screen, then is within the screen (the mind).[8]

Wavelength is constructed from images that present a 45-minute zoom that narrows gradually across the space of a New York loft. Throughout the duration of the zoom,

which is punctuated by 'four human events including a death',[9] the film is constructed from sequences exposed on various film stocks – black-and-white and colour, positive and negative and shot through various coloured filters. Light changes from daylight to night, and from over to underexposure. The 'zoom' is gradual but not steady, often with brief superimpositions, which give the film the appearance of jumping forward, and then catching itself up – anticipating the point it is inexorably moving towards. The film thus presents and foregrounds many aspects of technical image manipulation, but, as Michelson argues, uses them to produce a work in which the overall impact is metaphoric: 'a grand metaphor for narrative form'.[10]

Michelson's analysis supports Sitney's, distinguishing *Wavelength* from the work of Brakhage as centred on a personal vision – an 'inner vision projected through the eye'. Brakhage's insistence on the significance of a 'hypnogogic' vision situated in the eye, which 'aspires to present itself perceptually, all at once, to resist observation and cognition'.[11]

If *Wavelength* and other later films by Snow, such as *Back & Forth* (1968–9), *One Second in Montreal* (1969) and *La Région Centrale* (1970–1), were influential on experimental/avant-garde films that followed it, they were also seen as problematic – especially in England.

For the English avant-garde filmmaker and theorist Malcolm Le Grice (1940, UK), *Wavelength* was in some ways a 'retrograde step in cinematic form'. Le Grice's objections to *Wavelength* were related to the issue of duration as a 'concrete' dimension. His concerns centred on his requirement for an exact correlation between shooting duration and projection time. On viewing, *Wavelength* implies some kind of one-to-one equivalence between the pro-filmic and the projection event, which Le Grice identifies as a contrived continuity which therefore places the film's context squarely within that of the narrative (and therefore for Le Grice, less radical) tradition.[12]

THE 'STRUCTURAL FILM' IN ENGLAND

By the mid-1970s Le Grice and Peter Gidal (1946, USA), the two main theorist/ film practitioners working in Britain, had developed a rigorous theoretical position, which came to be known as 'Structural/Materialist' film. Both artists, through the related activities of filmmaking, writing, and teaching exerted a powerful influence on the direction of experimental filmmaking (and consequently, on the development of experimental video) in this period. In a catalogue published to coincide with the 'Structural Film Retrospective' at the National Film Theatre, London in May 1976, Peter Gidal set out his 'Theory and Definition of Structural/Materialist Film'. In the introduction Gidal clearly sets out the central tenets of his position:

Structural/Materialist film attempts to be non-illusionist. The process of the film's making deals with devices that result in demystification or attempted demystification of the film process… . An avant-garde film defined by its development towards increased materialism and materialist function does not represent or document anything. The film produces certain relations between segments, between what the camera is aimed at and the way the 'image' is presented. The dialectic of the film is established in that space of tension between materialist flatness, grain, light, movement, and the supposed reality that is represented. Consequently a continual attempt to destroy the illusion is necessary. In Structural/Materialist film, the in/film (not in/frame) and film/ viewer relations, and the relations of the film's structure, are primary to any representational content. The structuring aspects and the attempt to decipher the structure and anticipate/recorrect it, to clarify and analyze the production process of the specific image at any specific moment, are the root concern of Structural/Materialist film.[13]

In addition to Gidal's 'Theory and Definition', The *Structural Film Anthology* contained a collection of essays on the seminal films of the movement made by artists working in the UK, Europe and the United States, including writings on the work of Michael Snow, Hollis Frampton, Ken Jacobs and Paul Sharits in the United States, Malcolm Le Grice, Peter Gidal, and William Raban (1948, UK) in England, as well as European artists Peter Kubelka (1934, Austria) and Wilhelm and Brigit Hein (1940 and 1942, Germany). The catalogue and screenings at the National Film Theatre were a clear attempt to address the issue of the predominance of the American film work, and to extend and refine P. Adams Sitney's early definition.

For Gidal, the so-called 'Structural Film' as outlined by Sitney in *Visionary Film* was simply 'another formalism'. In appropriating Sitney's term Gidal was aware of the dangers, stressing that in his formulation emphasis was to be placed on the idea of dialectic, rather than a mechanistic materialism. Gidal felt that Sitney's approach resulted in a fetishization of 'shape' (i.e. a tendency to make visible the organizing principles or system) and therefore to become a quasi-narrative. ('Merely substituting one hierarchy for another') Gidal posited that the use of specific formal devices, such as repetition within duration, facilitated a deciphering of the transformations produced by the relationships between the film and the cinematic techniques employed.[14]

Malcolm Le Grice's theoretical stance was more aligned to the position of the spectator and to issues related to duration. According to Mike O'Pray, Le Grice was sceptical of film debates of the 1970s, and his theoretical position was tempered by

the range of interests and formal developments in his own work throughout the period.[15] Le Grice's work has included multiple projector 'Expanded Cinema' (see below), graphic experiments and experimental narratives, and most recently, video and computer-generated imagery (see Chapter 15).

In an essay published in 1976, writer and critic Deke Dusinberre identified three distinct tendencies in English experimental film practice which, although drawing on the American model, were clearly and significantly divergent. He viewed the English project as one which sought a purification of cinematic signification and was critical of the theoretical contributions of both Gidal and Le Grice to this debate, claiming their contributions 'tended to obfuscate the immediate issues', which were, according to Dusinberre, on a fine line 'between a didactic literalness and an empty tautology'.

Dusinberre's essay is useful in relation to a discussion of the moving image context which was influential on video art practice in the UK. English experimental film culture of the 1970s was very influential on the art school debate, and the films discussed here were widely seen, with a retrospective at the National Film Theatre in 1977, and two major exhibitions at the Hayward Gallery: 'Perspectives on British Avant-Garde Film' in 1977, and 'Film-as-Film: Formal Experiment in Film: 1910–1975' in 1979.

As with the video art scene in this period, the art school was also the base of much English experimental filmmaking. The influence of the art school with its emphasis on co-operative film production, the use of shared facilities and pooled resources and expertise was echoed in the culture of the London Filmmakers' Co-op. The art school experience of these filmmakers was framed within a reflexive modernist and conceptual approach that emphasized the significance of the materials and techniques used in the making of the work, and their influence on meaning.

Of the three categories of film identified in Dusinberre's discussion of the English tendency, the approach referred to as 'structural asceticism' was closest to the American model, but also owed something to films identified with Fluxus. According to Dusinberre these films rejected any notion of a goal or transcendence, but whilst avoiding total abstraction, sought to 'efface the very cinematic image'. Films identified with this approach include a number of works by Peter Gidal; *Room Film 1973* (1973), *C/O/N/S/T/R/U/C/T* (1974), *Condition of Illusion* (1975) and some earlier films by Malcolm Le Grice; *Yes No Maybe Maybe Not* (1967), *Talla* (1967) and *Blind White Duration* (1967); as well as films by others including John Du Cane's *Cross* (1975), and Tony Sinden's *Reversal Rotation* (1975).

According to Dusinberre, the 'ascetic' structural film systematically rejected cinematic illusionism, in contrast to the US approach that favoured the establishment

of an equilibrium between illusionism (representation) and the material aspect (reality). The ascetic structural film presented 'cinema as light on a screen which evokes texture, depth, image, potential illusion'.[16] These films also employed a Warholian strategy of duration and repetition to deliberately evoke tedium in order to force the spectator into a confrontation with the cinematic image.

Dusinberre's second category is particularly significant in relation to video installation practice. 'Expanded Cinema' sought to emphasize the nature of cinema by foregrounding the projection event, encouraging the role of the audience in the semiotic process. This approach, with roots in both performance art and sculpture, emphasized the nature of the projection: the light beam, the surface of the screen, and the physical and perceptual space between. Examples of Expanded Cinema in the UK include Le Grice's *Horror Film 1* (1971) Tony Hill's *Point Source* (1974) and Annabel Nicolson's *Reel Time* (1973).

These works all involved a direct performance aspect, the filmmaker performing a specific action in relation to the film material. Events had a specific duration tied into the length of the film material and the filmmaker/performer's action.

Dusinberre identifies a further significant development which is both an important precursor and a formative influence on the development of video installation:

> ... when the role of the artist as performer is abandoned to the projector and beam and screen as the 'performers' of the piece, a concomitant shift in the role of audience takes place, a shift which transforms the earlier work into the specific projection cinema I am stressing here.[17]

This projection cinema incorporates the entire cinematic apparatus into the work – projector, light beam, screen and demands an audience perspective requiring a spatial involvement which has more in common with sculpture than with cinema. There is a corresponding tendency towards image repetition; 'projection time becomes tautological – that is the only time presented'. In this context the work of Anthony McCall (1946, UK); *Line Describing a Cone* (1973) and *Four Projected Movements* (1975) are mentioned, and to this I would add work by David Dye (1945, UK), for example *Unsigning for 8 Projectors* (1972).

The last of Dusinberre's categories – the 'landscape' film is also significant in terms of video art practice. For Dusinberre:

> The significance of the landscape films arises from the fact that they assert the illusionism of cinema through the sensuality of landscape imagery, and simultaneously assert the material nature of the representational process which sustains the illusionism. It is the interdependence of those assertions

that makes the films remarkable – the shape and the content interact as a systematic whole.[18]

The landscape films of Chris Welsby (1948, UK) (*Park Film* and *Windmill II*, both 1973, and *Seven Days*, 1974) and William Raban (1948, UK) (*Angles of Incidence*, 1973) are seen as differing from both the ascetic and projection films because they are not interested in deconstructing the illusionist nature of cinema, and significantly, especially in their use of time-lapse techniques, they do not present a one-to-one correspondence between the pro-filmic and projection events. Dusinberre also points out that these landscape films 'tend toward the poly sensory experience via its highly condensed image making and occasional multi-screen format'.[19]

The essay summarizes the similarities between the three categories, pointing out that all three foreground image production over image content, placing an emphasis on the imaging technology and the issues related to perceptions which follow on from this:

> This places the spectator in a continual moment of reflection, demanding an awareness of the act of apprehension tantamount to constant reflexiveness. This constant reflexiveness is indicative of a profound shift demanded by modern art which relocates the primary responsibility for meaning-making from the artist to the perceiver.[20]

In 1977 Chris Welsby selected a programme of landscape films, including a number of his own, as part of 'Perspectives on British Avant-Garde Film' at the Hayward Gallery in London. In his programme notes Welsby identified some of the themes which were important to an understanding of his films:

> In art the history of formalism has grown up in parallel with the history of technology. The medium of landscape film brings to organic life the language of formalism … in film; particularly the independent work done in this country, it manifests itself by emphasizing the filmic process as the subject of the work.
>
> The synthesis between these formalistic concerns of independent film and the organic quality of landscape imagery is inevitably the central issue of contemporary landscape art. It is this attempt to integrate the forms of technology with the forms to be found in nature which gives the art of landscape its relevance in the 20th century.[21]

In early films Welsby made use of time-lapse and other mechanical control devices to structure his filmic records of landscape environments. For example in *Windmill II* (1971) the speed of the camera motor is related to the speed of a windmill device,

so that wind-related elements in the film frame remain constant (e.g. the wind in the trees) whilst other movements within the fame, including the exposure, are affected by the changes. In later works such as *Seven Days* (1974) Welsby modified this procedural practice to one in which his intervening presence in the predetermined relationship between the cinematic apparatus and the landscape was made explicit. His intention was to provide a kind of human interface of mediation between the camera device and the natural world.

> My aim is to mediate between the predictable and unpredictable elements of the situation. My intention is to make films which are not about, but a part of this situation in its entirety.[22]

Most significantly it was Welsby's understanding of the filmmaker as the interface between the organic subject matter of the landscape and the cinematic mechanism to create a work that becomes an expression of this relationship.

MALCOLM LE GRICE: ABSTRACT FILM AND BEYOND

In *Abstract Film and Beyond* Malcolm Le Grice argued that films exploring notions of time and temporality could be understood as 'abstract' even though they used the camera (or perhaps more accurately, the lens) to produce the imagery. Discussing Man Ray's *Retour a la Raison* (1923) Le Grice identifies three significant ways in which the film uses photographically derived imagery to produce a specifically 'cinematic' abstraction.

1 A separation of the visual aspects of an object from their normal visual context. The use of extreme close-ups and/or strong lighting, rapid motion of objects, unusual camera angles or framing which renders the object ambiguous.
2 The montage of image sequences based on their kinetic or visual similarities.
3 The direct exposure of objects onto film stock (i.e. using the photogram technique), which ignores film frame divisions, thus drawing attention to the photochemical and material nature of film.[23]

Le Grice had made explicit a fundamental relationship between the works of filmmakers that had hitherto seemed to be poles apart. The notion that images produced using a camera pointed at the 'real' world could be considered 'abstract' was liberating. It made a clear link between the musical and fluid experience of the so-called 'absolute animation' films of the Whitney Brothers, Richter and Fischinger, the hand-drawn films of Len Lye and Norman Mclaren, the lyrical film essays of Stan Brakhage and the conceptual structuralism of Michael Snow and Chris Welsby. Video art can be seen to be part of a tradition that could embrace all of these works,

furthermore the work of video artists such as David Hall and Peter Donebauer are not as irreconcilable as they might at first seem.

Le Grice's films were also an important influence on video art in the UK and elsewhere. In the context of repeating loop structures and in its use of twin-screen projection, *Berlin Horse* (1971) was particularly significant. The original sequence which forms the core of the film was shot on 8 mm film and re-filmed through a series of coloured filters using a range of different film stocks: black-and-white, negative and reversal. The resulting film is a fluid weaving of forward and reverse motion producing a uniquely 'pure' cinematic experience. Although at the time Le Grice had stated he was 'uncertain about what it implies and also about its decorative qualities',[24] *Berlin Horse,* made at the beginning of the 1970s, is a confirmation of the value and significance of the exploration of the artificial boundaries between abstraction and representation in time-based art.

FROM FILM TO VIDEO

In the early days of video, many artists experimented with both mediums, often exploring the similarities and differences. Some shot on film and transferred the results to video, some worked with video and transferred to film. Filming or recording images off the TV screen was also a common strategy.

By the mid-1970s however, video art had begun to forge a distinctive practice, establishing the foundations of its own history. Artists chose to work with video for a variety of reasons, many of which distinguished it from film. As we have seen in previous chapters, emerging video art practice ranged from political activists (such as Guerilla TV and The Raindance Corporation in the USA, and TVX in the UK), to performance-based artists (such as William Wegman, Vito Acconci and Joan Jonas in the USA, and Gilbert & George, Kevin Atherton and Rose Garrard in the UK), to conceptual artists (such as David Hall, Tamara Krikorian and David Critchley), and abstract imaging experimenters (such as Peter Donebauer and Richard Monkhouse in the UK, Stephen Beck and the Vasulkas in the USA). Feminist artists such as Martha Rosler and Tina Keene also embraced video with enthusiasm, attracted by its lack of historical precedence and its political and aesthetic potential. Many of these artists made a transition from film to video, bringing skills and sensibilities drawn from their experience of working with film.

Daniel Reeves (1948, USA) took up video after initially working with film (see Chapter 10). After studying filmmaking at a Vietnam veteran's re-habilitation programme, Reeves found work in the educational TV department at Cornel University. He describes the discovery of his affinity with video, and its suitability for the kind of work that he wanted to produce, whilst engaged on a film project:

... I became really enamored and encouraged by the feeling the video camera could be as direct a tool (within certain restrictions) as a pen, or a brush or a carving tool... . Discovering that I could now go out with the camera, and although it was still a relatively clumsy 3/4 inch U-matic deck. But clumsy or not, it went on a back-pack, and with the camera you could just capture things right there, and look at them right there if you chose to... .[25]

THE VASULKAS

Pioneering US-based video artists Steina and Woody Vasulka took up video in the late 1960s (see Chapters 7 and 10). Steina was a classically trained violinist and Woody studied film at the Academy in Prague. Arriving in the USA in 1965, Woody began working as a film editor in New York, but felt constrained by the traditions of both narrative and avant-garde film and was attracted by the freedom he perceived that video offered: 'I was not very successful in making films – I had nothing to say with film. This new medium was open and available and just let you work without a subject'.

DAVID HALL: FROM FILM TO VIDEO

As previously described, British video artist David Hall trained as a sculptor, documenting his work using photography and film before abandoning both mediums to work exclusively with video.

Hall made his *7 TV Pieces* on 16 mm film for STV in 1971, thus ironically the earliest British video art was actually shot on film:

> I thought that on the whole art had very little social significance and was really kept in its sort of annex. It was just for the initiated. I wanted to try and push outside of that, and it seemed to me that using film—i.e. like cinema, and using video, like television, or better still on television, seemed to me to be a much more appropriate place to be as an artist...
>
> I was doing a bit of film and it occurred to me that TV would really be the ultimate place because everybody had a TV, and that's what they were keen to look at – they weren't keen to go to a gallery. Some people went to galleries, but everybody looked at television, and this was significant.[26]

'SCRATCH' VIDEO

Once frame-accurate video editing became accessible in the early 1980s, the looping of image sequences and/or repeat editing techniques were quickly adopted by video artists. By the mid-1980s this approach had become synonymous with 'scratch': fast repeat-action editing, often satirizing broadcast TV and with an

overtly political content. Dara Birnbaum's *Technology/Transformation: Wonder Woman* (1978) is an early precursor (see Chapter 8), but there were a number of precedents in the canon of experimental film. Charles Ridley's satirical wartime film *The Panzer Ballet* (1940) slyly edited goose-stepping Nazi troops to the tune of the *Lambeth Walk*,[27] and Bruce Conner's newsreel collage films such as *A Movie* (1958) and *Report* (1963–7) were significant early influences, as was Peter Kubelka's *Unsere Afrikareise* (1966).

'Scratch' video work was also characterized by its use of image processing. But the percussive montage of re-appropriated high-contrast colourized images is by no means exclusive to Scratch Video (see Chapter 9). The early work of Len Lye (1901, New Zealand – 1980, USA) for the GPO film unit, for example, *Rainbow Dance* (1936) and *Trade Tattoo* (1937) or *Rhythm* (1957), his ill-fated broadcast TV advert for the Chrysler Corporation, have a similar look and energy.

Lye pioneered and developed the technique of drawing directly onto film, a resourceful solution to the funding problem that dogged him throughout his filmmaking career. This method of filmmaking has become a genre of its own, and many experimental filmmakers have explored and extended its potential. Although there is no direct video equivalent, video artists who developed and built their own video tools to generate and manipulate the video signal offer an interesting parallel. (Some of the work of these artists is discussed in Chapter 7).

ARTISTS' FILM AND VIDEO: DIFFERENCES AND DISTINCTIONS

Any discussion about the relationship between experimental film and video art must include a reference to their differences. As has been demonstrated, video has its own distinct and unique properties that set it apart from film, and many artists have sought to explore these. In taking a decision to work with video, Woody Vasulka claimed 'video negates film':

> The idea that you can take a picture and put it through a wire and send it to another place – you can broadcast from one place to another – this idea of an ultimate transcendence – magic – a signal that is organized to contain an image. … it was clear to me that there was a utopian notion to this, it was a radical system and so there was no question of deciding that this was it.[28]

For the Vasulkas there was a crucial distinction between video and film in the relationship of the picture signal to the sound. Steina:

> It was the signal, and the signal was unified. The audio could be video and the video could be audio. The signal could be somewhere 'outside' and then

interpreted as an audio stream or a video stream. It was very consuming for us, and we have stuck to it.

I remember that Jonas Mekas didn't like video very much, and he said: 'why don't those video makers just make silent video? We all started with silent films'. This was the biggest misunderstanding of the medium I've ever seen. Video always came with an audio track, and you had to explicitly ignore it not to have it.[29]

THE FEMALE GAZE

Feminist video artist and writer Catherine Elwes (1952, France) identified some of her reasons for taking up video as opposed to film in the late 1970s, citing the influences of both Structural/Materialist film and Laura Mulvey's classic 1973 paper 'Visual Pleasure and Narrative Cinema'.[30]

I think initially it was an impatience with painting... . I needed a more direct and immediate way of communicating the stories that were in my head and that I was trying to get out... . For me the difference between film and video was like the difference between painting and drawing.

What put me off about film, principally, was the fact that I couldn't see it... . I also didn't like the waiting. ... Video was a bit like having a pencil with a rubber. I could put something down, and if I didn't like it I could just rub it out. To me it was much closer to drawing and that's why I felt an affinity with it.[31]

BILL VIOLA / STAN BRAKHAGE

Bill Viola's (1951, USA) use of the video camera seems to be almost anti-cinematic. He often uses the camera as if it were a kind of visual microphone. Viola has a particular notion of acoustic space and understands sound as both an object and a physical force. This concept provides a model for installations and tapes that are designed to engage the viewer both physically and emotionally. As a result, he speaks of scenes before his camera as 'fields' rather than 'points of view'. Thus Viola's concern to link physical and material existence to abstract, inner phenomena has evolved out of recognition of the unique properties of sound.

Viola's use of low-light cameras, developed for surveillance purposes in *The Passing* (1991) for example, provides a visual experience that sharply contrasts with the cinematic. Viola's murky low-resolution monochrome sequences of nocturnal desert landscapes and domestic interiors are further subjectivized by the employment of ultra-close microphone techniques. But this subjective use of the camera/sound environment draws directly on the early work of the filmmaker Stan Brakhage in which the gaze of the camera is tied in to body movement, subjective vision and

human consciousness. Compare the sequence of Brakhage trudging up the hill in *Dog Star Man/The Art of Vision* (1961–5), with Viola's shadow figure stumbling down the hill in *The Passing*.

It is also interesting to compare Brakhage in his essay 'The Camera Eye', from *Metaphors on Vision* written in 1963, with Viola, quoted in an interview made 30 years later.

> *Brakhage:* The "absolute realism" of the motion picture image is a contemporary mechanical myth. Consider this prodigy for its virtually untapped talents, viewpoints it possesses more readily recognizable as visually non-human yet within the realm of the humanly imaginable. I am speaking of its speed of receptivity which can slow the fastest motion for detailed study, or its ability to create continuity for time compression, increasing the slowest motion to comprehensibility… . I am dreaming of the mystery camera capable of graphically representing the form of an object after it's been removed from the photographic scene. The 'absolute realism' of the motion picture is unrealized, and therefore potential magic.[32]

> *Viola:* For me, one of the most momentous events of the last 150 years is the animation of the image, the advent of moving images. This introduction of time into visual art could prove to be as important as Brunelleschi's pronouncement of perspective and demonstration of three-dimensional pictorial space. Pictures now have a 4th dimensional form. Images have now been given life. They have behavior. They have an existence in step with the time of our own thoughts and imaginings. They are born, they grow, they change and die. One of the characteristics of living things is that they can be many selves, multiple identities made up of many moments, contradictory, and all capable of constant transformation, instantaneously in the present as well as retrospectively in the future. This is for me the most exciting thing about working as an artist at this time in history. It is also the biggest responsibility. It has taught me that the real raw material is not the camera and monitor, but time and experience itself, and that the real place the work exists is not on the screen or within the walls of the room, but in the mind and heart of the person who has seen it. This is where all images live.[33]

The boundaries and distinctions between artists' video and experimental film are fast dissolving, if not – as some would argue, now completely irrelevant. The reasons for this are not merely technological, but also social, economic, and aesthetic. It is certainly true however that the development of high-resolution digital projection,

non-linear editing, and image-processing computer software have accelerated the process of convergence. New methods of distribution, presentation and dissemination are clearly also an important factor.

For artists who began working in the 1970s and 1980s film and video have represented two distinct paths of related practice that share many of the same concerns and historical precedents. Many video artists have experimented with film, just as many filmmakers have explored the potential of video as a creative tool. From the mid-1960s until the beginning of the 1990s video and film were distinct modes of expression with different, though related production techniques. Film practice has developed a considerable body of theoretical and critical discourse, which for the most part video has lacked, has always envied and has more than occasionally drawn from.

It may eventually be perceived that the split between film and video in the second half of the twentieth century was a kind of technical and aesthetic diversion in the history of the moving image, and that the convergence we are currently witnessing is simply the end of a brief, if productive detour.

For the Vasulkas, Daniel Reeves, David Hall and many others who chose to work with video at the time, the attraction of video was the potential of a new electronic moving image medium that demanded to be explored on its own terms, and yet also clearly drew on the film medium with its rich traditions, its cultural and aesthetic legacy and its critical and theoretical framework.

Video artist Robert Cahen (1945, France) who made his first videotape *L'invitation au Voyage* in 1973, worked with film and video interchangeably during the 1970s, often using a mixture of film and photographic images in his works. His transition to video occurred during a period when he was working with the montaging of still imagery in *Trompe l'oeil* (1979).[34] This work uses a mix of images, techniques and materials and significantly the Spectron video synthesizer (see Chapter 7). For Cahen, the distinction between film and video is characterized by the manipulation of imagery after recording and is comparable to the relationship between natural sounds and recordings used by composers of electronic music:

> The construction of a videotape is done above all from basic material that is modified to express what the artist wants to say. It's an approach similar to the one used in musique concrète, where I started, which uses recordings, basic material that is already complete. It gives you the texture, the quality of sounds that will go into the work. The work doesn't yet exist.[35]

This relationship between video and music is an important factor in the development of video art. The influence and impact of ideas and techniques developed in electronic music will be explored in the next chapter.

5. MUSIQUE CONCRÈTE, FLUXUS AND TAPE LOOPS
THE INFLUENCE AND IMPACT OF SOUND RECORDING AND EXPERIMENTAL MUSIC ON VIDEO ART

The influence of experimental music on the development of video art through John Cage and Fluxism on Nam June Paik has already been discussed in some detail in Chapter 1, and the relationship between sound and image will be further discussed in Chapters 6 and 11, but there are other significant dimensions to the complex relationship between sound recording and artists' video. It could be argued that unlike film, video is a combination of sound and image. The technical origins of video recording are derived from principles developed from sound recording and this relationship has been acknowledged by a number of important video artists including Bill Viola, the Vasulkas, Robert Cahen and Peter Donebauer. This chapter explores some of the most important and influential composers and musicians who were involved with the development of experimental music and sound technology, many of whom provided a model and inspiration for video artists who came after them, or who worked alongside them.

GROUPE DE RECHERCHE MUSICALE, PIERRE SCHAEFFER AND MUSIQUE CONCRÈTE

The impact of sound recording on experimental music was profound and offers interesting parallels to the relationship between images the 'real' world and the process of video recording. For example the French video artist Robert Cahen drew on formative musical experiences to develop his approach to video. Cahen studied electro-acoustic music composition at the Groupe de Recherche Musicale (GRM) in Paris, part of France's national radio and television network, with Pierre Schaeffer (1910–95, France), the inventor of *musique concrète*, a form of electronic music composition that was constructed from recordings of everyday environmental sounds.

Schaeffer began experimenting with phonograph recordings in the late 1940s, developing ideas which lead to his formulation of *musique concrète*, a term he adopted in order to emphasize the sculptural dimension of his sound manipulations. Schaeffer created 'sound objects' with recordings of natural and environmental sounds such as bells ringing, trains, and humming tops, which were processed, transformed and re-arranged using a variety of electronic techniques, including reverse recording, changes of speed and removal of the attack and decay, recording loops of these sounds

onto disc. In 1949 sound engineer Jacques Poullin and composer Pierre Henry (1927, France) joined Schaeffer to construct a large-scale composition – *Symphonie pour l' homme seul.*

In his discussion and appraisal of *musique concrète*, writer and composer Michael Nyman was very critical of both the approach to abstract sound composition and their first attempt at a major work using its principles. Nyman felt that Schaeffer and Henry had developed:

> … a curiously backward-looking technique and aesthetic, being unable or unwilling to discover a method which would be hospitable to these new sounds … one finds fugues and inventions and waltzes as methods of organizing sounds which are typically not used for their own sake but for their dramatic, anecdotal or associative content – not for nothing was the first 'classic' of musique *concrète*. *Symphonie pour l'homme seul*, described by its makers, Schaeffer and Henry, as 'an opera for the blind'.[1]

By 1950, Schaeffer and his colleagues had begun to work with magnetic tape, making their first public performance at the Ecole Normale de Musique and the following year the GRM was formed. The GRM studio soon attracted a number of important composers including Pierre Boulez (1925, France) Olivier Messiaen (1908–92, France), and Edgard Varese (1883, France – 1965, USA) who composed the audio tape component of *Deserts* for tape and orchestra there in 1954.[2]

Through Schaeffer, the GRM had strong links with the Conservatoire National Superieur de Musique (CNSM). This network of connections between broadcasting, musical and audio-visual institutions encouraged and fostered experimentation and creative exchange between musicians, technicians, artists and other disciplines.

In parallel to the establishment of the GRM in Paris, was the emergence of an audiotape studio at the WDR (West German Radio) in Cologne, Germany. Werner Meyer-Eppler (1913, Belgium – 1960, Germany), Robert Beyer (1901–89, Germany) and Herbert Eimert (1897–1992, Germany), set up the studio in 1951, differentiating their approach from the Paris studio from outset by limiting themselves to the manipulation of 'pure' electronic sound sources using precise serial compositional techniques. Karlheinz Stockhausen (1928, Germany) who had studied with Schaeffer in Paris, produced *Studie I* (1953) and *Studie II* (1954) at Cologne both composed from pure sine waves. The Cologne studio soon attracted a host of new composers including Mauricio Kagel (1931, Argentina – 2008, Germany), György Ligeti (Romania, 1923; Austria, 2006) and Ernst Krenek (1900, Austria – 1991, USA). The studio's purist electronic approach had ended by 1956 with the composition of *Gesang der Junglinge* by Stockhausen and Krenek's *Spiritus Intelligentiate Sanctus* as

both these works used a combination of electronically produced sounds and natural sound sources, effectively blurring the distinction between electronic music and musique concrète.

As was outlined in Chapter 1, on the advice of Wolfgang Fortner, Nam June Paik had begun to work at WDR in 1959, and it was whilst in Germany that Paik first encountered the work and ideas of John Cage.

JOHN CAGE AND THE MUSIC FOR MAGNETIC TAPE PROJECT

In 1951 John Cage, Earle Brown (1926–2002, USA), Christian Wolff (1934, France), David Tudor (1926–96, USA) and Morton Feldman (1926–87, USA) formed the Music for Magnetic Tape Project, an informal group working with borrowed equipment and facilities and a fund of $5,000 donated by a wealthy young architect named Paul Williams. The group produced four works in its short life, including *For Magnetic Tape*, a dance commission by Wolff, *Octet I* by Brown, and *Williams Mix* by John Cage, named for its benefactor. Cage's composition was formed from a collection of between 500 and 600 sounds which were recorded, copied and carefully catalogued and then selected and organized using chance operations to determine the organization and editing. All the recorded sounds were first divided into categories: (A) urban sounds (B) rural sounds (C) electronic sounds (D) manually produced (including musical) sounds (E) wind-produced sounds (including 'songs') and (F) 'small' sounds which required amplification. Each sound was also classed as to whether its frequency, overtone structure or amplitude remained constant (c) or varied (v). So, for example Cvvv would signify an electronic sound whose frequency, overtone structure and amplitude were varied throughout its duration.[3]

Williams Mix was Cage's first work for tape and he eventually rejected the notion of audiotape composition, convinced that it was incompatible with his notions of indeterminacy and live performance. Cage had pioneered the use of live electronics in the concert hall in 1939. According to Michael Nyman, *Imaginary Landscape No. 1* was the very first live electronic piece. The composition employed two microphones, one for the percussion and the other to pick up sounds generated by two variable-speed turntables playing radio station test frequencies. *Imaginary Landscape No. 2* (1942) made use of an even wider range of electronic devices in addition to the variable-speed turntables, including audio oscillators and an amplified coil.[4]

CAGE, GEORGE BRECHT AND FLUXUS

The same year that John Cage composed *Williams Mix* he arranged a mixed media event at Black Mountain College in North Carolina. This event contained a number of simultaneous actions and included Cage at the top of a ladder delivering a lecture

with programmed silences, painter Robert Rauschenberg playing scratchy records on a hand-cranked gramophone, David Tudor at the piano, and Merce Cunningham and dancers among the audience, with the simultaneous projection of slides and movies. Cage was particularly interested to move beyond 'pure' music towards theatre and had devised the piece with his companions using a scheme devised using chance operations. This event has often been considered the prototype for many later mixed media 'happenings' in the 1960s.[5]

Influenced by Cage's use of chance operations, George Brecht (1926–2008, USA) adopted the technique in the early 1950s to explore new ideas for his work. In 1958, he enrolled in John Cage's class at the New School of Social Research in Greenwich Village, New York.[6] Brecht began composing theatrical musical pieces and between 1959 and 1962 produced a series of works grouped together in *Water Yam*, a series of minimal musical event activities using simple objects and actions such as combs or dripping water. These compositions comprised a set of instructions or score that operated in a space between poetry and performance. As Brecht once described it: 'Event scores are poetry, through music, getting down to facts'.[7]

Water Yam (1960–3) a boxed collection of George Brecht's music scores produced during this period, was an important influence on the development of Fluxus, an influential anti-art movement formulated by George Maciunas (1931–76, USA). Jackson Mac Low (1922–95, USA), an artist involved with Fluxus and one of Brecht's fellow classmates in Cage's course at the New School describes the significance of Brecht's approach and its influence on Maciunas on the development of Fluxus:

> Maciunas' principal idea, derived mainly from his interpretation of the works made by George Brecht in the early 1960s, La Monte's 1960 Compositions, and to a certain extent my own verbal and performance works and those of Dick Higgins, was that there was no need for art. We had merely to learn to take an "art attitude" towards any phenomenon encountered. Making artworks, he believed then, was essentially a useless occupation. If people could learn to take the "art attitude" towards all everyday phenomena, artists could stop making artworks and become economically "productive" workers. Works such as those by George Brecht were useful as transitional means towards his state of things.[8]

For many John Cage was the spiritual father of Fluxus. Not only because many of the most influential figures of Fluxus had been enrolled in Cage's class at the New School, but also because of his particular approach to music, to notions of theatre, the influence of Zen and the use of chance operations. Cage had a notion of himself as one of the many roots of Fluxus, but was also aware of the diversity and complexity of the movement, and the difficulty in defining or categorizing it:

... kind of a source, like a root; there were many roots and I was just one. You've seen the tree design that George Maciunas made of Fluxus. Well you recall that the roots are given at the top and my name is connected with one of the roots. So I wasn't the only one who brought it about, but I was one of the ones. And I never had ... oh, a sense of being one of the roots. It was George Maciunas who actually thought of Fluxus, who put me in his design of the tree with roots. It was his idea. But his idea of Fluxus is not necessarily another person's idea of Fluxus. So there could be, and I think there must be, so many people involved with Fluxus who don't think of me as a member of Fluxus, or as having anything to do with it.[9]

La Monte Young (1935, USA) another composer who influenced the formation of Fluxus, first came across the music and ideas of John Cage whilst in Darmstat in Germany in 1959 (as did Nam June Paik). Cage's influence on Young was in terms of the use of random numbers to determine duration, number of events and timings, and the presentation of non-musical events within a traditional concert hall setting. Unlike Cage, Young concentrated his work around single events or objects. For example, in *Vision* (1959) Young used random methods to specify the spacing and timing of eleven carefully described sounds to be made over thirteen minutes. Similarly in *Poem for Chairs, Tables, and Benches, etc., or Other Sound Surfaces* (1960) random methods such as consulting the telephone directory were used to determine the timings for an event in which these items of furniture were to be dragged, pushed or pulled around the floor of the concert hall.

La Monte Young's *Composition* pieces of 1960–1, cited as an important influence on Maciunas' formulations of Fluxus, were all of a 'singular event'. For example, *Composition 1960 Number 10*: 'Draw a straight line and follow it'. Or *Composition 1960 Number 2*, which instructed a performer to build a fire in front of an audience, or *Composition 1960, Number 5*, specifying that any number of butterflies be turned loose in a performance area.

In October 1960 the Fluxus artist Yoko Ono (1933, Japan) invited La Monte Young to direct a series of mixed media concerts she was planning to present in her lower Manhattan loft (in the area now known as Tribecca). These events attracted a sympathetic mix of artists and intellectuals, among them Marcel Duchamp (1887–968, France), John Cage, and Jasper Johns (1930, USA), and featured a number of Young's early compositions, including *Composition 1960 Number 10* and *X for Henry Flint* (1960) which was especially influential. It calls for the repetition of any loud percussive sound, repeated any number of times. Although Young decided to abandon repetition as a compositional device in his subsequent work, *X for Henry*

Flint was highly influential on other minimalist composers (see below). It also seems likely that this work had an influence on videotape work such as Joan Jonas' *Vertical Roll* (1972) (see Chapter 8).

Many Fluxus musical events were concerned with exploring a relationship with the audience as a 'social situation', or with a re-evaluation of aspects of particular musical instruments, but generally there was a trend in Fluxus towards aggressive, even destructive acts towards the cultural value or significance of certain musical instruments.[10] We have seen how this attitude towards for example the piano, was extended by Nam June Paik to the television set in Chapter 1. Another connection with Fluxus and the early history of video art occurred in 1963 at the 'Yam Festival', organized by Robert Watts and George Brecht. Wolf Vostell staged a performance in which a mock funeral was given for a television set, still playing as it was interred.

FROM TAPE LOOPS AND PROCESS MUSIC TO MINIMAL MUSIC: TERRY RILEY, LA MONTE YOUNG, ALVIN LUCIER AND STEVE REICH

If *musique concrète* and John Cage's *Williams Mix* can be characterized as music created directly onto a recording medium, so-called 'minimal music',[11] began in a similar way, but then evolved out of a reaction to such a compositional technique. Karlheinz Stockhausen's 1956 composition *Gesang der Junglinge* was instrumental in bridging the gap between electronic music and *musique concrète*, blending electronic sounds and taped voices. Stockhausen was also an influential teacher and his approach influenced many artists and composers throughout Europe and the USA, among them two young Americans, Le Monte Young and Terry Riley.

Terry Riley (1935, USA) began collaborating with La Monte Young in 1959 at the University of California at Berkeley and in 1959–60 Young and Riley were joint composers-in-residence for the Anne Halprin Dance Company in Los Angeles. After Young left Berkeley for New York City, Riley began to experiment with repetition as the basis for musical structure, making and manipulating audiotape loops to compose *M Mix* (1961) which comprised recorded speech, distorted 'found' sounds and piano for choreographer Anne Halprin's *The Three-Legged Stool*.

During a period in Paris in 1963, Riley gained access to the ORTF studios whilst composing *Music for the Gift* (1963). A sound engineer assisting Riley to create a particular echo effect he required, hooked two tape recorders together into the same tape-loop configuration – creating what Riley later called a 'time-lag accumulator'. The basic idea is simple, but allows for a complex and gradual building of sound textures. The first tape recorder plays back a sound, a moment later (the time it takes the tape-loop to reach the second tape machine's recording head) the second machine records the resulting sound. The first machine then plays back this new recording, and

after the gap, the second machine records the result. Gradually this process builds a progressively complex layered sound track.[12] This technique has been an important compositional tool for other composers themselves influential on video art including Brian Eno (1948, UK), and Alvin Lucier (1931, USA) (see below).

Returning to California in 1964, Riley joined the San Francisco Tape Center, developing a new instrumental piece that drew on the tape looping techniques that he had developed. The score for *In C* (1964) which does not specify the number of musicians or the type of musical instrument, consists of 53 separate short musical modules, each of which can be repeated as often or as seldom as a player wishes. Therefore the individual performers move at their own pace to the steady beat of a pulse through each of the 53 modules arriving in their own time at the end. The notion of individual performers operating in a mode similar to a repeating tape-loop to produce overlapping musical textures was drawn form Riley's experience with composing for tape, but adds an important unpredictability in that the live performers were expected to interact in a way that draws on jazz improvisation.

> It was not just *In C's* use of constant repetition that would prove important. More than any previous piece of minimalism, it also forcefully reasserted tonality as a viable force in New Music. Its title should be taken literally: *In C* is defiantly and unashamedly in the key of C, and this at a time when atonal serialism still ruled the New Music world. And its kinetic repetition was grounded in a steady, unrelenting beat called "The Pulse", provided by one performer who does nothing but drum out Cs at the top of the keyboard. By re-embracing the primal forces of unambiguous tonality, pounding pulse and motoric repetition, Riley threw down the gauntlet before the hermetic, over-intellectualized new music mainstream.[13]

Alvin Lucier became director of the electronic music studio at Brandeis University in 1962, and formed the Sonic Arts Union in 1966 with composers Gordon Mumma (1935, USA), David Behrman (1937, Austria) and Robert Ashley (1930, USA) in order to promote and perform each other's music. Lucier was later appointed director of the department of electronic music at Wesleyan University (1970). In 1968 he began experimenting with compositions that explored the acoustic properties of natural and artificial spaces, of which his composition *I Am Sitting in a Room* (1970) is perhaps the best known. In this work Lucier records the following speech:

> *I am sitting in a room different from the one you are now in. I am recording the sound of my speaking voice, and I'm going to play it back into the room again and again, until the resonant frequencies of the room reinforce themselves so that any*

semblance of my speech, with perhaps the exception of rhythm, is destroyed. What you will hear then are the natural resonant frequencies of the room, articulated by speech.

As described, Lucier recorded, played back and re-recorded the sound produced by the tape apparatus, and with each successive recording the sounds produced by the acoustic characteristics of the space are progressively reinforced, whilst others such as the characteristics of the original speech are gradually eliminated, and by this process the spoken word is systematically transformed into pure musical sound. Composed in 1970, *I Am Sitting in a Room* was first performed with 15 generations of the composer's speech at the Guggenheim Museum in New York in March of the same year, accompanied by a series of Polaroid images by his wife, video artist Mary Lucier (1944, USA) (see Chapter 13). This influential work which has been performed and recorded by a number of other musicians, and was conceivably an important influence on the 1974 video tape *This is a Video Receiver* by David Hall (see Chapter 8).

Brian Eno began experimenting with audio tape recorders in the 1960s, and became involved with the work of Cornelius Cardew (1936–81, UK) and the Scratch Orchestra. His experiments with tape led to the devising of a 'closed' tape-loop system that linked the output of a second tape recorder back to the first, which was in turn re-recorded along with new material. Eno's work with British rock guitarist Robert Fripp resulted in the first application of his tape-loop system for Fripp's band King Crimson and later for Eno's solo recording 'Discrete Music' in 1975. Eno himself has worked with the video medium, for example his installation *Mistaken Memories of Mediaeval Manhattan* (1980–2) which presented a continuous 'real-time' recording of images recorded of the view from his New York studio on a camera turned on its side to provide a vertical image.

American composer Steve Reich (1936, USA) first began using audiotape loops to produce *It's Gonna Rain* in 1965. Constructed by repeating sections of a fragment of a speech made by Black preacher Brother Walters recorded in Union Square, San Francisco, Reich played two identical loops simultaneously on two tape recorders in his studio and observed that they gradually fell out of synchronization with each other (or, as he called it, 'out of phase'). In the final version of *Its Gonna Rain*, Reich used eight loops of that same speech fragment to build up a musical composition packed full of unforeseen rhythmic combinations. In 'Notes on Compositions 1965–73' Reich explained that his attraction to electronic music had come from an interest in the musical potential of recorded speech: 'what seemed interesting to me was that a tape recorder recorded real sounds like speech, as a motion picture camera records real images'.[14]

Although Reich had been working with tape loops since 1963, the main impetus

for this new work was the experience of working with Terry Riley on the inaugural performance of *In C* (1967), a composition that simultaneously combined many different repeating patterns. Inspired by Riley's use of repeating structure, and looking for a new way of using repetition himself as a compositional technique, Reich decided to play a recorded tape-loop against itself in a canonic relationship:

> *In the process of trying to line up two identical tape loops in some particular relationship, I discovered that the most interesting music of all was made by simply lining the loops up in unison, and letting them slowly shift out of phase with each other. As I listened to this gradual phase shifting process I began to realize that it was an extraordinary form of musical structure. The process struck me as a way of going through a number of relationships between two identities without ever having any transitions. It was a seamless, continuous, uninterrupted musical process.*[15]

In 'Music as a Gradual Process' Reich described an approach to musical composition that had developed out of his tape-loop pieces *Come Out* and *Melodica*, both composed in 1966. Through this tape work Reich became interested in the idea of process music, defining his practice in a 1968 manifesto:

> I do not mean the process of composition, but rather pieces of music that are, literally processes…. I am interested in perceptible processes. I want to be able to hear the process happening throughout the sounding music.
>
> Performing and listening to a gradual musical process resembles: pulling back a swing, releasing it, and observing it gradually come to rest; turning over an hour glass and watching the sand slowly run through to the bottom; placing your feet in the sand by the ocean's edge and watching, feeling, and listening to the waves gradually bury them.[16]

For Reich this was music in which a predetermined procedure determines both the detail and the overall form of the music, and as such resembles very closely P. Adams Sitney's formulation for the Structural film. Reich's involvement with tape technology had brought him very close to the sensibility of experimental filmmakers, and visual artists of the time. In 1966, Reich had moved to New York City, and his music of this period was often performed in visual arts centres. For example, *Melodica* (1966) was performed at the Museum of Modern Art, New York, 12/68, and *Piano Phase* (1967) at the Guggenheim Museum and the Walker Art Center, Minneapolis (1970).[17]

'Music as a Gradual Process' was published in the exhibition catalogue of 'Anti-Illusion: Procedures/Materials' at the Whitney Museum of American Art in New York in 1969. The filmmaker Michael Snow was one of the performers of *Pendulum Music* (1968) on three occasions in New York art galleries between 1969

and 1971.[18] Reich extended these ideas through works that included *Slow Motion Sound* (1967), *Violin Phase* (1967) and *Piano Phase* (1967). Experiments playing a piano against a taped loop in late 1966, had led to the composition of *Piano Phase*, in which two live pianists beginning in unison, repeat the same pattern of twelve notes.

In 1969, working with electronic engineer Larry Owens from Bell Laboratories in New Jersey, Reich developed an electronic instrument called the 'Phase Shifting Pulse Gate'. Basically speaking this was a twelve-channel rhythmic device for live performance, driven by a digital clock, which could be fed up to twelve constant sounds from either a microphone or electronic source. Each of the sound channels is capable of 'gating' (selectively allowing the signal through) for a controllable time period, and of controlling the phase shift so that gating occurs within a specified time period. Reich built the machine and first used it in a live performance at New York's New School in April 1969. A second performance using the device took place the following month using eight oscillators tuned to the same scale as four log drums used in the same concert. This was the final performance using the device, as Reich was dissatisfied with the musical qualities of these works.

Reich has himself expressed an interest in the potential of video as a medium of expression. He has recently produced a number of large-scale works, in collaboration with his wife, the video artist Beryl Korot (see Chapter 13) that attempt to integrate an interest in sound sampling techniques with video installation. In *The Cave* (1993) and *Three Tales* (2002) they have staged hybrid video theatre pieces that successfully combine video and sound technologies to powerful effect.

CONCLUSION AND SUMMARY

There is a clear and crucial relationship between the development of experimental and electronic music and video art. First and perhaps foremost, the seminal influence of John Cage on the development of Fluxism; his employment of chance operations as a compositional technique, his use of electronic devices such as the microphone, radio receivers, and his profound influence on Nam June Paik, are all significant to the subsequent development of video art.

It is also necessary to acknowledge the fundamental relationship between the audio and video signals and the methods of manipulating and transforming them, as has been stressed by artists including Robert Cahen, Steina and Woody Vasulka, Peter Donebauer, and many others. This relationship links the development and exploration of the related technologies and points the way to an understanding of the nature of the potential of video as a fluid and malleable art form that parallels music in its scope and power.

The relationship between experimental music of the late 1960s and early 1970s

and the development of artists' video can be seen in the close collaboration and cross-fertilization of ideas between key figures in both disciplines. In New York City for example, video artists, filmmakers, performance artists, musicians and composers such as Alvin Lucier, David Tudor, Michael Snow, Steve Reich, Beryl Korot, Mary Lucier, La Monte Young, Joan Jonas, John Cage, Nam June Paik, Charlotte Morman, Vito Acconci, Richard Serra, Yoko Ono, Bill Viola, the Vasulkas and many others presented, performed and debated their work in venues such as The Kitchen in New York, influencing, and sharing ideas, concepts and exploring and investigating new technological and creative potentials and possibilities. Similarly in major European cites such as London, Paris, Milan, Amsterdam, Cologne and many others, artists and musicians attended each other's events, performances, screenings and concerts.

Throughout the 1960s and early 1970s radical new approaches to art emerged in Europe and North America; the Situationists, Fluxus, Conceptual Art, process art, Arte Povera, etc., all eschewing the art object in favour of more ephemeral forms such as performance, body art and installation. This radicalism included an active search for new materials and media, alternative venues, new audiences and methods of dissemination and a newfound political and social awareness. This prevailing attitude united many artists, prompting experimentation with new forms and an interest in hybrid approaches and collaborative projects, which cut across traditional media boundaries.

6. THEORY AND PRACTICE
THE INFLUENCE AND IMPACT OF THEORETICAL IDEAS ON EARLY TECHNOLOGY-BASED PRACTICE IN THE 1970S AND SOME SIGNIFICANT AND INFLUENTIAL FIGURES IN THE DEVELOPMENT OF THEORETICAL DISCOURSE AND THEIR IMPACT ON CONTEMPORARY ART AFTER MODERNISM

WALTER BENJAMIN: THE WORK OF ART IN THE AGE OF MECHANICAL REPRODUCTION

First published in 1936, Marxist critic Walter Benjamin's influential essay *The Work of Art in the Age of Mechanical Reproduction* envisioned a radical expansion of the influence of technology on the development of art. His notions of the potential of the arts for social and political change through its use of new and developing technologies were free from traditional ideas about the hierarchical divisions between technique and craftsmanship. Identifying the dawn of art as linked with notions of magic and religious ritual – Benjamin was critical of the 'aura' surrounding the unique art object, which historically demanded the viewer's personal presence, most often via an experience requiring a pilgrimage to a special, often sanctified location – the church and monastery, the court of the nobleman, the museum or gallery.

Although written when television was in its infancy, and prior to the invention of video, Benjamin (1892, Germany – 1940, Spain) was responding to ideas which had been envisaged by Paul Valery (1871–945, France) who, in his book *Aesthetics, the Conquest of Ubiquity*, had accurately predicted that images and sounds would eventually be made available 'on tap' to the householder:

> Just as water, gas and electricity are brought into our houses from far off to satisfy our need in response to a minimal effort, so we shall be supplied with visual or auditory images, which will appear and disappear at a simple movement of the hand.

In his essay Benjamin examined the gradual transformation of the art object and its aura as technological processes of reproduction developed, beginning with early mechanical processes including the printing press, the woodcut, and bronze-casting, completing this analysis with late nineteenth- and early twentieth-century technological developments such as photography, sound recording, and the cinema. Benjamin's thesis was that the increasing fidelity of the copy to the original had progressively reduced the ability of an elite group to own and control the power and influence of art, which with undeniable political and revolutionary

implications would bring about a complete reversal of the purpose of art in society:

> For the first time in world history, mechanical reproduction emancipates the work of art from its parasitical dependence on ritual. To an ever-greater degree the work of art reproduced becomes the work of art designed for reproducibility ... the instant the criterion of authenticity ceases to be applicable to artistic production, the total function of art is reversed. Instead of being based on ritual, it begins to be based on another practice – politics.[1]

This erosion of the aura surrounding the original artwork also had an impact on the role and public perception of the artist – hitherto historically defined and romanticized. In Benjamin's essay an exploration of this issue is limited to a discussion of publishing in which the distinction between author and public was losing its basic character, which according to Benjamin was becoming 'merely functional' – he notes that the 'privileged character of respective techniques is lost'. However, the wider implications of this idea were grasped by a number of artists who worked with imaging technology, especially those who made a decision to use video as an art medium in the late 1960s. For example, Douglas Davis (1933, USA), an influential American video artist and writer deeply inspired by Benjamin's ideas, understood that technological processes had a directly liberating effect on the role and activity of the artist:

> In the past, the role of the artist could be tightly controlled. A certain mode of dress, background and physical craftsmanlike skill with the hand demarcated the possibilities. Now the dividing line is blurring ... technology steadily reduces the need for specialized physical skills in art.[2]

In both his writing and his practice Davis saw the instantaneous live aspects of video technology as an important step in a continuous process that would lead to the eventual eradication of the 'spectator ritual' in art – the activity of, as he called it, 'the going to the temple'. Although by no means a Marxist, Davis and a number of his contemporaries such as Frank Gillette, and David Ross, did subscribe to a radical political, almost utopian ideal for art, with video as a significant and necessary stepping-stone. For Davis and his fellow video activists 'the next step is to get rid if the intervening structure, the cameras, monitors and telecasting circuitry'.[3]

NORBERT WIENER AND CYBERNETICS, CLAUDE SHANNON AND INFORMATION THEORY

The American mathematician Norbert Wiener (1894, USA – 1964, Sweden) published his influential book *Cybernetics* in 1948, and two years later the first edition of his book *The Human Use of Human Beings* was published, discussing

the implications of this new field and extending Wiener's ideas to a wider and less specialized public.

Wiener had coined the word cybernetics from *Kybernetes*, ancient Greek for 'steersman', to describe a new theoretical approach to the interdisciplinary study of language, messages and the nature of control and communication systems in machines, animals and humans. In *The Human Use of Human Beings* Wiener posited that:

> Society can only be understood through a study of the messages and communication facilities that belong to it; and that in the future development of these message and communication facilities, messages between man and machines, between machines and man, and between machine and machine are destined to play an ever-increasing part.[4]

Developing ideas that would eventually lead to the founding of cybernetics, Wiener realized that the concept of feedback was crucial to an understanding of the way that humans and animals make continuous adjustments in relation to their surroundings and situation – a process of prediction and control of the organism takes place within the nervous system. In humans and animals, a small part of the past information output is fed back to a central processor in order to modify future outcomes.

Cybernetics, subtitled *Control and Communication in the Animal and the Machine* was the description of a general science of mechanisms for the maintaining of order within a universe that is heading towards entropy. Wiener's notion of a steersman controlling a boat through the random and chaotic forces of a flowing river to stay on course is a useful analogy. He saw that there was a crucial connection between control and communication. The steersman maintains control of the boat by constantly monitoring, adjusting and re-adjusting the rudder to compensate and correct its course. Wiener sought to describe a general law in mathematical language that was common to both the control of machines and of biological systems. Cybernetics imbued new technical meanings to notions of communication and language that could now be expressed via mathematics and equations, and can be seen as part of a paradigm shift away from the Newtonian model of the universe with its emphasis on energy and matter, to a model based on notions of information.

Information Theory, developed by the mathematician Claude Shannon (1916–2001, USA), is the other major strand of a new paradigm in scientific thinking that emerged during the late 1940s. Shannon, working on ways to develop a mathematical tool for describing the performance of electrical relay circuits, realized that George Boole's (1815–64, UK) logical algebra, developed nearly a century before, could be

used to build an information storage device, which paved the way for the development of the digital computer.[5]

Later, whilst working for Bell laboratories Shannon became involved with research into the fundamentals of communication and information systems. In his research Shannon was seeking mathematical descriptions of information through an investigation into the nature of the laws of energy. His ideas, first presented in two papers he published in 1948 theorized notions connected to the transmission of information via 'noisy' media, which were fundamentally tied into the relationship between energy and information. Shannon demonstrated that any message could be reliably transmitted providing the right code can be devised. Although these ideas inspired the technological breakthroughs responsible for the development of colour television, for example, they were also more widely significant. In fact, his ideas were so widely applied to disciplines outside his own that Shannon felt that information theory, as it came to be known, had been taken too far. It was universally perceived that the information model was very useful in presenting natural phenomena as complex networks of communication rather than as intricate mechanistic devices as they had previously been seen. Breakthroughs such as the decoding of DNA were a direct consequence of such an idea, as was the development of Noam Chomsky's (1928, USA) important work on the fundamental structures of human language.[6]

Wiener himself identified the significance of cybernetics to a wide range of issues in areas of thought beyond the originally defined discipline:

> It is the purpose of cybernetics to develop a language and techniques that will enable us indeed to attack the problem of control and communication in general, but also to find the proper repertory of ideas and techniques to classify their particular manifestations under certain concepts.[7]

This notion of an analysis of general communication and the establishment of a clear relationship between technological systems and human communication was highly influential. The ideas of Shannon and Wiener were applied to many disciplines within the related fields of science, engineering and technology, but they were also very influential on new cultural theories, especially those that sought to make an analysis of cultural institutions which made extensive use of technological communication systems. One very highly significant and influential example of this is the work of a Canadian literary academic turned media theorist named Marshall McLuhan.

MARSHALL MCLUHAN AND *UNDERSTANDING MEDIA*

Marshall McLuhan (1911–80, Canada) first began to write about the impact of the mass media and its influence on a potential shift in human consciousness in *The*

Gutenberg Galaxy (1952) and *The Mechanical Bride* (1951), but it was the publication of *Understanding Media* (1964), that had the most direct impact on the development of artists' video. *Understanding Media* introduced McLuhan's famous phrase 'the medium is the message' and presented his influential notions about the development of a 'global village' brought about by the development of electronic communications networks. McLuhan's ideas were inspirational and motivating to the new generation of artists who emerged in the mid to late 1960s – indeed McLuhan argued that the artist's role in the deployment of the new technologies in society was both timely and crucial:

> For in the electric age there is no longer any sense in talking about the artist's being ahead of his time. Our technology is, also, ahead of its time, if we reckon by the ability to recognize it for what it is. To prevent undue wreckage in society, the artist tends now to move from the ivory tower to the control tower of society. Just as higher education is no longer a frill or luxury but a stark need of production and operational design in the electric age, so the artist is indispensable in the shaping and analysis and understanding of the life of forms, and structures created by electric technology.[8]

McLuhan's notions of television as a cool, 'high participation' medium, whose 'flowing, unified perceptual events', were widely discussed and debated by artists and media activists who began working with video in the early 1960s. In 'Television: The Timid Giant', a chapter specifically about TV, McLuhan's description of the TV image could fit easily into many video art manifestos of the period (or, for that matter, considerably later, see, for example, David Hall's 'Towards an Autonomous Practice', 1976, cited in Chapter 1).

> The TV image is not a still shot. It is not photo in any sense, but a ceaselessly forming contour of things limned by the scanning finger. The resulting plastic contour appears by light through, not light on, and the image so formed has the quality of sculpture and icon, rather than of picture.[9]

McLuhan's notion of television as 'our most recent and spectacular electric extension of our central nervous system' influenced by ideas formulated by cybernetics, was compelling and highly influential. Some of these notions now seem so fundamental to an understanding of the medium that they often go unchallenged. Contrasting the low intensity/low definition of TV with that of film, McLuhan saw TV as a complex *gestalt* of data that did not present detailed information about objects, but instead provided a diffuse texture. He formulated television as an extension of the sense of touch, involving a 'maximal interplay of all the senses'. McLuhan saw this as the reverse of most technological developments that he identified as an 'amplification',

and therefore a separation, of the senses. Television, on the other hand, presented a 'mosaic space' – comparable in concept to ideas in modern physics, and most significantly, modern art, which reversed the process of analytical fragmentation of sensory life. For McLuhan, this mosaic form was not a visual structure, but was more akin to the sense of touch, requiring 'the participation and involvement of the whole being'. McLuhan contrasted this 'iconic mode' which 'used the eye as we use our hands in seeking to create an inclusive image, made up of many moments, phases and aspects of the person or thing' with a visual representation which deliberately isolated a 'single moment, phase or aspect' in time and space. For McLuhan the visual stress on uniformity, continuity and connectedness, derived from literacy, was a technological system for the implementation of continuity via fragmented repetition. The TV image and electronic information-patterns, like other mosaic forms, were instead, 'discontinuous, skew and non-lineal'. Thus, the televisual image is the antithesis of literacy. Representational art, with its specialization of the visual (and extension of the literal), is defined as viewing from a single position. The tactual, iconic mode is synaesthetic – a complex mix of all the senses.[10]

Following on from this is a notion that the tactual form of the television image is its defining characteristic, that the form dictates or imposes its meaning:

> It is the total involvement in all-inclusive "nowness" that occurs in young lives via TV's mosaic image. This change of attitude has nothing to do with programming in any way, and would be the same if programs consisted entirely of the highest cultural content. The change in attitude by means of relating themselves to the mosaic TV image would occur in any event.[11]

It is not surprising that McLuhan's analysis of communication systems and the structures of human consciousness were highly influential on artists and media activists. Mirroring the formalist preoccupations of contemporary art practice of the time, McLuhan's notions about the crucial relationship between shifts in cultural consciousness and new forms of technology identified video as a key development in a comprehensive programme for social change.

Frank Gillette (1941, USA) video artist and founder of the Raindance Corporation (see Chapter 3) compares McLuhan's influence on American art of the 1960s with that of Sigmund Freud on the emergence of Surrealism in the 1920s. From the perspective of the late 1990s Gillette sees the most significant art movements of the period – Pop Art, Minimalism, Conceptualism and even the Greenbergian formalism of Abstract Expressionism, as being, in the main, responses to McLuhan's worldview.

Gillette posits that McLuhan's ideas about the relationship between medium and message began to be influential during the same period as the emergence of Pop

Art was displacing the dominance of Abstract Expressionism and as the distinctions between high and low culture were being challenged. However, rather than being seen as a direct influence, McLuhan's ideas were absorbed in an indirect osmosis:

> Passing through the art worlds semi-permeable membrane like some unacknowledged solvent. It was received within the art world's precincts as a particular strain of the overall "eschatological heave" (Mailer's coinage) which branded every aspect of 60s culture – visual, political, theoretical and popular.[12]

Gillette saw McLuhan's notion of an overlapping of the end of the mechanical age with the dawn of the electronic era as analogous to the end of Abstract Expressionism and the emergence of Pop Art, directly quoting McLuhan: 'The partial and specialized viewpoint, however noble, will not serve at all in the electric age. At the information level the same upset has occurred with the substitution of the inclusive image for the mere viewpoint'. In Gillette's view, Abstract Expressionism represented a very specialized and 'noble' viewpoint and Pop Art's aesthetic practice was all-inclusive in its absorption of mass media imagery.

American video artist Martha Rosler (1943, USA) however, was more critical of McLuhan's approach, characterizing his view of the history of technology as a simplistic 'succession of Technological First Causes'. Pointing out that artists inevitably fell in love with his notion of the artist as 'the antenna of the race', McLuhan's theories offered both artists and community activists with what she termed 'the false hope' of a technological utopia based on 'the idea of simultaneity and a return to an Eden of sensory immediacy'. Rosler's critique posits that through McLuhan's influence artists were seen to be endowed with mythic powers enabling them to re-apply notions of the formalist avant-garde to contemporary culture which fulfilled their 'impotent fantasies of conquering or neutralizing the mass media'.[13]

For example, Gene Youngblood's *Expanded Cinema*, published in 1970, virtually paraphrases McLuhan at one point, describing TV as a 'sleeping giant'. Youngblood's book is an enthusiastic summation and comprehensive survey of the technological communication tools and aesthetic preoccupations of the late 1960s. It presents a post-McLuhan view of audio-visual technology, identifying expanded forms of video as the key to a revolutionary reshaping of the nature of human communication.

> Television is a sleeping giant. But those who are beginning to use it in revolutionary new ways are very much awake… . But the new generation with its transnational interplanetary video consciousness will not tolerate the miniaturized vaudeville that is television as presently employed.[14]

But *Expanded Cinema* goes far beyond an analysis of 1960s attitudes to experimental

film and video. The book attempts to trace the development of an externalizing of human consciousness, a projection of human inner thought to the space 'in front of his eyes'. Youngblood enthusiastically endorses technological progress as a libratory force, declaring that a fusion of audio-visual technology with the process of art and learning was the key to the growth of the individual. Expanded Cinema, Youngblood believed, would 'create a heaven on earth'.[15]

This intersection of political and social change, technological and artistic critical transformations gave rise to an enthusiasm for a potential new image/information-based society. Critic David Antin described the mixed metaphors of biology, technology and political change endorsed by Youngblood and his contemporaries as 'Cyber-scat – a kind of enthusiastic welcoming prose peppered with fragments of communication theory and McLuhanesque media talk'.[16]

Chris Hill identifies American confidence in technology and its potential to produce a transformation in society in this period as partially underwritten by a post-war investment in science and technology. Clearly McLuhan's terminology reflects this attitude and its influence on the arts, claiming art as 'a laboratory means of investigation'.

In the mid-1960s American writer and critic Susan Sontag summarized the prevailing attitude to the crucial relationship between art and technology in United States among artists and intellectuals, clearly reflecting the legacy of McLuhan:

> … there can be no divorce between science and technology, on the one hand, and art, on the other, any more than there can be a divorce between art and the forms of social life.[17]

Some British video activists, taking their cue from the more advanced American models of independent production at the time, drew directly on the theoretical ideas of cybernetics and information theory in their work. As described in Chapter 1, John Hopkins and Sue Hall, experimenting with video as a tool for social, political and creative change in London in the early 1970s were very conscious of the source and origins of their inspiration on the nature of video and its potential as a communication tool:

> *Hopkins:* My view of video was that it was a new communications medium. This was my metaprogram – my overview. When Sue and I started working together in late 1973, she also shared that view.

> *Hall:* I came from Shannon and Weaver and Cybernetics. Mathematic and communication theory, none of which I claim to have fully understood … I wasn't thinking about art at all… . But gradually I came to see it as a kind

of communications sub-set… . One of things that most interested us was the theories that in the most general form would apply across all these areas… . What we wanted to know was if there were any general rules like relativity theory.

Hopkins: A general theory of communications.

Hall: We were into this as expressed mathematically by Claude W. Shannon of Bell Labs in 1948–49 as an equation, out of which the international telephone network was constructed – the fact that you could pick up that computer now and plug it in is actually dependent on the fact that those equations work.[18]

Many of the artists who began working with video in the late 1960s and early 1970s were influenced by the prevailing ideas of McLuhan, especially his notions of broadcast television and its distinctive properties and the way in which those properties affected the programme content and the underlying message. 'The Medium is the Message' was a pervasive and powerful slogan, and the embodiment of an influential idea.

The Marxist critique of Walter Benjamin and his notion that the powerful reproductive power of the photographic process would remove the aura from the art object certainly had important resonances for artists who chose to work with a medium that challenged the hegemony of object-hood and stressed activity and the ephemeral. Its impact on ideas relating to the rise of Conceptual Art, Body art and Fluxus is significant and crucial.

Artists who sought a theoretical underpinning to their work with a complex technological medium such as video were attracted to ideas that could be articulated and explored using the language and insights developed through cybernetics, and communication theory. They understood that these new concepts had a direct bearing on the way that communication systems functioned and operated within society and sought insights into how to engage with this new technological medium in a society that was being transformed by it.

SOME SIGNIFICANT AND INFLUENTIAL FIGURES IN THE DEVELOPMENT OF THEORETICAL DISCOURSE AND THEIR IMPACT ON CONTEMPORARY ART AFTER MODERNISM

Although much of the early history of artists' video is centred on the intrinsic and unique properties of the medium, during the 1980s there was a shift away from this tendency towards what the American critic and cultural theorist Rosalind Krauss has characterized as the 'post-medium condition'. Krauss is often cited as a major influence on the introduction of the ideas of thinkers from disciplines which had previously been considered to be outside the study and practice of art. This group of continental European philosophers, psychoanalysts and writers (nearly all originating

from France) includes Roland Barthes, Jean-François Lyotard, Jacques Lacan and Jacques Derrida. In *A Voyage on the North Sea: Art in the Age of the Post-Medium Condition*, Krauss argued that with the convergence of media (which is at least partly a result of the rise of electronic and digital media), the earlier 'Greenbergian' conception of 'pure' art forms that seek to explore and identify with their unique formal properties had become untenable.[19]

JACQUES DERRIDA (1930–2004, FRANCE)

Derrida is the principle theorist of deconstruction – a form of analysis that requires detailed readings of any text under consideration, which has been influential on the analysis and discussion of contemporary visual art as well as the development of post-colonial and Queer theory. Prolific and influential in Western Europe and the United States, Derrida published three influential works in 1967 (*Speech and Phenomenon, Writing and Difference* and *Of Grammatology*) that established his reputation. In these works, Derrida attacked the notion that the spoken word developed prior to writing – a tendency he called 'logocentrism', and a central feature of deconstruction. Derrida argued that Western philosophy since Plato has been logocentric – making speech the origin and primary site of truth, with writing a secondary supplement. According to Derrida logocentrism was a form of ethnocentrism; privileging Western phonetic alphabets over all other forms of writing, establishing Western reason as the sole criterion of knowledge.

Derrida maintains that deconstruction is not a methodology but an approach that functions by exploring the dynamics of meaning through the internal logic of the text under analysis. Derrida coined the term 'différance' (meaning both and simultaneously 'to differ' and 'to defer') which is used to suggest that meaning is never fixed, but rather, always in motion. The concept of différance is central to Derrida's critique of any theory of language that suggests that there can exist an idea that freezes the perpetual shifting of meaning, and therefore also implies it cannot have a single point of origin.

In his writings on visual art, Derrida has argued that the material support of a work of art – the canvas, the video screen or the celluloid film-strip, has a tendency to become invisible. In his essay 'Videor', Derrida discusses Gary Hill's seven-monitor installation *Disturbance (among the jars)* (1988) (in which Derrida himself appears) declaring that attempts to define the video medium in relation to its unique material qualities were 'badly put', claiming that 'the specificity of a new art ... is not in a relation of irreducible dependence... '.[20]

For Derrida, discourses on art seek to claim an authority over, or attempt to subordinate the visual whilst simultaneously demonstrating how apparently 'silent' works

of art can also be perceived as authoritarian, and thus in Derrida's view interpretations are always situated in a dynamic relationship between these two possibilities.[21]

JACQUES LACAN (1901–81, FRANCE)

Lacan was a French psychoanalyst who has had a very significant influence on the development of feminist theory, literary criticism and the visual arts, as well as on the field of psychoanalysis itself. In the early 1930s Lacan was for a time associated with the Surrealists, and their influence on his ideas of 'the fragmented body' (see below), and on the relationship between dream structures and language is significant.

Lacan's first important contribution to psychoanalysis; the concept of the 'mirror-phase', is crucial to his theory on the origins of human subjectivity and desire. Related to Sigmund Freud's concept of Narcissism, Lacan argued that a young child's recognition of its own reflected image in a mirror is the trigger for a contradictory dialectical perceptual process in which the child recognizes itself as potentially autonomous and complete. At the mirror-phase this recognition of the self is illusory and incomplete, and Lacan argued, an indication that the ego could be understood as an illusion associated with a fear of the 'fragmented body' – a fear that the unity reflected in the mirror image could be under threat of destruction or disintegration. Thus for Lacan the ego is at least in part an imaginary construct based on this alienating and contradictory early identification with the mirror image.

Extending this initial formative subjective experience, Lacan's concept of human desire is related to a sense of a lack (or absence) of 'being' rather than a desire to possess something perceived as missing. Desire is for Lacan a dialectic concept – a wish to receive that which is complimentary in order to heal a split or division in the subject.

Lacan postulated a similarity between the structure of the unconscious and that of language, and in turn defined language as a system of signs that developed and produced their meanings via their interaction, positing that meanings were never fixed, but fluid. However, Lacan argued that certain key signifiers, in particular the phallus, occupied a more privileged status, which provided an element of stability, but rendered him open to later criticism by the philosopher Jacques Derrida (see above).

ROLAND BARTHES (1915–80, FRANCE)

An important literary critic and theorist, Barthes was principally concerned with concepts related to literature, language and social interaction. Barthes argued that all forms of writing reflect social values and ideologies, and that language is never neutral. The publication of *Mythologies* (1957) brought him to the attention of wider

public and in this work he sought to develop a critique to uncover and decode the historical and political ideologies embedded within all forms of writing.

In the mid-1960s Barthes made a major contribution to the establishment of Semiology (defined by its originator, the Swiss linguist Ferdinand de Saussure (1857–1913, Switzerland) as the general study of signs within social life) and Structuralism, which emerged during this period as the two most important discourses of contemporary thought, with the publication of his two seminal books: *Elements of Semiology* (1964) and *Introduction to the Structural Analysis of Narratives* (1966). In these and subsequent works, such as *The Fashion System* (1967) Barthes argued for a broadening of Saussures' original definition of Semiology by insisting that all social sign systems (visual images, film, gestures, music, video etc.), could be analyzed and decoded.

In *La Mort del'auter* (*The Death of the Author*) published in 1968 and in *Image, Music, Text* (1978), established a significant break with the traditional notion of the importance of the creative individual artist in the understanding and interpretation of any given work. In this influential essay Barthes criticized this traditional approach to textual analysis on the grounds that it considerably reduced the potential for more complex readings.

Camera Lucida: Reflections on Photography (1980), one of his most influential works (and his last book), is a powerful exploration of the meanings and power of the photographic image. The book is an evocation of melancholic loss, influenced by his grief following the death of his mother in 1977.

GILLES DELEUSE (1925–95, FRANCE)

Although Deleuze is considered a philosopher, his work is extremely wide ranging and complex, and in addition to monographs on major philosophers (Bergson, Kant, Spinoza, Nietzsche, Leibniz and Hume), he has written about the Cinema, Francis Bacon, Proust and Kafka.

In 1969, Deleuze was appointed professor of philosophy at the University of Paris VIII where he met the psychoanalyst Félix Guattari (1930–92, France) with whom he formed a long-lasting partnership, co-writing a number of important and influential books, in particular *Anti-Oedipus* (1972) and *A Thousand Plateaus* (1980). For Deleuze these works were partly a response to the political upheavals in France in the late 1960s, opening up ideas for a new philosophy of desire in the 1970s. Deleuze and Guattari were critical of Freudian (and Lacanian) ideas about the nature of human desire, centred on Freud's Oedipus complex, and its notions of a repressive and conventional family structure. Instead, they argued desire was polymorphous and could be depicted as a complex tangle of roots comparable to that of the rhizome, which could potentially spread in any and all directions.

During the 1970s Deleuse was very politically engaged in a number of causes including homosexual rights, Palestinian liberation and prison reform.[22] It was also during this period that Deleuse formed a close friendship with the philosopher and social theorist Michel Foucault (1926–84, France).

Deleuse published two influential and important books on the cinema – *Cinema 1: The Movement-Image* (1983) and *Cinema 2; The Time-Image* (1985), and their impact on engaging with cinema as an art form is substantial partly because he was the first influential philosopher to discuss the medium at such a detailed level. These two works analyze the impact of cinema on the experience of space and time; the first volume discusses the 'movement-image' in cinema using Charles Pierce's (1839–914, USA) semiotic classifications in the history of cinema before World War II; and the second book discusses the development of the 'time-image' in which there is a different way of understanding movement, as subordinated to time. The viewer experiences the movement of time itself and consequently scenes, movements and language has become expressive of forces rather than representative of them.[23]

JULIA KRISTEVA (1941, BULGARIA)

Kristeva is a philosopher, cultural theorist and psychoanalyst (and more recently novelist) who has produced a substantial and influential body of work across the fields of political and cultural analysis, art history and linguistic and literary theory. In general, Kristeva's work is generally characterized as 'post-structuralist', along with Jacques Derrida, Michel Foucault, Gilles Deleuze and Judith Butler. She was a member of the editorial group *Tel Quel*, an avant-garde literary journal (1960–82).

In 1969 Kristeva published *Word, Dialogue and Novel*, developing the influential concept of intertextuality: 'Any text is essentially a mosaic of references to or quotations from other texts; a text is not a closed system and does not exist in isolation. It is always involved in a dialogue with other texts… '.[24]

In *Semiotik* (1969) Kristeva developed her theory of 'seminanalysis' (coined from a combination of 'semiotics' and 'psychoanalysis') in which she explores ideas relating to the limits of language, studying the desires and drives in the prelinguistic stage of young children, which was then equated to avant-garde literature of the late nineteenth century. Seminanalysis is Kristeva's approach to a linguistic analysis that avoids the text designing its own limits and stressing the heterogeneous nature of language.[25]

Although Kristeva's main concerns rest within notions of the politics of marginality, her relationship to feminism is controversial and complex. Her ideas on the relationship to the mother are central and also form the core of her psychoanalytic practice. She has called for what she terms a 'civilized feminism' which would include

a re-appraisal of the significance and value of motherhood and an end what Kristeva views as divisive concepts based on gender differences, with women in 'phallic competition' with men.

Publications and writings in the 1990s are less positive and relate to a sense of generalized distress in society and lack of a sense of direction presented by her patients during analysis.[26]

PAUL VIRILIO (1932, FRANCE)

Virilio is a cultural theorist who is best known for his ideas about the relationship between technology, speed and power, related to developments in architecture, the visual arts and warfare. During the 1950s Virilio studied phenomenology with the philosopher Maurice Merleau-Ponty (1908–61, France). In the early 1060s Virilio began collaborating with the architect Claude Parent (1923, France). He participated in the Paris uprisings in May 1968, and was made Professor at the Ecole Speciale d' Architecture in Paris and was subsequently involved with the founding of the International College of Philosophy along with Jacques Derrida and others.

Although Virilio has been linked to both postmodernist and post-structuralism, he rejects all such labels. Developing a 'war model' of urban civilization, Virilio coined the term 'dromology', the science of speed – declaring that the 'logic of acceleration lies at the heart of the organization and transformation of the modern world'. According to the writer and academic John Armitage, Virilio does not seek to diverge from the notion of modernism but instead postulates a critical analysis of modernism via a catastrophic perception of contemporary technology, or as Virilio himself defines his approach – as that of a critic of the art of technology.[27]

Virilio's most important contribution to cultural theory is related to notions about the significance of the military-industrial complex and its impact on the spatial organization of cultural life in the city. He developed a model of the development of society in *Speed and Politics: An Essay on Dromology* (1986). In contrast to the Marxist idea, Virilio argues that the development of capitalism was not primarily economic, but was instead driven by technological, military and political changes, thus putting forward a military conception of history. Exploring and examining the relationships between the development of information technology and the organization of cultural space via the emergence of new information and communication systems in more recent publications such as *Polar Inertia* (1999), *The Information Bomb* (2000) and *Strategy of Deception* (2000) Virilio has made an important contribution to the development and emergence of 'Hypermodernism'.[28]

JUDITH BUTLER (1956, USA)

Butler is a post-structuralist philosopher who has had a considerable influence on visual and performance artists working with gender and sexual identity issues and concerns. Her work has also been instrumental in the development of 'queer theory', through ideas and concepts explored in her two early publications *Gender Trouble: Feminism and the Subversion of Identity* (1990) and *Bodies that Matter: On the Discursive Limits of Sex* (1993), which draw on concepts from Western philosophy psychoanalysis and feminist theory.

In *Gender Trouble*, Butler challenges established arguments of feminist theoreticians including Julia Kristeva (see below) and Luce Irigary, arguing that much feminist theory provides a basis for a conformist sense of gendered identity, critiquing the psychoanalytically derived insistence on sexual difference and further challenging the notion of a separation of the linguistically defined terms of 'sex' and 'gender', countering that both terms are socially and linguistically determined.[29]

Butler's notion of the performative draws on a Derridian reading of John Langshaw Austin's (1911–60, UK) speech act theory, in which speech is itself understood to be a form of action; a particular practice that can be used to create and affect reality through speaking.[30] Drawing on this concept, Butler posited that gender was performatively produced, arguing against a pre-existing essential notion of male or female prior to language. In *Bodies that Matter* Butler emphasized that her performative definition of gender was not simply a matter of free choice, but rather that acts of gender performance were shaped by cultural discourse.[31]

JEAN-FRANCOIS LYOTARD (1924–98, FRANCE)

The philosopher Lyotard is best known for his book *The Postmodern Condition: A Report on Knowledge* (1979), but he has also written widely on politics, aesthetics and philosophy. His early work focused on phenomenology, structuralism and politics. At the beginning of the 1970s Lyotard focused on the development of a philosophy based on Sigmund Freud's theory of the libido. Seeking a theory that would make sense of the complex and diverse forces and desires underpinning any political and social system, *Libidinal Economy* (1974) develops a philosophy of society using the idea of libidinal energy as a 'theoretical fiction' providing a useful framework in order to gain a theoretical understanding of the complex workings of society as a whole.[32]

In later work, Lyotard rigorously explored the notion of postmodernism, defining it as a profound shift of perception brought about by the changes in the organization of knowledge. With the decline of labour, post-industrial society is centred on the commodification of knowledge and therefore the traditional notion of 'progress' is rendered obsolete. Lyotard has defined the postmodern as 'incredulity towards

metanarratives'. These metanarratives can be defined as overarching concepts (or 'grand narratives') about human history and the goals that legitimize knowledge and cultural ideas. Lyotard felt the two key metanarratives in Western history centred on a progressive movement towards social enlightenment and the progression of knowledge. Following on from this is a sense of postmodernity as an age of fragmentation and plurality.[33] Lyotard proposes a replacement of these metanarratives with a multiplicity of 'little narratives' which are disconnected and fragmentary.

In *The Sublime and the Avant-Garde* (1984) Lyotard has revitalised the nineteenth century notion of the sublime to identify works that challenge the rules of representation simply by 'being there and saying nothing'.[34] Postmodern art for Lyotard has an ability to disturb and this disturbing quality is a manifestation of the sublime; postmodern art attempts to present the unpresentable and this contradictory experience of pleasure and pain in the viewer is an experience of the sublime.

SUMMARY

In recent years the convergence of hitherto distinct art media has been an important factor in the rejection of modernism. Artists working with the moving image have been influenced by the work of a number of significant cultural theorists and philosophers whose ideas, concepts and approaches from disciplines outside the boundaries of traditional art criticism such as linguistics, psychoanalysis, deconstruction, feminism, Post-Colonial and Queer Theory. Many of the most influential of these thinkers have developed critical ideas which are important to artists, critics, curators and academics involved in the production and exhibition of contemporary art, and are particularly relevant to lens-based media such as film, photography and video art practice.

7. BEYOND THE LENS
ABSTRACT VIDEO IMAGERY AND IMAGE PROCESSING

Despite the overriding concern with the specifics of the technology by artists using video and a desire for social and political change, there was also an inevitable confrontation with representation and illusionism. Procedures such as the examination of the light effects on the camera pick-up tube, the instantaneousness of the image, and vidicon image retention, inevitably referred the viewer back to the intrinsic nature of the electronic image. Stuart Marshall points out that in many ways this is the antithesis of the modernist self-referential object. Thus, in their attempt to produce a self-reflexive modernist practice, video artists founded a new oppositional practice centred on a critique of the dominant modes of representation.[1]

Video artists working directly with the video signal developed a different angle, often eschewing issues of representation altogether. In marked contrast to this notion of the camera as crucial to video as art, British video artist Peter Donebauer pointed out that the prime aspect of video for him was the electronic signal, stating in a thinly veiled criticism of David Hall's theoretical position:

> ... this rather deflates the theories of certain academics in this country who have tried to define an aesthetic based around television cameras, monitors and video tape recorders. Video can happily exist without any of them![2]

American video artist Stephen Beck (1950, USA) who, like Donebauer, built his own video-imaging tools, worked to free himself from the conventions of traditional video technology, especially the camera and lens-based perspectival representations.

> For me the direct video synthesizer functions not as something artificial, as the term "synthetic" has come to connote, but as a compositional device which "sculpts" electronic current in the hands of an artisan... . Another aspect of synthesizers is that they can be used by an image composer to achieve specific images that exist internally in his mind's eye, where no camera can probe, that is to cull images from a subjective reality or non-objective plane.[3]

As Gene Youngblood argues in his essay 'Cinema and the Code', in video the frame is not an 'object' as it is in film, but a time segment of a continuous signal which

creates the possibility of a syntax based on transformation rather than transition. Using electronic imaging tools it is possible to create a moving image work where each image metamorphoses into the next. Although this was prefigured in hand-drawn animation film, Youngblood points out that once the electronic image is produced digitally, it becomes possible to produce a *photoreal* metamorphosis in which photographically 'real' objects can be transformed:

> It is possible digitally because the code allows us to combine the subjectivity of painting, the objectivity of photography and the gravity-free motion of hand-drawn animation.[4]

Youngblood suggests that via the 'code' (i.e. digital image manipulation of the electronically produced photographic image) perspective becomes a temporal as well as a spatial phenomenon. This technology enables the removal of the image from the frame, treating it as an object, or image plane. This allows the creation of what Youngblood calls 'parallel event streams', which enable new semiotic strategies. As an example, Youngblood cites the possibility of images of past or future events sharing the frame with a current event, contrasting this with mechanical cinema's restrictive temporal perspective:

> There is no temporal eloquence in film. But digital video suggests the possibility of establishing one image plane as "present" with other time frames visible simultaneously within the frame. This would extend the possibility of transfiguration (metamorphosis) into a narrative space composed of layers of time, either as moving or still images.[5]

For examples of pioneering video work which explores notions of the potential for unframed parallel events occupying areas within a single frame, Youngblood cites the work of the long-time associates Woody and Steina Vasulka, who are discussed below.

Central to Youngblood's essay is a notion about the crucial position of technology in the development of human perception. He states that 'the evolution of vision is dependent on machines, either mental or physical', citing Austrian filmmaker and art historian Peter Weibel (1945, Vienna) who pointed out that human vision has always been 'machine assisted', giving as examples the work of Durer, Spinoza, Vermeer and the Impressionists.[6]

VIDEO IMAGE PROCESSING AND SYNTHESIS

According to American writer Lucinda Furlong, video image processing in the USA had its origins as one aspect of a range of alternative strategies which sought to subvert

the traditional broadcast television image and attempted to 'conjure up the new realities' associated with hallucinogenic drugs.[7]

Furlong identifies the establishment of a connection between electronic image processing and the modernist fascination with the inherent properties of video as a key aspect of its move towards critical and curatorial attention and acceptance. She quotes, by way of example, from the catalogue notes from the first exhibition of US video art at the Whitney Museum of American Art in New York:

> It was decided … to limit the program to tapes which focus on the ability of videotape to create and generate its own intrinsic imagery, rather than (on) its ability to record reality. This is done with special video synthesizers, colorizers, and by utilizing many of the unique electronic properties of the medium.[8]

It would seem, initially, that the image-processing video work of the late 1960s and early 1970s opened up the way for the institutional acceptance of video art in general in the USA. But the predominance of this approach was short-lived and by 1974 image-processing work was judged 'deficient' by many of the critics and curators who had originally embraced it, because of its perceived link to so-called 'modernist pictorialism'. According to US critic Robert Pincus-Witten:

> The generation of artists who created the first tools of 'tech art' had to nourish themselves on the myth of futurity whilst refusing to acknowledge the bad art they produced. [The work] was deficient precisely because it was linked to and perpetuated the outmoded clichés of modernist pictorialism – a vocabulary of Lissajous patterns – swirling oscillations endemic to electronic art – synthesized to the most familiar expressionist juxtapositions of deep vista or anatomical disembodiment and discontinuity.[9]

During the period between 1965 and 1975, which could be considered as the defining period of video art, there was significant research activity among artists working with video to develop, modify or invent video-imaging instruments or synthesizers. This first generation of video artist/engineers include Ture Sjölander, Bror Wikström, Lars Weck, Eric Siegal, Stephen Beck, Dan Sandin, Steve Rutt, and Bill and Louise Etra, in addition to the well-documented collaborative work of Nam June Paik and Shuya Abe. The work of these pioneers is important because in addition to exploring the potential of video as a means of creative expression, they developed a range of relatively accessible and inexpensive image manipulation devices specifically for 'alternative' video practice.

TURE SJÖLANDER AND *TIME*

In September 1966 Swedish artists Ture Sjölander (1937, Sweden) and Bror Wikström broadcast *Time*, a 30-minute transmission of electronically manipulated paintings on National Swedish Television. Sjölander and Wikström had worked with TV broadcast engineer Bengt Modin to construct a temporary video image synthesizer which was used to distort and transform video line scan rasters by applying tones from waveform generators. The basic process involved applying electronic distortions during the process of transfer of photographic transparencies and film clips. According to Modin they introduced the electronic transformations using two approaches: the geometric distortion of the scanning raster of the video signal by feeding various waveforms to the scanning coil, and video distortion by the application of various electronic filters to the luminance signal.[10]

In 1967, Sjölander teamed up with Lars Weck, and using a similar technological process, produced *Monument*, a programme of electronically manipulated monochrome images of famous people and cultural icons including the *Mona Lisa*, Charlie Chaplin, the Beatles, Adolph Hitler and Pablo Picasso (see Chapter 10 for a further discussion of this work). This programme was broadcast to a potential audience of over 150 million people in France, Italy, Sweden, Germany and Switzerland in 1968 as well as later in the USA.

It seems likely that these pioneering broadcast experiments were influential on the subsequent work of Nam June Paik and others. According to Ture Sjölander, Paik visited Stockholm in the summer of 1966 and was shown still images from *Time* whilst on a visit to the Elecktron Music Studio. Additionally, Sjölander is in possession of a copy of a letter dated 12 March 1974 from Sherman Price of Rutt Electrophysics in New York, acknowledging the significance of *Monument* to the history of 'video animation', and requesting detailed information about the circuitry employed to obtain the manipulated imagery. In reply, Bengt Modin, the engineer who had worked with Sjölander, provided Price with a circuit diagram and an explanation of their technical approach to the project, claiming he 'no longer knew the whereabouts of the artists involved'.[11]

THE PAIK-ABE SYNTHESIZER

The Paik-Abe Synthesizer, built in 1969 is one of the earliest examples of a self-contained video image-processing device. As we have seen, Ture Sjölander and his collaborators had brought together video-processing technology in a temporary configuration to produce their early broadcast experiments, Paik's synthesizer was a self-contained unit built expressly and exclusively for the purpose. The instrument, or video synthesizer, as it came to be known, enabled the artist to add colour to

a monochrome video image, and to distort the conventional TV camera image. Influenced by the development of audio synthesizers produced in the early 1960s by pioneers such as Robert Moog, video synthesizers drew on the fact that the same analogue electronic processes produced both audio and video signals.

> People like Nam June (Paik) and Shuya Abe were good examples of what we would now call computer hackers, where this sort of kluging of found stuff would happen. The Paik-Abe Synthesizer was a color encoder from a color camera and a video mixer. They didn't invent those components, they were found… .[12]

Extending a dialogue that they had begun in Tokyo in 1964, electronic engineer Shuya Abe (1932, Japan) and Nam June Paik began building a video synthesizer in 1969 at WGBH-TV in Boston, possibly spurred on by the work of Sjölander in Sweden. Frustrated by the difficulty of working in the conventionally designed TV studio, Paik conceived of a video studio compressed into a piano keyboard:

> The editing process in VTR [video tape recorder] is very clumsy, worse than in film. I wanted a piano keyboard that would allow me to edit seven different sources bang-bang-bang, like that – real time editing. The first thing I thought of was seven cameras with seven sources that could be mixed instantly by a console. So the machine has two suites: the piano keys for instant mixing and also a tiny clock that turns the color around, from ultra red [sic] to ultraviolet. The player can change the colors. The seven cameras are keyed into seven different colors themselves: one camera makes only red, another only blue, another so and so. The seven rainbow colors are there. Mixing them together makes what you see.[13]

The completed and functioning machine, initially dubbed 'The Wobbulator' by Paik was first used during *Video Commune*, a four-hour broadcast from WGBH in 1970, in which standard camera images were distorted using the multiplicity of controls available on the synthesizer. Paik described some of the features and complexities of his machine to Lucinda Furlong:

> The console can distort the pictures once they come in from the cameras. Inside there are many delicate devices. He (Abe) put many controls into the console – contrast controls, brightness controls, color contrast controls. Every knob on it is functional, and there are sixty of them.[14]

The Paik/Abe video synthesizer, as it came to be known, was one of the first of several video devices intended to distort and transform the conventional video image. In 'Tracking Video Art: Image Processing as a Genre', Furlong claims that video artists and alternative media activists had been actively seeking ways to make video images

which looked different from conventional television in order to challenge the institution of television broadcasting:

> Image processing, as we now know it, grew out of an intensive period of experimentation that for some, in a vague way, was seen visually to subvert the system that brought the Vietnam War home every night.[15]

ROBERT CAHEN, FRANCIS COUPIGNY AND THE TRUQUER UNIVERSEL

During the late 1960s the research department of the French broadcasting network, the ORTF, run by Pierre Schaeffer (see Chapter 5) developed a number of prototype sound and image processors under the supervision and direction of electrical engineer Francis Coupigny (1936, France). The most significant of these in terms of video image processing was the 'Truquer Universel' ('Universal Faker') a video modulating instrument, which was installed next to the video production studio. The Truquer comprised a central video image processor with the potential for an infinite number of additional processing modules, accessed by variable slide controls, thus it was considered 'universal'. Image-processing modules available for composers and producers to experiment with included image keying, and the potential to assign electronically simulated colours to specific luminance levels, positive/negative image and colour inversion, image mixing and fading, chroma-key, the generation of image masks for wipes, and the modulation of the video image via sound or music. The Truquer, developed in 1968 to serve as a device to facilitate new and experimental television productions, was made available to filmmakers, artists and designers. A number of experimental video works and television productions were produced using the device, including works by video artists Dominique Bellour, Piotr Kamler (1936, Warsaw), Olivier Debre (1920–99, France) and Robert Cahen.

Cahen's work with the Truquer Universel began in 1968 when he first encountered the machine in the studios of the GRM in Paris (see Chapter 5), whilst a student. In 1971, after completing his studies in music applied to audio-visual media, he was offered a research contract and asked to head the experimental video lab at the GRM. Cahen had familiarized himself with the functions and capabilities of the Truquer during his research as a student, but began to work with the instrument in earnest with the making of his video tape *L'invitation au voyage*, completed in 1973. In this work Cahen began to draw on his expertise and training in the electronic sound manipulation techniques of *musique concrète*, experimenting with the potential of video image processing to blend and combine multiple image sources including 16mm film and still photography:

> In this work I tried painting the image in movement, without hesitating like a

child who puts too much colour on the picture, to make it dribble and vibrate.
I tried at the same time to make the black and white photos come alive, their
colours becoming superimposed giving a semblance of movement to the frozen
image and that fascinated me.[16]

In this work and others (including *Trompe l'oeil, L'entr'apercu, Horizonatales coleurs*)
made during the same period, Cahen drew very directly on his musical training
seeking to make works that were truly audio-visual in nature. His training had
taught him to listen to sounds in a decontextualized manner, disconnecting them
from their origins – a mode of thinking that enabled him to look at images without
being limited to their original meaning or signification. Working with the Truquer
Universel he sought to develop new work with moving images in a way that he had
previously done with music. The Truquer and later the EMS Spectron (see below)
enabled Cahen to approach the moving images in a similar fashion:

The possibilities of transforming the image enabled me to distance myself from
the direct representation of reality as the main means of communication, and
to rediscover in the textures of generated images a different reading of reality.[17]

Whilst European artists such as Sjölander, Wilkström, Weck and Cahen had explored
the potential of electronic imaging with pre-existing tools which had been developed
for the broadcasting of new experimental electronic imaging compositions, a number
of American artist/engineers during the same period developed their own video-
imaging and electronic image-processing instruments. Often self-contained and with
particular creative requirements, these instruments were designed to meet the specific
needs of their own video work. (For further discussion of the work of Robert Cahen
see Chapter 10.)

ERIC SIEGEL

In 1969 Eric Siegel (1944, USA) showed his *Psychedelevision in Color* at the Howard
Wise Gallery as part of the celebrated and pioneering exhibition 'TV as a Creative
Medium'. Seigel, who had been experimenting with television and video since
the mid-1960s had, with encouragement and finance from Wise, built a crude
video colourizer to add colour to an existing black-and-white television image.
Psychedelevision in Color was essentially a reworked monochrome image that used
video feedback and colorized effects to break down and distort a photograph of Albert
Einstein. With further funding from Howard Wise, Siegel began work on a video
synthesizer in 1970. Like many of this generation of video artist/tool makers, Seigel
was basically self-taught:

I never thought I'd see the end of it. It was one of those projects that was a little too big and it was a heavy trip because I was taking on a level of sophisticated electronics that was just a little above my head.[18]

Although Siegal completed his prototype synthesizer, it was never marketed, as he and Wise differed on how it should be developed. Wise sought a manufacturer to build it under license, but Siegel was afraid that his design would be stolen, and preferred to build it himself. Siegel's synthesizer was never manufactured, although the colourizer was briefly marketed, with ten units sold at approximately US $2,400 each.

Eric Siegel was only briefly active on the US video art scene. By 1972 he had become disillusioned and unhappy with the direction he perceived video art to be taking:

A whole sub-culture was forming and it turned me off … it was a whole frame of mind that the country was in. What was going on that I was a part of was more than just technology. There was a human element, a human spirit. We were using the technology; it was our servant, not our God.[19]

STEPHEN BECK AND THE DIRECT VIDEO SYNTHESIZER

Around 1968, whilst experimenting with the sonic generation of oscilloscope images, artist/engineer Stephen Beck (1950, USA) began seeking more precise methods of controlling light. His first attempt to build a device was the 'Number 0 Video Synthesizer', used in collaborative performances with electronic musician and composer Salvatore Martirano (1927–95, USA).

In 1970 Beck was invited to be Artist in Residence at the National Center for Experiments in Television (NCET) in San Francisco.[20] Whilst at NCET Beck completed his 'Direct Video Synthesizer' and used the new instrument to produce a series of tapes called *Electronic Notebooks*. Intended as both documentation of the technical research and works in their own right, these tapes were made by artists and composers including Don Hallock (1940, USA), Bill Roarty, Willard Rosenquist, Bill Gwin and Warner Jepson (1931–2011, USA) as well as by Beck himself.

The Direct Video Synthesizer, intended as a performance instrument, was designed to produce video images without a camera. Beck saw his machine as an 'electronic sculpting device' designed to generate four key aspects of the video image – colour, form, motion and texture. In a subsequent version, Beck extended the scope of the device to include circuits to generate the elemental images of air, fire and water. Beck's stated concern was to open up television as an expressive medium and to go beyond the manipulation of the conventional camera image to produce non-objective imagery.

In his essay 'Image Processing and Video Synthesis', Beck discusses the various

approaches of American video artists to the construction and use of video-imaging tools, outlining and summarizing the instruments in use at the time (1975), identifying four distinct categories of electronic video instruments:

1 Camera Image Processing
2 Direct Video Synthesis
3 Scan Modulation/Rescan
4 Non-VTR Recordable.

In this survey of the range and variety of electronic imaging instruments, Beck explains attempts by artists to explore the unique potential of video and to exploit:

> … the inherent plasticity of the medium to expand it beyond a strictly photographic/realistic representational aspect which characterizes the history of television in general.[21]

Beck also identified two tendencies in the designing and building of video-processing instruments by artist-engineers:

1 The images produced are a direct result of the circuitry and design of the instrument.
2 The instrument has been developed in order to produce a particular visual or psychological effect.

I. CAMERA IMAGE PROCESSORS

This type of instrument is designed to modify the monochrome video image from a black-and-white television camera. It usually includes a colourizer, which adds chrominance (colour) signals to the video signal, keyers and quantizers to separate luminance value levels in the signal in order to add synthetic colour and/or to insert additional images into the original. Further circuits may include modifiers that enable effects such as polarity inversion and mixing via the superimposition of multiple image sources. This category of instrument includes the Truqueur Universel, the Paik/Abe synthesizer, some of the image processors used by the Vasulkas, the Hearn Videolab and Peter Donebauer's 'Videokalos Image Processor'[22] (see below).

2. DIRECT VIDEO SYNTHESIZERS

Designed to operate primarily without a camera signal, these instruments contain circuitry to generate a complete video signal including colour generators to produce chrominance signals, form generator circuitry designed to produce shapes, lines, planes and points, and motion modulators to move them via electronic waveforms including curves, ramps, sines, triangles and audio frequency wave patterns. These instruments

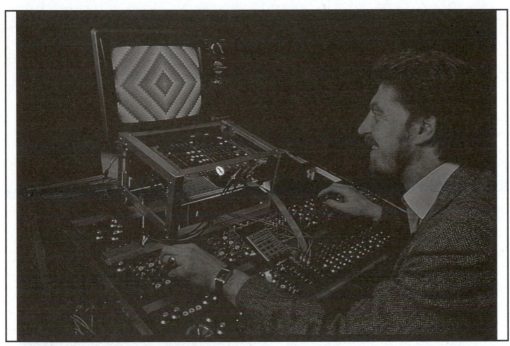

7.1: Stephen Beck operating his *Video Weaver*, 1976. Courtesy of the artist, www.stevebeck.tv

also contain texture amplifiers which produce 'brush effects' such as shading and chiaroscuro and textural effects such as grain. Instruments in this category include early digital computer processors such as the Fairlight (CVI), Stephen Beck's own 'Direct Video Synthesizer' and the EMS 'Spectron' designed by Richard Monkhouse (see below). Beck also designed and built the 'Video Weaver' in 1975, inspired by the analogy between weaving and the construction of the television image. The circuits for Video Weaver were incorporated into his 'Direct Video Synthesizer' and used to produce a series of tapes called *Video Weavings* (1975).

3. SCAN MODULATION/RESCAN

In this process images are produced using a television camera rescanning an oscilloscope or cathode ray tube (CRT) screen. The display images are manipulated (squeezed, stretched, rotated, etc.) using magnetic or electronic deflection modulation. The manipulated images, rescanned by a second camera are then fed through an image processor. This type of instrument was also used without an input camera feed,

the resultant images produced by manipulation of the raster. Examples of this type of instrument include Ture Sjölander's 'temporary' video synthesizer (1966–9), the Paik/Abe Synthesizer, and the Rutt/Etra Scan Processor (1973) (see below).

4. NON-VTR RECORDABLE

Beck included this category for completeness. This approach is basically a 'prepared' television set, to present a non-recordable distorted display, with which resultant images would need to be recorded using rescanning methods, such as Nam June Paik's *Magnet TV* (1965), and Canadian video artist Jean-Pierre Boyer's 'boyétizeur' (1974). This category therefore also includes Bill Hearn's 'Vidium Colourizing Synthesizer' (1969) as used by Skip Sweeny (1946, USA) in his video feedback work and by Warren Burt in Australia.

DAN SANDIN

Like Eric Siegel and Stephen Beck, Dan Sandin (1942, USA) was interested in light shows and kinetic art. Initially working with conventional colour photography, it occurred to Sandin, a trained physicist, that he could achieve more interesting results

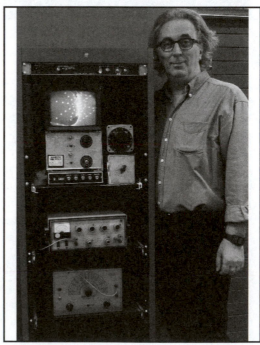

7.2: Jean-Pierre Boyer with his *Boyétizeur*, 1974.
Courtesy of the artist.

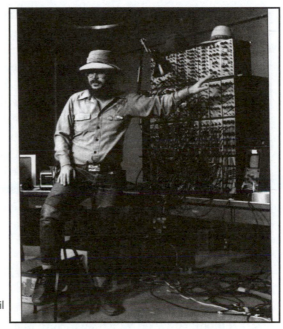

7.3: Dan Sandin with the first IP, built by Phil Morton, 1974. Courtesy of the artist.

using electronics. Through his experience with light shows, Sandin was familiar with the Moog sound synthesizer, and he began to speculate about the potential to create a video equivalent around 1968:

> We just considered the processing modules in the audio synthesizer, and what it would do to the image if you ran the signal through a module that had been modified to have sufficient bandwidth to handle video. And that pretty much specified what the analog synthesizer turned out to be.[23]

Teaching kinetic art and interactive sculpture at the University of Illinois, Sandin got involved with video during the wave of protests in 1970 that resulted from the Kent State riots, running an ad hoc 'media house' cable-casting live political debates:

> There was something about the black and white image that I found very attractive and tactile. I remember I found myself stroking the TV screen and staring at the TV image ... it became clear that this old idea of this image synthesizer and my new attachment to video was something I could pull off.[24]

Securing a US $3,000 development grant from the Illinois Arts Council, Sandin developed his image processor over the next three years. His proposal had been

to develop an affordable programmable video-processing synthesizer combining a number of important functions including keying, fading and colourizing into one unit. The 'Sandin Image Processor', or IP was designed as a set of stackable modules, which could be reconfigured depending on the function or image processing required. Like the Direct Video Synthesizer and the Videokalos IMP (see below) the Sandin Image Processor was designed for use in live performance situations. Unlike other artist/engineers, however, Sandin made a decision to make the plans for the IP available for others to build. Sandin and video artist Phil Morton (1945–2003, USA), founder of the video programme at the Chicago Art Institute, spent over a year preparing a parts list and circuit diagrams for plans that were made available to anyone who wanted them. As a result of this unique approach, ten IPs were built by artists, interested in experimental video and electronic imaging.[25]

THE RUTT/ETRA SCAN PROCESSOR

Steve Rutt and Bill Etra developed the 'Rutt/Etra Scan Processor' in 1973. Rutt and Etra obtained a US $3,000 grant from the TV Lab at WNET to develop a more controllable version of Nam June Paik's 'Wobbulator' (the Paik-Abe video synthesizer), a modified TV set which he used to make manipulated video images of Richard Nixon and Marshall McLuhan. Bill Etra had approached Steve Rutt to suggest that they explore the possibility of producing a 'Wobbulator that Zoomed'.[26]

> Paik had figured out (with technical advice and support from Shuya Abe) how to make something move across the raster, but it wouldn't stay in the spot that it had been moved to.[27]

The Rutt/Etra Scan Processor modifies a conventional video image by the electromagnetic deflection of the electron beam of the CRT monitor display which is built into the Scan Processor. Because the raster image rather than the waveform code is altered, the resulting images must be 'rescanned' – re-recorded using a video camera. Approximately 20 Rutt/Etra Scan Processors were hand-built and sold for approximately US $7,000–8,000 each, before the partnership ran into financial difficulty and the operation was discontinued.

Woody and Steina Vasulka have made the most systematic use of the Rutt/Etra in their video work since its inception in 1974, such as *C-Trend (1974)*. *The Matter* (1974), and *Art of Memory* (1987). (See Chapter 10 for a detailed discussion of this tape.) Woody Vasulka wrote an introductory paragraph about the Scan Processor in the 1994 *Ars Electronica* catalogue for an exhibition he curated on electronic art:

The instrument called the Rutt/Etra, named after the inventors, was a very influential one. Etra, with his art affiliations, had placed the instrument much closer to the hands of individual artists for the right price. Almost everybody I respect in video has used it at least once. Its power was in the transformation of the traditional film frame into an object with lost boundaries, to float in an undefined space of lost identity: no longer the window to 'the' reality, no longer the truth.[28]

OTHER VIDEO IMAGE-PROCESSING TOOLS AND ARTISTS WHO WORKED WITH THEM

Various artists have used the video synthesizers discussed above. For example, Gary Hill used the Rutt/Etra to produce *Videograms* (1980–1). Often artists used a combination of image-processing machines, for example Paik's *Merce by Merce by Paik* (1978) was composed of video images processed through the Paik/Abe synthesizer, the *Rutt/Etra Scan Processor*, and various colourizers and video keyers. In *Complex Wave Forms* (1977) Ralph Hocking (1931, UK), who had established the Experimental Television Center in 1970, worked with signal oscillators designed and

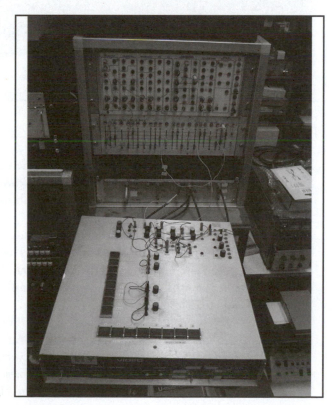

7.4: Stephen Jones, *Video Synth No 2*, 1979. Courtesy of the artist.

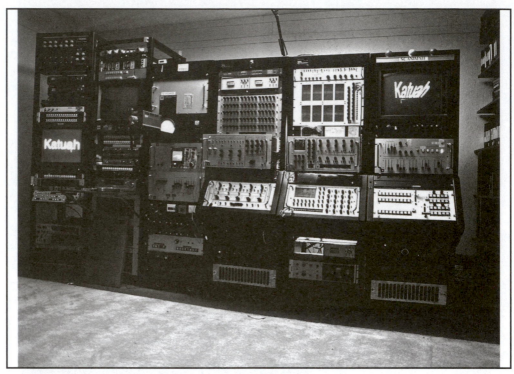

7.5 *Scanimate*. Courtesy of Dave Sieg.

built by David Jones and Richard Brewster, and then processed through a Paik/Abe Synthesizer.[29] Ernie Gusella (1941, Canada) made *Video Taping* (1974) and *Exquisite Corpse* (1978) with Bill Hern's 'Video Lab', a combination of video switcher, keyer and colourizer.

Other artists who developed imaging tools include the Australian video artist and musician Stephen Jones, who designed and built his own analogue video syntheziser/colourizer based on circuit diagrams provided by Dan Sandin for the IP which Jones used in a number of works including *Stonehenge* and *TV Buddha* (Homage to Nam June Paik) (both 1979).[30]

Tom DeWitt Ditto (1944, USA) produced a number of early abstract works combining video-imaging and cinematographic techniques such as *The Leap* (1969), *Fall* (1971) and *Otta Space* (1978). In 1977, he developed an early motion tracking system using chroma-key techniques called 'Pantomation', and in 1978 he set up the Video Synthesis Laboratory with Vibeke Sorensen (1954, Denmark).[31] Sorenson,

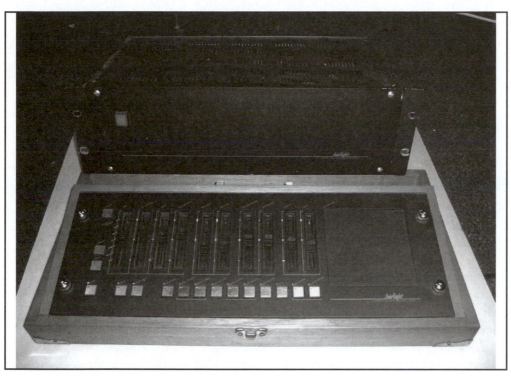

7.6: *Fairlight CVI* 1984. Courtesy of Stephen Jones.

who is well known for her later 3D and stereoscopic work using digital animation techniques, produced a number of early abstract visual music video works including *Videocean* (1976) and *Moncules* (1978), which she produced using the Rutt-Etra Scan Processor.[32]

Ed Emshwiller (1925–90, USA) was trained as a painter and began experimenting with video and computer imagery in the early 1970s.[33] Important early video works include *Scape-Mates* (1972), *Thermogenesis* (1972), and *Crossings and Meetings* (1974), produced at the TV Lab at WNET/13 in New York. One of Emshiller's most influential works, *Sunstone* (1979), considered a landmark tape because of its representation of 3D electronic space, was developed using the 'Scanimate', an early analogue computer system designed to produce 'real-time' video image effects.[34]

In 1984, the Australian electronics company Fairlight introduced a hybrid analogue/digital video image processor and 'paint box' called the Fairlight CVI designed by engineers Peter Vogel and Kim Ryrie that allowed the user to 'paint'

directly over the top of, or with inputted video sequences in real time. Popular with a number of artists in Australia, the UK, Europe and the USA in the mid-1980s, the CVI had a range of unique effects that provided artists with a digital image palette including freeze-frame, chroma-key, colourizing and posterizing, mirroring effects and the ability to stretch and zoom the video image. Video artist Peter Callas (1952, Australia) produced a number of important works with the Fairlight including *Double Trouble* (1986), *Night's High Noon: An Anti Terrain* (1988), *Neo Geo: An American Purchase* (1989) and *If Pigs Could Fly* (*The Media Machine*) (see Chapters 1 and 10).[35] UK video artist Steve Hawley's *Trout Descending a Staircase* (1987) commissioned for BBC TV's 'The Late Show' and a number of works by the Japanese Duo 'Visual Brains', were also made using the Fairlight CVI.

THE VASULKAS: DIALOGUING WITH TOOLS

Steina and Woody Vasulka are two of the most prolific and significant video artists to have experimented with image manipulation technology in the United States. Working exclusively with video and sound since the late 1960s, the Vasulkas have taken a systematic and rigorously formal approach, evolving a working method characterized by an interactive dialogue between the artist and electronic imaging technology, in a process of exploration which they have termed 'dialogues with tools'.

Woody Vasulka (Bohuslav Peter Vasulka, 1937, Czech Republic) trained as an engineer and then as a filmmaker at the Prague Academy of Performing Arts. Steina (Steinunn Briem Bjarnadottir, 1940, Iceland) studied violin and music theory and received a scholarship to study at the music conservatory in Prague where she met Woody. The couple married and emigrated to the USA, settling in New York City in 1965.

Initially Steina worked as a freelance musician, and Woody was employed as a multi-screen film editor, but by 1969, they had decided to work exclusively with video, producing their first joint video tape – *Participation* that same year. Soon involved in the core of the New York avant-garde film and experimental video scene, they co-founded 'The Kitchen' in 1971 in order to continue and extend a collaborative exchange with other artists and activists working with video, sound and performance.

Over a period which continues up to the present, the Vasulkas have explored the potential for video via a comprehensive body of work which seeks to provide the foundation for a new electronic language and to explore and define the frontiers of digital and televisual space. In a recent interview, Woody explained his early fascination with the electronic image and the political implications of his decision to move from film to video in the late 1960s:

The idea that you can take a picture and put it through a wire and send it to another place, you can broadcast from one place to another – this idea of an ultimate transcendence, magic, a signal that is organized to contain an image. This was no great decision, it was clear to me that there was a utopian notion to this, it was a radical system and so there was no question of deciding that this was it. Also I was not very successful in making films, I had nothing to say with film. This new medium was open and available and just let you work without a subject.[36]

The Vasulkas characterize their early approach to video as primarily 'didactic', for many years working with the materiality of the video image towards the development of a 'vocabulary' of electronic procedures unique to the construction of a 'time/energy object'. They saw this formal approach to video as very much aligned with the American avant-garde film movement of the time, and felt initially that they were part of a new wave of formal experiment in video:

… when we conceived of video as being the signal – the energy and time and all of that, we thought we were right there, smack in the middle of it. These were the radical times in experimental film and there were all these people starting up in video. We were all discovering this together. We erroneously thought that everybody conceived of video this way: this "time/energy construction". Now I realize we were very much alone. We were never lonely because we thought we were in the middle of it, but we were. We never had any followers who practiced this time-energy organization.[37]

This conception of video as 'pure' signal enabled the Vasulkas to identify the significance of the fundamental relationship between sound and image in video, an inherent property of the electronic medium that set it apart from film, and it was an exploration of this idea that characterized their earliest work. Steina sees this relationship as crucial to an understanding of video as a medium for art:

It was the signal, and the signal was unified. The audio could be video and the video could be audio. The signal could be somewhere "outside" and then interpreted as an audio stream or a video stream. It was very consuming for us, and we have stuck to it… . Video always came with an audio track, and you had to explicitly ignore it not to have it.[38]

This exploration of the relationship between the electronic encoding of picture and sound also provided the Vasulkas with their first model for an emerging dialogue with electronic tools – the audio synthesizer, an instrument which also enabled them

to begin to explore 'pure' video imagery which was free from the camera, or more specifically, from images produced via the lens. For the Vasulkas, it was a question of exploring a potential for video which was entirely different from either film or broadcast television:

> How do you interact with the television screen? It's a "time construct". Normally it constructs a frame – the illusion or representation of a frame, and its normally organized so precisely that you are not supposed to see that its actually organized line by line using some kind of oscillators inside and if you turn the television on when there is no broadcast signal, there are free-running oscillators – two horizontal and vertical oscillators. As soon as there is a broadcast signal it locks onto it, it becomes a slave to a master which is the broadcast signal. The signal itself governs. So we would put into the input a sound oscillator – or oscillators, and we saw for the first time that we could get an image from a source other than the camera. So our discussion was about departing from the camera, which television insisted upon having, and still does. The second principle was to get the tools to organize time and energy in order to produce a visual or other artefacts. So we started with interference patterns. Interfering with that time structure, anytime you interfered with that it would organize itself and that was our entrance into the synthetic world from the audio tools.[39]

Working with electronic imaging technology to produce video works in this period, the Vasulkas were not interested in making 'abstract' video, but were attempting to develop a vocabulary of electronic images through a systematic deconstruction process. Alongside their videotape and multi-screen works produced throughout the 1970s, the Vasulkas developed a range of special machines in collaboration with a number of electronic engineers and makers designed to explore and develop a medium-specific vocabulary, the most important of which were:

The 'Field Flip-Flop Switcher' (1971). A variable-speed programmable vertical interval switcher which enabled selection between two image sources, produced by George Brown.

The 'Dual Colorizer' (1972). A two-channel device for the colourization of black-and-white video images according to differences in the grey scale, made by Eric Siegel.

The 'Multikeyer' (1973). A device that can assign up to six layers of separate video images, allowing manipulation of their foreground/background relationships.

The 'Programmer' (1974). A programmable control device for the automatic

7.7: Woody Vasulka, *C-Trend*, 1974. Courtesy of the artist.

7.8: Woody Vasulka1974. Courtesy of the artist.

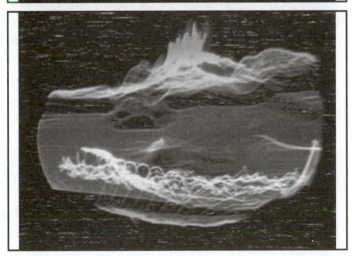

7.9: Woody Vasulka, *C-Trend*, 1974. Courtesy of the artist.

operation of a stored sequence of instructions for the Multikeyer. Both constructed by George Brown.

The Rutt/Etra Scan Processor (1974). As described above, a device which used a programmable deflection system of the CRT to manipulate standard television images.

Jeffrey Schier describes what he calls the 'Vasulka effect' in the section of the 'Ars Electronica' catalogue on the Rutt/Etra:

> The raster's size, position and intensity can each be modulated through voltage control signals. These voltage control signals fulfil a commercial function: to generate swooping titles and sliding graphics. A more esoteric use is demonstrated in the "Vasulka Effect". The input video brightness connects to the vertical position control. This causes the brighter parts of the video to "pull" the raster lines upward. When combined with other synthetic waveforms, the raster forms a three-dimensional contour map where video brightness determines elevation. The generation of video objects built from the underlying raster structure is evident in videotapes created by the Vasulkas.[40]

The Rutt/Etra Scan Processor and other machines enabled the Vasulkas to produce a body of work with a very clearly identified analytic objective. For example, in *C-Trend* (1974), Woody Vasulka used the Rutt-Etra Scan Processor to manipulate a video image of urban traffic flow. The horizontal lines of the video luminance signal are translated into a graphic display. The video frame, or raster, has been reconfigured, making visible the 'space' between frames -the horizontal and vertical blanking.

Time/Energy Structure of the Electronic Image (1974–5) was also produced exclusively with the Rutt/Etra Scan Processor (Rutt/Etra model 4). In an exploratory article, designed to open up further dialogue, Woody Vasulka set out his intentions, and identified the influence of this new tool on his ideas:

> Compared with my previous work on videotape, the work with the Scan Processor indicates a whole different trend in my understanding of the electronic image. The rigidity and total confinement of time sequences have imprinted a didactic style on the product. Improvisational modes have become less important than an exact mental script and a strong notion of the frame structure of the electronic image. Emphasis has shifted towards a recognition of a time/energy object and its programmable building element – the waveform.[41]

In both these tapes Vasulka was interested in the Scan Processor's ability to produce non-camera imagery in which the 'light/code interface' occurs at the video monitor of the processor, with the video waveform displayed as a visible image. Vasulka's

intention was to systematically explore the potential image manipulations of the Scan Processor with the larger purpose of laying the foundations for the establishment of a new visual language free from the constraints of the conventional lens-based image:

> To me this indicates a point of departure from light/space image models closely linked to and dependent upon visual-perceptual references and maintained through media based on the camera obscura principle. It now becomes possible to move precisely and directly between a conceptual model and a constructed image. This opens a new self-generating cycle of design within consciousness and the eventual construction of new realities without the necessity of external referents as a means of control.[42]

The work in this period, and Vasulka's description of his thinking and the influence of the instrument on his ideas, demonstrates the evolution of the process of the Vasulka's art. As is clear from the range of instruments listed above, the Vasulkas did not work exclusively with the Rutt/Etra Scan Processor. The *Matrix Series* (1970–2) for example, was developed using the video keyer – a device for combining multiple audio and video signals to produce a series of works of layered multiple images and sounds. The *Matrix Series*, produced with an almost scientific rigour, explored the limits of existing video and audio technologies, and the boundaries between analogue and digital imaging systems. Early proponents of multi-monitor video, the Vasulkas presented *Matrix 1*, a compilation of works from the *Matrix Series,* as a 'video array', a bank of twenty monitors.[43] This work presents a sequence of abstract forms that move in synchronized horizontal waves across this field of monitors.

Woody and Steina's collaborative work across more than 30 years of commitment to video is complex; the Vasulkas have constantly influenced, inspired and challenged each other. Their oeuvre includes scores of works; collaborative video tapes, multi-screen displays and installations, and live performances as well as individual tape works and installations.

For Steina this collaborative influence led to the development of an extended series of works called *Machine Vision*, begun in 1975, which include *Signifying Nothing* and *Sound and Fury* (both 1975), *Allvision* (1976), *Switch! Monitor! Drift!* (1977), *Summer Salt* (1982) and *The West* (1983). These works all feature an interrelationship between a mechanical camera support and an environment, which brings to mind the parallel work of the English landscape filmmaker Chris Welsby and the work of Michael Snow in *La Région Centrale* (1971) (see Chapter 4).

The Vasulkas consider the development of the *Machine Vision* series to be part of the 'dialoguing' process; both with each other and with the machines they developed:

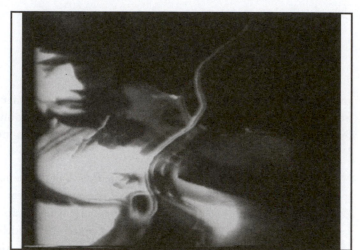

7.10: Steina, *Violin Power,*
1978. Courtesy of the artist.

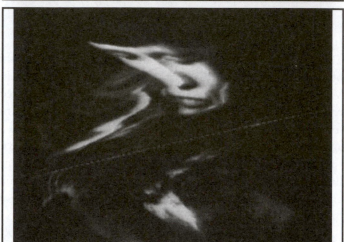

7.11: Steina, *Violin Power,*
1978. Courtesy of the artist.

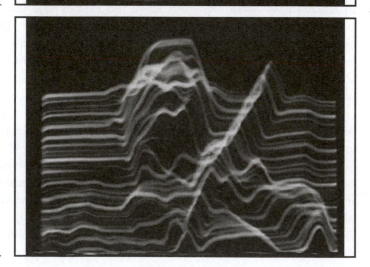

7.12: Steina, *Violin Power,*
1978. Courtesy of the artist.

First of all, we have always wanted to be inspired by the machines, we always wanted to have an equal partnership where the machines will suggest to us what we do; or the machine shows us. You put a camera on a machine and you see what it does. It's not imposing your "superior" view on the camera. Especially for me it led to this whole thinking about what is the hegemony of the human eye, and why are we showing everything from this point of view, and who is the cameraman to tell the rest of the world what they can see, wasn't it just out of the view of the camera that all of the action was? All the things that I had never thought about before because I was a musician. This whole idea of the tools as hardware, and then the tools as the signal and signal processing was very important, and there was the dialogue in between.[44]

Although the majority of video artist-engineers involved in producing hardware specifically for development of their own work were based in the United States, there were several British artists engaged in comparable activities, two of the most significant are Richard Monkhouse and Peter Donebauer.

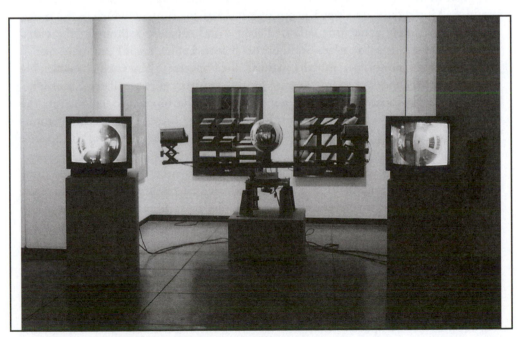

7.13: Steina, *All Vision Machine*, 1976. Courtesy of the artist.

RICHARD MONKHOUSE AND THE EMS SPECTRON

Richard Monkhouse (1950, UK) is a self-taught electronics engineer. After graduating with a Masters degree in Natural Sciences from Jesus College, Cambridge in 1972, Monkhouse worked on government defence projects for a year at Marconi-Elliot Avionic Systems, where he learned how to design circuits – 'all those resistor values had been a mystery'. He then joined EMS Ltd. (Electronic Music Studios), a London-based company specializing in the manufacture of sound synthesizers, initially involved with the design of a video display component for a new audio instrument:

> Nobody else at EMS had much expertise in video and I was, if you like, a promising newcomer/ slave. I was given the job of designing some video sync. circuitry. So I got a colour video monitor and a sync circuit and I started to plug direct RGB video signals from the digital timing circuit into the colour monitor. I suddenly realized how amazing pure colour video imagery actually is. In fact I got so excited by the pure colours that I was getting that I damaged the Trinitron monitor feeding in stronger and stronger colours, I heated up and bent the masks![45]

Intrigued by the visual quality and purity of the colour images he had been able to produce, Monkhouse developed a prototype video instrument which went much further than simply generating coloured stripes and squares: 'I thought: the video synth, what a concept. I've never heard of that before: Let me see if I can make one'.[46]

Monkhouse's prototype, initially named the 'Spectre', generated considerable interest at EMS, and was soon taken up by the company director Peter Zinovieff.[47] The machine was capable of taking a monochrome video camera feed, colourizing the image to eight levels with digital control of colour brightness. After further demonstrations in the UK, a colour encoder was added, enabling the output of the Spectre to be recordable.

For the basic layout and configuration of his video synthesizer, Monkhouse drew on the design of the EMS VCS 3 audio synth, which featured a pin-based patch board, giving the instrument considerable flexibility by facilitating countless routing possibilities without the need to resort to an enormous patch field of video connectors.

Although the Spectre was a novel idea with an untested market, EMS manufactured and actively promoted the instrument, making it available for £4,500 in 1974. In the December 1974 issue of *Video and Audio-Visual Review*, a full colour image produced via the Spectre appeared on the cover, and the magazine contained a substantial article written by Monkhouse entitled 'The Moving Art of Video Graphics – or How to Drive a Spectre'. Comprehensively illustrated with images and diagrams, this six-page article presented in considerable detail the functions and operations of

7.14: Spectre prototype, 1974. Courtesy of EMS.

7.15: EMS Spectron (Production model), 1975. Courtesy of EMS.

the prototype Spectre. Monkhouse also outlined the basic philosophy and approach behind the design of his instrument:

> Up to now there has been little work on direct video synthesis – most effects units (such as wipe generators, chromakey units, and colourizers) have been kept separate, and only used directly to treat signals that originate from a conventional camera scene set up. In our Spectre video synthesizer, a different concept has been used; rather than produce another special effects unit I have endeavoured to group together units with a highly perceptual impact in a way that gives total freedom to combine shapes and colours logically, and in a very general way.[48]

David Kirk, reviewing the production version of the now renamed Spectron the following year, also discussed the machine in some depth, using many of the same diagrams and illustrations featured in Monkhouse's article, considering its uses and potential market:

> This is the most fascinating tool that could ever be offered to the abstract artist whose imagination is better than his brushwork. More important, it is the ideal basis from which to commence a study of that relatively new art form: electronic painting. Fabric design, television special effects, perception studies, and "the ultimate discotheque light show" are among the applications suggested by the manufacturer. I could add to "perception studies" my own suggestion of "post-perception studies" since working with the Spectron has greatly increased my hitherto limited ability to "see" colour images with my eyes closed.[49]

Although working as an electronics engineer and employed to develop the new prototype, Monkhouse was not simply interested in the technology for its own sake, but wanted to make creative use of the machine he had designed. Even before leaving

EMS in 1975, Monkhouse had begun to use the Spectron to produce his own video work:

> I was fascinated with its potential, not in a technical way, but because of what it could do. I was interested to explore what it could do within its limitations, and to explore what I thought its powers were – given the limitations of what I had available to me. I wasn't in an art college, and I didn't have access to a lot of colour cameras. I only had the resources that I got from EMS.[50]

The idea to work with video as a creative medium hadn't occurred to Monkhouse until he had built the encoder for the Spectron. It was also around this time that cheaper colour video recorders were becoming available in the UK, and it was this further impetus that enabled Monkhouse to begin producing his own video work, including experimentation with video feedback.

Monkhouse had been inspired by the computer film work of John (1917–95, USA) and James Whitney (1921–81, USA). In 1971 he attended a lecture by John Whitney Jr., who had recently been given a grant by IBM for a project to reconstruct the senior Whitney's early work. Drawing on these inspirations, Monkhouse began to produce video work with a combination of direct video synthesis, 16mm film loops of computer graphics displays, video feedback and oscilloscope patterns, cutting his images to pre-recorded music tracks. Working with the Spectron in combination with other computer and video equipment of his own design, Monkhouse continued to experiment with video and computer animation, producing a number of innovative works including *Shine on You Crazy Diamond* (1977) and *Transform* (1978). He has continued to experiment with mathematically generated images, working with IBM PC-based raster graphic displays.

As has been previously discussed, the French video artist Robert Cahen systematically explored the capabilities of the Spectron in a series of videotapes he made in the late 1970s. Initially working with the Truquer Universel developed at the GRM, as discussed previously, Cahen turned his attention to the Spectron which he discovered whilst working at the INA (Institut National de l' Audiovisuel), producing *Sans Titre* (1977), *L'Eclipse* (1979), *Trompe l'oeil* (1979) and *L'ent'apercu* (1980). The design and architecture of the Spectron and its affinity with audio synthesizers was an important factor here and connects to issues previously discussed in connection with experimental music (see Chapter 5). Cahen was especially interested in the Spectron's capacity to generate an electronic weave of imagery to produce a kind of 'curtain that gives a craving to see what is hidden behind'. In fact, at this time Cahen was so entranced with the machine and its capabilities that he was dubbed 'Spectroman' by his colleagues at the INA![51]

Images of the Spectron also feature in another French artist's work. Chris Marker's film *Sans Soleil* (1982) presents images of a fictional Japanese video artist operating the controls of the synthesizer, with close-ups of the device and some resultant processed images. EMS sold a number of Spectrons overseas – for example, in Australia the video artist and electronic music composer Warren Burt (1949, USA) worked with one of the earliest Spectrons to develop an extended series of works including *Five Moods (3x4x) (for Ned Sublette), Return to Uranus (after Ruggles) Veils 2, Watermusic, Dazzler (after Monk)* and *Gorgeous Formalisms (Even 5 More Moods, Yet)* (all 1979).[52] Besides this impact on work by a number of significant international artists, Richard Monkhouse's Spectron also caught the attention of an artist working closer to home.

PETER DONEBAUER AND THE VIDEOKALOS IMAGE PROCESSOR

In 1974 video artist Peter Donebauer, interested in the potential of the Spectron video synthesizer, visited Richard Monkhouse at EMS in Putney, south London. This initial meeting was the beginning of a collaboration that lasted many years and included the building of several video instruments and a tour of live video/music performances (see below).

With the intention of finding a way to continue the abstract video work he had been producing using the colour TV studio at the Royal College of Art, Donebauer was seeking a machine that shared characteristics with the Spectron. Essentially he wanted a compact, affordable camera-processing instrument which combined some of the basic features of a conventional studio video mixer capable of cross fades, a keyer and a video wipe generator, a multiple colourizer plus a 'genlocked' sync. pulse generator and encoding/decoding cards. Agreeing to work together, Donebauer and Monkhouse set out to design and build such an instrument.

In his article 'Video Art and Technical Innovation' Peter Donebauer used Stephen Beck's categorization to provide a context for a discussion of his own approach to working with video.[53] His particular interest had been to develop video work that explored and established relationships between music and visual phenomena. Inspired by the work of Theodore Schwenk, the author of the book *Sensitive Chaos* (1963), who developed the 'drop picture technique' to photograph the surface patterning of water, Donebauer worked with a Portapak to record video images derived from a homemade device to vibrate a thin film of water over a loudspeaker. These preliminary black-and-white 'sketches' formed the basis of more ambitious work that followed.

Forming a collaborative partnership with composer/musician Simon Desorgher, Donebauer began working in the television studio at the Royal College of Art to explore parallels between electronic music and colour video. These collaborations, based on notions of live feedback and improvisation between video artist and

musician, were an attempt to produce visual work composed from abstract natural forms using music as a model:

> The major theme that emerged from working in the studio was the whole notion of the feedback process... . The performance itself is a feedback situation, and when you point the camera at a monitor you get these feedback patterns. I became very interested in the fact that the resulting images from video feedback were natural forms. They were organic-spirals, eddies, obviously related to the phenomenon that creates shells, galaxies, etc. Through this process I was suddenly thrown back into my earlier fascination with nature. Here I was, probably using the most advanced technical equipment available to an artist at the time, and suddenly I realized these electronic processes were mimicking the forces at work in nature.[54]

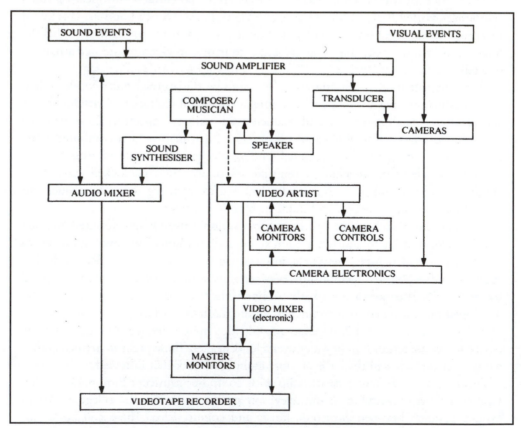

7.16: Peter Donebauer, *Diagram of live performance elements*, 1978. Courtesy of the artist.

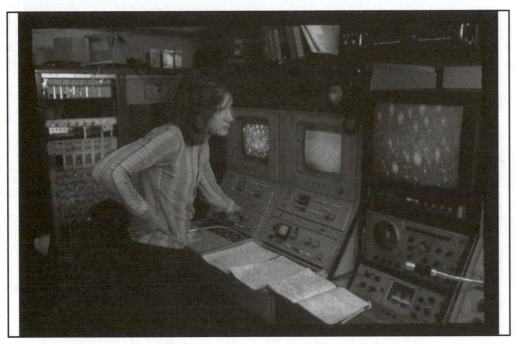

7.17: Peter Donebauer during BBC Transmission, 1974. Courtesy of the artist.

One of the most significant aspects of video for Donebauer was its immediacy – he saw a direct analogy between performing with a musical instrument and his working process with 'live' video in the TV studio. Donebauer developed a method of producing a 'real-time' continuous recording that was the record or documentation of a collaborative performance. The videotapes produced by this method were selected from the best 'takes' using this process.

In 1974 Donebauer was commissioned by BBC television to produce a videotape for broadcast on *Second House*, an arts magazine programme.[55] Because the BBC had no portable video recording equipment at the time, the work was transmitted via an outside broadcast microwave link from the TV studio at the RCA. This experience of the flexibility and ephemerality of video had a deep effect on Donebauer's sense of the medium and on the subsequent development of his work:

> Putting the signal down a wire somehow seems logical, but having it disembodied before it was recorded and then transmitting it back and forth across eight million people profoundly affected my sense of the medium ... it made me realize that the signal was everything. The signal is completely ethereal – it has no

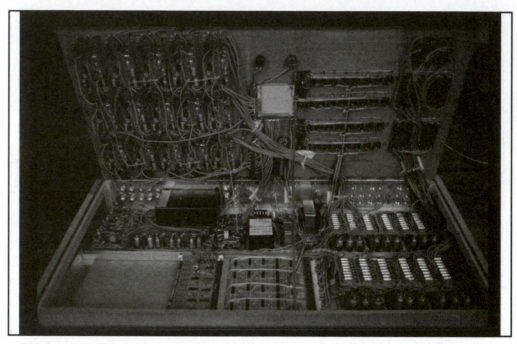

7.18: Prototype Videokalos interior, 1976. Courtesy of the artist.

substance…. . The fact that it's transmittable is a very peculiar aspect. Getting and staying closer to that sense of magic and wonder was very important.[56]

This experience of the video signal as paramount led directly to the development of Donebauer's own video-processing instrument, as mentioned above. After leaving the RCA, and with only occasional funding, Donebauer found it difficult to continue working in the way he had become accustomed to.[57] His solution was the development of a video image-processing tool, analogous to a sound mixer, but to be used 'live' like a musical instrument.

The 'Videokalos Image Processor', designed during 1975 in collaboration with Richard Monkhouse was intended as a 'live' performance instrument, providing even better 'real-time' control than the TV studio. According to Donebauer it had more precise colour mixing and allowed greater control of video feedback images because the entire unit was self-contained. In the RCA television studio for example, the vision-mixing console had been in a separate room from the engineering control area where he worked, requiring an additional operator. With the Videokalos, Donebauer was able to control the entire process himself.

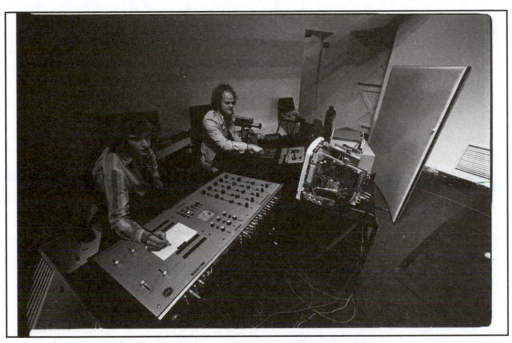

7.19: Peter Donebauer and Richard Monkhouse, VAMP Performance, 1977. Courtesy of the artist.

Although the Videokalos IMP did not redefine his work, it did enable Donebauer to produce new video work in other locations. The main intention in building the Videokalos was to gain the same level of control as he had had in the studio, but with simpler means. Donebauer also hoped it would bring him into closer contact with the medium: 'I felt that getting involved with the integrated circuits, chips and transistors and all the rest of it, would get me closer to the heart of the medium.'[58]

Although most of the videotapes Donebauer produced in the period between 1973 and 1983 were performed 'live', they were performed largely for tape. The first complete videotape to make use of the Videokalos IMP was *Merging-Emerging* (1978). Recorded in real time, with no subsequent editing, *Merging-Emerging* was produced using a procedure in which all the participants – Donebauer, two dancers, and two musicians (flute and violin), had visual and aural feedback which enabled them to modify and adapt their contributions during the recording session (see Chapter 10 for a more detailed discussion of this work). In 1979 Donebauer and Desorgher formed VAMP to present their collaborative work to live audiences,

touring venues across the UK, the first and only time this was attempted.[59] Donebauer did not do many:

> I'm not really a good performer – I'm not extrovert enough. All my work was performed, but largely for tape. That may have been a mistake in retrospect. If I'd been more outgoing I might have tried to do more live work. But the finances were dreadful…. It was terribly difficult.[60]

Although VAMP's tour was a unique event, the live aspect was central to Donebauer's philosophy. His videotapes are all derived from a 'live' performance – the final released version being the best 'take' of a studio recording session. For Donebauer this 'liveness' was a key part of the aesthetic, drawn both from the influence of Zen painting and from early television broadcasting. Donebauer's approach to video was also highly influenced by his perception of music as an abstract language, and his notion that live video produced by an interaction between performers could be perceived in a similar way:

> The condition of music is that it is the live production of organized sounds that extend in time and affect our inner selves without the necessity of mediation through verbal or conceptual structures.
>
> The condition of video is that it is the live production of organized images that extend in time and affect our inner selves without the necessity of mediation through verbal or conceptual structures.
>
> As one plays a musical instrument the result is an immediate feedback through the ear of what the body and the mind has created.
>
> As one plays a video instrument the result is an immediate feedback through the eye of what the body and the mind has created.
>
> Video is the visual equivalent of music.[61]

By combining his ideas about the parallels between music and video, his interests in Zen calligraphy and gestural painting and the immediacy and fluidity of the video signal, Donebauer saw a potential for the medium, based on its inherent properties, which challenged the more formal conceptual definitions of his contemporaries. Donebauer's ideas were firmly tied into the technical possibilities, but in contrast with more constraining definitions, they embraced the transcendent potential of video in a way that echoes the enthusiasm of Gene Youngblood in *Expanded Cinema*. Donebauer wrote in 1976:

> Video as a medium is unparalleled by any other in its ability to allow immediate visual and aural experience extend in time and be recorded…. Video however

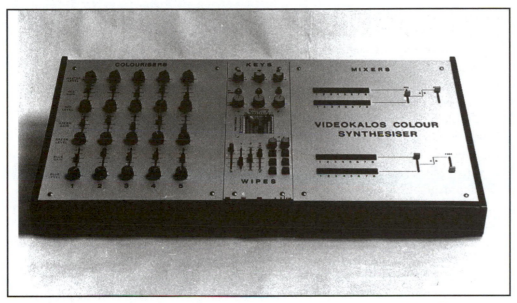

7.20: The Videokalos Image Processor, production version, 1977–8. Courtesy of Peter Donebauer.

is undefined. As electronic technology pushes back frontier after frontier in terms of size and processing techniques so does video expand its possibilities. In a contemporary world where many aspects of our external environment are appearing to be finite, the interaction of human consciousness with electronic possibilities seems to be without limit.[62]

Donebauer's attitude to video is informed by working directly with the medium in a live and interactive way. This attitude is embodied in the Videokalos IMP, and was crucial to both the development of the instrument and to the subsequent development of Donebauer's video work.[63]

Whilst the development of the Videokalos did not result in specifically new technology, its unique configuration reflected Donebauer's approach to 'live' video performances and the needs and requirements to facilitate their production. The instrument's design offered a high degree of flexibility for the synthesis and manipulation of colour video imagery. When working with the Videokalos it was possible to work with up to five independent video inputs, each of which enabled the colourization of monochrome camera sources or the manipulation of the level and gain of component (Red, Green and Blue) colour sources. There were also three further inputs to a wipe generator (for vertical and horizontal, curved and circular wipes) a

keying panel, as well as an eight-input switcher/mixer. Drawing on its EMS heritage the machine had a 22x22 hole pin board that was used in conjunction with the three key channels, each selectable as a triggering source from any of the monochrome or RGB outputs. It was possible to produce very complex key effects with up to four levels of colourization within a single video image. It was also possible to combine positive and negative colour mixtures within each key level.[64]

Although he was not initially aware of the work of American pioneers such as Beck, Seigel or Sandin, Donebauer's work both as an artist and as an electronics designer has much in common with his US contemporaries. His interest in the 'live' aspects of video technology, the influences of music and electronic sound synthesizers on the development of his video work and the Videokalos IMP are comparable. Between 1974 and 1980 Donebauer produced a number of innovative abstract video tapes financed by the Arts Council of Great Britain: *Entering* (1974), *Struggling* (1974); and the British Film Institute: *Circling* (1975) *Teaming* (1975) and *Dawn Creation* (1976). In 1981–2 he produced *The Water Cycle*, an ambitious 50-minute work in seven sections for Thorn EMI, to be distributed on the VHD videodisc system, which due to a corporate decision, was never issued. He has on several occasions produced new works, most significantly *Mandala,* released in 1991.

As with his US counterparts, Stephen Beck and Eric Seigel, Donebauer has for a number of years turned his creative abilities to more commercial work, as owner and chief executive director of Diverse Production Ltd, a London-based media production group. He has recently however made a decision to return to his career as an artist, developing a range of new durational landscape video works for large screen projection.

CONCLUSION

The key artists discussed in this section: Nam June Paik, David Hall, Stephen Beck, the Vasulkas, Robert Cahen, Ed Emshwiller and Peter Donebauer have all established their practice in relation to the specifics of developing video-imaging technology. As Gene Youngblood has pointed out, there is a crucial relationship between the development of new technological systems and the language inherent in them: 'Our task is to discover it, identify it, draw it out and name it'. He points out that 'Vasulka has built his machines in order to discover the language in them'. Youngblood also cites Peter Weibel in pointing out that human vision has always been 'machine assisted'.[65]

By outlining some of the most significant events in the development of the video medium from the perspective of fine art, I have attempted to identify how inextricably video art and video-imaging technology are intertwined. Early video artists explored and investigated the unique properties of the new medium; instant playback, live

monitoring, feedback, continuous real-time recording, simultaneous sound and picture, image degradation, repetition, image distortion, colour synthesis etc., not simply as ends in themselves, but because of the ideas and cultural meanings that were imbedded in them. Creative explorations and applications of these and other techniques have inspired artists to create works which are both a testament to the developing technology and a reflection of the concerns of the times and culture they are part of. All of the video artists I have discussed have drawn on their experience and knowledge of working with video technology for inspiration and creative exploration, developing a vocabulary for an evolving visual language, and opening up the territory for future developments.

American filmmaker Hollis Frampton (1936–84, USA) once said that video art emerged out of the 'Jovian backside' of TV,[66] and clearly the earliest video art referenced broadcast television, both in terms of its technological pedigree and its social function. But artists working with video quickly sought to create their own context, simultaneously seeking to free art from its institutional and ideological straightjacket, and to stake claim to new formal territory. Video art quickly developed a number of sub-genres: single-screen video tapes, video sculpture/installation, 'abstract' synthesized video, performance documentation, 'guerrilla TV', agit-prop, community action, etc., all of which are at least partly a manifestation of a particular and specific response to forms of available technological configurations.

PART II

A DISCUSSION OF SOME REPRESENTATIVE AND INFLUENTIAL VIDEO ARTWORKS SET IN RELATION TO THEIR TECHNICAL AND CRITICAL CONTEXT

This section of the book discusses and examines a number of specific representative works by a range of significant artists under four main headings, acknowledging and highlighting the impact of the most significant technological developments that have been identified in the first section of the book. Specific video artworks are discussed under the following four categories: 'Non-broadcast' portable video; Frame-accurate editing; Electronic/digital image manipulation techniques and Video display formats for installation. The video works in each chapter have been chosen as examples only, as there are a great number of important and significant works that have been produced in the period under consideration by other artists in numerous countries.

It is also important to point out that the artists discussed within individual chapters did not work exclusively with one particular approach or mode. So for example, Joan Jonas and Steven Partridge produced works that were tightly edited, Gary Hill and Judith Goddard made single-screen tapes, and Dara Birnbaum and Wojciech Bruszewski have made installations. These four chapters serve only to provide some specific examples of the ways in which artists responded to the techniques and methods that became available to them at the time, and to show how these forms were explored and gave rise to a decoding of the meanings and creative potential inherent in the developing technology at the time of their production.

Across the period under discussion there was a shift away from the 'modernist' preoccupations of early video (during which many video artists were involved with an investigation into the inherent properties of video such as nature of the recording process and its components of lines, fields and frames, the camera and its functions and operations, and the television 'box' and its viewing condition), towards broader issues and concerns about the nature or representation and the social/political

implications of the media. This shift can be seen in the work made by the artists in this section, from the materialist concerns in works such as *Monitor* by Steve Partridge, *The Video Touch* by Wojciech Bruszewski, David Hall's *This is a Television Monitor*, or Michael Snow's *De La*, through to works that are clearly addressing issue-based and socio-political concerns such as Serra and Schoolman's *Television Delivers People*, Birnbaum's *Technology/Transformation: Wonder Woman*, the Duvet Brothers' *Blue Monday* or Dan Reeve's *Obsessive Becoming*. Some of the video works examined seem to occupy a special territory – not purely formal but celebrating the fluid new potential of video as an art medium, presenting both a subjective viewpoint and challenging the established approach of broadcast television. Works such as *Vertical Roll* by Joan Jonas; Robert Cahen's *Juste le Temps; Art of Memory* by Woody Vasulka *With Child* by Catherine Elwes and Bill Viola's *The Reflecting Pool* are both lyrical and personal, but through their poetic exploration of the technological form and their innovative manipulation and deconstruction of narrative conventions, draw on the legacy of the materialist period and share a postmodern concern for the issues of representation.

8. IN AND OUT OF THE STUDIO
THE ADVENT OF INEXPENSIVE NON-BROADCAST VIDEO

By the early 1970s, attracted by instant playback and recording of image and sound and the potential of re-recording and erasure as a creative process, artists had begun to explore the possibilities and potential of the Portapak, a battery-operated portable video recorder and camera ensemble. This equipment was relatively inexpensive (approx US$2,000) and very simple to operate.[1] Its portability and ease of operation made it ideal for use by an individual operator, and artists could work with it on their own in the privacy of their own studios – no technical crew or expensive and cumbersome lighting required. The black-and-white camera which was connected to the recorder by a thick umbilical cord, was capable of producing images in relatively low-light levels, and since it had a built-in microphone and automatic sound level control (although there was no manual override) basic synchronized sound recordings were the norm. The recorder used 30-minute 'open reel' ½-inch tapes, and although the camera was equipped with a pause control – the cut between scenes was crude and often caused 'unstable' edits between shots or sequences. Artist's tapes from this period were subsequently most often continuous unedited recordings, the documentation of performances or presentations made 'live' to camera with a simple ambient soundtrack – often the human voice. The quality of the image recordings was grainy, low-resolution (and often low-contrast) and with a distinct high pitched whine of the automatic volume control (AVC) mechanism on the soundtrack. Simple editing could be accomplished by copying selected portions of the tape using a second video recorder, but the picture edits were fairly inaccurate and often unstable, and since the position of the soundtrack recording was displaced from that of the image track, accurate sound and picture edits were impossible to achieve using this level of equipment.

The configuration of the Portapak also made it possible to connect the unit directly to a black-and-white video monitor (or by using the built-in RF converter, to a domestic TV receiver), which enabled the sound and picture to be monitored live, as well as facilitating instant playback of the recording. This closed-circuit aspect was also particularly attractive to artists, and was the basis of numerous installations as well as providing the possibility of so-called video 'feedback', achieved when a live

video camera is pointed at a monitor displaying the camera image. This phenomenon was explored and developed by artists of this period who were especially interested in non-representational imagery (see Chapter 7). Re-recording of the video image was also a technique much exploited by artists working with early non-broadcast video. Tapes such as Joan Jonas' *Vertical Roll* and Steve Partridge's *Monitor* are examples of this technique. David Hall's *This is a Video Monitor* was accomplished by making a series of re-recordings, each one a generation further from the original.

For the most part, this work was produced outside the broadcast television context – technically of low quality, the recordings were deemed by those in the industry to be unfit for broadcasting. As we have seen, many of these videotapes (and other comparable works) were deliberately critical of the broadcast industry, on ideological, political and/or aesthetic grounds, and in many countries artists' video often deliberately took up a position critical of broadcast television and sought alternative strategies for production and distribution.

MONITOR, STEVE PARTRIDGE, UK, 1975 (BLACK-AND-WHITE, SILENT, 10 MINUTES)

In *Monitor* Steve Partridge used the instant playback and live monitoring capability of the Portapak to explore the relationship between the video image and the monitor as object, in an elegant and deceptively simple video tape. In the mid-1970s the artist identifies the key strengths of the Portapak as an artists' tool and describes his early preoccupations with the medium:

> Everything about the nature of half-inch video seems to make it ideally suited to individuality and creativity. Artists are able to use video equipment either completely alone or in small groups. No specialized professional skills are needed to operate the equipment, and tape costs far less than film. All of this seems to make video a truly human-sized medium.
>
> My own videotape work has been largely concerned with an exploration of the video process per se ... *Monitor* is a careful reorganization of time scales and images of a revolving monitor producing a disorientating illusion.[2]

In *Monitor* a close-up image of a small monochrome video monitor is framed centrally and displayed on an identical monitor that has been placed onto the edge of a tabletop. The image is visually composed so that the edge of the table passes diagonally through the video frame, and the identical composition is then repeated within the monitor in what initially appears to be a 'feedback' arrangement, in which it is possible to discern that the same image of this video monitor is repeated in diminishing size five times, one frame inside the other. (This arrangement also implies that the series of images extends to infinity.) This composition is 'held' static

for approximately 30 seconds after which a (right) hand appears 'inside' the frame of the first monitor and is placed on top of the monitor casing. This action is echoed immediately on the 'outside' monitor image, with an 'identical' hand copying the action and coming to rest on the top of the monitor casing. The (left) hand then appears, bottom left, inside the screen and is followed by the mimicking of that action on the 'outside' monitor. The hand slides along the lower edge of the monitor until it reaches the bottom corner of the screen. Grasping the two opposing corners of the screen, the monitor, turned slowly over onto its left side, is then adjusted to appear centrally within the screen. The hands on the 'inner' monitors are then repositioned to maintain their top and bottom corner configuration – each subsequent action is executed by the hands on the 'inner' screens and then 'copied' by the outer pair.

Basically each of the five generations of recorded sequences (one recording was made for each of the 'layers') of the routine was recorded separately and sequentially, using the previous recording as a 'prompt'. The entire routine was first recorded all the way through once, and then played back on the monitor whilst the action was re-recorded. The resultant recording of each new generation was then re-recorded as the action was restaged. This routine was repeated five times, creating a recording of the same action across five generations.

Monitor is divided into two parts, each section of the tape featuring a different physical movement of the monitor within televisual space; section one rotates the monitor on the horizontal axis through 360 degrees, section two turns the monitor through a vertical axis to show the outside of apparatus on either side of the picture tube. Partridge uses this simple strategy to effectively imply the sculptural potential of the video monitor.

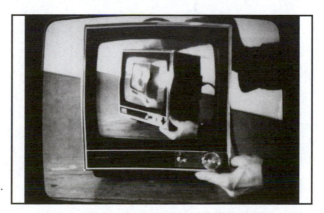

8.1: Stephen Partridge, *Monitor*, 1975.
Courtesy of the artist.

Although Partridge describes the work as one that provides a 'disorientating illusion', I read the piece as being decidedly anti-illusionary, in that it presents the display of the video monitor as the 'subject' of the work. The tape has been recorded without sound, and the visual image shown is produced as a direct result of the actions of the hands moving the monitor within the image display. In its making and its functioning *Monitor* exploits and foregrounds inherent properties unique to video – instant playback and 'live' monitoring. These facilities enabled Partridge to both monitor the effect of his actions on the screen, and to present these actions as the 'subject' of image. This and similar works produced during this period (the early to mid-1970s) occupy an important critical position relative to the dominant forms of representation in television. As Stuart Marshall pointed out in 'From Art to Independence', the early modernist practice of video artists in which the properties of imaging technology were the major preoccupation, brought these artists into a direct confrontation with issues of signification:

> Video's attempt to produce a modernist practice therefore produced a second
> unexpected consequence, the establishment of a critical relation to dominant
> technology and its representational practices.[3]

TELEVISION DELIVERS PEOPLE: RICHARD SERRA AND CARLOTA FAY SCHOOLMAN, USA 1973 (COLOUR, SOUND, 6 MINUTES)

In *Television Delivers People*, Richard Serra (1939, USA) and Carlota Fay Schoolman (1949, USA) use a stark televisual form to present a critical analysis of the political and ideological function of American broadcast television. Using an electronically generated scrolling text (yellow lettering on a blue background) set to banal 'interlude' music, the tape presents a series of short texts which directly address the viewer, confronting him/her with a revealing analysis of the socially controlling functions of television broadcasting and so-called 'mass entertainment' and news.

> The product of tele-
> vision, commercial
> television, is the
> audience.
>
> Television delivers
> people to an
> advertiser.
>
> There is no such thing
> as mass media in the
> United States except
> for television.

Mass media means
that a medium can
deliver masses of
people.
Commercial television
delivers 20 million
people a minute.

In commercial broad-
casting the viewer
pays for the privilege
of having himself sold.
It is the consumer
who is consumed.

You are the product
of TV.

You are delivered to
the advertiser who is
the customer.
He consumes you.

The viewer is not
responsible for
programming—

You are the end
product.

You are the end
product delivered
en masse to the
advertiser.

You are the product
of TV.

This directly confrontational strategy utilizing terse and hard-hitting phrases set to a background of upbeat 'elevator music' cuts across the divide between television programme maker and audience presenting a political 'electronic manifesto' which spells out the relationship between the viewer and the medium of American broadcast television in the 1970s.

By reflexively utilizing the medium he is criticizing, Serra taps into a strategy in keeping with the counter-corporate tactics of early video collectives, a strategy which remains integral to video artists committed to a critical dismantling of the media's political and ideological stranglehold.[4]

This work, which could technically have been broadcast (it was in fact cablecast a number of times in New York state) makes effective use of very minimal video technology. The text and background were electronically generated, giving the tape a spare low-budget appearance, as if it were an information bulletin, or a pre-programme transmission on a community TV channel or cable network. Because of this minimal 'look', the tape clearly originates from 'outside' the broadcast TV environment, therefore deconstructing not so much the form of television programming, but rather broadcasting's overall strategy.

The tape goes further than simply critiquing broadcast television, extending its scope to target the role of television networks and beyond to the large corporations that control them and the political state they represent:

The NEW MEDIA STATE
is dependent on
television for its
existence.

The NEW MEDIA STATE
is dependent on
propaganda for its
existence.

Corporations that own
networks control
them.

The stark and minimal appearance of this work strips away any pretence of 'entertainment' or even news or documentary, opting for a direct appeal to the mind and emotions of the viewer:

You pay the money
to allow someone else
to make the choice.

You are consumed.

You are the product
of television.

Television delivers
people.

The work is effective not simply because of the message conveyed via the text, which through coherent persuasive argument outlines the relationship between television entertainment, news and information, the maintaining of the status quo and corporate and political control, but because of the direct televisual power of its form.

THIS IS A TELEVISION RECEIVER, DAVID HALL, UK, 1976 (COLOUR, SOUND, 8 MINUTES)

Although this video tape was made especially for a BBC *Arena: Art and Design* television programme about video art broadcast in 1976, it was a remake of *This is a Video Monitor* (1974) originally intended for a non-broadcast context.[5] In Hall's original tape, a woman's face and voice (television producer Anna Ridley) were the images and sounds presented on the video monitor. This earlier version, shot in black-and-white on a Portapak, presents an extreme close-up of a woman's face, her long hair framing each side of the screen. She speaks directly to the camera, pacing her monologue with a slow and careful delivery. She appears to be miming the words, as they can also be heard 'off camera' occasionally, slightly ahead of her lip movements. The words the woman speaks describe in careful detail the nature of the image and sound being experienced with an outline of the technical processes that are providing the message:

> This is a video monitor, which is a box. The shell is of wood, metal or plastic. On one side, most likely the one you are looking at, there is a large rectangular opening. This opening is filled with a curved glass surface which is emitting light. The light, passing through the curved glass surface, varies in intensity over that surface, from dark to light and in a variety of shades of grey. These form shapes, which often appear as images. In this case, the image of a woman. But it is not a woman. There is also another opening, probably on the same side as the curved glass surface, or adjacent to it, which is emitting this sound. The sound is produced by vibrations on the cone inside this other opening. The sound is very similar to a woman speaking, but it is not a woman's voice. Because these sounds are so similar to a woman speaking, and because the image of the woman's lips appears to be simultaneously forming the same words, the sounds are heard as though coming from the image of the woman's mouth, but they do not.

The woman stops speaking, her image fades to black and a male voice (Hall's?) shouts 'cut'. The recording is stopped and there are several seconds of 'blank' tape, with

'now' or 'static' appearing briefly on the screen. After this slight gap a new recording begins and the image of the woman's face reappears. Cropped slightly closer and noticeably degraded, it is a copy of the first, distinctly less well defined and with increased contrast. A copy of the entire sequence is presented, with both image and sound degraded.

This copying process is then repeated for a third time with predictable results; the framing is closer still and the contrast is markedly harsher. Both the image and the speech are still recognizable – but only just.

By the fourth 'generation', the image has been completely abstracted, and is no longer recognizable. The sound is also significantly distorted, but is still, though very 'metallic', understandable.

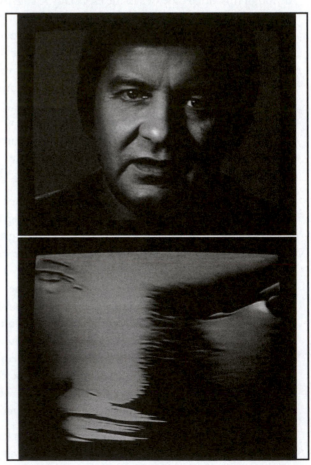

8.2: David Hall, *This is a Television Receiver*, 1976. Courtesy of the artist.

The fifth and final pass renders the image into moving patches of light and shade; the sound has degenerated into acoustic 'noise', though still recognizable as having characteristically human speech patterns.

In the version made for BBC TV, *This is a Television Receiver* (1976), the woman was replaced by the well-known newsreader Richard Baker, lending his presence and authority to the work, and reinforcing the status of its broadcast television setting. This power is further enhanced by the work's placement within the *Arena* programme: as the tape begins the broadcast programme unannounced, the entire *This is a Television Receiver* speech (modified slightly from the 1974 text in order to make it suitable for a male image and voice), and the first re-copied segment are presented before the familiar and identifiable *Arena* programme logo and signature tune was introduced.

This is a Television Receiver is a restaging of the earlier tape, and it does not have the conceptual rigour of the original. Not only is the tape interrupted by Hall's speech to camera in the *Arena* broadcast, but also the video image is not permitted to break down beyond recognition. The original five repeated sequences have been reduced to four, and there are steps missing in the procedure, as the progressive deterioration was clearly much more difficult to attain with broadcast video recorders. The quality loss of the image from one generation to the next was minimal, so Hall had to 'cheat' in order to replicate the effect of the original tape.[6]

Hall's interest in the broadcast context for video art has been discussed previously (see Chapter 1), and the *Arena* broadcast gave him a unique opportunity to present his ideas to a wider public. Despite the conceptual shortcomings discussed above, *This is a Television Receiver* was an elegant and effective statement – perhaps even definitive.[7] In some ways the work is more effective than *This is a Television Monitor* precisely because it was *on* TV, and because of the participation of the broadcast TV presenter Richard Baker. The choice of Baker for the presentation was inspired, as at the time of broadcast, Baker was the quintessential presenter – professional, authoritative, trusted.

As is clear from his *Arena* statement, Hall's broadcast aspirations for video art were in many ways centred on the issue of venue. For Hall, contemporary art required a contemporary medium and this included a careful consideration of the relationship of that medium to the venue. For Hall, the gallery was too prescribed, whereas the medium of television offered both a new venue and a potential new audience:

> [The art gallery] was very much kind of closeted. It was annexed – it had less and
> less social relevance in many respects. Things like radio and cinema, and latterly
> television were really the things that people looked at... . I thought that on

the whole art had very little social significance and was really kept in its sort of annex. It was just for the initiated. I wanted to try and push outside of that, and it seemed to me that using film. i.e. like cinema, and using video, like television, or better still on television, seemed to me to be a much more appropriate place to be as an artist.[8]

VERTICAL ROLL, JOAN JONAS, USA, 1972 (BLACK-AND-WHITE, SOUND, 20 MINUTES)

Joan Jonas (1936, USA) began making live performances in 1968, previously working as a figurative sculptor, until studying dance with choreographer Trisha Brown (1936, USA) in New York City. Jonas began working with a Sony Portapak after a visit to Japan in 1970 and began using the video equipment as an integral part of her dance performances. In parallel with her public performance work Jonas experimented with video, making more intimate works such as *Duet* and *Left Side, Right Side* (both 1972) which explored the relationship between personal and image space. In her subsequent video work Jonas became interested in dealing with ritual, making use of costumes and masks from other cultures including the Minoans, the Hopi Indians and Japanese Noh Theatre, as well as drawing from magic shows and early cinema. Extending her practice of using mirrors in her live performance, video enabled Jonas to explore a further level of reflection, relating this experience to her audience via live closed-circuit transmission, presenting the video monitor as an 'on-going mirror'.

Space was always a primary concern, and in considering the space of the monitor I then dealt with its boxlike structure, positioning it in relation to myself. I tried to climb into the box, attempting to turn the illusion of flatness to one of depth. The focus was off myself.[9]

Translating a notion of electronic sound delay she had previously used in her outdoor performances, Jonas adopted the maladjusted vertical roll control of the video monitor as a method of de-synchronization – in her own terms – an 'out of synch frequency'.[10]

Vertical Roll begins with a silent rolling image of a blank video screen. The final tape is a recording of a performance made in front of a video monitor which is displaying the recording of a previous performance on a maladjusted monitor on the floor of Jonas' studio. At the beginning of the sequence Jonas' face appears in front of the monitor from the top of the screen. She picks up a spoon and begins to hit the glass of the screen in synch with the rolling of the image, giving the image an insistent rhythmic physicality. The camera gradually zooms into the screen, defocusing the image until it appears blank. The sound of the spoon then changes to a more distant

beat (now being made with a block of wood) but still to the same driving rhythm, and without missing a beat. The image of a black-and-white patterned cloth appears, moving and shifting across the frame of the screen. The movement is clearly human, and is eventually identifiable as the performer herself, who then enters the frame wearing a mask, her face appearing upside down, as the camera has now been turned over. Jonas rotates her position again: now with her feet close to the camera, she appears to be 'walking' on air with the camera below her looking up. The image fades to a blank screen and a still photograph of a naked woman appears, initially slightly out of focus and eventually losing focus altogether. The legs of a female figure approach, marching in time to the vertical roll and its insistent beat, jumping up and down both with and against the beat, as if jumping over the edge of the frame. Jonas then drops to the floor, tapping the floor and placing her hands in positions to create the illusion that she is clapping to the rhythm of the roll. After another slow defocus, Jonas enters the frame from the right, rotating her body slowly as the image of her torso (clad in a two-piece jewelled costume) moves through the frame. The camera pans way from her body (or she moves out of frame) to her shadow on the wall, her outstretched hand holding the spoon. The figure moves out of shot to the left and Jonas' face appears close up in front of the video monitor, as she slowly looks towards the camera, filling the frame momentarily before leaving the frame from the bottom of the picture. The image cuts to black.

Jonas made *Vertical Roll* in 1972, using the tape as part of a live performance entitled *Organic Honey's Vertical Roll* the following year. Concerned with the presentation of an altered perception of physical space in the room beyond the video monitor, Jonas presented *Organic Honey* as a kind of alter ego who evolved from her involvement with the video image – especially the live video image from the closed-circuit television system that was an integral component of her live performance pieces. Around the time of making *Vertical Roll*, Jonas described her intentions with the work, identifying its relationship to an exploration of video space, movement and the body:

> I'm developing many different identities and states of being translated into images appearing on my monitor. In performances, the audience sees the simultaneous discrepancies between live activity and video images. The monitor is an on-going mirror, but it does not reverse left and right. The vertical roll of the monitor was used in my work as a structural device with which activities were performed in and out of synch with its rhythm. I play with the peculiar qualities of the TV, imagistically and structurally. The vertical roll seems to be a series of frames in a film, going by slowly, obscuring and distorting the movement.

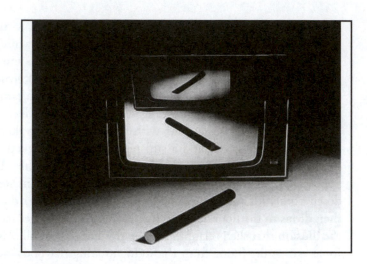

8.3: Wojciech Bruszewski,
The Video Touch, 1976.
Courtesy of the artist.

Portions of the movement are lost as the mind passes or jumps the monitor. The vertical roll affects one's perception of the TV image and of the space around the monitor. Floors seem to rise when you look away from the continuous vertical roll. I would like to do a horizontal roll. *Vertical Roll* was taped off the monitor. Reflections from the room were on the surface of the monitor.[11]

THE VIDEO TOUCH, WOJCIECH BRUSZEWSKI. POLAND, 1977, BLACK-AND-WHITE, SOUND (7/77; 1 MINUTE, 40 SECONDS, 5/77, 1 MINUTE, 20 SECONDS; 1/76, 3 MINUTES, 40 SECONDS; 8/77, 3 MINUTES, 16 SECONDS)

Working with both film and video in the 1970s and influenced by ideas and theories developed through 'Structural' film, particularly the 'Structural-Materialist' films and theories developed in the UK (see Chapter 4), Wojciech Bruszewski (1947–2009, Poland) produced a series of short experimental works exploring the implications of film and video recording on the nature of reality and human perception.

In *The Video Touch*, a compilation of short video experiments, Bruszewski includes a number of voice-overs that have been edited onto the soundtrack to accompany the visuals. These texts provide a context for the works and present the visuals as a series of propositions that address human perceptual preconceptions.

All my works are concerned with elementary situations. An analysis of these situations allows me to discover mind structures still functioning but useless.

THE VIDEO TOUCH 7/77

The tape begins with the image of a centrally placed video monitor displaying the back of a loudspeaker that is suspended from above by its cables. Behind the

loudspeaker, there is an image of the rear view of the video monitor, so that we are able to simultaneously see both the font and back of the display apparatus. There is a continuous buzzing sound from the speaker, produced by acoustic feedback. A figure (the artist or his assistant?) enters from the right of frame, and crouching beside the monitor, reaches for the loudspeaker, the live video image of his hand appearing on the screen as it disappears behind the monitor. Grasping the speaker, he sets it in motion, causing it to swing to and fro in an arc so that it becomes visible beyond the screen and as an image (seen from the front) when it swings behind the monitor. The speaker swings back and forth like a pendulum, making a repeated transition from image to object and from front to back. As it swings, the feedback sounds change pitch as it passes through the image on the screen and appears as an object outside the boundaries of the screen. The speaker/ pendulum is made to swing physically and spatially, alternating between front and back, between image and object, it seems to be able to occupy alternate electronic and conceptual spaces.

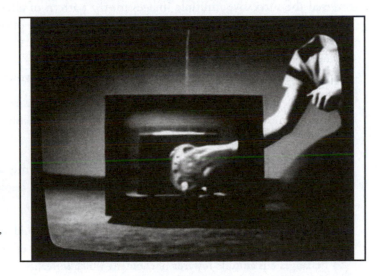

8.4: Wojciech Bruszewski, *The Video Touch*, 1977. Courtesy of the artist.

THE VIDEO TOUCH 5/77

A domestic water tap protruding from a tiled wall is shown in medium close-up. The artist's hand enters the frame from the right (from behind the camera?) As he opens the tap, the water is seen to flow upwards in a curve from the spout of the tap. The ambient sound is of the water trickling from the tap. The hand re-enters the frame and closes the tap. Visual cues suggest conventional readings that are easily disrupted with simple camera framing and compositional devices.

THE VIDEO TOUCH 1/76

A large video monitor in the centre of the screen is displaying the image of an identical monitor, and another inside that, in a live feedback arrangement. The monitor screens show a blank neutral grey field, and the sound track is ambient. A hand grasping a short wooden baton (8–10 inches long) enters the frame from the left, and places the baton in front of the monitor within the left-hand portion of the screen. This image is twice repeated within the frame of the monitor on a successively smaller scale, one image inside the other. This image is held for approximately 10 seconds.

The picture within the second monitor is then electronically reversed, so that the baton now appears to be placed in the exact opposite position to the first generation image. The hand again enters the frame and removes the baton. There is the sound of a switch being made, and there is momentary change to the light levels on the screens. This sequence of events is repeated three times, each time the baton is placed in a different position in front of the monitor, so that when the second image is reversed the successive multiple images form a pattern of alternating realities. In the final sequence, the baton is leaned against the glass surface of the monitor screen. The near-simultaneous electronic transmission of video imagery has created anomalies in our notions of spatial perception.

In the compilation version of *The Video Touch* (1977) a voice-over then reads a text:

> There exists now a need to gather the experiences with the use of mechanical and electronic media according to some actual and comprehensive theory of seeing.

THE VIDEO TOUCH: 8/77

This piece is prefaced by a voice-over that identifies the artist's interest in the relationship between sound and image, particularly how perceptions of one can be influenced or affected by changes to the other.

> The attachment to audio-visual perceptions of the world imprints a strange mechanism in our consciousness. Disturbances in one of these two channels changes our attitude towards phenomena which in reality is totally different.

The close-up image of a stopwatch appears on the screen. Immediately beneath it in plain black lettering are the words 'Time Structures'. A hand enters the frame, starts the watch counting and centres the object within the frame. The sweep hand of the stopwatch counts the seconds in real time, but on the soundtrack the ticking has been accelerated and then is gradually slowed to normal speed, only to gather speed again. The stopwatch runs continuously for approximately three minutes during which time the sound alternately speeds up and slows down.

In these and other video works such as *Input/Output* (1977) and *Outside* (1975) Bruszewski sought to explore the anomalies that the medium exposed, and suggested that new theories of human perception were required in the light of developments of electronic moving image recording and transmission. His works of this period were simultaneously analytic and poetic, austere and didactic, humorous and reflective.

> What I do is nothing else than setting traps for what exists. I try to set the traps on the borderline of the "spiritual" and the "material" of "what we know and think of" and "what there is".
>
> This procedure systematically follows results in the destruction of the convention of what exists, at the same time the mechanical and electronic means of transmission, as the channel which is clear and unlimited by mental schemes acts as the catalyst for the reaction whilst the hypothetical 'what exists?' in the first meaning outside of the potential energy of destruction.

MARCA REGISTRADA [TRADEMARK]; LETICIA PARENTE, BRAZIL, 1975 (BLACK AND WHITE, 10 MINUTES, 34 SECONDS. CAMERA: JOM TOB AZULAY)

Although Leticia Parente (1930, Salvador – 1991, Rio de Janerio) is best known for her video work, the medium was one of many she explored. *Marca Registrada* was made whilst Parente was a member of a pioneering group of Brazilian artists led by Anna Bella Geiger, which included Sonia Andrade, Fernando Cocchiarale and Paulo Herkenhoff, who produced a number of influential early works in video, exhibited both in Brazil and beyond.[12]

The video work of this group had a number of significant common characteristics – they present or perform simple actions in domestic spaces, there is no dialogue and they are continuous, unedited sequences performed in a single 'take'. (They have this aspect in common with works by artists in many countries who began working with the new medium in the early period, as noted elsewhere in this book.)

In *Marca Registrada*, Parente initially presents us with the image of a woman's bare feet and lower legs. As the tape progresses the woman is shown walking slowly from right to left across a plain tiled floor to sit down left of frame. (There is no discernable audio, instead the soundtrack is of static or 'audio noise'.) The camera pans-up and zooms in as the woman's hands enter the frame and we are presented with a close-up of her hands holding a needle and thread. After several attempts in 'real time', the needle is threaded and the camera pans away to refocus on a close-up on the upturned sole of her left foot. Slowly and carefully the woman begins to work on her foot, using the thread to form written letters onto the sole of her own foot. Eventually we are

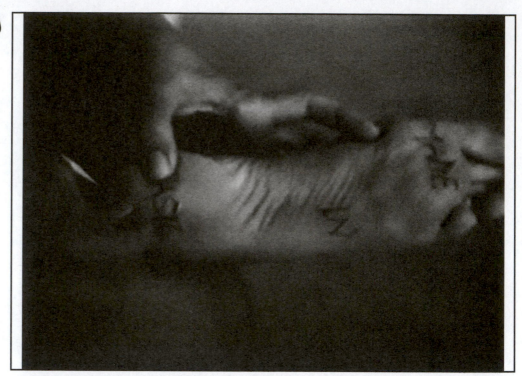

8.5: Leticia Parente, *Marca Registrada (Trademark)*, 1975. Courtesy of André Parente.

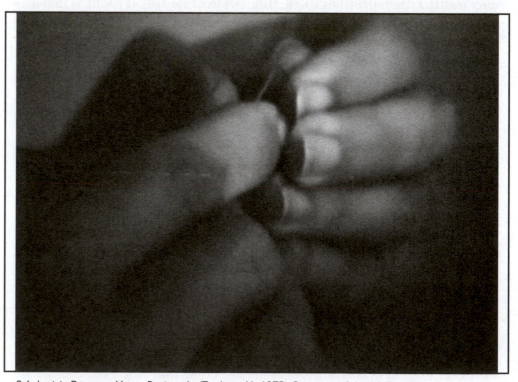

8.6: Leticia Parente, *Marca Registrada (Trademark)*, 1975. Courtesy of André Parente.

able to see that she has sewn the words 'Made in Brasil' onto the sole of her foot. As soon as she has finished, she snips the end of the thread with a small pair of scissors, stands up and moves out of frame. The tape ends.

According to her son Andre this gesture was inspired by a game played by children in the northeast region of Brazil, and is related to a theme which links to a number of her video works, for example, *In* (1975) and *Tarefa 1 (Task 1)* (1982) which centre on themes related to the reification of the individual, the oppressiveness and repetitiveness of daily household chores and the plight and position of women in Brazilian society.[13]

For Parente, video provided the means to confront tactile and visceral bodily experiences at a profound level and to combine them with an experience of the immediate surrounding environment. In relation to this aspiration, video provided an experience of time that was 'enlarged' in a way that was comparable to the ability of photography to enlarge the detail of an image: 'The technology maximises to the fullest possible extent through all access paths and all voices that provide the ability to penetrate the occurrence'.[14]

With the continuous recorded action and gesture in *Marca Registrada*, Parente sought to focus on the plight and position of the individual, her belonging. The action of sewing these words (in English) onto her foot was a statement about the individual's complex and contradictory relationship her native country: 'The trademark may resemble the branding iron … but it is also the basis for the structure over which an individual will always be constituted in his/her historicity: when standing on the sole of the foot'.[15]

In this and many of Parente's video works of the period, the deliberate objectification of her body – standing in for any woman because of the way in which she frames and records her performed activities – functions on multiple levels: as a critique of the objectification in visual art of the female body; as a critical response to the Brazilian Government's covert desire to create an ideal or model citizen; and on the notion of the individual as a passive consumer of American-made products.[16] According to Elena Shtromberg, this strategy also enabled Parente to avoid the potential censorship of her work:

> Using the body as the site for text, and ultimately as the inscribed locus for a critique of the dictatorship, is an expert manoeuvre given censorship restrictions on explicit textual critique in Brazil. Through the subversion of an everyday activity associated with women, Parente's work activates the body's polysemic condition as a site for political, social and gender critique.[17]

CONCLUSION

The early Portapak, taken up by many artists because of its ease of operation, compact portability, its combined sound and image and because it could be used by a single operator in the privacy of his/her own domestic or studio space, was often initially used to document live performances or 'body art' (see Chapter 12). Because the particular configuration of the early portable video format (½-inch open reel) made editing difficult and inaccurate, many artists worked in real time, or developed ingenious solutions to circumvent this problem, 'rescanning' or re-recording sequences to create more fluid and less fragmented videotapes. Examining and re-examining the video image and the new 'televisual space' also suited the more conceptual and philosophical reflections on the nature of language and the complex relationships between representation and meaning that were characteristic of conceptual and minimal art of the period. The ephemeral nature of the television image and video tape recordings also suited artists who wanted to challenge and critique an increasingly commodified art market. Feminist and other marginalized artists and groups were attracted to the new medium because of its lack of historical precedence and as yet unrealized potential for directly addressing alternative audiences.

9. CUTTING IT
ACCESSIBLE VIDEO EDITING

In the mid- to late 1970s, accurate video editing of low-gauge formats had become accessible to many artists. Initially a number of custom-made ½-inch editing systems had been designed, for example the 'editometre' system in use at the National Film Board of Canada in Montreal, which was adapted and widely copied by other community and artists workshops including the Fantasy Factory in London and other countries such as Australia (see Chapter 1). This system made it possible to accurately cut both sound and picture simultaneously by synchronizing two ½-inch mains machines (for example, the Sony AV 3670). In the UK Richard Monkhouse had designed 'Trigger Happy' for John Hopkins and Sue Hall, as an interface between a Sony Portapak and an AV 3670, and other similar custom-made solutions were in use in many countries. Soon after this Sony introduced the U-matic tape format (see Glossary) with editing machines such as the VO2850 and VO 2860 with dedicated automatic editing controllers (RM 400 and RM 440) which provided artists and other independent users to make nearly frame-accurate (±3 frames) edits of image and sound, and to cut picture and sound independently, a feature that, with the old ½-inch format, was nearly impossible and very haphazard. This accessible, accurate image and sound editing had a major impact on the work of many artists. Although some artists had previously been given access to sophisticated video editing systems in television broadcast facilities and workshops, the new accessible video editing systems provided by the U-matic format had an impact on existing video artists who had been using video and attracted a new generation to the potential of video as an art form. By the early 1980s many artists were accessing multi-machine editing systems with post-production effects, which enabled the mixing of images in addition to the simple 'cut'. The works discussed below all highlight the power of sound and picture montage, and contrast with the 'real-time' approach of video made by artists discussed in the previous chapter.

KEEPING MARLENE OUT OF THE PICTURE, ERIC CAMERON, CANADA, 1973–6 (BLACK-AND-WHITE, 3 MINUTES, 45 SECONDS)

Part of a series of short related works grouped under the collective title *Numb Bares*

1 (1976), which includes 1. *Behind Bars*; 2. *Between cameras A*; 3. *Pan from left to right*; 4. *Matilda, off camera*; 5. *Numb Bares A*; 6. *Breasts +2*; 7. *Cut to black*; 8. *Legs-Running*; 9. *Between cameras B*; 10. *Mary had a little lamb*; 11. *Numb bares B*; 12. *Meanwhile at Home…*; 13. *Between cameras C*; *Keeping Marlene out of the Picture*; 15. *Erasure*; 16. *Sto/ol*; 17. *Dialogue*; 18. *Ha-ha*; 19. *The End*; and 20. *Credit*.

Eric Cameron (1935, UK), trained as a painter and art historian, and began working with video in 1972, drawing on the approach to process painting he had developed over the previous decade:

> I attempted to devise a similar way of working that would allow me to manip-
> ulate the equipment of the video medium in ways that would generate sounds
> and images I had neither perceived nor anticipated in advance of viewing the
> resulting tape.[1]

Increasingly interested in Conceptual Art and the debates and theoretical ideas that were developing around it, Cameron had abandoned painting, convinced that to continue with it would only lead him to 'endless repetition'.[2] This interest in conceptualism and its discourse, combined with a fascination for a Duchampian attitude to the human body, sexuality and intimacy, led him to begin his video experiments by working with Sue Sterling, a life-drawing model at the University of Guelph. (An approach that he later noted might be construed as both 'conservative and self-consciously reactionary'.[3]) Working with a Portapak, Cameron made a recording whilst moving the camera over the model's naked body with the lens in close contact. Juxtaposing this against a second tape, a video recording of a close-up slow pan around the walls of his daughter's bedroom led to the development of an idea for a two-channel installation – one monitor representing the 'figure', the second, the 'ground'. These two tapes – *Sue* and *Bedroom* opened the way to the formulation of ideas for a number of procedurally less complex works exploring the potential of video as a medium for art, described in Cameron's 1972 essay 'Notes for Video Art (Expurgated)'. The essay outlines a number of projects and ideas for an approach to video that is both highly conceptual and ironically humorous. Among the ideas Cameron describes are throwing a video camera, still attached to the recorder via its (specially extended) umbilical cable from the observation platform of the Empire State Building in New York, the transformation of the camera into the model of a dog which is then taken for a series of 'walks', and inserting a camera equipped with a wide-angle lens into his own mouth repeatedly for the duration of the tape.

These and other projects outlined in the essay were all concerned at an important level with a particular notion of 'video time' which contrasted with the spectator's experience of time in more conventional art forms such as painting. In his essay

Cameron prescribed a set of rules and operations which included an insistence on a strict one-to-one correspondence between the duration of the recorded action and its playback, a requirement that the lens was not to be refocused during the recording session, and that the resultant works were to be displayed in an art gallery to allow the spectator freedom of movement and choice. The works outlined were also, most significantly, to contain no editing.

Subsequently however, Cameron developed notions about the editing process that suggested a procedural approach for the development of a new work – *Keeping Marlene Out of the Picture* grew directly out of this new approach.

> I decided that editing would be admissible as long as it was the total content of the tape. It would still be "imitating the processes of art" (Clement Greenberg's phrase) rather than capitulating to television.[4]

Making use of studio equipment (1-inch tape) rather than a Portapak, this work features precise control over the editing and is carefully lit and composed. Cameron has produced a number of versions of this short tape, some with more explicit sexual overtones, achieved by the rapid intercutting of the subject's (Marlene Hoff) naked body, but in the version preferred by the artist because of its 'greater psychological power', Hoff is shown fully clothed, always very briefly, either leaving or entering the frame.[5]

Keeping Marlene Out of the Picture begins with the title superimposed across the screen, which fades to reveal the corner of an interior in an institutional reception space. (The entrance foyer of the library at the University of Guelph, where Cameron was teaching at the time.) The static composition is carefully balanced – the left-hand side of the frame dominated by a large potted plant, a door in the centre of the frame, and a plastic stackable chair placed to the right. Throughout the tape, the ambient sound is subdued, the occasional footsteps and distant snippets of conversation punctuated by interruptions created by the jump cuts Cameron uses to keep his subject from crossing the frame.

There is no apparent procedural pattern to the editing structure beyond the obvious strategy to edit 'out' Marlene every time she enters the frame. Initially the cuts occur as soon as the subject enters the frame from any direction, often with only the appearance of her shadow as an indication of her approach, but increasingly the motivation for the cut seems randomized, and there are eventually shots of Marlene leaving the frame as well as entering it.

> I was certainly conscious of a kind of progression in the unfolding of the sequence of incidents throughout the piece, beginning with very slight hints,

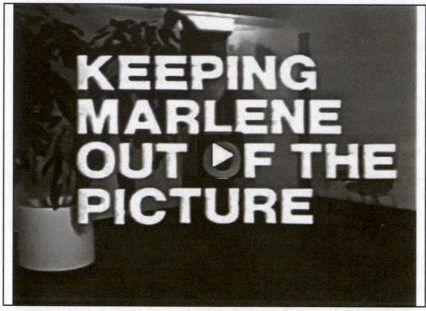

9.1: Eric Cameron, *Keeping Marlene Out of the Picture*, 1973. Courtesy of the artist.

9.2: Eric Cameron, *Keeping Marlene Out of the Picture*, 1973. Courtesy of the artist.

9.3: Eric Cameron, *Keeping Marlene Out of the Picture*, 1973. Courtesy of the artist.

shadows etc., and the going on to more emphatic incursions, but the process was poetic rather than systematic.[6]

There are also occasional repeat edits – a triple repeat when Marlene runs into the frame from the right, and a multiple repeat action of the centrally framed door opening and shutting, establishing a momentary staccato rhythm. For the most part Marlene is seen in profile or from the back, although she occasionally approaches the camera or is seated facing the screen when the plastic chair has been moved.

In the last few moments of the tape the title caption reappears, with the letter 'K' of the word '*Keeping*' tilted to the right. A figure passes through the frame (the artist?) obscuring the image, leaving just two 'O's from the title, then as a voice 'off camera' shouts 'OK', the letter 'K' reappears upside down briefly before the image cuts to white.

The subliminally sexual content of *Keeping Marlene out of the Picture* emerges out of the wider context of *Numb Bares I*. In other segments, for example *Ha-ha*,

Breasts + 2 and *Behind Bars*, this erotic theme is much more explicit. For Cameron the externalizing of content was (and is) a crucial issue in both his painting and in his video work. The final version of *Numb Bares I*, re-edited in 1997 was an attempt to reconcile form and content. Reflecting on the new video technology of the 1990s Cameron was very aware of the issues it raised within his own oeuvre, especially in terms of the shift away from the concerns of modernism towards more politically motivated content in the late 1970s by many artists working with video:

> The new machine forces the issue of subject matter in the old sense. At one time I do recall asking myself what there was in the world I cared about sufficiently deeply to allow it to become the subject matter of my art. I think it must have been about the same time, in the aftermath of Greenbergian modernism, that many other artists were asking themselves the same question and arriving at answers that had to do, in one way or another, with issues of social justice. My answer was quite different.[7]

TECHNOLOGY/TRANSFORMATION: WONDER WOMAN, DARA BIRNBAUM (USA, 1978–79, COLOUR, 5 MINUTES 25 SECONDS)

Dara Birnbaum's (1946, USA) *Technology/Transformation: Wonder Woman*, completed in 1978 and produced as part of a series of television studies, was one of the earliest video art tapes to appropriate broadcast television material as part of a critical strategy. In 1981 Birnbaum described her approach to using TV material:

> I am a pirater of popular cultural images ... choosing what is most accepted and used for portrayal. Each work's created movements of suspension/arrest call into question authorship and authenticity. I choose to reinvest in the American TV image ... in order to probe distributed senses of alienation and their subsequent levels of acceptance.[8]

Technology/Transformation: Wonder Woman uses multiple repetitions of short actions of sound and image via rapid-fire video editing techniques and a close analysis of the lyrics of the TV programme theme song (using computer graphic displays of the song lyric texts) to highlight and critique the stereotyped messages and cultural assumptions of the US television series *Wonder Woman*.

> Wonder Woman spins like a top, as she gets into her cape. Then she blocks bullets with her magic bracelets (also bumps into ineffectual men, then says in a bone-dry delivery: "We've got to stop meeting this way"). We see her robotically at work, like the title of the tape, Technology/transformation – spinning and sparking. She resembles a Wonder Woman doll abandoned by a child. She

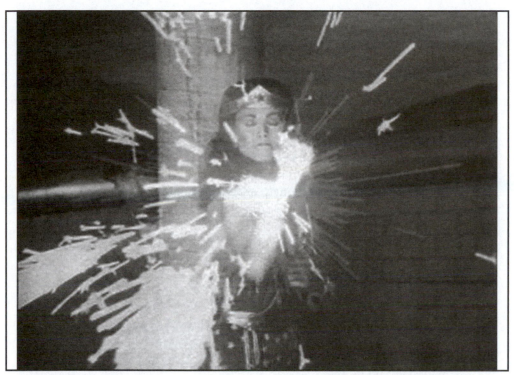

9.4: Dara Birnbaum, *Technology/Transformation: Wonder Woman*, 1979. Courtesy of Electronic Arts Intermix, EAI, New York, http://www.eai.org

keeps running without a story or a (dramatic) purpose, except the memory of old games.[9]

Birnbaum uses a simple multiple repeat-edit strategy to critique and deconstruct the fantasy TV programme, unlocking some of the assumptions behind the programme's message by highlighting and exaggerating its absurdity. The tape begins with ten fast repeat edits (both sound and picture) of a screen-filling explosion, then cuts to seven multiple repeat edits of a fragment in which the actress Linda Carter, dressed in 'civilian' clothes, is spinning before the camera in preparation for her transformation into 'Wonder Woman'. Each of these repeats includes the image of an explosion, which fills the screen area before cutting back to a repeat of the sequence. After the seventh repeat, the sequence cuts to the spinning super-heroine making her transformation. She runs across the frame from the right and past the camera to a freeze on the left of the screen, in a music and image sequence that is repeated four times. Wonder Woman (in full costume) is again shown spinning, this time in front of a

clump of trees, in a sequence that is shown seven times, with the repeated sound phrase 'Wonder Woman' from the theme song serving as punctuation. The uniformly fast pace is now broken as Wonder Woman stops spinning in front of a wall of mirrors which she approaches. She scratches the mirror surface. This action and music track is repeated three times before there is a further transformational explosion showing Wonder Woman's alter ego doing further pirouettes in front of the mirrors. This is repeated three times and then is cross-cut with a shot of the fully costumed Wonder Woman. Wonder Woman passes through the mirror, encountering one of the interchangeable (male) characters, before protecting him from a hail of flying bullets in a twice-repeated action sequence. Wonder Woman is then shown running in a rural landscape setting in a triple repeat montage, before beginning to spin once again. This is repeated ten times in a reprise of the earlier repeat cluster using the same sampled theme song fragment. The sound and image of the explosion which began the tape is now repeated twenty times before cutting to electronically generated scrolling captions (white text on a blue ground) which present the banal lyrics of the song playing on the soundtrack:

"I-I-I III"
 "I-I-I AHHH"
 "I-I-I III"
 "I AM WONDER"
 "WONDER WOMAN"
 "I AM WONDER"
 "WONDER WOMAN"
 "YEAH"
 "OHH"
 "I AM WONDER"
 "WONDER WOMAN" … etc.

Birnbaum's rapid-fire editing technique in *Technology/Transformation: Wonder Woman* entirely eliminates the narrative from the original television series, leaving only the fantasy element. This multiple repeat strategy accentuates the absurdity of the original material and questions the programme-maker's assumptions about the target audience. Birnbaum breaks the spell of the original television material by cutting away everything else from the original and exaggerating the 'magic' of the special effects. Bairnbaum's deconstructive editing technique was made possible by access to low-cost frame-accurate editing equipment that had become available during this period enabling her to appropriate a technique previously developed by experimental filmmakers such as Bruce Conner (1933–2008, USA)

in his tightly edited collages of archive film footage *A Movie* (1958) and *Cosmic Ray* (1961).[10]

This approach with its high speed re-editing and manipulation of 'off-air' and 'found' material was influential, spawning a 'genre' of political video work in the United States, the United Kingdom and elsewhere in the early 1980s, which came to be known as 'Scratch Video'. Examples of this work include a number of key works produced by George Barber (1968, Guyana) in the mid-1980s such as *Yes Frank, No Smoke* and *Absence of Satan* (both 1985). Barber, a prolific video artist who has continued to work with the medium up to the present day, was also responsible for the publication of two influential compilation tapes: *The Greatest Hits of Scratch Video, Vols. 1 and 2*, which included his own and other Scratch Video works by UK-based artists such as *Night of a 1000 Eyes* (Sandra Goldbacher and Kim Flitcroft) and *Blue Monday* by the Duvet Brothers (see below for a more detailed discussion of this work). Other significant Scratch Video works of this period include *The Commander in Chief* (1985) Gorilla Tapes/Luton 33 (Jon Dovey, Gavin Hodge and Tim Morrison); *Tory Stories* (1983) by Pete Savage; and Józef Robakowski's *Sztuka To Potega (Art is Power)* (1985) (see below).

WITH CHILD, CATHERINE ELWES, UK, 1983 (COLOUR, SOUND, 17 MINUTES, 15 SECONDS)

Catherine Elwes' videotape *With Child* presents a highly personal view of thoughts and feelings in the period leading up to childbirth. The tape builds an autobiographical narrative in which the artist's pregnant condition is given wider connotations. Elwes speaks of the conflicting and complex feelings associated with the period of her pregnancy via a series of tight close-ups and simple camera movements, employing an editing technique that at times resembles stop-motion animation. The tape makes a personally 'political' statement via the maker's own pregnancy. Elwes uses her autobiographical position as the subject and the author of the work, turning around the traditional view of women as the 'object of the gaze' and the subject of discourse. Drawing on Laura Mulvey's highly influential essay 'Visual Pleasure and Narrative Cinema' in which she argued that the 'look' of the camera in conventional narrative film was always masculine, thus perpetuating images of women as objects of male desire.[11] Elwes was also influenced by the feminist politics of the women's movement:

> Like many women artists of the time, I drew on autobiographical material and I followed the feminist principle of consciousness-raising in which women exchanged accounts of their lives and applied a wider political analysis to their personal experiences. This gave rise to the slogan "The Personal is Political" and so provided the philosophical and methodological basis of my work for many years. Video offered the perfect medium within which to explore autobiography

and manifestations of the self. The technology produced instant image feedback and could easily be used in a private space like a mirror, the images accepted or wiped according to the perceived success of the recording.[12]

Told almost completely via the close-up, the scale of *With Child* is magnified. Elwes was particularly interested in using the camera as an instrument of self-examination, whilst simultaneously preventing the viewer from getting too close. The 'tactility' of video is questioned and addressed. *With Child* somehow implied intimacy without actually allowing it:

> My tapes weren't confessional but had much more to do with the body – much more to do with a kind of self-examination – about the outside. Thinking about it – the close-up was very important. Close-ups of hands, the close-up of a leg, close-up of the breast... . Getting as close as you can possibly get... . There's a moment somewhere between abstraction ... if you're say, 5 ft away from your subject, there isn't a sense of intimacy, there's a sense that you're looking at an image of somebody... . It seems to require that the camera is an exact distance from the object – probably about 5 or 6 inches-to get that sense that you're 'there but not there', and therefore the possibility of touching what you can't touch.[13]

Through the use of intimate close-ups of her face, and of the brightly coloured but slightly tatty child's toys and clothing, and the cocooned environment of the nursery, Elwes provides us with fragmented details of the intimate and enclosed walls of her domestic life. The camera magnifies moments of her personal time and location, her confinement – the 'outside' world of the garden is only ever glimpsed at through windows.

With Child is also witty and tender, and through simple narrative devices it eloquently presents a series of complex and contradictory feelings: anxiety, anger, aggression, love, fear, sexuality, anticipation and hope, whilst also tackling a wider and more political theme:

> Elwes' work operates at a threshold where relations of power are thrown into question, in a way that would not be possible if the exercise of patriarchal power were absolute. More than that, by playing, in the instance of *With Child* with the iconography of pregnancy, she again re-centres the discourse of sexuality around the issue of femininity in a motion which is socially illegitimate. Because after all the image of a pregnant woman is no simple signifier in a visual language but a picture which, in motion, attracts narratives around it. Here is a condition which is unstable: a condition that cannot be maintained, a plenitude that reaches its fullest just at the moment of highest drama at which it must come to an end.[14]

9.5: Catherine Elwes,
With Child, 1983.
Courtesy of the artist.

9.6: Catherine Elwes,
With Child, 1983.
Courtesy of the artist.

Elwes' use of sound is especially significant and skilful. Using an editing technique that echoes her fragmented camerawork, sound is used as a form of punctuation, emphasizing her careful and precise visual juxtapositions. Elwes cuts together 'samples' of sounds: mechanical toys, clock chimes, a child's piano, a blending of mother and child's heartbeat, rainfall and wind to produce a montage evoking nostalgia and intimacy.

In *With Child*, Catherine Elwes made effective and powerful use of the then newly available Sony 'Series Five' (VO 5850/RM 440) U-matic editing suite, creatively exploiting the system's capabilities for the fast and accurate editing of sound and picture:

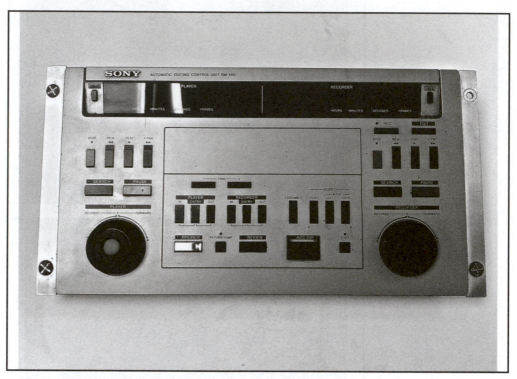

9.7: Sony RM440 edit controller, photo by the author.

Suddenly when U-matic editing came along, what it did for me personally anyway, was to unleash a natural weakness for narrative. Whereas the earlier work had related much more to performance, once I was able to edit more accurately I found myself more able to make narratives. Although there weren't any words in them, nonetheless I was aware of building narratives.[15]

BLUE MONDAY, THE DUVET BROTHERS (RIK LANDER AND PETER BOYD MACLEAN), UK, 1984 (COLOUR, SOUND, 3 MINUTES, 40 SECONDS)

Blue Monday can be clearly seen to be part of a genre of video art, influenced by the work of artists such as Dara Birnbaum, which later came to be known as 'Scratch Video'. Scratch was an early 1980s phenomenon in the UK and elsewhere, which arouse through a combination of political, ideological, technical and social forces prevalent at the time. The growth of the home video recorder was a factor in this phenomenon, as was a fascination with the television imagery that had shaped and

influenced the visual culture of the post 1960s generation. The social and political climate of the period was also an important factor, especially the decline of post-war socialism and the rise of Thatcherism.

> Some artists are now trying to make direct social comments with scratch. The Duvet Brothers for instance, cut together urban wastelands and well-fed conservative politicians. The pace is snappy and the images are well oiled by the inevitable disco soundtrack. We are left wondering whether to debate the evils of unemployment or get up and dance.[16]

As artist and academic Jeremy Welsh (1954, UK) points out, Scratch Video had two basic tendencies: the 'graphic' approach of artists such as George Barber in *Scratch Free State* (1984) and Kim Flitcroft and Sandra Goldbacher, who collaged glossy and seductive televisual imagery into new electronic realities such as *Night of 1000 Eyes* (1984), and the slightly later 'agit-prop' tendency of Gorilla Tapes/Luton 33 and the Duvet Brothers. Welsh suggests that the agit-prop branch of Scratch Video was derived from community video rather than from the art school, drawing on powerful image sources such as the Thatcher/Regan alliance against the background of the political and social unrest in the period 1984–5.[17]

Blue Monday by Rik Lander (1960, UK) and Peter Boyd MacLean (1960, UK) known collectively as the Duvet Brothers, juxtaposes images of affluence, privilege and prosperity (e.g. men in top hats, school boys attending Eton, a man lighting a cigar with a five-pound note, the Royal family, etc.) against images of fascism: Oswald Mosley and the 'black shirts', police fighting with protesters at a political demonstration, etc. This is followed by a full screen text graphic: 'Rich Get Richer … Poor Get Poorer' rapidly cut to a music track by the pop group 'New Order'. This sequence is followed by images of a surgeon working in an operating theatre with the superimposed caption: 'Private'. This text/image superimposition is keyed onto a tracking shot of an over-crowded graveyard, panning across countless tombstones. A shot of the Russian Red Army on parade in full uniform intercut with images of the police manhandling striking protesters swiftly follows. This image of the marching soldiers continues, digitally compressed and framed into a square in the bottom right of frame. All of this imagery is edited together seamlessly, with skilled use of slow motion, image mixing and graphic effects to aid the montage, all cut to the beat of the music track.

The first words of the lyrics come in: 'How does it feel, to treat me like you do?', and we are shown images of smug Tory party leaders assembled together during a conference: Michael Heseltine, smirking and chewing gum; a sinister-looking Margaret Thatcher, shot from a low camera angle. This is followed up by a panning

shot of the whole party, looking complacent and bored as the wrecker's ball smashes yet another building and an isolated individual walks across the expanse of an urban wasteland.

Images of social unrest, civil action and mass protest are juxtaposed with images of authority and control; the police, heavy-duty military hardware, missiles, fighter planes, submarines, explosions – images of social control, military dictatorship and wasteful destruction. The tape ends with a return to the image of the man burning the five pound note.

The skilful deployment and montaging of 'found' images; the collision of text and graphics; the creation of meaning via the intercutting of images from diverse sources, have much in common with photomontage techniques developed by the Dadaists and Constructivists and employed for propaganda and political purposes in the early twentieth century by John Heartfield (1891–968, Germany), El Lissitzky (1890–941, USSR) and Aleksandr Rodchenko (1891–956, USSR) among others. However, the Duvet Brothers' output is ambiguous, as they produced tapes that spanned both sub-divisions of the Scratch genre. It could be said that the work is less about politics and more about the pleasure of manipulating images and sounds. *Blue Monday* is appealing because of its rhythmic montage and rapid pace, and it is likely that the rather heavy-handed political message was less important to the nightclub audience than the relentless movement of its highly orchestrated imagery. The tape has immediacy and an accessibility that enabled it and similar work to reach a wide audience. But the appeal of Scratch Video was also its limitation. Inevitably the broadcast media, hungry for new forms and styles – especially those with an immediate appeal and a populist approach, quickly absorbed the new style. As Jeremy Welsh observed, 'Once the 'otherness' disappeared, much of the radical potential went with it'.[18]

DER WESTEN LEBT [THE WESTERN LIVES], KLAUS VOM BRUCH AND HEIKE MELBA-FENDEL, GERMANY, 1983
(COLOUR, SOUND, 4 MINUTES AND 15 SECONDS)

In his essay 'Logic to the Benefit of Movement' Klaus vom Bruch (1952, Germany) sets out his attitude to mainstream broadcast TV and video technology and its potential as a medium for art. Committed to the notion that video is not synonymous with broadcast television, offering viewers a potential alternative views of life and ideas, vom Bruch sets out his own manifesto for artists working with video and their audiences, although it is not without his characteristic irony:

> Not everything that flickers is television. The monitor is mainly used to observe and control. It protects the social order. Whenever one does not want others

9.8: Klaus vom Bruch and Heike Melba-Fendel, *Der Westen Lebt*, 1983. Courtesy of Electronic Arts Intermix (EIA), New York http://www.eai.org

to come too close, it ensures that they keep their distance. On its familiar dull screen, people and things turn into objects. In this aquarium of unilateral use, the video artist swims from drop out to drop out. He uses his work to set himself apart from the slick diet of information and entertainment offered by the large public catering establishments. Instead of boring the viewers with a facade of starched gentlemen in pin-stripes or of entertaining them with scenes of catastrophes and quiz games, video artists (male and female) make statements. They take themselves and the conditions under which they live seriously, their statements are identical. The reception of a videotape is still based on the product of hours of work times hourly wage. This eventually leads to impatience and aggression.[19]

Vom Bruch's videotape *Der Westen Lebt (The Western Lives)* has much in common with his other work of the same period. Made in collaboration with Heike Melba-Fendel (1961, Germany) the tape draws on imagery and sound from the popular cinema and

slyly critiques accepted notions of technology and filmic propaganda. The carefully collaged imagery and sound of this work deliberately masks a satirical intent. As vom Bruch says ironically at the start of his essay: 'With a video camera in my hand, I work with good humour and assurance'.[20]

Der Westen Lebt combines a relentlessly repeating loop of a close-up image of the driving wheels and piston of a steam locomotive at speed with a flickering image of a playfully kissing couple (vom Bruch and Melba-Fendel). The driving rhythm of the repetitive images and the insistent pulse of the soundtrack, combine with the imagery to produce an erotic charge to the piece.

The tape begins with computer-generated titles. The captions with the artists' names are displayed in green against a black background and are followed by a brief close-up of an oscilloscope display visualizing the hissing noise of the soundtrack in a colour matching that of the text captions. The train wheel image fragment is cut in immediately, quickly establishing a forceful repetitive rhythm both visually and via the accompanying beat of the soundtrack. Several beats later the keyed and flickering image of the couple is introduced. These two distinctly different images are merged using an image keying technique (chroma-key?) and arranged so that the woman's head and face are framed by the train wheel and the steam from the pistons creates a kind of aura around the couple whilst also emphasizing the driving beat of the both the train mechanism and the mechanics of the editing process. A second repeating beat is added to the first and they set up an alternating pattern that increases the tempo and implies a level of erotic power. Approximately halfway through the tapes' duration, an additional visual element is also introduced, and a close-up of Melba-Fendel's head titling first up and down and then moving from side to side is combined with the other elements. This insistent and forceful energy is maintained for approximately four minutes and then as suddenly as it began the tape ends, fading rapidly to black and to silence.

This tape extends Klaus vom Bruch's fascination with the video and technology, ironically casting himself as hero. In works such as *Propellerband* (1979) and *Das Allierstenband* (1982) vom Bruch depicts himself as both hero and creator, juxtaposing and endlessly repeating images culled from cinema archives and war movies in a mock celebration of technology and the filmic depiction of conflict and war. For vom Bruch there is a crucial relationship between the erotic power of narrative cinema, technology and the machines of death and destruction.

> In *Der Westen Lebt* vom Bruch accentuates his outpouring of filmographic affection. … vom Bruch himself takes the place of Brando and all other cinematic heroes. The roar of the locomotive is a simulated sound edit of a fragmented

tap dance by Fred Astaire (!) The mechanical monster's power of movement is prolonged in the violence with which vom Bruch declares his passion. More than ever, vom Bruch ladens us with pathos, leaving logos and ethos behind him, among the ruins and the dead. The "Western" lives, but for how long?[21]

SZTUKA TO POTEGA [ART IS POWER]: JOSEF ROBAKOWSKI, POLAND, 1984–5 (9:10 MINUTES, MONOCHROME, SOUND, MUSIC: LAIBACH, LEBEN HEIβT LEBEN)

Josef Robakowski's dramatic videotape *Sztuka To Potega (Art is Power)* is set to a music track by the Slovenian avant-garde music group Laibach, known for their subversive cover versions of songs made popular by other groups. *Leben Heißt Leben* is Laibach's version of the pop anthem *Life is Life* originally written and performed by the Austrian rock band Opus. Laibach's interpretation of *Life is Life*, sung in German, has been arranged as a powerful and menacing military march.

The tape begins with a medium shot of a number of large military transporters hauling large and deadly looking missiles, slowly crossing the frame from left to right in a halting but relentless slow motion. The images are grainy monochrome, and have been rescanned – clearly copied from a television broadcast of a military parade – in a show of strength and power. After approximately one minute the image cuts to a tightly framed medium close-up of uniformed army officers, their eyes right as they pass before the camera. The image presents both the individuality of each face, and their uniformity – each face determined and intent. The rhythm and pace of the soundtrack has been matched to the inexorable movement and flow of the procession. The camera zooms into the screen and onto an individual face, increasing the visual screen texture and pattern of the video raster. As the procession of men surges forward, and each individual face passes through the frame, the swaying motion of the marching soldiers is enhanced by the camera perspective, which slowly zooms out again to reveal the lines of men in formation. The scene is cut to the front of the procession showing a group of three officers saluting, followed by flag bearers and ordered ranks of sailors, their arms swinging in unison, the high arc of their gloved hands blurring against the dark tones of their uniforms. The image is of a sea of men, many lines deep, marching in time to the relentless beat of the soundtrack music. The text 'SZTUKA TO POTEGA' (Art is Power) is superimposed in white letters in the centre of the lower section of the screen and held for approx 20 seconds, as the marching soldiers continue in close-up to cross the screen, their exaggerated arm movements marking the pace of their marching. A line of high-ranking officers are shown saluting and pass through the frame followed by another huge phalanx of soldiers in formation as the music track reaches a crescendo with a mix of guitar, voices and organ chords.

9.9: Josef Robakowski, *Sztuka To Potega (Art is Power)*, 1984–5. Courtesy of the artist.

A new angle is introduced at this point, and the image shows a car containing a single saluting soldier leading a large formation of marching troops at normal speed, closely followed by a change of pace in the music and close-up shots of a marching band, drummers, musicians and soldiers at quick pace as the tempo of the music increases. The rescanned image has been replaced with normal resolution footage as the parade is shown massing into groups and the image cuts to a wide-angle shot. This more distant view is maintained as images of light tanks driving in formation are presented, occasionally mixed with superimposed portraits of individual military heroes overlaid onto the moving rows of men and machinery. This relentless visual barrage of military hardware and manpower continues to build against the assertive declarations of the song lyrics; 'I'm flesh, I'm blood', etc.: the musical build-up synchronized to the final visual montage of rockets, missiles and weapons of power and destruction, as the music fades out and the images fade to black.

The source images for Robakowski's powerful critique of this display of military might and aggression are very clearly culled from televised footage of the annual May

Day parades in Moscow's Red Square at the height of the Cold War. It is important to note that when the work was made Poland was still under communist rule, and had only recently emerged from a period of martial law (1981–3), in which the owning of cameras by private citizens was prohibited. Many Polish artists and filmmakers continued to work, but were forced underground, unable to exhibit in public galleries and venues.

Sztuka To Potega (Art is Power) is clearly intended to be subversive. In common with work by the UK-based scratch artists such as the Duvet Brothers and Guerrilla Tapes, Robakowski has re-appropriated broadcast television material, shifting the originally intended messages and meanings to create a powerful and critical political statement. However, this approach to engaging in the making of subversive works in film and video was not new to Robakowski, and his involvement with politically critical experimental film and video can be traced back to his involvement with the Zero-61 group in the late 1960s and his co-founding of the Film Form Workshop at the film school in Lodz in 1970[22] (see Chapter 2). The group's manifesto declared its intention to 'make films, recordings, TV broadcasts, radio programmes, art exhibitions, various art events and interventions … and also engage in theoretical research and critical activity. To explore and expand the potential of audio-visual arts'.[23]

Sztuka To Potega (Art is Power) is also part of a larger personal project – a body of work in both film and video entitled 'My Very Own Cinema' which Robakowski has described as 'Something I'm working on when nothing is working out … a way of remembering myself, of recording my state of mind and my gestures and the powerful emotional states that have accompanied real life'.[24] For Robakowski this project is centred on the development of a new form of moving image that is very closely related to the development of video and its potential for a cinema of the personal based on the intimate, and this is bound up with the technological development of portable video recording equipment in the 1970s and beyond. In his 1976 essay 'Video Art: A Chance to Approach Reality', Robakowski argued for the potential of video as an artistic movement with the power to undermine the institution of broadcast TV: 'laying bare the mechanisms of manipulating other people and pressuring them by telling them how to live'.[25]

Sztuka To Potega (Art is Power) is an exposé of the totalitarian regime in power during the 1980s in Poland, and a conceptual exploration of the video medium and its relationship to state television, as well as part of Robakowski's larger keen project to explore the potential of video as an art form.

CONCLUSION

As it became technically possible to electronically edit video and sound sequences with some degree of accuracy, artists such as Eric Cameron who had initially explored the potential of video in 'real-time' recordings decided it was time to break the artistic taboo. The potential of video as a medium to explore, subvert, critique and deconstruct the messages and conventions of broadcast television and narrative was a crucial issue in the 1970s and 1980s. Just as it was fundamental to subversive and politically active artists such as Jozef Robakowski, it was also attractive to feminist artists such as Catherine Elwes and Dara Birnbaum who were interested in contributing to the postmodernist resistance that the new medium heralded. Because of its flexibility, versatility and increasing ubiquity, it provided a channel for the expression and presentation of alternative viewpoints and the subversion of traditional representations.

Video artists such as Klaus vom Bruch in Germany, Dara Birnbaum in the USA and the Duvet Brothers in the UK quickly began to exploit the power of the medium to appropriate and manipulate images and meaning with fast accurate editing that became more freely available by the early 1980s. These artists were not working with basic editing tools available to community and low-budget video producers, but accessed 'state-of-the-art' independent facilities that were proliferating at the time to service a new independent broadcast sector that was opening up in the USA and Europe. Technical advances were not just being made at the 'bottom end' of the market: the new industrial/professional formats such as 'hi-Band' U-matic, and 'Betacam' were now viable for broadcast. Rik Lander of the Duvet Brothers for example, worked as an editor at Diverse Production in London, accessing the facilities after hours for his own work.

Access to sophisticated and accurate editing facilities often also provided additional benefits, as post-production suites also increasingly offered the opportunity to manipulate and adjust the image itself, as we will see in the following chapter.

eorge Barber, *Tilt,* 1984, Courtesy of the artist.

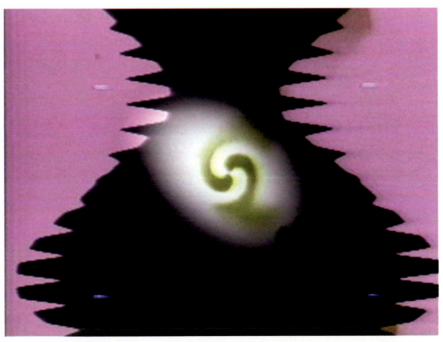

Steven Beck, *Illuminated Music,* 1972–3. Courtesy of Electronic Arts Intermix (EIA), New York. http://www.eia.org

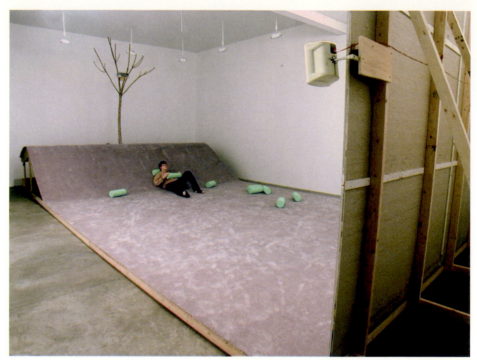

Guy Ben-Ner, *Wild Boy*, 2004. Courtesy of the artist.

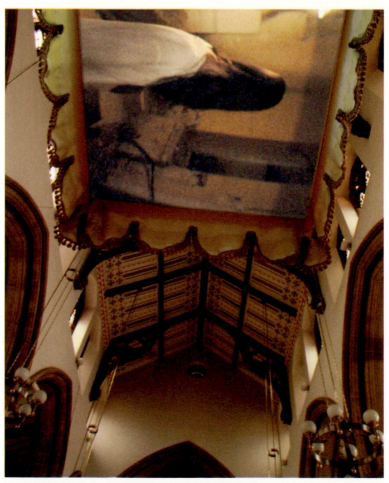

Vince Briffa, *Playing God*, 2008. Courtesy of the artist.

Robert Cahen, *Juste le Temps*, 1983. Courtesy of the artist.

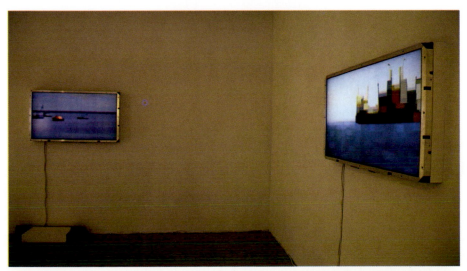

Peter Campus, *Passage at Bellport Harbor*, 2010 and *Fishing Boats at Shinnecock Bay*, 2010. Courtesy of the artist.

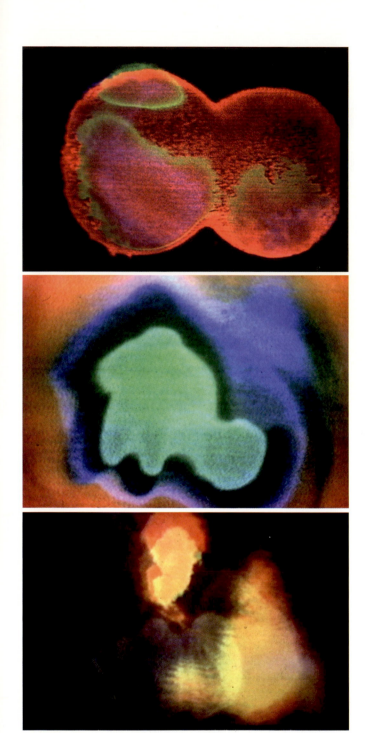

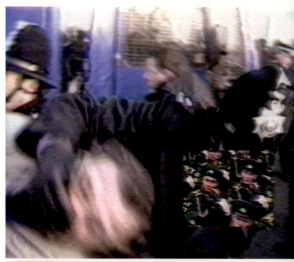

Peter Donebauer, *Merging-Emerging*, 1978. Courtesy of the artist.

Duvet Brothers, Blue Monday, 1984, Courtesy of the artist.

Terry Flaxton, *In Re Ansel Adams*, 2008. Courtesy of the artist.

Clive Gilllman, *NLV1*, 1990. Courtesy of the artist.

David Hall, *A Situation Envisaged, the Rite 2*, 1988–90. Courtesy of the artist.

Judith Goddard, *Television Circle*, 1987. Courtesy of the artist

Steve Hawley, *Trout Descending a Staircase*, 1990. Courtesy of the artist.

Stephen Jones, *Stonehenge*, 1978. Courtesy of the artist.

Malcolm le Grice, *Even Cyclops Pays the Ferryman*, 1998. Courtesy of the artist.

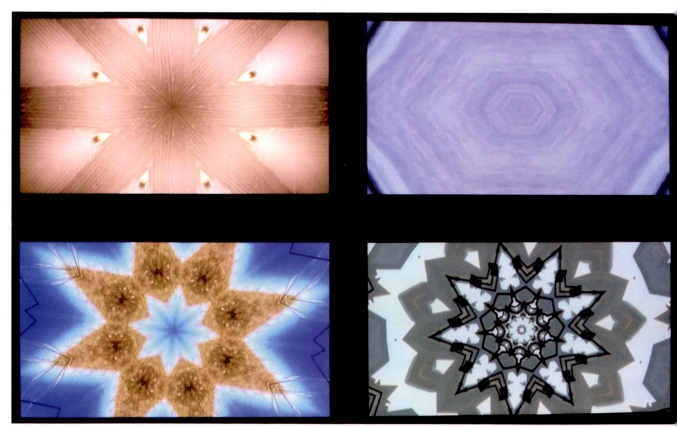

Mary Lucier, *Four Mandalas*, 2009. Courtesy of the artist.

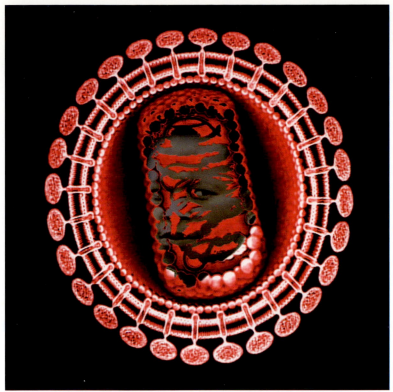

Churchill Madikida, *Virus*, 2005. Courtesy of the artist.

Chris Meigh-Andrews, *For William Henry Fox Talbot (the Pencil of Nature)*, 2002. Courtesy of the artist.

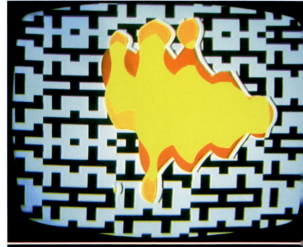

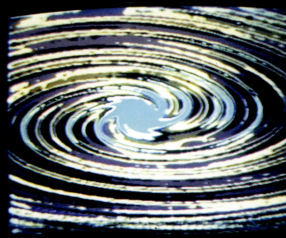

Chris Meigh-Andrews, *Sunbeam,* 2011. Courtesy of the artist.

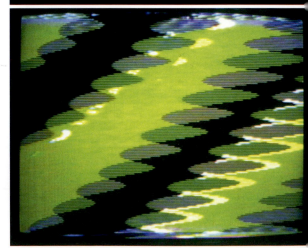

Richard Monkhouse, *Images produced by the EMS Spectron,* 1977. Courtesy of the artist.

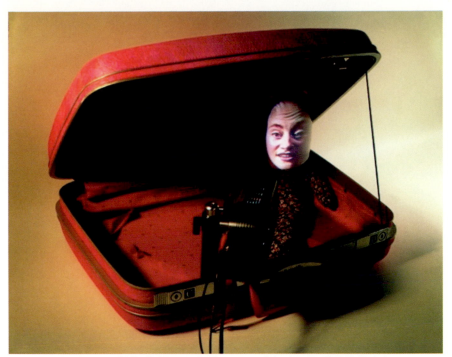

Tony Oursler, *Escort*, 1997. Courtesy of the artist and the Lisson Gallery, London.

Nam June Paik, *Zen for TV*, 1961. Courtesy of Carl Solway Gallery, Cincinnati, OH

Jacques Perconte, *Impressions-Infinite*, 2010. Courtesy of the artist.

Peter Callas, *Night's High Noon*, 1988. Courtesy of the artist.

Dan Reeves, *Obsessive Becoming*, 1995. Courtesy of the artist.

Dan Sandin: *Live performance at Electronic Visualization Event 3*, 1978. Courtesy of the artist.

Eric Siegel, *Einstine*, 1968. Courtesy of Electronic Arts Intermix (EIA), New York, http://www.eia.org

Steina, *Summer Salt*, 1982, Courtesy of the artist.

Studio Azzurro, *Il Natatore*, 1984. Courtesy of the artist.

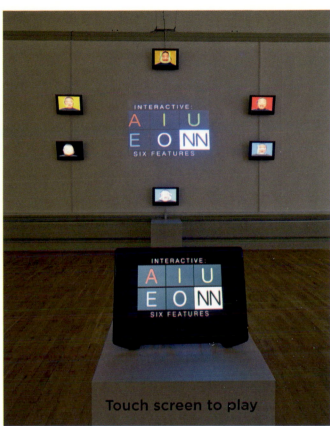

Takahiko Iimura, *Interactive AIUEONN*, installation at Harris Museum & Art Gallery, Preston for Digital Aesthetic 2012. Courtesy of the artist. Photograph © Simon Critchley.

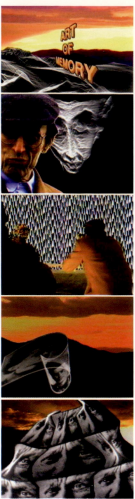

Woody Vasulka, *Art of Memory*, 1987. Courtesy of the artist.

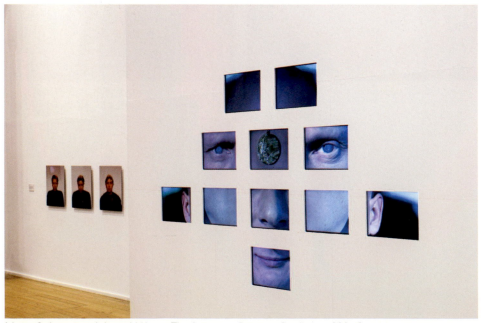

Marty St James and Anne Wilson, *The Swimmer, Duncan Goodhew*, 1990. Courtesy of the artists.

10. MIXING IT
ELECTRONIC/DIGITAL IMAGE MANIPULATION

In parallel to the development of new editing tools, video artists explored the potential of video technology to enable the mixing, transformation and manipulation of the video signal. Video, like audio, is an electronic signal that can be altered and transformed. Infinitely malleable, it can be amplified, distorted, colourized, mixed and multiplied. As has been discussed in Chapter 7, some artists were particularly interested in the potential of video as an abstract form, whilst others preferred to explore its qualities as a medium for the representation of the visible world, but many artists of both persuasions were interested in the fluid nature of the medium and its infinitely flexible signal. As new video-imaging tools and techniques were developed, artists explored the possibilities and expressive implications of the medium. This section discusses a few examples of works in this complex area made by artists who are also discussed elsewhere in this book.

MONUMENT, TURE SJÖLANDER AND LARS WECK (WITH BENGT MODIN), SWEDEN, 1967 (BLACK-AND-WHITE, SOUND, 10 MINUTES. COMMISSIONED AND BROADCAST BY NATIONAL SWEDISH TV, 1968)

Monument, characterized by Ture Sjölander (1937, Sweden) as a series of 'electronic paintings' is a free-flowing collage of electronically distorted and transformed iconic media images. Set to a similarly improvised jazz and sound effects track, images of pop stars, political and historical celebrities and media personalities, culled from archive film footage and photographic stills have been electronically manipulated – stretched, skewed, exploded, rippled and rotated. The relentless flow of semi-abstracted monochromatic faces and associated sounds seems to both celebrate and satirize the contemporary visual culture of the time. In its fluid mix of visual information it generalizes the television medium, draining it of its specific content and momentary significance. It creates a kind of 'monument' to the ephemeral – all this will pass, as it is passing before you now.

Archive film footage and photographic stills of iconic faces and people – Lennon and McCartney, Chaplin, Hitler, the *Mona Lisa* – the 'monuments' of world culture, flicker and flash, stretch and ooze across the television screen. In some moments the television medium is itself directly referenced, the familiar screen shape presented

10.1: Ture Sjölander and Lars Weck, *Monument*, 1967. Courtesy of the artists.

and rescanned, images of video feedback, and at one point its vertical roll out of adjustment – anticipating Joan Jonas' seminal tape (see Chapter 8) although for very different purposes. The work anticipated a number of later videotapes, particularly the distorted iconic images of Nam June Paik. Gene Youngblood described the psychological power and effect of these transformations in his influential and visionary book *Expanded Cinema*:

> Images undergo transformations at first subtle, like respiration, then increasingly violent until little remains of the original icon. In this process, the images pass through thousands of stages of semi-cohesion, making the viewer constantly aware of his orientation to the picture. The transformations occur slowly and with great speed, erasing perspectives, crossing psychological barriers. A figure might stretch like silly putty or become rippled in a liquid universe. Harsh bas-relief effects accentuate physical dimensions with great subtlety, so that one eye or ear might appear slightly unnatural. And finally the image disintegrates into a constellation of shimmering video phosphors.

Sjölander and his collaborators at Sveriges Radio (The Swedish Broadcasting Company) in Stockholm had worked together on a number of related projects since the mid-1960s, beginning with *The Role of Photography*, his first experiment with electronic manipulations of the broadcast image in 1965. This project was followed with the broadcast of *Time* (1966), a 30-minute transmission of 'electronic paintings' produced using the same temporarily configured video image synthesizer that was later used to create *Monument*.

The system that Sjölander and his colleagues used involved the transfer of photographic images (film footage and transparencies) to videotape using a 'flying spot' telecine machine (see Glossary). This process produced electronic images that they transformed and manipulated by applying square and sine signals with a waveform generator during the transfer stage, often using this process repeatedly to apply greater levels of transformation (see also Chapter 7).

For Sjölander and his collaborator Lars Weck (1938, Sweden), the broadcasting of *Monument* was the epicentre of an extended communication experiment in electronic image making reaching out to an audience of millions. Kristian Romare, writing in the book published as part of an extended series of artworks which included publishing, posters, record covers and paintings after the broadcasting of *Monument*, describes the scope of Sjölander and Weck's vision and aspirations for the new image-generating technique they had pioneered:

> Here they have manipulated the electronic manipulations of the telecine and the identifications triggered in us by well-known faces, our monuments. They are focal points. Every translation influences our perception. In our vision the optical image is rectified by inversion. The electronic translation represented by the television image contains numerous deformations, which the technicians with their instruments and the viewers by adjusting their sets usually collaborate in rendering unnoticeable. Monument makes these visible, sues them as instruments, renders the television image itself visible in a new way. And suddenly there is an image generator, which fully exploited – would be able to fill galleries and supply entire pattern factories with fantastic visual abstractions and ornaments. Utterly beyond human imagination.[1]

Monument was broadcast to a potential audience of over 150 million people in France, Italy, Sweden, Germany and Switzerland in 1968 as well as later in the USA. Subsequently Sjölander produced *A Space in the Brain* (1969) based on images provided by NASA, extending his pioneering electronic imaging television work to include the manipulation and distortion of colour video imagery. *A Space in the Brain*

was an attempt to deal with notions of space, both the inner world of the brain and the new televisual space created by electronic imaging.

Sjölander, originally a painter and photographer, had become increasingly dissatisfied with conventional representation as a language of communication and began experimenting with the manipulation of photographic images using graphic and chemical means. For Sjölander, broadcast television represented a truly contemporary communication medium that should be adopted as soon as possible by artists – a fluid transformation and constant stream of ideas within the reach of millions. The televised electronic images Sjölander and his collaborators produced with *Time, Monument* and *Space in the Brain* were further extended via other means. The television system was exploited as a generator of imagery for further distribution processes including silkscreen printing, posters, record covers, books and paintings that were widely distributed and reproduced, although ironically signed and numbered as if in limited editions.

MERGING-EMERGING, PETER DONEBAUER, UK, 1978 (COLOUR, SOUND, 14 MINUTES). MUSIC COMPOSED BY SIMON DESORGHER. FUNDED BY THE BRITISH FILM INSTITUTE)

Merging-Emerging is the first of Peter Donebauer's tapes made using the Videokalos Image Processor (IMP) (see Chapter 7). Recorded 'live' and mastered on 2-inch videotape (broadcast standard) with no subsequent editing, it is the 'best take' of a 'real-time' recording of a collaborative performance.

Merging-Emerging is the videotaped record of an interaction between Donebauer (working with three video cameras, the Videokalos IMP, and a live video feedback loop), two dancers (male and female) and two musicians (playing flute, violin and electronics). Donebauer organized his electronic modifications of the colour and form of the video images to be displayed live, enabling the performers (musicians, video artist and dancers) to respond to each other's actions and adapt their own contributions accordingly. The working procedure included an opportunity for the collaborators to discuss the thematic approach prior to the recording session, with Donebauer suggesting an overall treatment, which was then elaborated by the participants. This allowed considerable scope for improvisation and interpretation, both prior to and during the recording sessions, and the working procedure allowed for and encouraged developments and revisions, similar to the way that jazz musicians often collaborate. The instant playback and live image relay of video made this feasible. Parallels to live music and theatre improvisations are obvious, but the additional element of live video image processing allows for the development of previously unexplored non-narrative and time-image-movement relationships.

Donebauer, interested in exploring relationships between technological media and

larger more 'natural' and elemental forces, felt that working with video gave him a new way of approaching abstract themes:

> ... the medium allowed a very fast exploration of abstract forms. By manipulating this technology to obtain feedback in certain ways, you created these forms which were recognizable. This was a form which could be used to create nature itself – eddies of water, gasses or astronomical forms. You recognize those forms either because you've seen them before through scientific imagery, or because you recognize them in nature – in the whirls of a shell or something. Or perhaps they are strong, symbolic archetypes – certain shapes which touch deeply inside our past consciousness.
>
> ... My particular interest was in the exploration of consciousness and archetypal forms. Video was a very fast way to do it. Other mediums had explored it – photography for example. I think it was the fact that video was obviously an unexplored form. A new technology had allowed a new form to emerge.[2]

Merging-Emerging is the first of Donebauer's tapes to incorporate representational imagery. The title of the work refers to the emergence of the human form, initially unrecognizable but gradually emerging through the quality and nature of the movement, and finally through the slowly shifting focus of the cameras. Donebauer has often used defocused cameras in his work, a technique he found liberating.

> One day when I was working in the studio at the Royal College, the cameras lost focus. I was transfixed. My whole world was changed – I never shot anything in focus ever again! When the cameras are severely out of focus, it creates a wonderful immediate form of abstraction. All these devices are so controlled to provide an accurate reproduction of what's in front of them, suddenly to have that thrown off gives a huge burst of inspiration.[3]

The initial image of the tape is of video feedback (see Chapter 12) a formal device unique to live electronics which Donebauer considered fundamental to his approach, representative of the self-reflexive nature of video and an expression of the energies and forces at work at both the micro and the macro scales in nature.

The tape has a simple unifying structure, with the collaborative performers working to present a gradually unfolding process, the emergence of the constituent visual (video), musical (acoustic) and choreographic (movement) elements that constitute the piece. All three of these disciplines require a structure derived from pacing, and in this work the pace is the unifying feature, as the interrelationship between the chromatic and compositional changes, the choreographic movements and the musical

tempi form the core of the experience when watching the tape. Thus the interaction between the collaborative elements is at the core of the work.

In this tape Donebauer worked predominantly with primary colours – reds, blues and greens, using the electronic colour palette and soft-focused 'abstracted' forms in place of the traditional perspectival depth that is the norm of conventional televisual space. Throughout the tape, the experience is of a slowly evolving relationship between colour, form, movement and sound – there is a development towards representation from abstraction and then back again to abstraction, although Donebauer claims it is not so much 'abstraction', as an attempt to represent primal universal energy in moving visual terms.

For Donebauer, the tape also explores notions about the complex interrelationships between male and female:

> [Merging-Emerging] … depicts the emergence of human form from an unformed primal energy mass. The content of the tape thus refers to the relationship of male and female energies to larger cosmic energies of which they are part.[4]

THE REFLECTING POOL, BILL VIOLA, USA, 1977–9 (COLOUR, SOUND, 7 MINUTES)

The Reflecting Pool is the first tape in a set of works grouped under the generic title, *The Reflecting Pool – Collected Work 1977–80*. The full list of the works in this series is: *The Reflecting Pool* (1977–9) 7:00 minutes; *Moonblood* (1977–9) 12:48 minutes; *Silent Life* (1979) 13:14 minutes; *Ancient of Days* (1979–81) 12:21 minutes; *Vegetable Memory* (1978–80) 15:13 minutes. These were produced in association with WNET/Thirteen Television Laboratory, New York and WXXI-TV Artists' Television Workshop, Rochester New York.

Completed in 1979, *The Reflecting Pool* marks a change from Viola's earlier more formal approach to single-screen video work. This tape is more concerned with the visionary – with themes of transcendence and spirituality. In works made in the period before this such as *Migration, The Space Between the Teeth* (both 1976) and *Sweet Light* (1977) Viola considered his approach to be 'structural', in that they were more directly concerned with the video medium – with an emphasis on an exploration of the medium's scope and inherent properties.

> My work up until then had been about learning to play the instrument. That's also the history of video. A lot of early work is difficult to look at; you are essentially watching someone learning their scales.[5]

In the period between 1977 and 1979 Viola became increasingly interested in visionary and mystical literature, in particular the writings of William Blake, P. D.

Ouspensky, Jalal al-Din Rumi and Lao Tzu.[6] Concurrent with this period of research Viola developed notions about video as a medium with which it was possible to express ideas about the 'invisible', or perhaps more accurately that video could be used to bridge the gap between visible phenomena and the forces of energy behind them.

Viola's interest in these invisible forces led him to seek ways to use video – a medium seen by many to epitomize the literal. (It is, after all, the preferred medium for news and documentary, and the medium of surveillance.) It is this paradoxical aspect that Viola sought to exploit – even making use of the traditionally 'authentic' device of the fixed camera, symbolic of the unbiased and unmanipulated 'neutral observer'. In an interview with the art historian Jorg Zutter, Viola identified his use of the static camera fixed to observe and record 'fields' rather than 'views'. In this approach to the use of the video camera he cites the influence of the acoustic properties of the interiors of Italian medieval cathedrals and churches that he frequented when he was technical director of Art /Tapes/22 in Florence.

> I felt that I had recognized a vital link between the unseen and the seen, between an abstract, inner phenomenon and the outer material world. I began to use my camera as a kind of visual microphone ... I realized that it was all interior. I started to see everything as a field.[7]

Viola, writing about video in that period paraphrased Nam June Paik: '[video] is a form of communication with the self via a responsive machine'.[8] The 'responsive machine' of video includes, for Viola, a wide range of electronic image techniques specifically associated with the medium: slow motion and high-speed photography, image intensification, superimposition, low-light video, freeze-frame, keying, etc.

In *The Reflecting Pool* the external world is presented initially with an 'authentic' static framing. The viewer sees a low-resolution video image of a dark pool of water set in a forest clearing, green trees reflected on its shimmering surface. The video frame is divided roughly in half, the reflecting pool, which is bounded by manmade straight edges, occupying the bottom portion of the frame. The soundtrack is another of Viola's 'fields' – ambient forest sounds, birdsong, and wind, but predominantly flowing water – presumably from a nearby stream 'off camera'.

A clothed male figure (Viola?) emerges from the forest, approaches the undulating pond and stands poised at the waters edge in the centre of the frame peering down into the pool. His figure is reflected on the water's surface, the combined image of the figure and his reflection bisecting the frame and producing a vertical axis. The image is completely symmetrical, divided horizontally by the pool's edge, and vertically by the figure and his reflection. The man hesitates, wavering in indecision, but

clearly contemplating action, for approximately 45 seconds before leaping forward and up into a crouching position exclaiming loudly as he does so. At this point the image freezes, and the viewer is aware for the first time that the image is not 'authentic', and that some form of 'special effects' have been employed. Not only does the frame freeze in a standard and predictable 'video effect' treatment, but also more surprisingly, the surface of the water in the pool continues to move. There is a slightly perceptible 'jump' in the image frame (the entire image shifts slightly to the right), but it appears that the crouching figure is frozen mid-air in the centre of the screen whilst the rest of the sequence continues to move forward in time. The changes are now all within the framed area of the pool, bounded on all sides by its manmade borders. The colour and light level of the pool slowly shifts, the water initially darkening before becoming calmer and lighter, reflecting more of the surrounding forest. A small stone is thrown into the pond 'off camera' (not spatially off camera, but temporally – as the pond sequence is repeatedly 'cut to' after the stone hits the water, so that the ripples are seen to form without apparent cause). This ripple sequence is repeated three times, each time allowing the water to settle before the repeat. The reflection of another figure is seen, but no corresponding 'real' figure is in evidence. The reflected figure walks along the edge of the pond which horizontally bisects the frame and walks 'off -camera' to the right of the frame.

Throughout this portion of the tape, the crouching figure of the diver gradually and imperceptibly fades into the background, the colours of his clothing subtly blending into the forest behind. There is a larger splash in the pool, again without an apparent source for the disturbance, followed by a brief sound off camera (the crunch of a footstep?) Next, a pair of reflected figures (male and female?) walk along the edge of the pool from the right, crossing the vertical axis of the frame. One follows the other until they stand together in the left-hand corner of the pool briefly, and then fade as the reflecting pool becomes brighter and greener. The water is now revealed to be in reverse motion as ripples converge before coalescing into a momentary disturbance which is abruptly cut to an image of the water at night, revealing a single lit figure reflected in the black void. This bright reflection then moves across right, out of frame. The daylight colour of the pool returns and the soundtrack changes to include a pulsating sound from 'off camera'. A submerged swimmer suddenly emerges from the water near to the centre of the frame. This naked male figure climbs out of the pool and stands momentarily on the edge of the pool centre frame with his back to the camera, and then disappears into the forest, his movement edited so that he fades out and reappears further from the frame. Fade to black.

In *The Reflecting Pool* video technology is used to present an almost mystical

transformation of energy. Viola manipulates the temporal continuity of an inter-action between man and nature – freezing, reversing and contradicting linear time to choreograph the relationship between them.

> The human condition is dualistic. The sages and philosophers have tried to transcend this state which is not ultimately possible. The very real and positive thing in this condition is the present. That's the fulcrum of our desires, our fears, our anticipations in life, our memories. It's all now… . So I use the image of a dance, two elements momentarily interacting, and then moving off somewhere else.[9]

With the careful deployment of a simple electronic masking device Viola splits the video frame into two separate time frames in which reflections do not correspond to the action above. The pool's surface no longer simply mirrors the human action; they have become temporarily separate worlds, temporally split although still unified within the visual frame of the television screen.

> *The Reflecting Pool* becomes a parable of mystic experience. A water surface no longer throws a subject's mirror image back at him. Instead the man first disap-pears into a point of iridescent light, metamorphosed into nothing, before rising up again out of the water. He has trodden another sphere, a secret strange world of which we, as yet, know nothing.[10]

OBSESSIVE BECOMING, DANIEL REEVES, UK/USA, 1995 (COLOUR, SOUND, 56 MINUTES. FUNDED BY CHANNEL FOUR TELEVISION AND ARTS COUNCIL ENGLAND)

Daniel Reeves' *Obsessive Becoming* makes virtuoso use of a myriad digital video-imaging techniques to build a reconstructed exploration of a dark and intimate family myth. Woven together from range of family snapshots, home movie footage, inter-views, computer-generated texts and re-enacted fragments of childhood memories, the images are tumbled, twisted and transformed, they emerge and morph across and through the frame using the television screen as a site for personal catharsis. The centre of Reeve's video piece, broadcast by Channel Four Television in the UK, is an analysis of a dark past – violence, sexual abuse, bigamy, cruelty, deception and abandonment. Reeves uses video (and perhaps even more significantly, the medium of television) to trace and present an exploration of his family history and a meditation on the relationship between masculinity and violence. Part family history, part personal analysis, the tape is also an accomplished work of visual poetry, a complex and fluid blend of the personal and the social. Family film sequences are chroma-keyed into iconic moments of historical significance. Film, video, texts, and photographic images merge, blend and transform in virtual space which seems somehow to be

10.2: Dan Reeves, *Obsessive Becoming*, 1995, Courtesy of the artist.

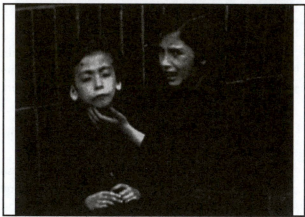

10.3: Dan Reeves, *Obsessive Becoming*, 1995, Courtesy of the artist.

'outside' of conventional time structures; Reeves uses duration to produce a stasis, a kind of temporal 'gallery' within which we can contemplate his digital audio-visual construction as if it were a sculptural object. This complex mix of images, sequences, texts, sounds and music is compelling, disturbing and questioning. There is neither a conclusion, nor even a climax in the conventional sense; instead the work presents a complex mosaic of ideas about kinship, love, genetic inheritance, Buddhist philosophy, masculinity and death.

> A lot of people become frustrated because there's no map – it's not spelled out. The relationships are somewhat unclear – who is who. That's always been a working method of mine because I feel that it allows people … to enter into the work more fully. There never is any resolution, I believe, in anything, so there is

no definitive clarity, there's no end product, there's no result, it's like the words that are embedded in it – "no place to go, nothing to do, nothing to be".[11]

Obsessive Becoming does have a narrative; Reeves traces his family history, revealing a web of deceit and lies surrounding the identity of his 'real' father, the 'truth' of which had been hidden from him until he was 30 years old. This painful narrative unfolds gradually, simultaneously revealed and contained within the multi-textured images, movements, texts and sounds he presents.

At times the piece veers deliberately very close to sentimentality. The personal nature of the material, the emotional tone of the voice-over (spoken in Reeves' own voice), and the circling and claustrophobic family images and sounds draw too close:

> All this cloying romance, and desire, this longing to leave and be left, this whining and pining for the shadow of the shadow of love turns the soul into an empty night-club filled with the litter of broken and empty hearts …

This text scrolls across a seamless and unceasingly fluid montage of monochrome and colour snapshots and movies showing images of his family and relatives to the strains of a sentimental love song. There are images of 'masculinity' too; archive film of a native dugout, warrior oarsman with a shaman at the helm, boys armed with toy guns, a child in an animal costume boxing, a platoon of soldiers sloughing knee deep in a river, a dead soldier's body floating face down in the water, a caged tiger pacing, an astronaut trips, falls and is blended with an electronically twirling child in a white nightshirt, conjuring the image of a dream, or a nightmare.

Although there is a deeply personal story at the core of the work, there is a wider theme too, as the images of violence against childhood open out suddenly to embrace a broader stage. Now the tumbling child in the nightshirt is flying through the sky over bombed and ruined cities, and it is family homes that are targeted – the innocent are being tortured everywhere.

Reeve's repertoire of digital effects is comprehensive and dazzling. *Obsessive Becoming* is a virtuoso blend of video, photography, film, computer-generated images and texts which are combined, recombined and blended using chroma-key, morphing, paint-box effects, slow motion, colourizing, and animation. No image is static; they are blended from one to another seamlessly to create a stream of cascading visual sensations, which stir the viewer emotionally and physically.

Reeves' skilled blending of video manipulation and digital imaging techniques in *Obsessive Becoming* involved considerable experimentation over a long period. Working closely with video-imaging tools throughout the tape's long gestation period, Reeves was constantly reviewing the work and revising his techniques:

> With *Obsessive Becoming* it wasn't five years in production – it was probably ten years because I started in '85 with my first Amiga, and it wasn't till '93 – almost '94 when I finally went 'Aha!' This is the dream world that I wanted to get to. To be able to tear an image apart and re-form the image with complete freedom. Even though you are only working in two dimensions, it's the apparent three dimensions.[12]

Daniel Reeves has evolved a practice in which his control of imaging technology is crucial to any reading of his work. His understanding of the relationship between the video medium and his personal, spiritual and poetic sensibility is in a careful balance. Through a working practice that spans several decades he has investigated the nature of the video image via the camera and computer to arrive at a point where his control of the medium allows for the possibility of what film and media historian Patricia Zimmermann has termed 'healing through images'.[13]

Zimmermann has also pointed out that Reeves uses video at both the shooting and the post-production phase as a method of transforming personal trauma:

> The act of shooting functions as an exorcism of personal trauma that settles into spiritual resolution by transferring the Zen Buddhist notion of the present moment to the production process, an action that counters postmodernism's severance of the sign from the referent to create new meaning. Reeves' work forages for signification itself, an archaeology of the visual as a space where trauma is scripted into memory.[14]

Reeve's deep understanding of the power of the video image stems from his intimate knowledge of its material qualities. This began with an exploration of the portable video camera, used for the first time in his 1981 videotape *Smothering Dreams*, when Reeves began to use broadcast video on location, and was further extended by the use of a domestic camcorder in *Ganapati: Spirit of the Bush* (1986):

> I became really enamoured and encouraged by the feeling the video camera could be as direct a tool (within certain restrictions) as a pen, or a brush or a carving tool.... So through the years, every time there was a new technical development, and this is not so much an issue of technical quality although that interested me, but it was more that the camera became more and more an extension of my own body ... like having another eye in which you could pick up anything and everything.[15]

For Reeves this intimate engagement with the elements of video-imaging technology extend beyond the camera to embrace electronic and digital image control, the ability to get into the frame in order to unlock the poetic potential of the medium. Working at the television lab at WNET with advanced broadcast digital image-processing technology such as ADO (Ampex Digital Optics) and Quantel 'paintbox', Reeves then began to modify domestic equipment (specifically Commodore Amiga computers) in order to find a way of working for extended periods in order to achieve a more complete control of his imagery. Through this working practice, he forged a new relationship to the medium:

> You begin to understand how the fields and the frames and the pixels relate to each other. At some point you want to make the poetic leap – you do, you must. The leap of poetry that Robert Bly alludes to in his work, where even though you know all that, you jump beyond it. Somehow the image just stands above itself.[16]

In the final section of *Obsessive Becoming* Reeves uses image morphing techniques to stress family resemblance and mark the process of time and ageing. Under Reeves's precise control the electronic image reveals itself as truly plastic. His control of pace and duration and masterful blend of images and sounds from a multitude of sources are orchestrated in a way that rivals music in its fluidity and emotional power.

> What's interesting about "video" whatever that is, is that it does create the possibility of this grand fusion of materials. I always have at some stage what I call a marriage edit, a final edit where all the reels are brought together and all the segments are embedded in the finest wine – the best tape that you can get.[17]

ART OF MEMORY. WOODY VASULKA, USA, 1987 (COLOUR, SOUND, 36 MINUTES. WITH DANIEL NAGRIN, H. A. KLEIN. VOICE: DORIS CROSS. COLLABORATION: BRADFORD SMITH, PENELOPE PLACE, STEINA, AND DAVID AUBREY. PRODUCED WITH THE DIGITAL IMAGE ARTICULATOR DESIGNED BY WOODY VASULKA AND JEFFREY SCHIER AND THE RUTT/ETRA SCAN PROCESSOR)

Art of Memory was shot and mastered entirely on low-band U-matic, with all image processing and electronic sound and picture manipulations done in Vasulka's studio in Santa Fe (New Mexico), except the final six-channel mixes, which were completed at a local facilities house. The work is composed of three principal visual elements: colour video recordings of desert and mountain landscapes; black-and-white documentary film footage and archive photographs (including the Spanish Civil War, the Russian Revolution, World War II, atomic bomb tests, etc.) and computer-generated shapes which are used to 'contain' and frame the documentary material which is then chroma-keyed into the landscape images.

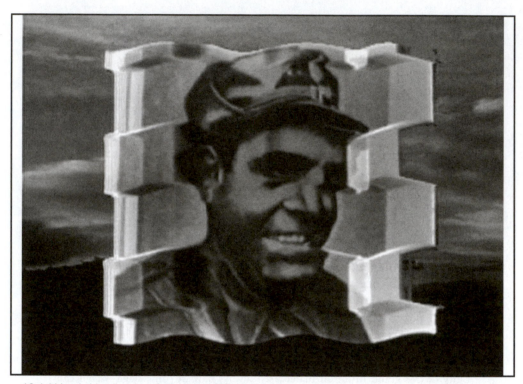

10.4: Woody Vasulka, *Art of Memory*, 1987. Courtesy of the artist.

Vasulka has carefully orchestrated these three image sources, meticulously organizing the relationships between them using a detailed visual coding system that became the 'score' for the video and sound editing process. The frame-accuracy of the image relationships of these three elements was maintained when combined electronically using a custom-made video synchronizer Vasulka constructed by adapting a digital audio synchronizer.[18]

As with his previous 'narrative' work – *The Commission* (1992) there are no traditional video edits, or 'cuts' in *Art of Memory*. Images and sequences shift from one to the other through a series of transitions and electronic 'wipes'. Most often scenes and sequences are revealed and terminated by an enveloping darkness, and this occurs throughout the tape, as if the electronic vistas on the screen were closed off momentarily before being revealed again – often with the accompanying sound of a closing vault door.

The flowing and scrolling documentary images of the historical past in *Art of*

Memory float freely across timeless desert landscapes – the images becoming 'time-energy' objects removed from their conventional chronological, historical and conceptual framing. Vasulka worked predominantly with two image-processing tools – the 'Rutt-Etra Scan Processor', and the 'Digital Image Articulator' (see Chapter 7) to produce mathematically generated, almost organic objects that contain and present the visual material. This technique of containment enabled Vasulka to avoid narrative associations, de-contextualizing the historical and documentary aspects of the image sequences, presenting the black-and-white images as a component of a metaphorical landscape in which the electronic image simultaneously contains and re-configures the photographic. The digitally produced space becomes a kind of electronic theatre in which images and sequences emerge momentarily before being re-submerged into the undercurrent of history and memory.

In his close analysis of *Art of Memory*, Raymond Bellour describes the work as containing an experience of 'constant mobility' between the cinematic shot as a 'unit of comprehension' and its destruction and reconstitution. For Bellour, Vasulka's tape presents an experience

> … of unceasing intersections and crossings and one that would seem to defy any drawing of distinctions. Nonetheless – and such is the power of the tape – the idea of the shot, the feeling of the shot, though split, fractured, and as it were, vaporised, still endures. The shot remains the decoupage and memory device, for the contemporary spectator as well as for the spectator whose mind scans the history of wars captured by cinema in this century, which has become a history of cinema itself.[19]

Two human figures also occupy this timeless electronic landscape – a middle-aged man (Vasulka's alter ego?) played by Daniel Nagrin (1917–2008, USA) and a winged figure (the Angel of Death or perhaps Walter Benjamin's 'angel of history'?),[20] which although observed, refuses to be captured photographically. This conflicting interaction is the only fragment of narrative in *Art of Memory*; the rest of the piece is a lyrical blend of sound and picture in which ephemeral image-objects occupy a timeless metaphorical landscape. The protagonist is haunted by the images that he is witness to – listening to Robert Oppenhiemer's anguished post-Hiroshima quotation from the *Bhagavad-Gita*, and attacked by the angel for his attempted photography.

The multi-layered sound is an important device in the work. Sampled and repeated loop structures reinforce notions of the temporality and the malleability of memory. Voices and sounds are unrecognizable and yet emphatic, the music is compelling and nostalgic – evocative of an outdated technology and a half-forgotten cinema newsreel – fading memories.

There is nostalgia for the medium of cinema here too – Vasulkas' training as a filmmaker, his admiration for the political filmmakers of the period before World War II, his abandonment of cinema in favour of the electronic image and more recently his transition from analogue video to digital space. *Art of Memory* also marks the end of a period of work for Vasulka, who, on completion of this tape, abandoned his work within the frame for the development of a series of constructed installations collectively entitled *The Brotherhood* (1990–6), that explore the potential of the machine to reconfigure space. For Vasulka, previously involved in a systematic exploration of the electronic and digital codes of the moving image and the 'time-image object', this is a radical departure and a partial admission of the 'failure' of his previous 'narrative' work.

Art of Memory is a complex and moving work – the achievement of a mature artist who has systematically built a vocabulary of images through nearly two decades of exploratory dialogue with the fundamental elements of his chosen medium – the signal, the camera, and the 'time-energy structures' that the artist believes are unique to video. The work brings together a profound understanding of electronic imaging with a poetic questioning of the value of lived experience to shed light on fundamental questions about the nature of memory, perception and their relationship to the visual world.

JUSTE LE TEMPS (JUST ENOUGH TIME), ROBERT CAHEN, FRANCE, 1983 (COLOUR, SOUND, 13 MINUTES, 30 SECONDS. SOUNDTRACK: MICHEL CHION. VIDEO EFFECTS: STEPHANE HUTER, JEAN-PIERRE MOLLET. EDITING: ERIC VERNIER. CAMERA: ANDRE MURGALSKI. PRODUCED BY THE INSTITUT NATIONALE DE L'AUDIO-VISUEL (INA) PARIS

Robert Cahen had originally intended to present a meditation on the experience of looking out of a train window – the depiction of a simple and mundane action. But from this initial impulse *Juste le Temps* was developed into an enigmatic narrative fragment, relating a chance encounter between a man and a woman that also seems to be the departure point for a larger and more complex story. The tape is enigmatic and mysterious, creating and suggesting suspense and uncertainty. The accomplished blend of image and sound create a fusion of reality and imagination, of exterior appearances and interior spaces that hint at the complexity of human visual perception. Cahen's rendering of subjective perception via electronically manipulated imagery is powerful and enigmatic.

The tape presents the subjective view of two passengers on a train travelling through a landscape. Cahen described his intention:

> I wanted to convey what happens when you find yourself in a train and you look
> around, trying to register surprising things happening in the distance, where the

10.5: Robert Cahen, *Juste le Temps*, 1983. Courtesy of the artist.

landscape goes by more slowly ... close up, everything glides by, is rubbed out,
becomes fluid.[21]

Cahen has electronically transformed the views of the passing landscape in order to
suggest that some kind of exchange occurs between the two passengers. However,
in *Juste le Temps* the landscape also becomes a significant character, portrayed as
the catalyst in a set of oppositional relationships between image and sound: train
interior/ exterior landscape (Nature/Culture?) sound/silence, male/female, light/dark,
sleeping/ wakefulness. The work hinges on an exploration of the transition between
various states of being.

The image and sound transformations in *Juste le Temps* present a subjective mental
state that can be shared by the viewer. The abstraction of the landscape is given a
narrative impulse — they seem to occur as a response to the woman's drowsiness and

her balance on the cusp between sleep and wakefulness, but as with the soundtrack, the images also have their own autonomous function. In this approach, Cahen has drawn on his training in *musique concrète* and the teachings of Pierre Schaeffer (see Chapter 5) in which the principal idea 'is linked to what is called *reduced hearing* – the hearing of a sound decontextualized from its original source'.[22]

Cahen worked principally with the Truquer Universel, a video synthesizer that enabled the creation and transformation of colour, texture and multi-level imagery (see Chapter 7) to produce the video transformations in *Juste le Temps*. Alongside these techniques Cahen built up a complex layering of images that were mixed with an oscilloscope display to produce a textured image that is reminiscent of those created by the Vasulkas using the Rutt/Etra Scan Processor. Cahen has also manipulated the colour, altering the 'natural' palette of the video camera for one that merges and alternates between the 'natural' and the 'artificial', between the everyday and the poetic:

> My goal was to offer viewers a story that would allow them to travel too, by identifying with the video permutations. I wanted both reality and its transformation to exist at the same time.[23]

Sandra Lischi refers to filmmaker Robert Bresson's notion of an 'eternally wet canvas' to describe the fluidly transforming colours and textures in *Juste le Temps*, also quoting Jean-Paul Fargier's reference to a 'flexible minerality' in Cahen's treatment of images and colour. The complex blend of depth and surface, of monochrome and colour and temporal fluidity in *Juste le Temps* is often in some sense 'painterly', as cultural theorist Paul Virilio suggests in his commentary on the journey in *Juste le Temps* which he sees as transporting the spectator on a tour through the history of painting.[24]

The tape is also in an important way sculptural and musical, so that ultimately it suggests a synthesis of many genres and forms. Most significantly it is the blend of ideas from earlier temporal art forms including music, photography and cinema, with an exploration of the capabilities of electronic imaging technologies that distinguishes *Juste le Temps*.

Although he trained in audio-visual techniques, Cahen collaborated closely with the composer Michel Chion (1947, France) in the production of the complex soundtrack, and on many levels the relationship between sound and picture reflect the structure of the work. The soundtrack is a blend of sweeping musical sounds; a piano can be easily identified – punctuated with the sudden interjection of natural fragments; the chiming of bells, the joyful cry and the splash of a child plunging into a swimming pool, the rhythmic pulse of the train travelling along the tracks. This

soundtrack contributes and reinforces Cahen's ideas and the diversity of sources of inspiration for the work:

> Once from a train I saw kids playing around a fire. And just when the train went
> by I saw one kid push another into the fire. It made a very strong impression,
> especially since only my imagination could supply what happened next.[25]

The train journey itself is an important and powerful metaphor. For Cahen the train crossing the landscape provides a method for making a transition from one state to another, the spectator and the passenger share a vantage point from which to experience a transformation. In this sense the primary image in *Juste le Temps* is the passenger and her viewpoint. There is a relationship between the interior subjective worlds of an individual and the representation of an exterior reality. Seated at the window of a train the world is gliding by and what you see is dependent on the direction of your attention. In *Juste le Temps* the electronic sound and image manipulations seek to express complex aspects of experience that challenge conventional narrative constructions:

> Instead of words I use a deforming instrument which underlines what words
> cannot say, such as the movement of the body. It is a question of shadows or
> of what a shadow allows you to imagine: what remains of a shadow which is
> gradually or quickly discovered? Video allows you to give a voice to this shadow.[26]

NEO GEO: AN AMERICAN PURCHASE, PETER CALLAS, AUSTRALIA, 1989. (COLOUR, SOUND, 9 MINUTES, 17 SECONDS)

Neo Geo is one of the last in a series of videotapes that Callas produced using the Fairlight CVI, which he first began using soon after its introduction in 1986 (see Chapter 5). His videotapes of this period all make use of bold, highly coloured, superimposed graphic imagery and repeating animated layered surfaces. There is a clear visual influence from Pop Art, and at times the results resemble an animated silkscreen print, with a dynamic, high-contrast and chromatically saturated palette.

Callas' work with the Fairlight CVI during this period explored the potential of this unique device, which enabled the tracing and redrawing of images that could be stored in the computer memory and retrieved, to be used as stencils for super-imposition and layering, and made to cycle, scroll and pan across the video screen. Although the techniques Callas worked with can be compared in some ways to film animation, he was very aware of the distinctions and keen to point out the differences:

> I don't think an animator would think I was much of an animator. For example
> one of the other ways I used the Fairlight… . was a quick and easy two-frame

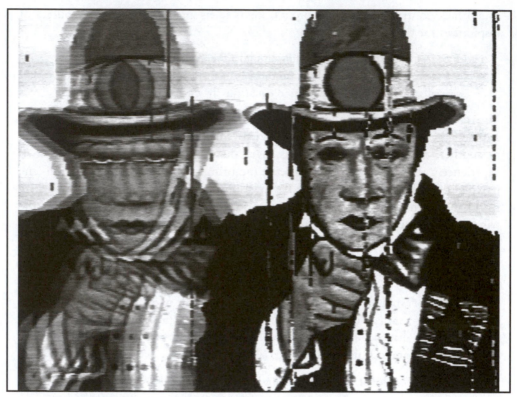

10.6: Peter Callas, *Neo Geo*, 1989. Courtesy of the artist.

animation technique. If you divided the stencil plane of the CVI into a checkerboard pattern and stamped an image onto the positive checks, and another image onto the negative checks and then rapidly interchanged them, you'd get a two-frame animation… . With any of the Fairlight effects you were limited to a 2D plane, but an infinite 2D plane which just kept scrolling over and over. So you could go in any direction and the image that left the top of the screen will reappear in the bottom and then move up again.[27]

Made whilst Callas was resident artist at PS1 in New York City during 1988–9, *Neo Geo* is a highly critical exposition of American culture, exploring the contradictory images and icons of the USA at the end of the twentieth century. The work is a densely layered and complex mix of cartoon-style drawings, graphics and visual iconography which bombards the viewer with sounds, colours and images that

increasingly saturate and overload the screen. As in the video works that precede *Neo Geo*, such as *If Pigs Could Fly (The Media Machine)* (1987) and *Night's High Noon – An Anti Terrain* (1988), Callas' post-colonial political and ideological perspectives emerge and engage through a playful and ironic juxtaposition of images of violence, war, technology, religion and popular culture.

As Scott McQuire points out in his catalogue essay 'Electrical Storms: High Speed Hisotoriography', Callas is an artist who has deliberately taken an international and cross-cultural perspective in his mature work; not only did he spend significant periods working outside his native Australia, but his interests and preoccupations are in the cross-cultural exchange and impact of the global circulation of images. In the mid-1980s Callas spent a number of years living in Tokyo and his experiences there deeply affected his perception of the television screen and the video medium. Whilst living and working in Tokyo his experience of the TV display as an aspect of architecture and urban space and of the video image itself as containing what he termed a 'territorial dimension', deeply affected Callas' view of the medium and its cultural impact and significance.[28]

In *Neo Geo*, Callas presents and challenges the viewer's expectations and assumptions about the meaning, currency and significance of cultural images and their iconic power – he harnesses an ironic and dark humour fused with energy and fluid expressiveness, employing animation and electronic montage techniques to pose unsettling questions. Throughout its nine-minute duration *Neo Geo* presents us with a multi-layered critique of the unique American blend of capitalism, religion and politics. The work confronts us with the cultural mythology of American consumerism via a barrage of sounds and images, symbols and texts – explosions, the dollar sign, the stars and stripes, the heroic frontiersman, Uncle Sam, etc. – all instantly recognizable and troublingly double-edged.

Callas' fascination with the contradictory and conflicting aspects of the images he works with is clearly central to the construction and structure of *Neo Geo* and to the images and sounds he has drawn together and orchestrated. His perception of video as 'either pre-literal or post verbal – a medium closer to painting than it was to film' is a useful reference for *Neo Geo* and the key to gaining a sense of how he developed this and other works he has made with the Fairlight CVI. Callas explains that he found video enabled him to work 'without scripts, without words even – and in real time', and experiencing the fluid unfolding of *Neo Geo*, one has a sense and appreciation of the expressive and creative opportunities this approach provided him with.[29]

CONCLUSION

As the electronic palette of video expanded in the 1980s and 1990s, artists were increasingly able to explore its potential for the almost unlimited transformation and manipulation of lens-based imagery. But these electronic manoeuvrings are not merely technique – they open up the potential for a pure abstract form of visual experience that explores ideas and emotions that underlie language and thought processes to explore relationships between perception and emotion. The early example of Sjölander's *Monument* anticipates what was to come, the fluid and elastic distortions and transformations of recognizable objects, faces and events in that historic early experiment are echoed and extended in the complex morphing sequences of *Obsessive Becoming* and the digital thresholds in *Art of Memory*. In *Neo Geo*, this fluid transformation of the electronic image was used to herald a newly emerging circulation of global imagery. The contemplative states evoked in the *Reflecting Pool* are also experienced in the spiritual world of movement, colour and light in *Merging-Emerging*, and expressed in the encounter between time, movement and landscape in *Juste le Temps*.

11. THE GALLERY OPENS ITS DOORS
VIDEO INSTALLATION AND PROJECTION

Since the first glimmerings of video as an art medium, it has been associated with the gallery. Vostell and Paik's earliest presentations at the end of the 1950s, although staged long before the term was coined, are perhaps best understood as installations. Outside of the television broadcast context, video has been presented in galleries and has required and demanded a different attitude, appreciation and understanding from its potential audience. Videotapes, shown on small monitors, grouped in multiples, or presenting 'live' images from closed-circuit cameras presented a new viewing experience challenging common assumptions about the nature of art, of television and increasingly about its relationship to cinema and sculpture. This chapter will discuss and present a small number of examples from the huge range of works produced by artists working with video during the period under discussion. As has been mentioned elsewhere in this book many, if not most artists who made video installations also produced single-screen works, and these two modes of working informed and influenced each other profoundly – all of the artists discussed below have also made single-screen works.

All but one of the examples in this chapter feature the video monitor as the basic component. Gary Hill's *Tall Ships* uses video projection, and this is increasingly the norm in current video practice. Chapter 14 discusses installation in some detail and includes further examples of projection work, interactivity and the participatory nature of video installation.

DE LA, MICHAEL SNOW, CANADA, 1969–72 (ALUMINIUM AND STEEL MECHANICAL SCULPTURE, ELECTRONIC CONTROLS, VIDEO CAMERA, FOUR MONITORS, 72X72-INCH CIRCULAR WOODEN PLINTH, 96-INCH DIAMETER OUTER WOODEN RING. STRUCTURAL ENGINEER AND CONSULTANT: PIERRE ABBELOOS)

De La is a sculptural video installation constructed from a modified version of the camera machine built for the production of Michael Snow's epic three-hour landscape film *La Region Centrale* (1971). The original machine, built by Pierre Abbeloos, a Montreal-based engineer, was designed to enable a film camera to shoot images in every direction from a central axis, changing camera angles, rotation speeds and complex panning movements without interruption. During discussions with

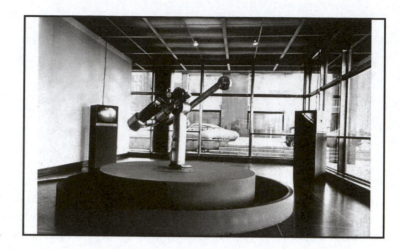

11.1: Michael Snow,
De La, 1969–72.
Courtesy of the artist.

Abbeloos, Snow had specified the maximum size of the machine and the size of the rotating arcs:

> Because of what I wanted to happen on the screen, it had to be at man-sized height from the ground … I started to think of the machine as an object in itself as it was being built and to see that it was beautiful; I was thinking of other uses for it when we made the film.[1]

After the filming of *La Région Centrale* in late September 1970, Snow decided to use the machine for other purposes. (Originally, as used for the production of the film, the machine was not intended to be visible, and only a brief glimpse of its shadow appears in *La Région Centrale*.) Snow asked Abbeloos to adapt the machine to support a video camera, which could provide a 'live' image to four video monitors, and the resultant sculptural work, entitled *From/De La Région Centrale* was exhibited at a private gallery in Ottawa. After this initial presentation the machine was modified: the motors, gearing and some of the electronic control circuits changed to enable the permanent operation of the machine, resulting in a new work, *De La,* shown in November 1971 at the National Gallery of Canada, Ottawa. Snow's observations about the installation highlight both the sculptural aspects of the structure and its interrelationship to the live video image:

> *De La* precisely has to do with seeing the machine make what you see…. There's a really interesting separation between the maker of the images and the images…. You can follow the movements that are made by the sources of the image as well as the results of those movements on the four screens. Contrary to the film, it doesn't have anything to do with affecting the sense of the fictional gravity….

> *De La* is a sculpture and it's really important that you see how the machine moves
> and how beautiful it is… . It is a kind of dialogue about perception.[2]

The installation presents a complex view of its own location and surroundings, including any observers, the ambient light and the video monitors themselves. The 'live' video camera provides monochrome images to the four monitors simultaneously, the sound provided by the rotating mechanism of the machine. For Snow the relationship between the machine as sculpture, its presence in the 'real' world, and its role in producing the images on the screen, is the central concern of the work. The work can be understood on one level as a metaphor for the artist himself observing the world, assimilating experiences and producing images:

> The TV image is magic, even though it is in real time; simultaneously, it is a
> ghost of the actual events which one is, in this case, part of. The machine that is
> orchestrating these ghost images is never seen in them: it belongs exclusively to
> the real side of this equation. The sound is an essential part of the concreteness
> of the machine; if it were silent it would tend more toward a representation and
> also have less 'personality' as a unique thing-in-the-world.[3]

Since exhibiting *De La,* Snow has made a number of video installations which feature 'live' video images and are designed to be experienced in 'real time'. For example, *Observer*, which was first shown in 1974, subsequently at 'White Box' in New York (1999) and most recently at the Centre Pompidou in Paris in 2002–3. *Observer* is usually installed at a location within an exhibition where a gallery visitor is likely to stand to look at another exhibit, most often positioned on a wall directly in front of them. The work consists of a large 'X' made of white sticky tape that has been placed onto the gallery floor, monitored via a live video camera that has been mounted on the ceiling above the X. The resulting video image is projected directly in front of the taped X, and when a spectator stands on the spot marked, they are confronted with a 'real time', head-to-toe image of themselves in a very flattened perspective, projected directly in front of them.

In 1978 Snow was commissioned to produce *Timed Images*, intended to be permanently installed within a university building located outside Toronto. The work involved a video camera positioned to provide a live video image of a photograph of people passing through a hallway that was shown continuously on a monitor installed in another part of the same building. According to Snow the equipment stopped working after a time and was never repaired.[4]

Intérêts (1983), installed in an exhibition about the history of video art in Charleroi, Belgium, consisted of a line of 21 monitors set up in a long row, mounted

on a single base. A video camera was positioned to provide a live image of the counter where entrance ticket purchases were made, providing images of the hands of the purchaser and of the ticket seller during the exchanging of money. All these transactions were recorded each day of the exhibition and subsequently displayed so that one after another the monitors displayed the previous transactions providing a cumulative result so that, by the final day of the exhibition all the monitors were filled with 'interest'.

That/Cela/Dat, commissioned by Thierry de Duve for an exhibition at the Palais des Beaux Arts, Brussels, was a video installation consisting of two large monitors and a video projection which drew on Snow's 1982 film *So is This*. Sentences in English, French and Dutch from the same text appeared one word at a time on the video screens in a 20-minute loop. The installation included a computer program that rotated the languages enabling them to appear at varying times on the three different screens.

Although known primarily for his work as a filmmaker, Michael Snow has worked with video consistently since the 1970s, maintaining that he has not been influenced by the work of other artists who have worked with video. Very aware of the strengths of the electronic and digital image Snow has often made use of its unique qualities. For example his 1982 film *Presents* made use of a Quantel 'Paintbox' to digitally stretch and squeeze the image, and subsequently when devising *Corpus Callosum*, a film that developed from *Presents*, Snow sought new software techniques to exploit the potential of the digital video image:

> From '82 to actual first shooting (1998) I worked on writing *Corpus Callosum* and following what could be done with digital animation. It became possible to do what I wanted after I met Greg Hermanovic who is one of the creators of an animation software called "Houdini" which we used in making the film. It was precisely the manipulability and inherent instability of video, the possibility to move pixels, to shape in a clay-like way that became possible with digital means and that wasn't possible with film that caused the making of *Corpus Callosum*.[5]

IL NUOTATORE (VA TROPPO SPESSO AD HEIDELBERG) [THE SWIMMER (GOES TO HEIDELBERG TOO OFTEN)] STUDIO AZZURRO (FABIO CIRIFINO, PAOLA ROSA AND LEONARDO SANGIORGI) ITALY, 1984 (25 IDENTICAL VIDEO MONITORS (2 ROWS OF 12, PLUS ONE FREE STANDING), 13 U-MATIC VIDEO PLAYERS, AND VIDEO SYNCHRONIZER. ORIGINAL MUSIC COMPOSED BY PETER GORDON)

Il Nuotatore (va troppo spesso ad Heidelberg) was first presented at Palazzo Furtuny, Venice in July 1984 within a specially constructed replica swimming pool and

subsequently restaged in numerous locations including Berlin, Cologne, Milan and Tokyo (1994) without the lido. Taking inspiration from a short story by Heinrich Böll, *Il Nuotatore* presents a fluid and continuous sequence of a swimmer repeatedly traversing a line of twelve video monitors. A second set of twelve television screens, placed back-to-back with the first, display numerous 'micro-events' – an emerging human figure, a floating lifebuoy, a diver, a sinking anchor, and a ball falling, all referenced to an additional plinth-mounted monitor imaging a clock face displaying the elapsed time.

Studio Azzurro, established in Milan by Fabio Cirifino (Milan, 1939), Paola Rosa (Rimini, 1949) and Leonardo Sangiorgi (Parma, 1949), is a collaborative group of artists who sought to operate across a range of artistic disciplines and traditions. From the outset they decided to emphasize their group activity in order to challenge traditional notions about the individual creative artist, drawing on political ideas and attitudes from conceptual and performance art, Arte Povera and Body Art, seeking new

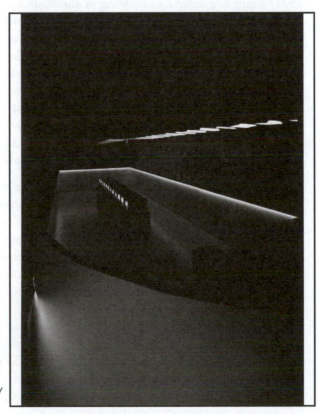

11.2: Studio Azzurro (Fabio Cirifino, Paola Rosa and Leonardo Sangiorgi), *Il Nuotatore (va troppo spesso ad Heidelberg) (The Swimmer (goes to Heidelberg too often)*, 1984. Courtesy of the artists.

alternatives to the restrictions associated with the creation of the art object, and emphasizing a continuous flux between the natural, the environment and daily experience.

Studio Azzurro began an extended period of research with video imaging and technology in 1982, opting to work with video – a medium that seemed to them at the time to be 'undisciplined, unruly and light-hearted'.[6]

Since that time, the group has produced an extended series of large-scale video installations and video theatre pieces or 'video environments', as Studio Azzurro prefer to call them. All crucially involve a significant element of audience interaction, the level of meaning communicated via an active participation rather than passive viewing of an audio-visual spectacle. For Studio Azzurro the video environment has the potential to place the spectator's role centrally within the work, thus exploring multiple possibilities of human interaction.

In *Il Nuotatore* as with other Studio Azzurro video environments of this period (*Storie per corse*, 1985, *Vedute (quelle tale non sta mai fermo)* 1985, *Il giardino delle cose*, 1991) there is a deliberate blurring of the boundaries between the natural and the artificial, the ephemeral video image and the physical television object which 'treats space temporally and time spatially: with the screens of the monitors acting as limitations that imply a temporal passage of the image flow'.[7]

For *Il Nuotatore* Studio Azzurro developed an electronic synchronizer to link the video sequences playing on 12 separate video players creating an illusion of continuous movement across the 12 monitors in the installation. This fluid movement across the screens within the environment of the installation was an early manifestation of a strategy to engage the spectator in an interactive and participatory process, countering the notion of screen-based video art as a passive viewing experience:

> *Il Nuotatore* was the starting point for a growing interest and awareness of the poetic applications of interactivity. The 12 video players that create the illusion of the flowing image across a line of video monitors were linked together electronically using a specially developed synchronizer that allowed the tapes to provide an illusion of movement across the screens. *Il Nuotatore* is the point of entry. We have been following a path of technological development more related to a concept of interactivity that develops thought within the tradition of video art. It is an idea of technology as participative. This way, technology does not passively enter imagination, but activates antibodies against pacifying and invading technology. *Il Nuotatore* represents the root of these developments, containing these ideas in an embryonic state. The environment is the context that surrounds a series of videos. The gesture feeds the narrative dimension of the work. The monitor stops being a box and becomes the lens that highlights

the virtualization of reality. By putting a number of lenses beside each other, their contiguity reveals their ambivalence.[8]

TELEVISION CIRCLE, JUDITH GODDARD, UK, 1987 (SEVEN TELEVISION RECEIVERS IN STEEL WEATHERPROOF CONTAINERS, ONE VIDEO HOME SYSTEM (VHS) PLAYER. A TWSA 3D COMMISSION FOR TELEVISION SOUTH WEST, SPONSORED BY TOSHIBA UK LTD.)

Judith Goddard's (1965, UK) *Television Circle* was originally sited in Bellever Forest on Dartmoor on the west coast of England. The installation was later adapted for a gallery setting and presented at the Museum of Modern Art, Oxford as part of the survey exhibition 'Signs of the Times: A Decade of Video, Film and Slide-Tape Installation in Britain: 1980–1990'. At the time of its original conception, the notion of an outdoor installation composed of domestic video equipment was a radical idea, both a technical challenge for the artist and her sponsors, as well as for those who encountered it in the forest clearing.

The idea for the work had been prompted by an invitation to submit an idea for a new work to be commissioned for one of a number of previously selected sites within the South West of England. Goddard was intrigued by the potential and location of the Dartmoor site, and aware of the lack of accessible mains power, she proposed an outdoor video installation to be powered using a petrol generator. After consulting detailed 'Ordinance Survey' maps of the area, a visit to the proposed site confirmed the potential of the location and the viability of her plan, but suggested an alternative solution to the electricity supply question:

> When I actually went down to see it, it was just right! I discovered a clearing where one tree had been cut down leaving enough space to site the monitors in a circle. Conveniently the site turned out to be 300 metres from a Forestry Commission hut that had an electric supply in it, so after some health and safety discussions I was told that if we used 16mm armoured cable (trailing across the forest floor), we could use that as the power source. I liked the idea of plugging in to the National Grid on Dartmoor.[9]

Goddard's installation was created in response to the site – its location and timeless natural beauty providing a contrast and counterpoint to the temporary domestic technology of the installation and the ephemeral images presented on the screens. The work consisted of a circle (about 20 feet in diameter) of seven identical large-screen televisions, housed in steel boxes with weather and vandal-proofed 'Lexan' (a material used to produce riot shields for the police) screens displaying images from a single VHS source. The source tape (later distributed as a single-screen tape entitled *Electron*) was an edited video and sound montage depicting images of electrical

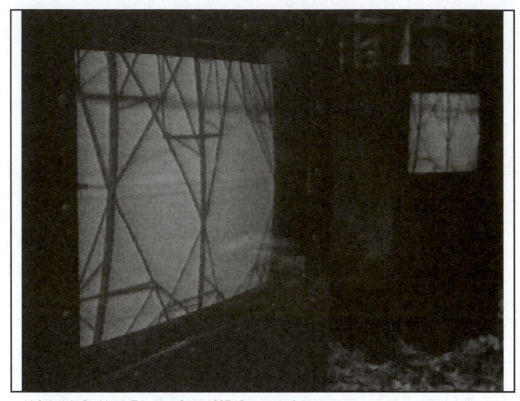

11.3: Judith Goddard, *Television Circle*, 1987. Courtesy of the artist.

energy, industrial power, electrical networks, including details of insects trapped in amber (referencing the origins of the word 'electron', derived from the ancient Greek word for amber), the electric ring of a domestic cooker, presented as a kind of contemporary mandala of light and power, the Houses of Parliament at Westminster, juxtaposed with suburban domesticity. In Goddard's own words the tape was a collage of 'images of mythology and technology – a physical and mental landscape and connections and interplay between the outer world and the inner realm'.[10]

Television Circle took the form of a contemporary monument, deliberately referencing the formation, historical and social significance of an ancient stone circle of which there were numerous authentic examples nearby. The installation's unusual siting and the way it referenced and challenged notions about the relationship between the natural landscape and electronic technology took many visitors to the location by surprise:

… judging by the reaction of some of the people who didn't expect to come across a video installation in a forest on the moor, it was quite a challenging intervention… . Someone said that it was a bit like putting a motorway in the middle of the forest, but then other people thought it was wonderful. This was 1987 when people really hadn't been exposed to video in an art context. One of the things that really worked well was the haunting quality of the soundtrack, which could be heard from quite a distance. People were drawn down the path and then they would come across this TV circle, among the trees and stone circles. There were layers to the work, but it was essentially a kind of memorial. One time when I went down there I found a family having a picnic on the ground in the middle of the TV circle – another time it was a couple of forest ponies.[11]

In a number of significant ways *Television Circle* was a pioneering and unique work – directly confrontational, whilst simultaneously suggesting a cultural continuity and the potential for new and challenging relationships between technology and nature, the domestic and the historical.

THE SITUATION ENVISAGED: THE RITE II, DAVID HALL, UK, 1988 (FIFTEEN IDENTICAL TELEVISION RECEIVERS, ONE VIDEO PLAYER)

The Situation Envisaged: the Rite II was first shown at 'Video Positive 1989' at the Tate Gallery, Liverpool. It is part of a series that included *The Situation Envisaged: The Rite* (1980), shown at South Hill Park Arts Centre, Bracknell, and *A Situation Envisaged* (1978), first shown in 'Video '78' at the Herbert Art Gallery, in Coventry, England.

11.4: David Hall, *The Situation Envisaged: Rite II*, diagram, 1980. Courtesy of the artist.

The Situation Envisaged: Rite II consisted of fifteen monitors assembled into a monolithic block, set close to a wall. Fourteen of these screens were turned towards the wall, the reflected display of the television broadcast images they were receiving, casting a glow of flickering colour and light onto the wall's surface. In the centre of this monolith, a single monitor, turned to face the audience, displayed a low-resolution image of the moon drifting across the frame. The soundtrack was a musical score derived from the audio signal of television broadcasts.

In *The Situation Envisaged: Rite II* Hall considered the phenomenon of broadcast television and the issue of placing video into a gallery environment.

In the catalogue for the 1990 exhibition *Signs of the Times*, at the Museum of Modern Art in Oxford, Hall outlined his approach to video installation. Since first working with video in the early 1970s, Hall had been engaged with an exploration of the relationship between broadcast television and video art (see Chapter 1 and my discussion of his videotape *This is a Television Receiver*, above). Hall, realizing the crucial position of television as the mediator of present-day cultural values, developed a strategy that involved the adoption of TV as 'the vehicle for an alternative meditation and critique' of contemporary culture. Related to this, and inextricably tied into the issue of making the work, there was the equally important problem of showing it. The broadcasting of video art tapes (or as Hall put it, 'Art as TV'), intent on a critique of television was resisted by broadcasters, and 'TV as Art' in the gallery was problematic both because of its ephemeral nature and its time-base. Ever since Hall had made his first video installation *60 TV Sets* (1972)[12] he realized that it presented a further fundamental set of considerations:

> Unlike single-screen works, installations are hybrids. They involve a physical structure, usually more than one screen. They have no place on TV, they are gallery works... . The immediate perception of a single monitor video screen is as a kind of window (unavoidably a television window). At the moment of attention the viewer assumes total disregard for the TV as object. But the introduction of a second monitor (or more) into the visual field presents a monumental problem. There are not just two, there is a conflict. Is one screen given attention, or is the other?
>
> ... there is an instant confrontation with the total construct – the physical, architectural, three-dimensional structure – within a physical space.
>
> Primarily a here-and-now spatial consciousness is operating, necessarily it must. What is displayed on those screens, in that other temporal dimension, comes second ... this is not a conventional viewing situation, it is not a living room; there is a multiple of screens, presented within a dominant and unique physical structure, in turn within a specific and unlikely environment.

So aside from the abstract objectives that may emanate from the video screen … physical and formal considerations must equally be made … all that was to be said via the screens must also acknowledge the specific context. And that simultaneously the context should not only integrate the screens (as a consciously formal component) but, by the character of its configuration, support their abstract content. This could not merely be an incidental system for display. The combination was the total work.[13]

This attitude to video installation, articulated in the above passage and implicit in Hall's work – especially in *The Situation Envisaged* series, exerted an influence on the practice of many video artists in the UK and elsewhere, including my own approach. Hall's conception of the crucial interdependence of relationships between the image content of the screen and the structure of the sculptural components can be seen as fundamental to the installations considered in Chapter 14.

TALL SHIPS, GARY HILL (1951, USA), 16-CHANNEL VIDEO INSTALLATION, USA, 1992 (SIXTEEN BLACK-AND-WHITE MONITORS WITH PROJECTION LENSES, SIXTEEN LASER DISK PLAYERS WITH COMPUTER-CONTROLLED INTERACTIVE SYSTEM. SILENT)

Sited in a completely darkened corridor (dimensions variable: between 60 and 90 ft). *Tall Ships* presented the viewer with an encounter with 16 black-and-white projected video images of human figures of various ages, genders and ethnic origins. As a visitor walked through the space, the image sequences were triggered electronically, causing the figures to approach the screen until they were approximately full size and they remained in this position until the viewer left the space. Each of the sixteen projections were independently interactive, which meant that any or all of the figures could be in any one of four positions; walking towards or away from the viewer, in the distance, or standing in the foreground.

Tall Ships was an interactive video installation in which the technological aspect was deliberately underplayed. The mechanisms of the installation, its novel image projection system, the 16-channel configuration and the method of triggering the sequence playback, were 'behind the scenes', placed outside the perception of the gallery visitor. Hill's concern in this work was clearly the illusion of the encounter with the represented human figures. The subjects were chosen fairly casually, and not for any 'representative' aspect, and according to Hill, with an element of chance, most often through personal relationship.[14]

Writer and artist George Quasha (1942, USA) discusses *Tall Ships* in relation to what he calls the 'videosphere', drawing an important distinction from a response to the video image as representation, to a response of 'immediate transformative awareness'. As he points out, the operative mechanism provoking audience response

11.5: Gary Hill, *Tall Ships*, Sixteen-channel Installation, 1992. Courtesy of the artist and Donald Young Gallery, Chicago. Photo by Dirk Bleiker.

11.6: Gary Hill, *Tall Ships*, Sixteen-channel Installation (Detail) 1992. Courtesy of the artist and Donald Young Gallery, Chicago. Photo by Dirk Bleiker.

to *Tall Ships* 'belongs to world of feedback rather than the work of filmic representation – image response, rather than imagistic representation'. Quasha is interested here in the notion that the feedback mechanism is located in the space presented within the work – the videosphere. *Tall Ships* simultaneously projects an image and a space for reflexive contemplation. For Quasha,

> Hill is an artist whose sense of space – whether imagistic or linguistic – derives from the possibilities revealed (that is, uncovered and created) by the experience of video. In short, we are pointing to a kind of self-awareness made possible by the videosphere, and yet unique to the extraordinary conditions of this piece.[15]

Tall Ships provides the viewer with an opportunity for the objectification of self-awareness in space and time simultaneously. In this installation the figures presented

are less 'images' and more like the 'fields' that Bill Viola considers when shooting his works (see above). The interactive nature of *Tall Ships* is crucial in its reinforcing of this expanded aspect of the videosphere. It supports the triggering of the psychological aspect of self-awareness – the impulse to respond to the individuals who seem to confront the viewer.

AIUEONN, SIX FEATURES, TAKAHIKO IIMURA, JAPAN. 1993/2012 (INTERACTIVE INSTALLATION, BASED ON A CD-ROM, DEVELOPED FROM THE VIDEO *AIUEONN SIX FEATURES* (1993), JAPAN)

A circle of six wall-mounted monitors displays six head-and-shoulder portraits of the artist, each corresponding to, and animating the different Japanese vowel sounds: A, I, U, E, O and NN (which, although sounding like a vowel, is not considered one). Each of the six distorting self-portraits are presented against a brightly coloured background – so, for example 'A' is against red, 'I' against yellow, 'U' is green, 'E', blue, etc. Each of these portraits is made to digitally distort in a comical manner as the artist pronounces the vowel sound.

In the gallery configuration, the sequences on the six monitors are synchronized, and because the sound only emanates from one of the monitors, five of the facial expressions are always therefore incorrect in relation to the vowel that is being pronounced. At the centre of the circle of monitors there is a seventh (projected) image that displays a face and sound that can be selected by the gallery visitor via a touch-screen panel which is set forward of the wall and screens. In this way visitors are invited to select picture and sound separately. Therefore, for example if the face of the vowel corresponding to the 'A' picture is selected, the sound will not be 'A', but any one of the other vowel sounds. This mismatching appears humorous (and complimentary to the comical pictorial distortions of the artist's face). Although Iimura's stated aim in this work is to separate the identities and properties of picture and sound, as an indirect consequence the work also presents a false sense of the basics of the Japanese language.

> In the … "interactive" part of the (work), one is however supposed to alter the relations between pictures/colors and sounds. This is a very simple but also striking statement about the arbitrariness of semiotic relations.[16]

Despite interpretations and perceptions about the semiotic possibilities of this work, Iimura claims that he did not intend the installation to have any specific or particular meaning beyond an attempt to be 'very universal'. He has explained in interviews that in spoken language the vowel usually acts as a signifier and is very different in what it signifies in different languages, and that in comparison with English, Japanese is more dependent on the vowel sounds. *AIUEONN, Six Features* exists in numerous

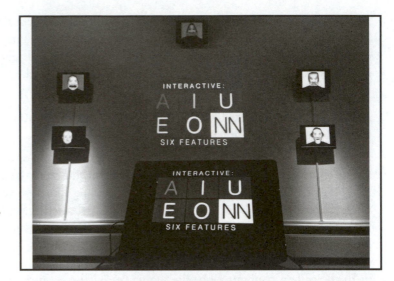

11.7: Takahiko Iimura, *AIUEONN, Six Features*, Interactive installation, 2012. Courtesy of the artist and Harris Museum, Preston.

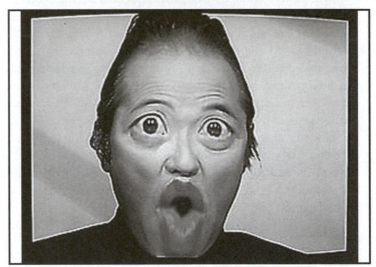

11.8: Takahiko Iimura, *AIUEONN, Six Features*, Interactive installation (detail), 1993. Courtesy of the artist.

forms other than as an installation – including as an interactive CD-Rom as a live performance, and as a kind of 'meta-game' in which the participant can form their own words from the six vowel sounds.[17]

Much of Iimura's work is centred on linguistic and conceptual ideas, and even in works that are not 'interactive' in the sense that they invite the audience to

physically participate in the way that *AIUEONN Six Features* does, they are not simply about what can be seen and heard on the monitor or from the screen, but are centred on the implications of the spectators' experience of looking and perceiving. A number of these works explore the relationship between word and image and the differences between the construction of meaning in English and Japanese. For example, in the Installation *As I See You, You See Me* (1990), two video cameras face each other and the written text 'I See You' is mounted on an adjacent wall. The artist is recorded walking back and forth between the two cameras repeating this phrase in the both Japanese and English. As with previous installations such as *This is a Camera Which Shoots This* (1980) Iiumra is interested in dealing the complex interrelationship between the image of the word, the word of the image and between speech, text and sound. Iimura describes this approach to the relationship between words and images as 'The Phenomenology of the Self' and draws directly on the ideas of Jacques Derrida – specifically from *Speech and Phenomena* (1978) in which Derrida wrote: 'I hear myself at the same time as I speak'. Although the original Derrida quote was only concerned with speech, Iimura has extended this idea to include sight and the act of seeing oneself. Iimura is interested in the fact that the viewer of the video work would no longer be the one who speaks the words, but the one who sees and hears.[18]

Takahiko Iimura has a strong sense that technology and theory are not antagonistic, but highly complimentary and his experiments with interactivity and the relationship between theory, language and electronic and digital imaging is a testament to this insight. His video work, which includes all aspects and manifestations of the medium-live performance, installation, single and multiple channel video tape, spans 40 years, and provides a bridge between the approach of American and Western European art practice and the sensibility of Eastern aesthetics.

EXTENDING AND CHALLENGING THE GALLERY AND BROADCAST CONTEXTS

The video artists discussed in section two have adopted a range of strategies to making, exhibiting and presenting their work. Many of the artists who have made single-screen durational tapes have taken up a position in relation to broadcast television. A number of the works directly address the broadcast context: Sjölander and Weck's *Monument*, Serra and Schoolman's *Television Delivers People*, Hall's *This is a Television Monitor/Receiver*, and Birnbaum's *Technology/ Transformation: Wonder Woman* have all been broadcast in one form or another, and function most successfully in relation to television. They refer primarily to the broadcast viewing condition, referencing, deconstructing and/or critiquing the home television audience experience. Although very explicitly *not* broadcast television programmes in any traditional sense, they are

about television, and even when presented in non-broadcast situations such as the gallery, they address the television context.

Some works however, which include Elwes' *With Child*, Reeves's *Obsessive Becoming*, Vasulka's *Art of Memory*, and Viola's *The Reflecting Pool,* make no explicit reference to the broadcast context, and yet function well in this arena, operating as single-screen durational pieces with much in common, superficially at least, with broadcast television programming. All of these works have been screened on television at one time or another, although none, with the exception of *Obsessive Becoming*, was produced primarily for broadcast.

For the most part however, video artists working in this period functioned deliberately and explicitly outside of the television production structure, and most, if not all, saw themselves and their works in some important sense as being in opposition to mainstream broadcast television. The Duvet Brothers' *Blue Monday*, like *Technology/Transformation: Wonder Woman* was intended to be critical of conventional television, made to be shown outside of the broadcast context, via alternative distribution networks.[19] The tape was, however, once broadcast as part of a programme specifically devoted to the work of Scratch Video artists.[20]

Although Peter Donebauer's work has been broadcast occasionally, *Merging-Emerging* and many of his subsequent tapes were produced through a process of live interaction between the artist and his collaborative partners, including musicians and dancers. This unusual production process emphasizes the expanded potential for the work as a 'live' experience, similar to that of the participatory and active relationship between an audience and live musicians. Although Donebauer's works can be experienced via television and in closed-circuit gallery environments, they reach their full potential as works of art in this live viewing context. There is also a significant issue here in relation to the 'abstract' (non-representational) nature of Donebauer's tapes. All of his video work is non-narrative and non-representational and perhaps best described as 'gestural'. The live experience of this gestural content is totally lost when Donebauer's work is presented in gallery or broadcast format, and thus the most accessible and rewarding aspect of the work is absent.

Works such as Wojciech Bruszweski's *The Video Touch* and Steve Partridge's *Monitor* were intended to be shown in an art gallery outside of the broadcast context, but function primarily in a direct relationship to the everyday experience of the television box. Clearly making reference to a closed-circuit video system, these works have been shown primarily as gallery pieces, and distributed on videocassette by organizations such as LVA in the UK. Both works, although durational, refer directly to the television as object, forming a direct bridge to 'pure' sculptural video installation,

primarily intended to function within an art gallery environment such as, *De La, Il Nuototore* and *Rite II, The Situation Envisaged.*

Video artists working with installation often sought to explore spatial and physical relationships in relation to screen image content, frequently including numerous interactive elements. This 'participatory' dimension is of paramount importance in video installation, the audience engaging directly with the work at a physical and emotional level. In installations such as Judith Goddard's *Television Circle* and Gary Hill's *Tall Ships* this physical engagement produced an awareness of a radical new space for art spectatorship beyond the confines of the gallery or the narrative linearity of conventional television broadcasts. In the case of Takahiko Iimura's *AIEUONN Six Features*, this level of participation has been extended and enhanced by the addition of computer-aided interactive technology.

This sculptural and participatory audience engagement was particularly influential on my own decision to concentrate on installation work at the end of the 1980s. Given a commitment to video work that was decidedly *not* for broadcast, and an increasing interest in the relationship between images on screen and the placement of the monitors/screens within the space, a move towards multi-screen installation work was inevitable within my own practice. This attitude was not uncommon among artists who had chosen to work with video during this period.

12. THE UBIQUITY OF THE VIDEO IMAGE
ARTISTS' VIDEO AS AN INTERNATIONAL PHENOMENON

Although as we have seen in Chapter 4, the early history of artists' video was primarily centred on developments in Western Europe and North America, it has always been a medium in which there was an extensive cross-fertilization of influences and approaches characterized by the free movement of ideas and experimentation. Artists, curators and writers have been increasingly interested in the medium and its potential to challenge and reach new audiences and over the last two decades artists' video has become a global phenomenon.

This chapter contains a number of examples of work by artists from countries and regions where video art has more recently began to emerge such as China, the Middle East, Pakistan and Africa. In some cases the artists under discussion have returned home from studying in art schools and academies in countries where the medium has already become more main-stream such as the USA, the UK and Germany. But elsewhere, particularly in China for example, political and social changes opened the way for the recognition of the medium as a valuable addition to the artists' repertoire.

TURBULENT, SHIRIN NESHAT, USA, 1998 (TWIN-CHANNEL VIDEO PROJECTION INSTALLATION, USA. MONOCHROME, SOUND. 9 MINUTES, 8 SECONDS. DIRECTOR OF PHOTOGRAPHY, GHASEM IBRAHIMIAN; MALE PERFORMER: SHOJA AZARI; MALE SINGER: SHARARM NAZARI; FEMALE PERFORMER AND COMPOSER: SUSSAN DEYHIM)

In a darkened gallery space two large-scale square, black-and-white images are projected onto adjacent walls. Both images begin with an image of the same auditorium, one full, the other empty, which then quickly cuts to a continuous panning shot (from left to right) showing the same auditorium. In the image on the left-hand screen, the seats are all occupied by men identically dressed in white shirts with black trousers. In the image on the right, the auditorium is empty, the seats folded. In the left image a male singer enters onto the stage, bows to his audience, and turns away to face a microphone. In the adjacent image a shrouded and silhou-etted figure (female?) enters the frame and faces an identical stage, although the auditorium is still empty. The male performer begins to sing a classical Persian song, with words by Jalal ed-Din Rumi, a thirteenth-century Sufi poet. The passionate and emotional tone of the singing suggests to a Western audience, unfamiliar with the

meaning and content of the lyrics, that the song might express romantic and secular love rather than the religious content is was written to convey. During this impassioned and compelling performance, the other performer, seen only from the back, remains mysterious and anonymous and seems simply to be looking out at the empty auditorium, perhaps lost in thought, or perhaps listening passively to the performance emanating from the opposite screen.

As the male performer completes his song and turns to receive and acknowledge his applause, he is suddenly distracted, and turns away from his masculine audience again to face the camera (and the off-screen audience) and approaches the microphone, but not to sing, instead he is listening, concentrating on the sounds coming from the performer on the other screen. On this other screen the performer is gradually revealed as the camera begins to track with a continuously encircling and swirling motion, and is finally revealed as a woman dressed in a traditional chador as she begins to perform a powerfully emotional but wordless, rhythmic musical chant. In marked contrast to the man's poetic and precise lyrics, the sensuous, abstracted emotional – almost primal sounds of the woman produce an expression of loss and yearning. The two screens now seem to have become linked, as the male performer seems drawn in to focus on the woman's performance, listening intently, captivated and mesmerised by her lamenting *cri de coeur*.

As her electronically enhanced and wordless song fades out, the image of the man is digitally frozen, and his expression of uncertainty is held, as the female performer completes her gestures signalling that her song is complete. Both images fade to black.

For Sharin Neshat (1957, Iran), an artist of Iranian origin who has been educated in the United States, the work does have a feminist perspective, but rather than a specifically Western feminist approach *Turbulent* begins with an attempt to depict the Iranian experience:

> The reality of contemporary feminism in Iran is that resistance is an essential part of a woman's experience. As a result, women are very tough, the exact opposite of the outside image we have of these women. My attempt has always been to reveal, in a very candid way, the layers of unpredictability and strength that are not so evident on the surface.[1]

In this double-screen installation the viewer is presented with a complex range of potential possibilities and interpretations, as the work raises numerous questions and suggests multiple meanings. At an important level the viewer is asked to evaluate and examine both the visual and cultural context, and he or she is required to engage with the work via his/her personal political and cultural perspectives, as much as his or her chosen visual perspective. As the Canadian filmmaker Atom Egoyan has written: 'It is

precisely this unique quality of the work – its ability to be at once open and generous and yet so completely impenetrable that is so effective in terms of the way the work addresses and engages the spectator.[2]

Although at one level *Turbulent* presents the audience with a clear depiction and potential critique of the patriarchal authority and privilege in Iranian society, it also uses the formal device of the double screen to simultaneously evoke and present the multiple dualities of contemporary cultural life outside of the Iranian context: East/West, Secular/Religious, Male/Female, and perhaps most significantly, the roles and conventions of Active/Passive, both in terms of the way the that the male and female roles are interpreted and depicted and in terms of the way individual members of the audience can choose to engage with the work. The twin-screen format allows the spectator to select a viewpoint and to choose their own level of engagement and interpretation, and perhaps most importantly to become aware of that process.

For Neshat, *Turbulent* is the first of a series of three installations to explore the topic of the roles of Masculine and Feminine within the social structure of contemporary Iran – the other two–*Rapture* (1999) and *Fervor* (2000) complete the trilogy and for the artist also close the chapter. It was the experience of making this work and the ideas and themes that emerged from it that led to the other works in the series. For Neshat both *Turbulent* and *Rapture* are based on visual and conceptual opposites which centre on the way men and women respond to the society they are living within:

> The male singer represents the society's ideal man in that he sticks to the rules in his way of dressing and in his performance of a passionate love song written by the 13th-century Sufi poet Rumi. Opposite to him, the female singer is quite rebellious. She is not supposed to be in the theater, and the music she performs breaks all the rules of traditional Islamic music. Her music is free-form, improvised, not tied to language, and unpredictable, almost primal.[3]

This oppositional duality is representative of a wider set of concerns and issues that can be understood as universal and transcendent. Although *Turbulent* can be read as a critique of the position of women in Iranian contemporary life and the fact that they are prohibited from public singing, the work can also be understood to engage with issues that are not simply culturally specific, but address questions related to much wider concerns which connected to freedom and identity for both genders.

Turbulent also provides an example of the technical and formal convergence between film and video that has occurred over the last decade. In discussions and interviews the artist has referred to *Turbulent* and the other two works in the series as video installations, and yet at other times Neshat has spoken of the cinematic

nature of the work. Increasingly, this way of describing gallery-based moving image works is not contradictory. In fact, *Turbulent* was shot on 16mm film that was then transferred to video and projected digitally. This hybrid approach is a clear example of the formal significance of the interwoven nature of contemporary artists' video. The term 'video installation' refers to the preferred format of the display medium, which is chosen partly for its practical convenience over film projection, but also for its perceived gallery credentials, and the fact that it is not a conventional cinema experience, but has sculptural and participatory aspects that are more related to approaches developed in artists' video than to narrative or experimental film. This aspect is further reinforced by the fact that the entire work is available to be viewed and experienced on-line, with the twin images contained within the single screen of a personal computer. On close viewing, there are a number of manipulations and digital post-production modifications in *Turbulent* which are intrinsic to video – these include the shaping of the 16mm film format to provide the identical square frame of the installation, the freeze-frame editing of the male performer in the final moments of the left-hand frame, and the electronic manipulation of the women performer's voice. Whilst this kind of post-production is not exclusive to video, they are intrinsic to the artist's intention to construct a work in which the audience is required to actively engage with the work rather than to be immersed in a narrative or quasi-narrative experience.

WILD BOY, GUY BEN-NER, ISRAEL, 2004 (COLOUR, SOUND, 17 MINUTES, 19 SECONDS. MAN: GUY BEN-NER. BOY: AMIR BEN-NER) (THIS WORK HAS ALSO EXHIBITED AS AN INSTALLATION WITH A SET CONSTRUCTED FROM MATERIALS USED IN THE VIDEOTAPE INCLUDING A TREE AND A CARPETED HILL FROM WHICH VISITORS CAN VIEW THE VIDEOTAPE.)

Wild Boy is one of a series of deceptively playful narrative videotapes that Guy Ben-Ner (1969, Israel) began in the late 1990s and that feature himself and other members of his family. These works, which American film academic Tom Gunning has described as 'anti-movies, in which childhood fantasies meet adult ironies'[4] include *Berkley's Island* (1999), *Moby Dick* (2000), *House Hold* (2001) and *Elia – the Story of an Ostrich Chick* (2003). These videotapes often feature sets constructed within the domestic interior spaces of the artists' home/studio and involve a complex mix of slapstick humour, cinematic narrative, with references to performance art, literature and the often-conflicting roles of parent, father and artist.

Wild Boy takes the François Truffaut film *The Wild Child (L'enfant sauvage)* (1970) as its primary inspiration, but also references other works exploring the themes relating to the discovery and civilizing of a feral child, such as Werner Herzog's 1974 film *The Engima of Kaspar Hauser* and Rudyard Kipling's *The Jungle Book* (1894). The work also draws on numerous other sources and references, most significantly ideas

12.1: Guy Ben-Ner,
Wild Boy, 2004.
Courtesy of the artist.

12.2: Guy Ben-Ner,
Wild Boy, 2004.
Courtesy of the artist.

related to the silent film auteurs Buster Keaton and Charlie Chaplin and the performance work of the artist Dennis Oppenheim.

In *L'enfant sauvage* Truffaut himself plays the part of Doctor Jean Itard, the man who seeks to tame the feral child who is the central protagonist of the film. Guy Ben-Ner's *Wild Boy* makes a number of direct visual references to the Truffaut film, in an acknowledged homage to the French filmmaker; the scene in which the wild boy spends the night in a tree top, the drumming scene in which father and son mime to the Doors' 1967 track 'Break on Through to the Other Side' and numerous shared walks in the countryside.[5] In *Wild Boy*, Ben-Ner has cast himself as the doctor, echoing the narrative structure of the Truffaut film, but also engaging in a number of parallel narratives related to the role of parent and father to the child in his video, played by Ben-Ner's young son, Amir.

In *Wild Boy* Amir is initially shown running wild, then once captured, being educated and civilized – bathed, dressed and taught to speak and write through a series of inventive, playful and gently comic episodes. For Ben-Ner, this central theme of the wild boy and his education is the core idea of the work – to use the artist's own image, the 'magnet that attracts many ideas'.[6] In *Wild Boy* and earlier works of this period Ben-Ner seeks to weave a complex work that presents and explores the layers of power-relations that pervade both the culture and his own private life. The rich mix of cultural references built around the central story in *Wild Boy* is extended to reference Buster Keaton's work with his father Joe in his early family Vaudeville routines, Dennis Oppenhiem's live performance work with his young son Erik,[7] and the notion that silent cinema was 'tamed' by the introduction of spoken language and sound effects in the late 1920s.

Ben-Ner chooses to work with narrative structures because of his fascination with storytelling and a desire to reach a diverse audience. Guy Ben-Ner's works of this period aim to engage the viewer via a complex blending of the quotidian world of the domestic, the fantastic world of the adventure story, and the often conflicting roles of the family man and the artist, and the consequences of his personal choices:

> I was faced with the choice of either taking a studio and spending a lot of time there or staying at home and being a proper dad, and not getting a lot of practice [with my art] because I'm pretty obsessive whenever I do something … working at home but with the kids was a kind of compromise. As if I was saying: 'OK, I stay at home, but you have to pay for this.[8]

The narrative progression of *Wild Boy* is not just achieved by restaging selected cultural fragments, but is also communicated to the viewer through the cinematic agency of image and sound. For example, during the child's initial wild stage, the sound track includes 'natural 'sounds and effects such as birdsong and environmental atmosphere. Once the boy has been captured, the soundtrack disappears altogether, and the images are silent. The camera work also takes on a similar parallel function, fluidly tracking the boy's movements during the untamed stages, but becoming static and fixed once he has been caught and the process of education begins. In addition to the multi-layered *mis-en – scene*, the artist has been able to blend in aspects of documentary, as Guy Ben-Ner attests that within the work there are some significant and authentic moments – Amir's first hair cut, his first words in English, and the first time he puts on a shirt himself.[9]

Ben-Ner has stated that he was for many years fascinated by the writings and ideas of Jacques Lacan, and in *Wild Boy* there is a clear reference to the potential two-way

communication that develops as the father exchanges his form of learning – structure and language, for the boy's blissful prelinguistic state, offering Ben-Ner something valuable in return. As Rebecca Weisman points out in relation to the work: 'The unconscious 'other' that Ben-Ner's child reflects to him offers him the ability to unlearn and regress, in order to redefine, reconfigure and re-circumscribe his own subject-hood, moving within the semiotic space of video and film itself'.[10]

SHAN PIPE BAND LEARNS THE STAR-SPANGLED BANNER, BANI ABIDI, PAKISTAN, 2004 (7 MINUTES, 30 SECONDS, DOUBLE-SCREEN VIDEO PROJECTION, COLOUR, SOUND)

Shan Pipe Band Learns the Star-Spangled Banner is one of the first video works the artist Bani Abidi (1971, Pakistan) made after returning to her native Pakistan from a six-year period living and studying in Chicago. In this double-screen projection, a group of local musicians who earn their living playing at wedding ceremonies in Lahore are presented engaged in the task of learning to play the American national anthem, a tune that is clearly not part their usual repertoire. On one side of the projection screen the group are shown seated together in a rehearsal space, learning the tune by ear listening to a pre-recorded version of the *Star-Spangled Banner* on an old cassette recorder. The fixed-camera presents the group as they progressively pick up the melody and rhythms on their instruments (oboe, clarinet, bagpipes and drums), before finally playing their somewhat uncertain although instantly recognizable rendition of the anthem. The end result of their session is strange and unfamiliar rendition of the tune, but it has a delightfully local, if somewhat discordant sound. There is a sense that the music has been adapted and filtered through the process, although not entirely re-appropriated.

On the opposite side of the projection screen and running concurrently with the rehearsal session, the musicians are shown preparing for a performance, dressing up in colourful and rather formal garments which clearly draw on the design of the uniforms of a British military band, referencing Pakistan's colonial past and heritage.

The structure and presentation of the work has a clear pedigree, and follows an approach that has been explored by video artists when documenting a task-oriented performative activity. The installation makes effective and economical use of the double-screen format and has a powerful political message underlying its humour and affectionate depiction of the band and their performance. The work makes a clear and troubling statement about the precarious position of Pakistan – perched in transition between its colonial past and its current uncertain relationship to the United States and its global influence.

The artist was acutely aware of this position when making the work and wanted to express her perceptions of the situation in her home country, extending ideas she had

12.3: Bani Abidi, *Shan Pipe Band Learns the Star-Spangled Banner*, 2004. Courtesy of the artist.

previously engaged with in *Anthems* (2000), a split screen video work exploring the way in which popular music could evoke nationalist feeling. Abidi developed the idea for *Star-Spangled Banner* at the end of 2003 after returning to Pakistan from the USA. With this fresh perspective, the dynamics of the situation were very apparent to her:

> The "war against terror" had just begun and it all felt really wrong, that Pakistan was once again in the midst of a war that involved the US and Afghanistan … considering that the contemporary history of the country had already been shaped by the US/Soviet conflict in Afghanistan, with disastrous consequences. And I would often think of Pakistan as a young and faltering nation that was caught between global geopolitical movements (British colonization followed very soon by a kind of US colonization) … and how that left very little space for any real independence.[11]

Abidi met the members of the band whilst in Lahore and enlisted their participation via as she describes it – 'a purely commercial transaction'. The artist devised and set the task for the musicians, and recorded their progress over the two consecutive afternoons whilst they learned the music. She wanted the video documentation to convey their relaxed attitude to engaging with the exercise and to simultaneously make a wider and more political point. The multi-layered idea at the core of the work with its underlying message is central; there is a sense of acceptance and even indifference to the new political reality in which the band players have found themselves.[12]

Abidi did not study video whilst at art college, but began working with the medium after years of making paintings, sculpture and installations, discovering the experience of being able to work with time and sound particularly appropriate to her ideas. Her

first work with the medium was *Mangoes* (1999–2000) a single-screen work in which she plays the parts of two expatriate Pakistani and Indian women who, whilst eating mangoes together begin to argue as they reminisce about their childhood. Abid says she found this work liberating to make and to exhibit, in contrast to her experience of showing painting and sculpture and the effort of 'moving physical objects around the world'.[13]

Shan Pipe Band Learns the Star-Spangled Banner is a deceptively straightforward work in terms of its technical and formal approach. To some viewers this 'unmediated' depiction of the process with its fixed-camera documentation of a local band learning to play a new tune, might perhaps on first encounter appear simply humorous and even light-hearted. However the power of the work grows as it unfolds and the underlying meanings resonate even more powerfully as a result of Abidi's light touch and insightful approach to the medium.

30X30, ZHANG PEILI, CHINA, 1988 (SOUND, COLOUR, 32 MINUTES, 9 SECONDS (EDITED DOWN FROM THE ORIGINAL 180 MINUTES)

This 30-minute videotape, considered to be the first by an artist in China, was made partly as a response to an invitation to produce a new work for a Conceptual Art conference in 1987. However, it should be considered as neither a new departure, nor unique in Zhang Peili's oeuvre. Originally trained as a painter, the artist first began to explore the potential of a variety of alternative media in his practice during the 1980s, including photography and video. Since its initial screening *30 x 30* has become an iconic work, symbolizing the opening up of modern art in China, but this tape should not be considered in isolation from its broader context. As Robin Peckham points out in his essay on the work of Zhang Peili, proclaiming this particular work, and the artistic output of Peili in isolation, is problematic and deceptive:

> That Zhang Peili is so often hailed as the founding father of video art in China has actually done a disservice to the compelling connections between his own work and the critical artistc and pedagogical offshoots that have come to define the field of cultural production in China today. Recent scholarship and curatorial exegesis, however, seem poised to change our understanding of both his oversized place in the canon and the considerations behind specific works.[15]

The 1987 Hunangshan conference marked a turning point in Chinese contemporary art, and Peili's video tape *30x30* has come to symbolise a new wave of innovative Conceptual Art practice that has its roots in an approach that can be traced back to the mid-1980s and continues into the recent period.[16] The original version of *30x30* was a continuous three-hour recording of the artist repeatedly smashing and then

carefully gluing a 30x30 centimetre mirror back together again. (This 30x30 cm size could be understood to be approximately the size of a small TV screen, although TV screens are not square – 3:4 being the standard aspect ratio)

In an interview Peili claimed that he had not set out to make a statement with a new medium, but claimed his intentions were more straightforward, and that it was the capacity to present the documentation of his action in continuous 'real' time:

> [I] … wanted to create something vexing. It didn't employ any tricks to evoke joyful sentiments; I wanted to make people aware of the existence of time. The temporal aspect of video happened to suit this need.[17]

Visually the work is tightly framed to provide the viewer with a direct and fixed perspective of the activity. The artist sits cross-legged on the floor in front of a small, square unframed mirror. We do not see all of him, but there are occasional glimpses of his reflection in the mirror, his expression focused intently on his task, which is to repeatedly break and repair the mirror placed in front of him on the floor. The artist's hands are protected with white latex gloves, one hand occasionally holding a small tube of glue, the other carefully manoeuvring the shards of mirror into position. The sound is synchronous and ambient.

The latex gloves that Peili is wearing in the tape are a constantly recurring motif, and feature in many of his works and for Peili they represent and symbolise the Chinese government's institutional control and what he terms the 'hygienic instability' of the body.[18] The videotape's original 180-minute duration, spanning the length of entire Sony Betamax cassette tape, was in part a ploy to challenge the intended conference audience and their commitment to the aesthetics of conceptual purity in a desire to move away from the conventions of studio art. However, at a more general level the tape was a reaction to the increasing popularity of broadcast television entertainment and a desire to mock the perceived social impact and consequences of passive spectatorship in China.[19]

Peili's work, which includes performance, photography and installation as well as video and electronic art, is centered on his fascination for the social and political dimensions of these 'alternative' art forms and allied to an interest in the mismatch between lived reality and the mediated image of popular media. Since producing *30x30* Peili has exerted a powerful influence on subsequent generations of Chinese artists both through his work and via his teaching position at the China Academy of Art in Hangzhou, where he founded the department of New Media in 2003. In 2011 a major retrospective mounted at the Minsheng Art Museum in Shanghai presented many of his most significant and influential video and installation works from across his career. In addition to *30x30* the exhibition presented *Watermark* (2004), an

hour-long video recording of water droplets evaporating; *Uncertain Pleasure* (1996) a twelve-screen video installation showing close-ups of a hand scratching various parts of a male body; and *Water: Standard Edition of Cihai Dictionary* (1991) in which, the artist presents a recording of the well-known broadcast TV news reader Xing Zhibin, reading multiple dictionary definitions and meanings of the word 'water' in precisely 'approved' Chinese pronunciation – the equivalent of the BBC's 'Received English'. Equally significant and influential are video works that explore and critique issues related to state control and the institutionalization of the body such as the videotape *Hygiene No. 3* (1991) in which he carefully washes a chicken in a bowl of warm water and *Assignment No. 1* (1992), detailing a routine blood test displayed on twelve differently adjusted video monitors

However important a breakthrough *30x30* was in the history of Chinese contemporary art, Zhang Peili's video work should be understood as part of a larger body of work in a variety of related media that heralds the development of the trajectory of the subsequent generation of artists in China. Prior to making *30x30*, Peili also produced a number of important conceptual works that make use of text-based instructions such as *Art Project No. 2* and *About X?* (both 1987), which have also been highly influential on the direction of Chinese contemporary art in the decade that followed.

VIRUS, CHURCHILL MADIKIDA, SOUTH AFRICA, 2005 (COLOUR, SOUND, 2 MINUTES)

The South African artist Churchill Madikida (1973, South Africa) first began to work with video in 2002, initially only using the medium to document his live performance work which he subsequently reworked.[20] Much of his work contains a strong autobiographical element, and this intimate theme is extended to explore not only his personal history and experience but to investigate and represent his ethnic and national identity, and to make this available to others.

> My art is autobiographical and deals with my Xhosa and South African heritage as a form of positive identity and self-imagery, but it is also directed to the public at large so that people may learn about my culture. I reject some people's confinement through censorship that restricts our choices of representation. Through my art I aim to make societies understand themselves, risk self-examination, address issues, attitudes, and behaviors, and finally I aim to make those societies challenge themselves to be open to change.[21]

For a number of years Madikida has produced a series of works relating to the HIV/AIDS virus including a set of lambda prints *Virus I–V*. These works share their iconographic imagery with his short video work *Virus* that continues and extends this approach to exploring the sphere of the personal and the intimate as a political

statement. Both the prints and the video present imagery derived from the micro-structure of the HIV virus itself, but referencing this personal experience by including the figure of the artist himself in the centre of the cell structure.

In his catalogue essay 'Inside Out' the South African artist and writer Colin Richards has written eloquently about the formal beauty of the imagery that Madikida depicts in the video and the related print series, describing the image that forms the area surrounding and enveloping the artist in *Virus* as a field bounded by complex structures:

> ... some of which appear to melt, or are perhaps at some point reflected in surfaces which distort them. In this instance such distortion involves processes of morphing which themselves suggest biological processes of mutation, and mutation is a key process in the catastrophe of HIV/AIDS. In many of the images the entire structure appears paradoxically both as a cut section and as a whole seen from the outside. This ambiguity is intriguing, as it involves an aesthetic of violence (a cut, a slice) and of wholeness.[22]

Within this ambiguous red field the male figure of the artist is initially presented crouched in a foetal position, but as the work unfolds, this human form gradually disintegrates and instead of developing towards birth, it is absorbed and transformed until it becomes an indefinable abstraction in which individual identity is eradicated through the progress of this devastating disease. As this stunning and disturbingly beautiful visual transformation takes place, the soundtrack comprises a song which compels the viewer to consider the loss and nostalgic longing for the past security of home and family. The melody, sung in the Xhosa language by the artist's sister, who tragically died of AIDS in 2005, contains the words: 'Sengikhumuli'khaya labazali bam abangishiya ngisemncane' '[I remember the home of my parents who left me when I was young]'.[23]

Virus is closely related to a video work that is the main component in Madikida's video installation *Skeletons in My Closet* (2004), which refers to situations in which the HIV/AIDS is contracted as a result of tribal circumcision rituals that are performed during traditional initiation rites.[24] In these works Madikida explores the fears and terrors that the HIV/AIDS pandemic is exerting on the population of the entire continent of Africa, and in a wider context raises discomforting questions about the relationships between disease and sexuality and in relation to the racial and gender stereotypes that have been inherited and propagated since the colonial era. His video work has extended the reach and impact of his performances, challenging taboos and stereotypical notions of identity and culture. Madikida works with video as part of

an exploration of his own background, but understands the power and impact of the medium to reach out to connect to others through its immediacy and directness.

> With my art I choose to reclaim the past, to explore my history and to work as a storyteller telling about our past, present, and future. Through visual representations, I connect the past to the present. It is my way of knowing what I know, a way to uncover how, where, and why I learned it, and a way to unlearn it. I think that in a society that preaches democracy and multiculturalism, it is important to have an art that expresses and illustrates diverse perspectives, even if it means producing controversial visual images that some people might not like.[25]

CONCLUSION

The works discussed in this chapter provide a glimpse into the way in which artists from a number of countries outside of Western Europe and North America have taken up the medium, either directly as their preferred medium or as a result of seeking alternatives to the more traditional mediums of painting, sculpture and photography. As in the West, however, they often began to work with video after using it initially for the documentation of performances and/or installations, as a development from photography, or as part of a mixed media approach. As in other countries, video proved attractive because if its immediacy, accessibility and ease of use, but also as it offered an alternative approach with a political 'edge', a medium that for many was still on the cultural fringes, and as such suited the ideas and attitudes of a new generation of artists. As had been the case with previous generations of artists who took up the medium, new technological changes continued to improve the ease of use, the versatility, the image quality and the accessibility of video. Camera/recorders became more compact and robust, became cheaper to purchase and produced higher quality and better resolution. Image playback and display began to rival film in terms of its picture quality and relative brightness, and the equipment was generally much more easily available.

But these technological developments were not the only factor in the development and spread of video as an art medium. Galleries, curators and the art market had developed new ways to collect, commodify and sell video. By the early 1990s private collectors had begun purchasing artists' video, major public galleries were acquiring and exhibiting video installations and tapes by key artists, and the medium was acknowledged to have a distinctive historical and critical perspective with its own unique trajectory.

PART III

**THE DEVELOPMENT OF ARTISTS' VIDEO AND VIDEO
INSTALLATION IN RESPONSE TO TECHNOLOGICAL
CHANGE AND ACCESSIBILITY**

The final section of this book discusses the development of artists' video in relation
to available technological categories during the period between under consideration.
The section explores the relationship between the emerging imaging techniques and
artists' video, highlighting the contribution of feminist art practice and examining
the influence of video technology on video art and the shift from modernist to
postmodernist discourse. There is a discussion of issues related to the accessibility
of image-production facilities, as well as the impact of this technology on the
development of formal innovation, its interrelationship to content and the art
historical context. Certain questions are raised with respect to the introduction of
key technological developments – for example: has the advent of high quality video
projection given rise to the pre-eminence of the 'cinematic' video installation? The
impact of digital technology on video art is also addressed – especially in relation to
issues of interactivity, non-linear editing, and of the convergence of film, video and
photography.

13. FIELDS, LINES AND FRAMES
VIDEO AS AN ELECTRONIC MEDIUM

By the mid-1970s many artists had regular access to colour video and had begun to explore its creative potential. The earliest colour work was produced using TV broadcast studio facilities, or by artists who had built or customized their own equipment. (See Chapter 7.) As has been previously discussed, Ture Sjölander and Lars Weck gained access to the broadcast studios of the Swedish National television in the 1960s to produce a number of works including *Time*, *Monument* and *Space in the Brain*. Robert Cahen's *L'invitation au voyage*, was produced at ORTF in Paris in 1973. The Vasulkas began working with colour in 1970, with *Decay 1*, Peter Campus made *Three Transitions* at WGBH in Boston whilst Artist in Residence in 1973, Bill Viola's first colour videotape, *Vidicon Burns* was completed in 1973 at the Synapse Video Center at Syracuse University, New York. Peter Donebauer's work with video, begun in 1972 in the studios of the Royal College of Art, was in colour from the outset. These are simply a few examples of works by a few of the artists discussed in this book – there were of course many others.

These forays into the realm of colour video were instigated by the availability and access to electronic imaging technology enabling accurate and reliable colour video production. In the United States the Public Broadcasting System (PBS), often considered as a 'fourth television network' running alongside and competing with the NBC, CBS and ABC commercial networks, provided a limited access to artists through a number of centrally funded residency programmes in the late 1960s and 1970s. For example the facilities at Boston's public television station WGBH were an important early influence on the development of video art in the USA. Established in the early 1960s, the station encouraged experimentation, with technical staff working alongside innovative producers and directors. In *Jazz Images* (1964) producer Fred Barzyk (1936, USA) instigated an experiment in which five cameramen were asked to experiment with video imaging to interpret music performed by the Boston Symphony Orchestra. In 1967 Barzyk produced *What's Happening Mr. Silver*, a weekly broadcast TV programme about pop culture hosted by Tufts University

Professor David Silver, who hosted the show in the nude reclining on a bed set up in the centre of the TV studio! In an interview with Gene Youngblood, Barzyk describes his approach, and the resistance he encountered from some of his technical staff:

> We tried to create new problems in the broadcast system so that we could break down the system as it existed. We adopted some of John Cage's theories: many times we'd have as many as 30 video sources available at once; there would be twenty people in the control room – whenever someone got bored they'd just switch to something else without rhyme or reason... . Initially there was a great deal of resistance from the engineering staff, as might be expected when you change somebody's job conditions ... the pressure is reversed to bring creativity out instead of repressing it; we have the most production oriented engineers in the whole country, I'd say. In effect we tell them the station is experimenting and we ask them not to be engineers.[1]

Drawing on and extending the experience of this experimentation with video technology and creativity in a broadcast context, WGBH established the New Television Workshops, an artist in residency programme with grant aid from the Rockefeller and Ford Foundations in 1967. Two years later the station broadcast 'The Medium is the Medium' a 30-minute compilation of works by numerous artists including John Cage, Allan Kaprow, Aldo Tambellini, Nam June Paik, Peter Campus and William Wegman.[2]

A similar project was funded from the same source to establish the Experimental Television Workshop at KQED in San Francisco on the American west coast. In the first year of the project at KQED, the work was entirely in black-and-white, and brought together artists from a diverse range of fields including composer Richard Feliciano (1930, USA), poet Joanne Kyger (1934, USA), writer William Brown (1928, USA), painter and sculptor William Allen and filmmaker Loren Sears (1939, USA). These artists and other contributors worked directly with Robert Zagone as director of the video sessions and Brice Howard, who organized and administered the project. Howard's notions about television and in particular the television screen as a medium are instructive of the approach and aspirations of the project:

> The monitor screen has some remarkable characteristics. Among other things, it itself is information irrespective of anything you put in it – sign, symbol, rhythm, duration or anything. It is delicious all by itself, if you want to enjoy it, though its matter is apparently of a totally random character. It is different, for example, from the reflective surface, which is a movie screen, off which light bounces with the image intact. But television is an electronic surface whose

very motion is affecting the motion that you're putting into it. And what is really the richest part of television, less its technology, less its cubist nature, less its incredible colorations and shapes and motions – its now, its capturing the damned actual with all of its aberrations. Television will help us become more human. It will lead us closer to ourselves.[3]

The television broadcast work of Gerry Schum has been discussed in detail earlier, as have Sveriges Television's (Sweden) support for Ture Sjölander in the late 1960s; the 1971 'TV interventions' of David Hall on STV in Scotland; the BBC transmissions of Peter Donebauer's *Entering* on 'Second House' in 1974; and the 1976 'Arena' special on artists' video, but there were important examples of the broadcasting of artists' video in other countries during this period. For example Jean-Cristophe Averty produced *Avec Nous le Deluge* ('With Us the Flood') for ORTF in France in 1963, ZDF (Zweites Deutsches Fernsehen), Germany produced *Das Kleine Fernsehspiel* ('Little Television Plays') during the 1970s and RTBF (Radio-Television Belge de la Communaute Francaise) offered a number of international artists access to production facilities and broadcasting in a monthly series entitled 'Videographie'.[4]

Offering artists limited access to broadcasting facilities was only one strand of the history. Much of the work done by artists in the first decade was made using the Portapak or formats considered to be impossible to broadcast by the engineers and television authorities. Sue Hall and John Hopkins advocated the broadcasting of 'low-gauge' video in the UK, but encountered considerable opposition. Broadcasters challenged the transmission of the work on technical grounds, as well as in relation to their radical content. The only access they were able to achieve was limited to news footage because of disputes with the television technicians union, the ACTT (Association of Cinematic and Television Technicians).[5]

Artists working with video in the early period sought opportunities to broadcast their work, as it was one of the only means of reaching an audience at the time. Until the advent of videocassettes such as U-matic and Betamax by Sony and VHS by JVC in the mid-1970s there was no other viable method of distribution. Whilst the television workshops such as the ones established at WGBH, KQED and WNET in the USA, offered artists limited access, many saw themselves as working in opposition to broadcast TV, with different political, social and aesthetic aims. During the 1970s the terms 'video' and 'television' were perceived as more interchangeable, and some critics and artists saw video art as the embodiment of change – the development and flourishing of the so-called 'new television'. But artists who worked with video were also interested in its potential as a tool to comment on and critique broadcast TV and the media industry. The establishment of video co-operatives, non-profit media

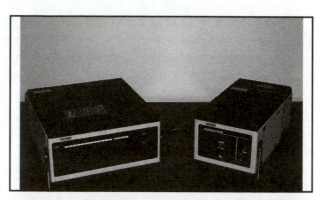

13.1: Sony VO 3800, Portable
U-matic recorder, 1976.
Courtesy of Richard Diehl,
http://labguysworld.com

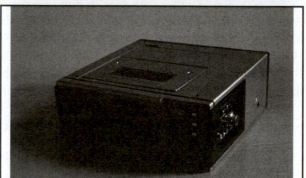

13.2: Sony VO 4800, Portable
U-matic recorder, 1980.
Courtesy of Richard Diehl,
http://labguysworld.com

centres, funded workshops, art gallery exhibitions and cable TV networks opened up new potential venues and alternative methods of distribution and dissemination of artists' video by the end of the decade.

CABLE TV AND VIDEO ACCESS

One potential alternative method of video distribution that had been available since the 1950s was cable television. Initially installed to improve television reception in certain areas of the United States, Canada and Europe, cable networks often included the provision of community access channels as an integral part of its service to subscribers. It was envisaged that these community access networks would facilitate public and civic debate, but most of this utopian idealism about the potential of this system to initiate change had faded by the mid-1970s.

This period of optimism about the future of non-broadcast video did have a number of important outcomes that have contributed to the development of independent video production and the dissemination of the resultant work.

In Canada, the National Film Board established the 'Challenge for Change', a programme in which ½-inch video was used as a catalyst as part of an attempt to help engineer positive social change within certain targeted local communities. As part of the same project, the French-speaking division of the NFB established Videographe, a video production centre, in Montreal in 1971. Here, Robert Forget (1947, Canada) in collaboration with others, developed the first automatic ½-inch video editing system, as previously discussed, encouraging and enabling artists and filmmakers to create videotapes which were distributed via cable stations throughout the province of Quebec (see Chapter 2).[6]

At the beginning of 1970s the American Federal Communications Commission (FCC) obliged cable TV operators in the USA to provide a community access channel.[7] As a direct result of this ruling a number of organizations were formed to enable access to video production facilities for interested groups and individuals. For example in 1972, George Stoney (1916–2012, USA), who had previously directed the Challenge for Change project, co-founded the Alternative Media Centre with Canadian documentary filmmaker Red Burns at New York University, providing access and training in the use of non-broadcast video technology.

Drawing on the experience of the National Film Board of Canada, the Australia Council set up a number of 'Video Access Centres' to provide low-cost non-broadcast production and post-production facilities. One of these, the Paddington Video Resource Centre expanded and developed their basic facilities to include colour and later extended their work to embrace television broadcast.

Cable television in Europe also had a brief flowering of creative potential in the 1970s. A group in Bologna, Italy developed a decentralized cable TV system that linked local government administrative offices, factories, community centres and educational institutions. There were a number of initiatives in countries including Germany (Nachbarschaft TV, Berlin, Televissen, Darmstadt), the Netherlands (Bilmer) and the UK (Swindon and Milton Keynes). Although none of these cable TV projects were specifically geared to provide access for artists, they encouraged the development of innovative non-broadcast alternative video which both drew on work made by artists and fostered the creative application of video-imaging technologies. They also sought to establish alternative production and post-production facilities and new distribution opportunities, and many of the individuals whose first experience of video was acquired through these initiatives have since become involved with artists' video. In the early days of video creative activity was less clearly defined and the independent sector included a mix of video activists, artists and community workers, and this cross-over created a rich cross-fertilized mixture of approach and outcomes.

SOUND AND PICTURE

The relationship between image and sound is of particular relevance to artists working with video. The video artist Steina has been quoted elsewhere in this book about her fascination with the interchangeability between the picture and sound signals (Chapter 7), and the influence of experimental music on the development of artists' video has been discussed in detail in Chapter 5. This image/sound dynamic is seen by many artists as crucial to an understanding of the medium and the genre. Paolo Rosa of the Italian video group Studio Azzurro describes video without sound as a 'mutilated object':

> It immediately becomes a dull, flat being, with no depth to it. Effectively in video the sound element, as well as performing its traditional role, also restores a spatial quality to the image. In some way it also extends the perspective of the image beyond the screen and out into the surroundings. It is the element … that continues to keep you tied to the flow of television…. . It essentially draws together the narrative continuum.[8]

Clearly an experience of video as an audio-visual medium includes an interrelated experience of sound and picture. They are experienced as part of the sensorium, and in combination are evocative of a three-dimensional experience.

The video installation work of Stan Douglas (1960, Canada) often explores the complex territories between image and sound. In *Evening* (1994) a triple screen video projection was augmented by the installation of special 'umbrella' speakers, designed to project the individual soundtracks downwards creating separate sound environments or zones that spectators could move between in order to compare different TV network presentations of the same news story. Moving away from the screens the individual soundtracks become indistinct, merging into an uncertain mix and loss of detail.

The broadcast TV news anchormen, replaced by actors reading from scripts prepared by the artist, presented news items from three Chicago-based TV stations of the late 1960s. Douglas juxtaposed the colour images of the actor/newscasters against the black-and-white archival footage of the original news features, contrasting the approach of the three rival TV stations, and critiquing television journalism and its desire to entertain rather than inform.

In *Hors-champs* (1992) Douglas presented a two-sided video projection of jazz musicians jamming, the usual club atmosphere of the music listening experience transformed by the cool formalism of the installation format.

Bill Viola, reflecting on his experiences making sound recordings in the interiors of cathedrals in Florence, identifies the discovery of the crucial relationship between

sound recording and video which helped him to identify important links between what he calls the 'seen' and the 'unseen', a discovery that transformed his approach to working with video:

> Here was the bridge I needed, both personally and professionally, and it opened up a lot of things that were closed off, myself included. Here was an elemental force that was between a thing and an energy, a material and a process, something that ranged from the subtle nuance of experiencing a great piece of music to the brute force of destroying a physical object by pressure waves. This gave me a guide with which to approach space, a guide for creating works that included the viewer, included the body in their manifestation, that existed in all points in space at once yet were only locally, individually perceivable. I began to use my camera as a kind of visual microphone. I began to think of recording "fields" not "points of view", I realized that it was all an interior. I started to see everything as a field, as an installation, from a room full of paintings on the walls of a museum to sitting at home alone in the middle of the night reading a book.[9]

In the early days of video the design of the Portapak ensured the unity of sound and image. The camera with its built-in mike was often used as if it were an extension of the microphone, with synchronous sound being an integral part of the audio-visual experience. In many early artists' tapes, especially those in which video was used to document an event or performance, and in those works in which the raw and real-time recording of the event was a testament to its authenticity, the corresponding relationship between sound and picture was perceived as an important asset.

Once it became technically possible to re-record the sound, either through the 'sound dub' control on the recording deck, or during post-production, artists were required to make a conscious decision to replace the live sound recording made during the initial taping session. (As Steina has pointed out – with video you had to make an effort *not* to record the sound.)

Dutch writer and video curator Rob Perree points out that in the early conceptual video works where the idea is considered more important than the visualization, image and sound have a logical bond. With the advent of video editing, the creative potential of both image and sound were considerably extended, and artists sought to develop and explore new relationships between sound and image.[10]

In Gary Hill's *Why Do Things Get in a Muddle? (Come on Petunia)* (1982), which is based on one of Gregory Bateson's dialogues from his book *Towards an Ecology of Mind*, the soundtrack both contrasts with, and is complimentary to, reversed sections of video imagery. The actors have learned to pronounce sections of the script

13.3: Gary Hill, *Why Do Things Get in a Muddle? (Come on Petunia)*, 1984. Courtesy of the artist and Donald Young Gallery, Chicago.

13.4: Gary Hill, *Why Do Things Get in a Muddle? (Come on Petunia)*, 1984. Courtesy of the artist and Donald Young Gallery, Chicago.

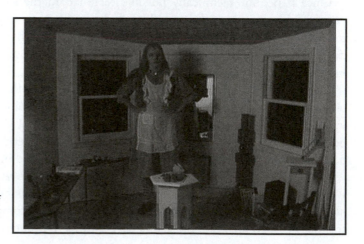

13.5: Gary Hill, *Why Do Things Get in a Muddle? (Come on Petunia)*, 1984. Courtesy of the artist and Donald Young Gallery, Chicago.

backwards phonetically, so that when the video sequences are subsequently played back in reverse, the words are rendered intelligible. The result is strangely compelling, if somewhat demanding of the viewer. The soundtrack and the visual sequences are simultaneously perceived to be running in opposite directions, drawing attention to the original recording process and its relationship to the viewing experience.

THE VIDEO SIGNAL AND THE CAMERA IMAGE

In the mid-1970s Mary Lucier (1941, USA) produced a number of installations and performance – based works in which a video camera was pointed directly at the sun and other powerful light sources. Her stated interest in this theme was to explore the notion that video had been invented to allow the human eye to gaze directly at the sun without fear of permanent damage to sight – to overcome through technology an ancient desire to look at the sun without fear of blindness. In *Dawn Burn* (1975), Lucier causes the camera pick-up tube to 'burn', by pointing it directly at the sun, permanently scarring the light-sensitive component of the video camera, leaving a visible trace of the intense light within the video-imaging system of the camera. *Dawn Burn* is a seven-monitor installation displaying the cumulative images made over seven days of a timed recording of the sun rising over the East River in New York City. Lucier retained the same viewpoint and the same lens focal length throughout the seven-day period (between 4 and 23 July). In the exhibition of the installation all seven days are presented simultaneously in sequence, with each tape showing an accumulation of image burn from the previous days.

Writing about *Dawn Burn*, Lucier describes some of her thoughts about the relationship between the human eye and the vidicon tube of the video camera:

> As the sun rises in *Dawn Burn*, giving heat and light and life to the city below, it engraves a signature of decay onto the technological apparatus; thus, light emerges as the dual agent of creation and destruction, martyring the material to the idea, technology to nature.[11]

Lucier's intention was to provide a metaphor for what she called the 'surrogate relationship' between the video-imaging system and the human eye/brain system. *Dawn Burn* was an attempt to evoke notions of trauma and memory in which scars from previous encounters inevitably affect any subsequent image.

In *Fire Writing* (1975), a 'live' video performance, Lucier extended her ideas by making use of a permanent vidicon inscription technique to retain marks made by pointing the camera directly at a laser beam and writing in the air by repeatedly sweeping the camera across the intense light sources. This action, made whilst the performer was standing on an elevated platform above the level of the video displays,

was linked to an influential essay by the artist and critic Douglas Davis (1933, USA), equating the video camera to a pencil – perhaps the most basic communication tool, in order to both demystify the camera and to increase its status by association with a tool of art historical significance.

Davis first wrote about his ideas on the video camera as pencil in 1973. Observing that many other artists when working with video were deeply involved with the technology and confessing to a personal boredom with machinery, Davis resolved to try to use the camera like a pencil – as naturally as he drew:

> It was a "soft" approach to technology, using it as an extension of me, not working from inside the equipment, following where that led. Unless you use the camera as you use your hand – poking it wherever you want it to poke – the work will never come out like a drawing can, that is close to your primal self … drawing is the freest form of static art, but you have to know what the pencil and paper can do.[12]

Davis' work at the time often involved the use of live telecasting as a way of 'injecting two-way metaphors into the human thinking process'. In works such as *Numbers: A Videotape Event for the Boston Symphony Orchestra* (1970), *Studies in Black and White* (1971–2) and *Talk Out* (1972) Davis explored and developed his notions about the 'liveness' of video, seeing the medium as a crucial step towards an ideal form of direct communication between individuals, a process that would ultimately destroy what he referred to as 'the spectator ritual' of art. Influenced by the ideas of Walter Benjamin and Bertold Brecht (see Chapter 6), Davis believed that ultimately it would be possible to rid the art process of the 'intervening structure' of cameras, monitors and broadcasting systems. *Studies in Black and White* is a set of four videotapes, first made using a Portapak, without editing, in continuous 'real' time. The remaining three tapes were made using a small television studio, making use of live video effects including split screens, mixing and luminance keying. In the fourth and final *Studies* tape Davis is shown learning how to operate a video mixing console whilst directing the movements and actions of the camera operators on the floor, the results of this operation presented directly to the audience: 'What you see is what I see, and find, in the same time. In this study I felt completely at home. It read to me then, and still does, as a living organism growing in front of you'.[13]

This real-time 'live' image of video is one of the fundamental technological differences between film and video. Among the first group of artists to work with video in both Europe and North America were those who used it as a tool to document and extend the notion of live performance. Bruce Nauman's (1941, USA) interest in bodily activities initially led him to use film to document his performances, but

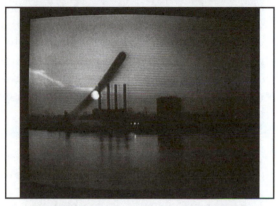

13.6 Mary Lucier, *Dawn Burn*, 1975. Courtesy of the artist.

13.7 Mary Lucier, *Dawn Burn*, 1975. Courtesy of the artist.

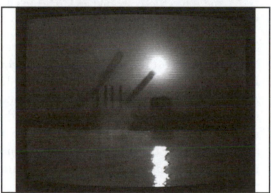

13.8 Mary Lucier, *Dawn Burn*, 1975. Courtesy of the artist.

13.9 Mary Lucier, *Dawn Burn*, 1975. Courtesy of the artist.

he switched to video in 1968 initially using it for convenience and accessibility over 16mm film. Nauman's first video works, which he called 'recorded performance activities' such as *Manipulating a Fluorescent Tube* (1968), were simply restaged versions of live performance works, but in subsequent pieces Nauman began to experiment with unusual camera angles and viewpoints as well as wide-angle lenses. Since his video camera and recorder were permanently installed in his studio, Nauman began to use them to systematically record his immediate environment, recording events such as pacing around in his studio. Frederick Perls' *Gestalt Therapy*, widely read at the time, was a significant influence on Nauman's approach. Perls' book is prefaced by his Gestalt prayer:

> I do my thing, and you do your thing.
> I am not in this world to live up to your expectations
> And you are not in this world to live up to mine.
> You are you and I am I,
> And if by chance, we find each other, it's beautiful.
> If not, it can't be helped.[14]

Nauman's *Stamping in the Studio* (1968) is one of a series of early video works that all last 60 minutes – the entire length of a single spool of ½-inch videotape. This work, as well as others made during this period, *Wall/Floor Positions, Slow Angle Walk* and *Bouncing in a Corner,* all focus on the execution of simple everyday physical activities that rely on the empathy of the viewer and the extent to which he or she responds to the authenticity and honesty of the activity of the artist. This sympathetic audience response is at least partly due to the spontaneity of the recording and the 'real-time' nature of the video medium, which communicates the directness of the bodily experience:

> If you really believe in what you're doing and do it as well as you can, then
> there will be a certain amount of tension – if you are honestly getting tired, or
> if you are honestly trying to balance on one foot for a long time, there has to be
> a certain sympathetic response in someone who is watching you. It is a kind of
> body response; they feel that foot and that tension.[15]

Nauman has also made a number of video corridor pieces that often included a mix of live and pre-recorded video images from cameras installed in unexpected or unusual places, providing the spectator with novel or unfamiliar views of themselves. In *Live Video Taped Corridor* (1969–70) a single video camera was mounted overhead at the open end of a narrow corridor, whilst at the opposite end two large monochrome monitors were stacked one on top of the other. The viewer was confronted with

a pre-recorded image of the empty corridor presented simultaneously with a live image of themselves within the space, presenting the viewer with a dislocation of the temporal and the spatial – a simultaneous experience of presence and absence, and of the present and the past.

Vito Acconci (1940, USA) in his video performance *Claim* (1971) had exploited the ambiguity of a live image to present a work in which an image of the artist was shown seated blindfolded at the bottom of a stairway leading to the basement of an industrial building. Visitors entering the derelict building via the street entrance at ground level were able to see via a television monitor that Acconci was armed with a metal crowbar, but could not be certain whether the image was live or had been pre-recorded. His image and sound filled the space – 'I'm alone down here … I'm alone in the basement … I want to stay alone … I don't want anyone with me … I'll stop anyone from coming down the stairs'. Acconci's intentions were to stake a claim over the territory of the building and to try to convince his audience that any physical contact was extremely risky. All of his work from this period involved notions of truth, and the establishment of what Acconci termed a 'power field' – a space in which to test his control of others.

Even before making *Corrections* (1970), his first video work, Acconci had claimed his body as an artistic space. Initially working as a poet, he had worked with photography, film and audiotape before beginning to explore the potential of video. *Corrections* employed the live feedback capabilities of video, enabling him to monitor his actions as he repeatedly attempted to burn the hairs on the nape of his neck. Writing about his intentions with this work, Acconci claimed he sought to explore the capacity of video to provide a vantage point from which to see himself from a distance.

> I need an action that can coincide with the feedback capacity – I have to find something to redo – I can sit in front of the monitor, stay concentrated on myself, have eyes in the back of my head, dwell on myself, see myself in the round.[16]

At the time, Acconci alleged that his concerns were purely physical rather than psychological, focusing specifically on issues connected with relationships and physical relations. For a period of four years, he worked with his partner Kathy Dillon, producing works such as *Pull*, *Prying* and *Remote Control* (all 1971) finally making a decision to end the relationship during *Air Time* (1973), a live video performance piece which blurred the boundaries between his public artist's persona and his private life.[17]

Frank Gillette and Ira Schneider's *Wipe Cycle* (1969) has already been discussed in Chapter 3. In this work the mix of pre-recorded 'off-air' material and 'live' and

delayed images of gallery viewers sought to present an experience that would break the conventional single-screen TV perspective by providing a complex mix of live images and multiple viewpoints.

Around the same period, the Austrian artist Peter Weibel produced a number of significant sculptural installations exploring the potential of closed-circuit video systems to allow the viewer to reflect on and interact within the electronic and signifying spaces that were produced. In *Audience Exhibited* (1969), video recordings of gallery spectators were simultaneously presented in adjacent rooms of the gallery, turning the spectators themselves into the subject of the exhibition. In *Beobachtung der Beobachtung: Unbestimmtheit* (*Observation of the Observation*) (1973) cameras and monitors in a three-channel CCTV system were arranged to prevent viewers from seeing their own faces from any position they occupied, highlighting the ability of the video surveillance system to mediate and control self-perception. In *Epistemische Videologie (Epistemic Videology)* (1974) Weibel set up a live electronic mix of texts from two opposing cameras shot through a sheet of glass. The work sought to make apparent the transformation of meaning that occurs no matter how 'transparent' the medium. *Der Traum vom gleichen Bewußt-Sein alle (The Dream of Everyone Having the Same Consciousness)* (1979) highlighted the differences between objects displayed in the physical space of the gallery and on display in the electronic space produced by the video image.[18]

Bill Viola has worked exclusively with video and sound since the early 1970s (see Chapter 9) and has in many of his early works explored the unique potential of video to present a mixture of the live and the pre-recorded. Viola's 1975 installation *Il Vapore* blends the past and present, making use of a simultaneous electronic blend of live and pre-recorded video images of the same tableau. A video recording of the installation within the gallery space was made in which the artist performed a ritual in which he slowly filled a basin with water and this recorded performance was later mixed with a live video image of the same configuration. Because of the perfect alignment of the 'real' objects arranged in the gallery space with the pre-recorded images of them, visitors to the gallery experienced an image of themselves in real time within the same image and acoustic space as Viola performing his solitary ritual. Viola has made a number of videotapes and installations that explored the poetic and spiritual implications of this technique including *Olfaction* (1974) and *Reasons for Knocking on an Empty House*. (1982)

This relationship between the perception of a real event and its juxtaposition against a pre-recorded event has been of particular importance to Viola, and notions about the relationship between visual perception and human consciousness have been at least partly derived from his experience of working with video as a recording

process. He wrote about the realization of this idea in some notes about the making of *The Red Tape* (1975), his first work using a portable colour video camera.

> Standing there with a camera and recorder, I was fascinated by the fact that the playback reality of those recorded moments was to be found more in the space through the lens of the camera, on the surface of the vidicon tube, than out in the space where I was standing, hearing, smelling, watching, touching. For me, the focus of those moments (when the recorder was going) was on that magic surface, and my conscious concentration was aimed there, inside the camera... . Recording something, I feel, is not so much capturing an existing thing, as capturing a new one.[19]

Viola's video work is particularly concerned with an exploration of the spatial presentation of physical sensation, of establishing and examining relationships between the electronic image and the physical world. Viola's use of sound fields and his interest in the video camera as a kind of visual microphone has been previously discussed (see above). As an extension and development of this notion, Viola has drawn on perceptual models based on his interest in sound recording and acoustics in a way that suggests a synaesthetic notion of the senses.[20] He understands the senses as unified within the body, interwoven into a single system that includes sensory data, physical sensation, bodily memory and imaginative space:

> In my work I have been most strongly been aware of the camera as representation of point of viewpoint of consciousness. Point of view, perceptual location in space, can be point of consciousness. But I have been interested in how we can move this point of consciousness over and through our bodies and out over the things of the world ... I want to make my camera become the air itself. To become the substance of time and the mind.[21]

Although Viola dislikes to be considered a 'video' artist – much preferring the term artist, rightly acknowledging the medium as simply the tool most appropriate to his time, his clear grasp of the essence of the video image and its relationship to physical and temporal bodily experience has been crucial to the development of his ideas and to the theoretical underpinning of his work. For Viola the essence of video is its 'liveness', with its roots in the development of sound – as he has stated: 'The video camera, as an electronic transducer of physical energy into electrical impulses, bears a closer original relation to the microphone than to the film camera'.[22]

The flow and flux of natural phenomena and the way in which these could be juxtaposed using the ambiguities of electronic space and time was also a feature

in Valie Export's early video work. For example in *Zeit und Gegenzeit (Time and Counter-time)* (1973), she contrasted the temporal reality of external phenomena relative to images contained within the televisual space. In this work slowly melting ice and freezing water were transposed, in an early example of the use of reverse playback of a video recording.[23]

COLOUR AND LIGHT

British video artist Judith Goddard (see Chapter 11) was first attracted to video for the quality of the colour and the aesthetic of the television image as a light source. She initially experimented with 16mm film, but was restricted to durations of less than three minutes because of production costs. Goddard found colour video suited her sensibility, especially the way it treated light and because it was a less expensive medium, she felt able to work with duration to explore notions of time and visual experience:

> Colour made a fantastic difference to the work and I wanted to have more of it. Video offered the moving image in colour and a 20-minute tape. I loved working with colour – still do … I was doing things like using an incredibly long focus-pull; the work was about 'looking'. I came out of a background in which the materiality of film was important, and so I started thinking about video in that way. But then I wanted to exploit the qualities of video as a medium in its own right. For example the fact that the light and colour emanates from the screen which is quite different from projected light … the screen has always been significant to me, and whether the image was a projection, or on a monitor was crucial. With video the fact that the light was coming out of the screen was really important, I had always liked Dutch painters like Rembrandt and Vermeer because they used light in that way.[24]

For Goddard this link to video and time was an important theme in her work from the start, connecting with pre-literary models of visual narrative that drew on her fascination with medieval art. This way of looking and presenting image sequences was linked to the way Goddard used time as a concrete duration, and her use of close-up detail to establish the image-sequence presentation.

> I used close-up shots a lot in my early work, using diopter lenses to get closer (macro lenses didn't exist on the earlier cameras). I was framing and editing images in order to remove the normal reference points of viewing. The viewer had to experience the image haptically. It's something I've continued to be interested in, how we perceive and experience an image.[25]

Pipilotti Rist (1962, Switzerland) uses colour distortions in many of her video tapes and installations, for example in *(Entlastungen) Pipilottis Fehler [(Absolutions) Pipilotti's Mistakes]* (1988) adjusting the images during recording and in post-production in order to deliberately exaggerate colour intensity and contrasts. Rist characterizes video as 'moving paintings behind glass', and exploits the technology to distort and intensify the colours in order to represent internal states of mind:

> I'm interested in the pictures that result when the RGB signal is out of synch – for instance if the three colour tubes are shifted, or the different signal values are over-modulated ... I'm interested in feedback and generation losses, like colour noise and bleeds. In my experiments with video it becomes clear to me how very much these supposedly faulty, chance images are like pictures in my own subconscious.[26]

Although better known as a pioneer of internet art, in his recent work Jacques Perconte (1974, France) has been exploring the possibilities of the colour palette of digital video, working with compression codecs in an extended series of projections and installation including *uaoen* (2003), *uishet* (2007), *Pauillac* and *Margaux* (both 2008), *Satyagraha* (2009) and *After the fire* (2010). Perconte is particularly fascinated with the perception and depictions of natural and manmade landscapes, and works with video projection in order to extend the scope and potential of digital media which he insists can be as 'aesthetically rich as any other classical art'.[27]

After a seventeen-year break in which he explored the potential of photography and computer drawing, Peter Campus (1937, USA) has returned to video, creating a corpus of new digital works, extending and deepening his oeuvre through an exploration of sound and colour. (See Chapter 14 for a discussion of his early video work.) Works such as *edge of ocean* (2003) engage directly with images of cyclic movement and the ambiguity and mystery of temporal flow in the natural world, drawing on his fascination for the philosophical implications of quantum mechanics. His exploration of chromatic abstraction of the video image has been extended in his most recent work. For example, *line of fire* (2008) truncates a high-definition wide-screen image of a seascape into three distinct bands of undulating colour; the foreground a pulsating red/orange, the sea pale green and ultramarine and the sky above a blend of pastel blue. These abstracted electronic colours, further simplified into elemental coloured blocks, shimmer and shift in harmony with the inexorable movement of the ocean.

VIDEO FEEDBACK

As discussed in Chapter 6, in cybernetics the term 'feedback' refers to the idea that an aspect of a past output of a system is fed back to a central processor as present

input to help to modify future output – the 'steersman' concept as put forward by Norbert Wiener. In video technology, the concept of feedback has a special significance, as it can be exploited to produce complex visual imagery. In video systems the visual component of the signal is designed to flow from one place to another – from camera to transmitter to television receiver, or in a closed-circuit system from camera to video recorder to monitor, or directly from the camera to a monitor. If the camera is pointed directly at the monitor, the picture signal is caused to cycle in an endlessly repeating loop known as video feedback, a process that is capable of producing images of startling beauty. In his essay *Space-time Dynamics in Video Feedback*, James Crutchfield has made a detailed study of the techniques and analysis of the physics behind the process. Crutchfield explains that video feedback can be understood as a type of space-time analogue computer and simulator that can be used to study spatial complexity and temporal dynamics, and he outlines the basic physics of video systems in some detail. Crutchfield's general purpose however, is to give a general awareness of the complex behaviour of video feedback and his explanation of the basic system is helpful in explaining the basic technical functioning of the video feedback mechanism:

> In the simplest video system video feedback is accomplished optically by pointing the camera at a monitor. The camera converts the optical image on the monitor into an electronic signal that is then converted by the monitor into an image on its screen. The image is then electronically converted and again displayed on the monitor, and so on ad infinitum. The information thus flows in a single direction around the feedback loop. This information is successively encoded electronically, then optically as it circulates. Each portion of the loop transforms the signal according to its characteristics. The camera, for example breaks the continuous-time optical signal into a discrete set of rasters 30 times a second. Within each raster it spatially dissects the incoming picture into a number of horizontal scan lines. It then superimposes synchronizing pulses to the electronic signal representing the intensity variation along each scan line. This composite signal drives the monitor's electron beam to trace out in synchrony the raster on its phosphor screen and so the image is reconstructed.[28]

Numerous video artists including Nam June Paik, Eric Siegal, Joan Jonas, Stephen Jones, Warren Burt, Peter Donebauer and Brian Hoey have exploited the visual potential of video feedback, some of which has been discussed in more detail in Chapter 7.

But video feedback as a phenomenon is also very seductive, and during the early years of video art it was used to such an extent that it became a not only a kind of

visual cliché, but according to some, even dangerous! The fact that the feedback system could provide an endless source of complex abstract imagery and could be produced so easily became its greatest drawback as a technique within the video artist's repertoire. Although simple to set up, it was very difficult to control. David Loxton, who ran the TV Lab, one of the first artist's access workshops at WNET in New York during the early 1970s, points out the drawbacks and pitfalls of the phenomena:

> Feedback is a totally self-perpetuating, self-creating thing. And a lot of people have called it the whore of video artists because it is very beautiful when you first see it, visually stunning; also it's not motivated by anything you can grasp, and it just happens, and you love it. But it has a tremendous danger, in that it is very difficult to control. … it's a very dangerous thing to get into, and it's very seductive, and hard to control.[29]

But much of this early abstract video art, so heavily reliant on technology, so seductive in its swirling complex abstract patterning and so much in line with the drug-fuelled counter-culture of the late 1960s and early 1970s, was very quickly out of favour, perceived to be fatally tied in to a utopian myth based on the notion that technology itself was the key to a new world order. As American critic Robert Pincas-Witten remarked at 'Open Circuits', a conference on the future of television which took place in 1974: 'It appears that the generation of artists who created the first tools of "tech art" had to nourish themselves on the myth of futurity whilst refusing to acknowledge the bad art they produced'.

British artist and writer Stuart Marshall points out that the break between modernism and postmodernism could be seen to have emerged from a different set of circumstances in the case of video art, than from those in the more traditional media of painting and sculpture, for example. Modernist artists working with video who sought to uncover a pure language of the medium were unable to do so as long as they excluded the issue of representation from their practice. According to Marshall, the modernist ambition to develop a medium-specific language from technology-based practice failed because of a fundamental misunderstanding about the nature of signifying practices. In Marshall's view meaning is produced by the superimposition of codes and conventions onto a material support.

By the mid- to late 1970s the modernist concern with reflexivity was giving way to a practice that favoured deconstruction, shifting from a medium-specific analysis to an examination of the dominant representational practices and seeking to construct an oppositional practice. Although this tendency can be seen with hindsight to have emerged in other modernist video practice, as it is clear that many 'modernist' works explored and articulated issues of representation that were not identified or discussed at the time, feminist theory had from the outset concentrated on issues of representation. The women's movement provided feminist artists with a cultural context to critique the dominant media representations of femininity, female sexuality and cultural stereotypes. Thus feminist artists and others who considered themselves to be excluded or marginalized and wished to critique and challenge the status quo sought to develop new work that intervened at an ideological level by deconstructing and disrupting dominant modes of representation.

Tamara Krikorian, herself part of the founding modernist LVA group in London, identified and summarized her own involvement with the emergence of this tendency in a catalogue essay published in 1979:

> My own interest in video, and indeed in television, stems from a formalist position, a formal analysis/ decoding/ construction of the medium, but it's not possible to consider television without taking into account its structure, not just

in terms of technology but also in terms of politics. This led me to realize that the reference points in working with any medium must come not only from the medium itself, following the modernist approach of 'pure art', but from relationships between types of work, painting and sculpture and video etc. The reference must also come from the artist's own experience as mediator between what has gone before and the raw material and the ideal, constantly restating and confronting the spectator with a discussion between the old and the new.[1]

According to video artist and writer Catherine Elwes, many feminist artists were attracted to video because of the confrontational nature and immediacy of the medium – the instantaneity and intimacy of video attracted women artists who were 'impatient to speak, visualize and become visible'.[2] Extending the one-to-one discussions and consciousness-raising practices developed through women's groups, feminist artists sought to explore issues through personal experiences and anecdotes. The portable video camera recorder and monitor combination facilitated intro-spective work by individuals working in the private interiors of the artist's studio and personal and domestic spaces. Videotapes could be made, viewed, screened to specific targeted and selected audiences, or erased and never made public. As has already been discussed with reference to the practice of Shigeko Kubota in Chapter 1, feminist artists were also initially attracted to the new medium because of its lack of a history as an art medium – free from the male-dominated precedence of the traditional mediums of painting and sculpture. But, according to Jean Fisher women artists' use of video and other media practices was not simply because of the medium's freedom from male-dominated aesthetic codes, but also because women and other disenfranchised groups denied the right to represent themselves and their subjective experience, found video and time-based media could provide a method of representing subjectivity and transforming a sense of self-hood from previously fixed notions of race, sexual orientation, gender and class which had been imposed by the dominant culture. Fisher argues that the experience and use of language and repre-sentation was in part defined by notions of ethnicity, gender and class, suggesting that women's art practice (and that of other marginalized groups) rejected a fascination with the static and autonomous art object, recognizing that it was inadequate as 'a model of subjectivity in a world of ever-shifting identities'.[3]

THE CONTRIBUTION AND INFLUENCE OF SHIRLEY CLARKE

Although better known as a filmmaker, Shirley Clarke (1919–97, USA) produced a number of important early video installations and tapes in the period between 1969–75, attracted to the new medium's potential for live transmission and

instantaneous playback, and drawing on her own early training as a dancer and choreographer. Although her work and approach was never overtly feminist, Clarke was well aware of the difficulties that women artists faced in having their work and contributions recognized and acknowledged. She always perceived herself as an outsider and related closely to others who were disenfranchised. In an interview with video artist Dee Dee Halleck, she spoke of her own experiences as woman artist and her sense of 'otherness':

> I identified with black people because I couldn't deal with the woman question and I transposed it. I could understand very easily the black problems, and I somehow equated them to how I felt … I always felt alone, and on the outside of the culture that I was in. I grew up in a time when women weren't running things. They still aren't.[4]

In 1971 Clarke formed and led the Teepee Video Space Troupe in New York, which included an array of artists and technicians including her daughter Wendy Clarke and members of Videofreex and Raindance Corporation such as Frank Gillette, Viki Polan, Skip Blumberg, David Cort, Dee Dee Halleck and Nancy Cain.[5] Teepee Video Space Troupe, based at Clarke's penthouse at Hotel Chelsea worked with live video displays, documentary and performance. Her ideas for the troupe and its ethos were drawn from the improvisation techniques developed by the jazz ensemble and from her own experiences and training as a dancer, and applied to an understanding of the capabilities and strengths of the video medium of the time:

> … one unique capability of video is that we are able to put many different images from many different camera and playback sources into many different places and into many separate spaces (monitors) and we can see what we are doing as we are doing it.
>
> We need to develop better motor connections among our eyes and our hands and bodies … we need balance and control to move our images from monitor to monitor or pass our camera to someone else.
>
> But mainly we need the skill to see our own images in our own monitors and at the same time see what everyone else is doing.
>
> We need to acquire the ability to see in much that same way that a jazz musician can hear what he is playing and at the same time hear what the other musicians are doing and together they make music.[6]

According to video artist and former Teepee Trouper Andrew Gurian, in his article 'Thoughts on Shirley Clarke and the Teepee Video Space Troupe', Clarke's most significant contribution to the development of artists' video in the USA were the

14.1 Video installation in Shirley Clarke's Studio, 1972. Photograph by Peter Angelo Simon.

unique and innovative workshops she ran with the Troupe. She sought to create an environment to explore video's capacity to provide live moving imagery that could be simultaneously transmitted to numerous locations and directions – blurring the traditional boundaries between participant and spectator. Contrary to her experience of filmmaking, Clarke perceived the virtual impossibility of editing early video as a virtue – the medium was designed to provide real-time live transmissions and displays of simultaneous multiple imagery. Also contrary to the traditions of film with its fixed seat auditorium, video displays could be an integral element of the architectural environment.[7]

During the period between 1971 and 1974 Clarke led a number of Teepee touring workshops in a variety of venues and institutions including the Kitchen, the Museum of Modern Art ('Open Circuits'), Antioch College, Baltimore, Weselyan College, Bucknell University, Film Study Center, Hampshire College and the University of Buffalo.[8]

Demanding and challenging, but also rewarding and ground-breaking for the participants, Clarke's work with the Teepee Troupe ended when she left for Los Angeles to teach video and filmmaking at UCLA in the mid-1970s. She went on to make single-screen video works for broadcast including *Savage/Love* (1981) and *Tongues* (1982) in collaboration with script-writer Sam Shepard and actor/director Joseph Chaikin, produced during a residency at the Women's Interact Center in New York City.[9]

Ulriche Rosenbach first began working with video at the beginning of the 1970s, using the medium to create what she called 'documents of her inner life'.[10] After teaching feminist art and video at the California institute for the Arts for a number of years, she returned to Germany in 1976 and founded 'Schule für Kreativen Feminismus' (School for Creative Feminism) in Cologne, which sought to bring women artists together to discuss their work, ideas, and experiences. The school continued as an outlet for women artists until it closed in 1980. In 1975, Rosenbach

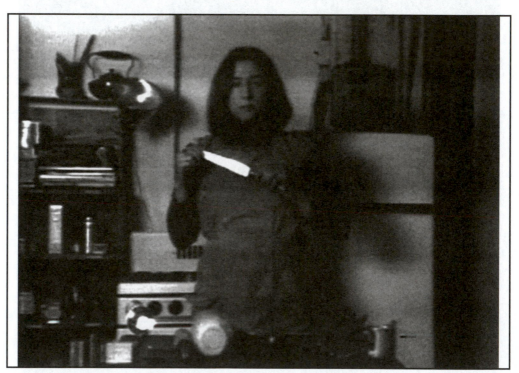

14.2 Martha Rosler, *Semiotics of the Kitchen*, 1975. Courtesy of EAI, New York, http://www.eai.org

co-founded Alternative Television (ATV) an alternative television station for artists' video, with Marcel Odenbach and Klaus vom Bruch, but this initiative failed to gain the support of German broadcast networks.[11]

Rosenbach's video work in this period explored themes related to 'the woman and her image in society and history as the Virgin Madonna, the chaste housewife, mother, and the cliché of the Amazonian'. Using performance and video tape, Rosenbach produced a number of significant works around these themes including *Eine Frau ist Eine Frau* (1972), *Madonna of the Flowers* (1975), *Dass Ich Eine Amazone Bin* (1975), *Reflexionen Uber Die Geburt Der Venus* (1976–8) *Medusaimagination* (1976).[12]

Martha Rosler (1943, USA) made a number of important videotapes that drew on her live performance work, extending her approach by using the video medium to highlight the cultural assumptions and preconceptions propagated by television. In *Semiotics of the Kitchen* (1975) she parodied a TV cookery programme, presenting a series of kitchen implements alphabetically ('Apron, Bowl, Chopper', etc.) towards the camera, demonstrating their use with exaggerated violence and blatant menace. Catherine Elwes describes the implicit threat:

> Rosler turns these familiar objects into domestic weapons and beats the air like a cool-headed murderess dispatching an invisible victim ... the underlying threat of Freudian castration, of losing both the symbol and member of manhood, is grimly laboured as Rosler hacks out the inventory of women's repetitive domestic slavery serving up her anger in carefully measured culinary gestures.[13]

Semiotics of the Kitchen parodies broadcast television and the stereotyping of women as nurturing homemakers simultaneously, drawing on performance art and extending its power by reaching audiences beyond those attending the original live presentation.

Video offered a potential for the development of a new language, and whilst drawing on the images and syntax of broadcast television, through its alternative technical accessibility and closed-circuit distribution it could be used to critique and deconstruct dominant ideologies and the patriarchal status quo. For many feminist artists, the instant replay of video offered an electronic mirror that could be used to construct a new and more positive reflection, an alternative set of less repressive images and appearances.

At the beginning of the 1970s, feminist artists strongly rejected modernism on the grounds of gender politics and for aesthetic reasons. They developed a range of strategies and approaches to break away from what they perceived as the male-dominated traditions of modernist rhetoric, seeking to reclaim the right to represent themselves through art. Concentrating on issues such as identity and subjectivity, they sought to

14.3: Katherine Meynell, *Hannah's Song,* 1987. Courtesy of the artist.

14.4: Katherine Meynell, *Hannah's Song,* 1987. Courtesy of the artist.

deconstruct patriarchal domination of representation and legitimize the female voice, paving the way for a shift towards postmodernism.

Katherine Meynell (1954, UK) examined notions of female subjectivity through the complexities of the mother-daughter relationship in two videotapes produced in the late 1980s – *Hannah's Song* (1987) and *Medusa* (1988). Meynell explores her subjective perspectives on multiple levels in these tapes, simultaneously reflecting on the mythological, the symbolic and the socio-political. In discussing the themes and impetus of her work, she has claimed that it was 'the direct result of the confusion and paradoxes of my beliefs as a feminist'.[14] Meynell's video work in this period was narrative-based – constructing 'empirical fictions' she explored the intricate intimacies and conflicts of birth and motherhood.

The relationship between accessible video-imaging technology and image content in feminist video can be perceived, for example in an examination of the difference between the visual appearance of works of the 1970s and the 1980s. In 'The Feminism Factor: Video and Its Relationship to Feminism', Martha Gever contrasts the flexibility and reliability of 1980s video equipment with that of the 1970s. She points out that video-making by individuals and groups working outside of the broadcast context had become commonplace by the end of the 1980s because of factors such as the decreased cost and increased reliability of the equipment. During that period video equipment had also become much easier to operate and therefore more accessible than that available to artists working in the previous decade. These technological developments extended to the means of distribution and dissemination of videotapes produced by women, and by the 80s the wide availability of VHS format tapes had become part of the cultural landscape. The comparatively low production costs of video when compared to film were also identified as a factor in making video attractive to women and women's groups and collectives, since, according to Gever (writing at the beginning of the 1990s) 'the collective economic status of women in this country (the USA) has barely improved in this period in spite of increased participation by women in the waged and salaried work force'.

Martha Gever maintains that although issues of representation were by no means limited to feminist artists, the fact that video was linked to television, and that its pre-eminence as a source of information and entertainment meant that it provided women artists with an array of techniques and cultural and historical reference points to draw on. These works in turn were seen to make a contribution to feminist debate including topics such as sexual identity and sexual politics as well as by work produced by black and Asian artists.[15]

Although working in a variety of media, including sculpture and photography, Mona Hatoum (1952, Beirut) like many other artists of her generation, began working with video after a period of doing live performances. For Hatoum *Measures of Distance* (1988) is significant because it represents the culmination of her earlier narrative and issue-based work. In an interview with artist Janine Antonin, Hatoum spoke about her dilemma with the presentation of an image of her mother:

> In *Measures* … I made a conscious decision to delve into the personal – however complex, confused, and contradictory the material I was dealing with was … . Once I made the work I found that it spoke of the complexities of exile, displacement, the sense of loss and separation caused by war. In other words, it contextualized the image, or this person, 'my mother', within a social-political context.[16]

In addition to *Measures of Distance* Hatoum has produced a number of important video installations including *Corps Étranger* (1994) and *Deep Throat* (1996) both of which make use of video images produced with endoscopic camera devices to record the interior of her own body. She sees the body itself a foreign territory, both in the sense that it is not possible to directly 'know' one's own physical interior, but also because the body imaged in Hatoum's installation is that of a woman:

> I called it Corps Étranger, which means "foreign body", because the camera is in a sense this alien device introduced from the outside. Also it is about how we are closest to our body, and yet it is a foreign territory which could, for instance, be consumed by disease long before we become aware of it. The "foreign body" also refers literally to the body of a foreigner. It is a complex work. It is both fascinating to follow the journey of the camera and quite disturbing. On one hand you have the body of a woman projected onto the floor. You can walk all over it. It's debased, deconstructed, objectified. On the other hand it's the fearsome body of the woman as constructed by society.[17]

A number of key feminist video works by women artists have been discussed in this book in previous chapters (see for example, Joanas' *Vertical Roll*, Bairnbaum's *Wonder Woman*, and Elwes' *With Child)*. These and other works by women artists working with video have been instrumental in heralding the shift from the modernist preoccupations with the material qualities of the medium to the postmodernist issues and concerns of representation. American writer Dianne Blackwell cites Carol Hanisch's influential feminist article 'The Personal is Political' in her 2008 essay discussing the work of video artists such as Rosler, Joanas and Birnbaum and its influence and impact on the development of postmodernist art practice:

> The early videos of the Sixties and Seventies produced by female artists marked the transition from modernism toward postmodernism. As Hanisch proposed, only by analyzing women's "personal problems" and identifying real sources of oppression could women gain "political" equality. Female video artists took on the task of feminist "consciousness-raising" within the remnants of modernism. They began by looking at the tools of their oppression: the language, the perspective, and the stereotypes that formulated the concept of "woman". In this semiotic analysis of repression, Second Wave Feminism's "consciousness-raising" was meant to break with past assumptions and create a new world of equality. When applied to creating art, this idealistic approach soon moved away from its modernistic origins.[18]

The subject matter and approach pioneered by feminist artists working with video

opened up the territory for artists of colour and those who sought to explore issues relating to alternative sexuality, ethnicity and race. In the UK video artists including Keith Piper (1960, Malta), Pratibha Parmar (1955, Kenya) and Isaac Julien (1960, UK), explored the potential of video as a medium for communicating and exploring ideas and issues including post-colonial politics, institutional and national racism, gay sexuality, black identity and the Diaspora.

In *Territories* (1984) Julien and members of Sankofa (the film and video collective he founded in 1983) collaged Super 8 film and video material with archive sound and documentary film footage to produce a complex and at times, semi-abstract celebration and examination of black British culture in the past and of the future.

In *The Nation's Finest* (1990) and *Trade Winds* (1992) Keith Piper also employed electronic collage and image-processing techniques to examine and uncover issues connected to the history of black experience and its relationship to a predominantly white host culture.

Pratibha Parmar's *Sari Red* (1988) is a poetic video tribute to Kalbinder Kaur Hayre, a young Asian woman brutally murdered in an unprovoked racist attack in the north of England. Lyrical and understated, the tape is a blend of imagery that combines the seemingly incongruous themes of a sensual celebration of the colour red and an indictment of mindless racist violence and hatred.

Video artist and writer Stuart Marshall, active in the UK since the early 1970s made a significant contribution to the development of video as an artist, writer, activist and tape maker. Early works such as *Go Through the Motions* (1974), *Still But No Stillness* (1975) used technical procedures and image/sound deconstruction techniques to deliberately 'fail to achieve audience deception'.[19] Later works such as his five-channel installation *A Journal of the Plague Year* (1984) and single-screen tape *Pedagogue* (with Neil Bartlett) (1988) were increasingly explicit in content and subject matter, dealing with issues of gay rights and homophobia. In the early 1990s Marshall made a number of works for television including *Over Our Dead Bodies* (1991) a Channel 4 programme celebrating the work of AIDS support groups, and *Blue Boys* (1992) an expose on the activities of the UK's 'Obscene Publications Squad'.

For gay, black and Asian artists working with video in the 1970s, 1980s and to some extent into the 1990s, the aesthetic and cultural questions raised by the work of these and other artists were significantly tied into issues of access to production facilities and distribution. As has been discussed elsewhere in this book, the alternatives to television broadcast were initially rare and until the introduction of VHS cassettes, which provided a potentially viable method of alternative distribution, public access to this work was very limited to specialist (and usually sympathetic) audiences in galleries, art schools, media centres and cultural institutions. As video technology

has developed and new digital techniques have become more widely available, issues of access and distribution have become less acute. With the rise of the Internet, with its potential as an alternative channel of dissemination via uploading and video streaming, previously 'marginalized' groups are more able to disseminate their work and reach their target audiences.

15. OFF THE WALL
VIDEO SCULPTURE AND INSTALLATION

VIDEO INSTALLATION: RELATIONSHIPS BETWEEN IMAGES AND SPACE

In 'Video Installation Art: The Body, the Image and the Space-in-Between' media theorist and critic Margaret Morse examines the nature and functions of video installation, speculating on some of the most fundamental questions raised in relation to what she considered 'undoubtedly the most complex art form in contemporary culture'.[1]

Morse's analysis of video installation presents the notion of an art form that can never be liberated from the act of production, pointing out that the gallery-dependent installation is in stark contrast to 'commodity media' such as painting or sculpture in which the museum represents the ultimate validation. Installations are by their nature, impermanent and ephemeral and never completely disengaged from their original location. The gallery space is simply the 'ground' for the installation – the sculptural objects and/or structures, their placing, and the televisual images must be experienced directly through the physical activities and presence of the spectator. Unlike performance, the artist is deliberately not present, leaving the gallery visitor to 'perform' the work. Video installation is emphatically *not* proscenium art, an attribute it shares with other non-commodity art forms that include performance art, earth works and Expanded Cinema. It is important to note, however, that although video installations share much with other so-called 'non-commodity' art forms, in recent years there has been a particularly significant commodification of video installation work, with galleries, museums and wealthy private individuals acquiring examples for their permanent collections.

In terms of the creation of a video installation, the artist's activities in the gallery are the final stage in a series of actions that includes planning and logistics, funding applications and innumerable organizational and practical considerations that both hamper spontaneity and prevent improvisation. Nevertheless, the inevitable risks involved in realizing the work in the gallery space create a tension, and Morse identifies this gap between the conceptualization of the work and the realization of an idea or proposal as being at the heart of an installation's cultural significance.

Thus the video installation can be seen as an experiment in the representation of culture:

> ... a new disposition of machines that project the imagination onto the world and that store, recirculate and display images ... [presenting] a fresh orientation of the body in space and a reformulation of visual and kinaesthetic experience.[2]

Drawing on the simile of 'Plato's cave', an imaginary space in which the spectator is separated and removed from that which is being watched, Morse discusses the video installation as a work in which the visitor is surrounded by the physical present – the 'here-and-now', engaging with a spatial experience which is grounded in an actual, rather than an illusionistic space.

> The underlying premise of the installation appears to be that the audio-visual experience supplemented kinaesthetically can be a kind of learning not with the mind alone, but with the body itself.[3]

Video installations have from the outset been mixed media – CCTV, combined with pre-recorded video, slide and film projections, sound and photography, often containing more than one tense or image space simultaneously. Morse suggests that the key to distinguishing between installations may be to determine whether the spectator is expected to engage in two and three-dimensional spatial worlds, or remain in the 'real' space of the gallery. All installation is ultimately 'interactive' – the viewer is presented with a kind of variable narrative of spatial and representational possibilities that s/he must negotiate. The notion of the 'site-specific' installation is an important issue particularly in terms of the relationship of the work to the exhibition space in which it is installed:

> Site-specificity implies neither simply that a work is to be found in a particular place, nor, quite if it is that place. It means rather, that what the work looks like and what it means is dependent in large part on the configuration of the space in which it is realized. In other words, if the same objects were arranged in the same way in another location, they would constitute a different work.... . What is important about a space can be any one of a number of things; its dimensions, its general character, the materials from which it is constructed, the use to which has previously been put, the part it played in an event of historical or political importance, and so on.[4]

There is a sense in which all video installations are site-specific, insofar as works installed in a gallery must be placed and tuned to the particularities of the site. Characteristics of 'site' include such factors as entrance positions, scale of space,

acoustics, light levels, type of space (its 'normal' function) etc. The most important issue in question is often the extent to which a work is site-specific.

Frederic Jameson characterizes an installation as a 'material occasion for the viewing process'. In his view there is a particular kind of spatial experience that characterizes postmodernism, a mode of address he refers to as 'spatialization':

> Conceptual art may be described as a Kantian procedure whereby, on the occasion of what first seems to be an encounter with a work of art of some kind, the categories of the mind itself – normally not conscious, and inaccessible to any direct representation or to any thematizable self-conscious or reflexivity – are flexed, their structuring presence now felt laterally by the viewer like musculature or nerves of which we normally remain insensible.[5]

Often, video installations whether projection or multi-monitor, seek to counter the notion that the television is a psychological space, with no existence in the physical world. There is a sense that single-screen works that do not in some way address the relationship to the space that they occupy offer a direct, almost cinematic experience, transmitting information via light and sound to the viewer without any direct engagement with the spatial or the physical.

MULTI-CHANNEL VIDEO – NON-CINEMATIC SPACE?

In the early days of video art, video projection was a rare occurrence. This was not simply because the equipment was notoriously unreliable, scarce and expensive, but also because the image was of such poor quality, especially when compared with film projection. Video projection in the 1970s and even in the early 1980s provided a low-contrast and a comparatively dim image, and due to the relatively low-resolution of the television image (525 lines in National Television Standards Committee (NTSC), 625 in Phase Alternation Line (PAL) (see Glossary: Television standards), it was also pretty fuzzy. Video artists who sought to explore notions of scale and/or the spatial characteristics of the medium invariably resorted to the use of multi-monitor, or as they were more often called, multi-channel works. Viewers confronted with a bank or array of monitors in a gallery or exhibition space were immediately required to assess the implied relationship between the images on display. A multi-channel work challenges a viewer to engage with the work on a spatial level, in that she/he is deliberately left free to make decisions about the order of priority of the images, the relative relationship between the multiple screens and the viewing position, and to consider the space between the screens, their relative size and even how they are mounted or displayed. A further potential level of signification can be articulated by the artist who has control of the images across the multiple screens as well as within

15.1: Beryl Korot, configurations of *Dachau 1974*. Courtesy of the artist.

the space of the single screen, and this is of course in addition to any manipulations of the soundtrack. This is clearly a complicated art form, requiring the sort of attention from the spectator that traditionally might be expected of music!

Many artists who experimented with video worked across the genres of single and multi-channel video, and the works were often complimentary or made in relation to one another. In the first London Video Arts (LVA) catalogue which was published in 1978, a substantial section (a third of the catalogue) was devoted to installation work with details of installations by international artists who were also tape makers, including Eric Cameron (Canada) Kit Fitzgerald and John Sanborn (USA) David Hall (UK) Takahiko Iimura (Japan), Christina Kubisch and Fabrizio Plessi (Italy), Beryl Korot (USA), Tamara Krikorian (UK) Mary Lucier (USA), Stuart Marshall (UK), Steve Partridge (UK), Tony Sinden (UK) and Elsa Stansfield and Madelon Hooykaas (Netherlands).

Beryl Korot's (1945, USA) *Dachau 1974* is a good example of an early multi-channel installation. This four-screen work was built around a structure that literally 'weaves' layers of meaning through its multi-layered construction. The work was not concerned to establish a relationship with the gallery space and in some ways it replicates the full frontal viewing experience of a multi-screen film, any difference to some extent connected to the intimate scale of the video images and their contrast with the image content. The viewer was encouraged to watch the piece in its entirety (24 minutes) and to face the screens seated on a bench placed at a specific distance from

the row of screens. In *Dachau 1974* the four identical monochrome television screens (22 inches in the original presentation at The Kitchen in New York) were presented in a horizontal line, their familiar boxes masked behind a panel so that only the shape of the screens was visible. A diagram mounted on the same wall provided the viewer with information about the sequencing and editing structure of the work.

In seeking a model for combining video images from a number of sources, Korot drew on her experience of weaving – specifically referencing the mechanical technology of the loom as a system of combining many elements 'both literally and metaphorically' developing patterns that evolved in time. In discussing this aspect of the work Korot made an analogy between weaving cloth and editing video sequences, which also demonstrated her understanding of the relationship between the artist and the technology she was using:

15.2: Beryl Korot, Structural diagram for *Dachau 1974*.
Courtesy of the artist.

> Just as the spinning and gathering of wool serve as the raw material for a weave, so the artist working with video selects images to serve as the basic substance of the work. All technology, in its capacity to instantly reproduce, store, and retrieve information, has moved continually in a direction that seeks to free us from labouring with our hands by giving us greater conceptual freedom to organize, select, and judge. For myself, it's becoming clear that the greater my understanding of the role of craftsmanship in working with the video medium, and the more manually active I remain in the selection process, the greater the possibility for making a technological work true to my intentions.[6]

The video sequences Korot selected to present were all recorded at the site of the former Dachau concentration camp in Poland. During recording, Korot concentrated on the symmetrical structures of the architecture, seeking ways to capture an ambience of the place as it was at the time of shooting (1974) which would reflect its own horrific and dark past. Korot sought to represent a spatial experience of the physical place through the developing temporal patterning of the work, and to accomplish this she assigned time values to specific images and their accompanying sounds, thus creating 'image blocks' via a repetition of the imagery. In the final exhibited work, channels 1 and 3, and 2 and 4 showed the same images (and played the same corresponding sounds). In line with her weaving analogy, Korot conceived of each channel as representing a thread, so that the pairs of channels (1 and 3) and (2 and 4) formed interlocking combinations, which Korot perceived as a method of binding the sequences across the duration of the piece.

Critic and curator John Hanhardt describes the experience of viewing the work in his 1976 essay 'Video/Television Space', pointing out the participatory aspect of *Dachau 1974*, which is an integral part of much multi-channel work:

> The rhythms articulated through the timing of sequences and juxtaposition of spatial perspectives create for the viewer a many-levelled experience. There is the nature of the images – selective compositions which cumulatively present the camp as a geographic, architectural place. The viewer is disturbed when he realizes what the place actually is. There is also the elegant structuring of sequences which involves the viewer on an exploratory participation into the interconnections and the decipherment of these sequences.

As has been discussed elsewhere in this book, artists working with video installations often seek to engage the viewer in a direct physical relationship with the apparatus of video and the resultant images, but this participatory aspect is not always only limited to the actions of the spectator. In Madelon Hookyaas and Elsa Stansfield's installation *Compass* (1984), exhibited at the Stedelijk museum in Amsterdam, a

15.3: Madelon Hooykaas and Elsa Stansfield, *Compass* 1984 (Outside). Courtesy of the artists.

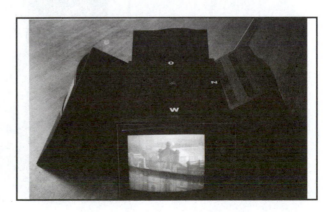

15.4: Madelon Hooykaas and Elsa Stansfield, *Compass* 1984 (Inside). Courtesy of the artists.

'live' video camera mounted on a wind vane on the roof of the gallery influenced the changes to images displayed on four monitors arranged on the four cardinal points of the compass. The images on monitors in the gallery were directly affected by the direction of the wind, providing an experience of the relationship between past and present, with natural forces as an active participant in the creation of the work.

Video artists have also exploited the potential of the television screen as a frame, analogous to the traditional painterly device. British video artists Marty St. James (1954, UK) and Anne Wilson (1955, UK) produced a series of video portraits in the early 1990s, exploring both a multi-image format with installations such as the fourteen-monitor *Portrait of Shobana Jeyasingh* (1990) and the 11 monitor *The Swimmer, Duncan Goodhew* (1990) and more intimate single-screen works, often commissioned and exhibited alongside more traditional portraits in formal gallery settings such as the National Portrait Gallery in London. This series of works included numerous commissioned portraits including *The Smoking Man – Giuliano Pirani* (1991), *Portrait of Neil Bartlett* (1990), *The Actress, Julie Walters* (1990). According to writer and video artist Jeremy Welsh, the single-screen portraits were the more successful:

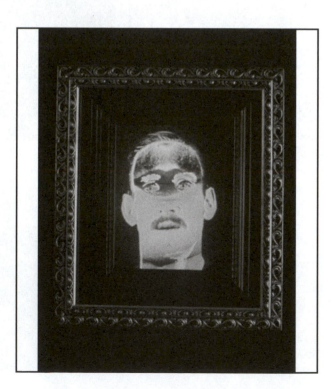

15.5: Marty St. James and Anne Wilson, *The Actor* (Neil Bartlett), 1990. Courtesy of the artists.

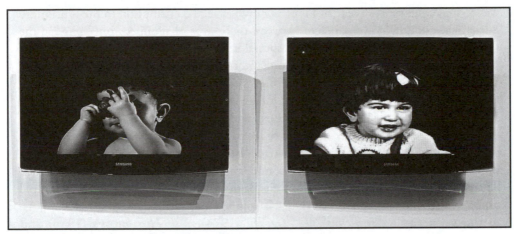

15.6: Marty St. James, *BoyGirlDiptych*, 2000. Courtesy of the artist.

Functioning best when their close conformity to the traditions of portraiture was subtly undermined by the management of time and change in the image. An apparently still face might suddenly speak, begin to cry or turn its head to follow the viewer's movements through the museum.[7]

Working alone, Marty St. James has extended and developed this approach in recent years, exploring the potential of digital moving image and monitor display as a medium for portraiture with works such as *Boy Girl Diptych* (2000) a double-screen work using images of his children recorded over a period of 11 years.

VIDEO SCULPTURE

In my own video installation work of the 1990s I have often sought to create multi-channel works in which the space between the monitors was of crucial importance to the experience. One of my primary intentions was to draw the attention of the spectator to their own perceptual relationship to the work they were engaging with. For example, in *Eau d'Artifice* (1990) a circular pyramid of 35 video monitors was arranged in seven layers, presenting images and sounds of flowing water to construct an artificial 'electronic' fountain within the gallery space. The visitor was encouraged to engage with the structure as one might a 'real' fountain. The installation ran continuously in a twenty-minute cycle of a compressed day, the ambient light and colour progressing from early morning through to evening before the water spout was shut off, allowing the reflected image in the 'reservoir' to settle, revealing the neo-classical face of the top spout before the entire cycle began again. My intention

was to make the viewer aware of his or her own crucial contribution to the illusionary 'idea' of the fountain – the spaces between each layer of monitors only *implied* the flow of water, thus the fountain was a special kind of 'fiction'.

Video sculpture, although a sub-set of multi-channel video, is less cinematic and more 'sculptural'. Gallery visitors are not expected to sit and watch a video sculpture from an appointed spot – they are encouraged to walk around it, to view it from all sides and angles, as if it were a traditional sculpture which has been considered 'in the round' by the artist. The images and sounds, although often important, are only elements to be read in relation to the structures and forms that are simultaneously the technical support for the image/sound and an integral element of the work. Video installations of this kind are often playful or deliberately ironic, for example much of the video installation work of Nam June Paik, such as *TV Chair* (1968–74), of the *Family of Robot* (1986), *TV Garden* (1974), *Fish Flies on Sky* (1975) and many others. In these and similar works, Paik is partly relying on the juxtaposition of the familiar domestic television into an incongruous physical situation – fixed onto the ceiling, wedged into the seat of a chair, or fashioned into a deliberately

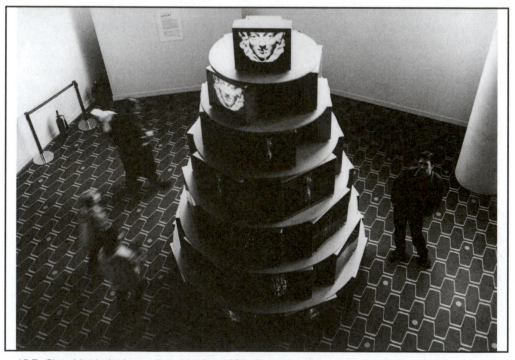

15.7: Chris Meigh-Andrews, *Eau d'Artifice*, 1990. Courtesy of the artist.

clumsy anthropomorphic representation. The images on the screen are often simple, repetitive and graphic, even perhaps of secondary importance, simply re-enforcing or complementing the physical structure – fish swimming in an aquarium, a static image of flowers, indiscriminate off-air footage that has been electronically processed, etc.

Swiss video artist Pipilotti Rist often uses the genre in an ironic mode in gestures that acknowledge the influence of Paik. Video installations such as *TV-Luster* (*TV Chandelier*) (1993), *Selbstlos in Lavabad* (*Selfless in the Bath of Lava*) (1994), *Eindrucke Verdauen* (*Digesting Impressions*) (1993) and *Fliegendes Zimmer* (*Flying Room*) (1995) similarly position the television as a sculptural element in ironic relationships to other domestic and familiar objects. In an essay Rist wrote to introduce an exhibition of Paik's work in 1993, she provides us with an insight into her own complex and playful attitude to video as much as his:

> The world in front of, behind, or between the window and TV is the biggest video installation imaginable. It is all just a question of point of view. Video is the synthesis of music, language, painting, mangy mean pictures, time, sexuality, lighting, action and technology. This is lucky for TV viewers and video artists. They love video; they love it with all its disadvantages, like the poor resolution of the image, reduced to 560x720 dots. They love it because of its disadvantages. It kick starts our imagination and, behind our eyeballs, turns into an orgy of sensation and imagination. The monitor is the glowing easel where pictures are painted on the glass from behind.[8]

Clearly however, not all video sculpture is ironic. A number of the works that have been discussed in detail in other chapters of this book – Bruce Nauman's *Video Corridor*, Michael Snow's *De La,* Judith Goddard's *Television Circle* and Studio Azzuro's *Il Nuotatore* are further examples of video sculpture. In these works there is no single viewing position from which to view the work, or even the images on the screens. In these and many other video sculptures there is a dynamic interplay between the images, sounds and the structure of the installation – the way the images are presented, how they are encountered and the relationship that is established or implied within the space or location of the work.

PROJECTION INSTALLATION: VIDEO WITHOUT THE BOX

One major consequence of the developing technological change in video is the rise of the video projector as a tool for artists and in gallery presentation. As was stated previously, the image quality of early video projection was disappointing, especially when compared with film, but some artists experimented with it successfully. In the early 1970s Keith Sonnier (1941, USA) produced a number of environmental works at the

Castelli Gallery in New York and at the Stedelijk van Abbe, Eindhoven such as *Video Wall Projection* (1970), which exploited the shortcomings of an early monochrome video projector.

During the 1970s Peter Campus (1937, USA) produced an extended series of projected video installation works that sought to deliberately confront the viewer with a self -image that defied or challenged normal expectations. In an important sense these works were participatory and sculptural in that they invited and even required audience participation. In *Shadow Projection* (1974) the viewer's projected image was made to coincide with his/her own shadow, one shrinking whilst the other increased

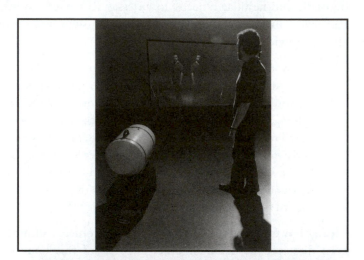

15.8: Peter Campus,
Interface, 1975.
Courtesy of the artist.

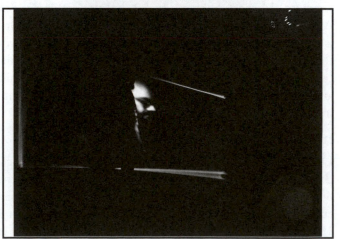

15.9: Peter Campus,
Mem, 1974. Courtesy
of the artist.

in size. In this and other works in the series, which also included *Interface* (1972), *mem* (1975) and *aen* (1977) Campus used disconcertingly simple arrangements of the 'live' video image and projection technology in conjunction with mirrors, inverted cameras or distorted projections to create and explore the new sensory conundrums of televisual space. In order to present this work Campus developed a particular configuration for his projection projects that meant that he often had to provide his own customized equipment:

> During the 1970s I worked with a Kalart Victor projector which ran on radio tubes and weighed about 150 pounds. I would travel with a lot of tube replacements in my suitcase. It used a cathode ray tube around 5 inches in diameter which was pointed backward into the rear of the projector. Surrounding the CRT was a parabolic mirror that was originally designed by Isaac Newton as a telescope element. It produced a beautiful image that has not been duplicated by the newer better smaller projectors.[9]

In many of these projection works and in his videotape *Three Transitions* (1973), Campus was particularly interested in exploring and representing notions of televisual space. All of these works confront the viewer with examples of complex co-existent physical and virtual spaces manifested via video technology. In the installations, the viewer is compelled to confront his or her own image, and to recognize and acknowledge the fascination of the live electronic mirror of video feedback.

In 'Video: The Aesthetics of Narcissism', the writer and theorist Rosalind Krauss identified a potentially problematic inherent 'narcissistic enclosure' in artists' video, but suggested that in works by Campus such as *mem*, it could be critically accounted for since the work allowed participating viewers to engage with and to become aware of their own narcissism. She described the process of this action and reaction and how it functioned in relation to the projected image on the gallery wall and the actions and awareness of the viewer:

> Campus' pieces acknowledge the very powerful narcissism that propels the viewer of these works forward and backward in front of the muralised field. And through the movement of his own body, his neck craning and head turning, the viewer is forced to recognize this motive as well. But the condition of these works is to acknowledge as separate the two surfaces on which the image is held – the one the viewer's body, the other the wall – and to make them register as absolutely distinct. It is in this distinction that the wall surface – the pictorial surface – is understood as an Absolute Other, as part of the world of objects external to the self. Further, it is to specify that the mode of projecting oneself onto that surface entails recognizing all the ways that one does not coincide with it.[10]

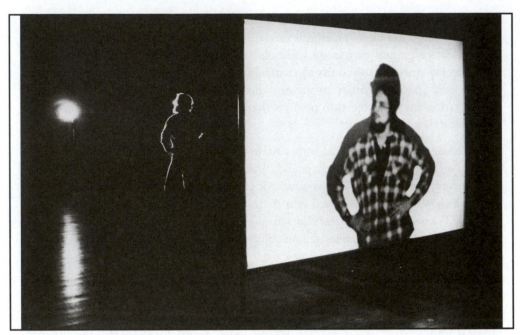

15.10: Peter Campus, *Shadow Projection*, 1975. Courtesy of the artist.

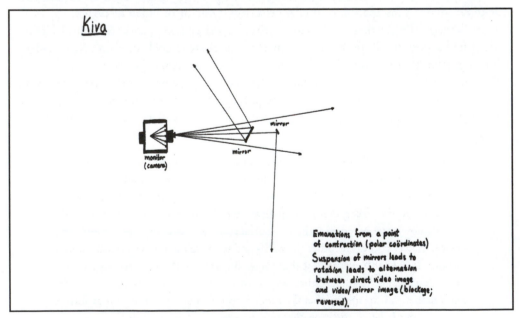

15.11: Peter Campus, Diagram for *Kiva*, 1971. Courtesy of the artist.

In works such as *mem, Shadow Projection* and *Interface* the viewer is participating in the work at a number of levels; actively involved in defining the image that is produced, decoding the operations and function of the mechanism of the installation and reflecting on the impulse which compels them to engage with it.

BREAKING THE FRAME

As with other aspects of video technology during the period under discussion, video projectors increased dramatically in quality and reliability, decreasing in size and bulk, whilst the cost of purchase continued to decrease. With this rapid change a growing number of artists began to explore the potential of this new mode of presentation. One significant feature of projection is the potential to project images onto surfaces (and objects) other than a conventional screen. Not only did this have an effect on the size of the image that an artist might consider, but it also presented the possibility of abandoning the traditional TV rectangle altogether. The standard broadcast TV ratio (3:4) that video artists had been confined and constrained by since the 1960s was no longer necessary or desirable, and this technological change helped to transform video art, liberating it from the inevitable reference of television, and as the resolution and brightness range of video projection increased, video began to be (almost) indistinguishable from film![11]

The work of Tony Oursler (1957, USA) provides an example of the potential of video projection to transcend the conventions of the rectangular television frame. Oursler began working with video in the mid-1970s, often making props and characters for his tapes, which he saw as an integral part of his working process. In this early period Oursler sought to create a dynamic tension between the interior space of the video presentation and the gallery space:

> The first installations were almost like screening rooms and the later installations were packed with information. I was very disenchanted with the television as an object which had been celebrated by the previous generation of artists, such as Nam June Paik and Dara Birnbaum, and others who found themselves in the position of converting a household appliance into art, whereas I felt like the magic of the appliance was hindered by the box itself. So most of my installations involved manipulating the video image to remove it one step from its physical origin into another space or dimension.[12]

Seeking a strategy to engage the viewer in a more active relationship to his work, and endeavouring to create a 'situation rather than an image', Oursler developed a series of installations involving the human figure. Particularly interested in the relationship between the power of technology and its relationship to human desire,

Oursler produced a series of talking dummies in the 1980s, experimenting with compact low-cost LCD video projectors to project human features onto their blank faces. Oursler used these talking dummies in an attempt to 'deconstruct the American narrative', describing the plots and highlights of popular feature films, engaging the viewer in an active relationship through memory and shared cultural experience.

In this series of video installations Oursler often deliberately isolated individual aspects of dramatic cinematic narrative to elicit a feeling of empathy in the viewer.

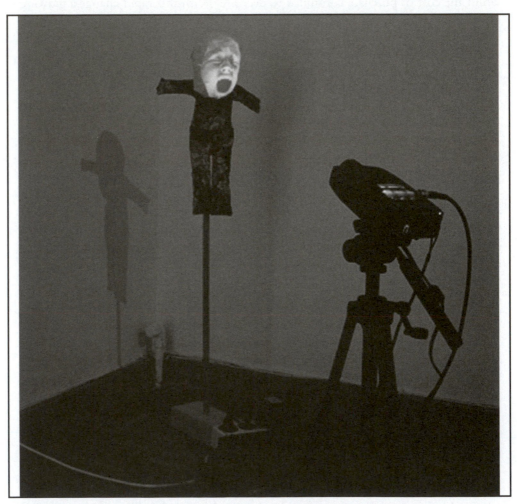

15.12: Tony Oursler, *Judy*, 1994. Courtesy of the artist and the Lisson Gallery, London.

In *Crying Doll* (1989) images of the continuously weeping face of performer Tracy Leipold (who has worked with Oursler on a number of his projects) were projected onto a diminutive doll. In this and other installations of the period, Oursler exploited another particular unique feature of video technology – its ability to present continuous and perpetual action:

> What makes the crying doll most effective is its superhuman ability to never stop weeping, which in turn becomes horrifying for the viewer, who eventually must turn away. It is that moment of turning away which the empathy test is all about.[13]

The technical improvements that have led directly to the development of low-cost, high-resolution and ultra-bright video and data projectors have contributed to a revolution in the presentation of video in the gallery and elsewhere. The video monitor, once the mainstay of the video installation and presentation, is now rare and in many ways its use often signifies an artistic statement, for example in Gary Hill's exposed CRTs (see Glossary) such as *In As Much as It Is Always Already Taking Place* (1990), *Between Cinema and a Hard Place* (1991) and *Between 1 & 0* (1993).

Advances in video projection have not only liberated video from its characteristic 3:4 aspect ratio and from the intimate scale associated with the television screen, but has also contributed to an erosion of the previously distinct characteristics between video and film. The dominance of video projection as the preferred presentation format in recent video work combined with other new technological developments such as the DVD and the computer hard drive has transformed the gallery exhibition of moving image work over the last decade. Curators now routinely include a mix of film and video in group shows, early classics of avant-garde film are presented in endlessly repeating loops alongside paintings and sculpture of the period, and projected video compilations juxtapose experimental film and video indiscriminately. This blurring of the distinctions and differences has its advantages – comparing the film and video work of artists who have worked with both media such as David Hall, Richard Serra or Robert Cahen can be instructive and illuminating.

The digital revolution has relentlessly eroded the distinctions between electronic and film-based moving image work. The convergence of computer manipulated imagery from a diverse range of sources – photographic, filmic and electronic – together with the development of image display technologies such as the plasma screen and high-resolution data projection has rendered the distinction between previously distinct media increasingly obsolete and largely irrelevant.

16. GOING DIGITAL
THE EMERGENCE OF DIGITAL VIDEO EDITING, PROCESSING AND EFFECTS

ACCESSIBLE DIGITAL EFFECTS

By the mid-1980s many video artists were able to gain access to post-production facilities that enabled complex manipulation and control of the electronic image. As has already been outlined, television workshops in a number of countries including France, Canada, the UK, Australia, Germany, and the Netherlands but most significantly, the USA, had provided certain artists limited access to comprehensive production facilities in the late 1970s. Additionally an important breakthrough occurred about the middle of the 1980s as a result of technological advances in consumer electronics and developments in computing. Alongside the rise of the new domestic and industrial video formats such as VHS, Betamax and U-matic, image-processing equipment such as time-base correctors, frame stores, video mixing desks, image keyers, colourizers and many other ancillary devices became available at costs that were within the reach of video and artists' collectives and even individual artist/producers. As this equipment became available to purchase at comparatively low-cost, access to individual artists who wished to hire these facilities also became more commonplace.

Prior to the 1980s digital image-processing equipment was only available at the broadcast level. Image-processing devices such as time-base correctors, digital frame stores, Quantel 'Paintbox' and Ampex 'ADO', were prohibitively expensive. Whilst these devices enabled and facilitated very complex control over the electronic image, they were expensive specialist tools requiring significant training and experience and were mostly restricted to qualified operator/editors employed by facilities houses or broadcast companies. Artists wishing to experiment with the creative and communicative potential of this level of image control were severely limited by cost, access and experience. Production costs of video work using this type of technology was high and the opportunities to gain this level of production funding few and far between.

By the early to mid-1980s however a new generation of low-cost digital equipment became available. Image processors such as the Australian Fairlight CVI, and digital frame stores such as the 147–20 made by the UK-based CEL electronics, made it

possible to produce true 'freeze frames'. Time-base correctors and synchronizers enabled artists working with video to edit, mix and 'wipe' video sequences from multiple tape sources ('A/B roll') and picture editing effects such as 'picture-in-picture' chroma-key devices gave artists the ability to selectively combine imagery from tape and video sources, etc. This explosion of low-cost complex electronic effects naturally led to a period of enthusiastic over-indulgence, and certainly many videotapes produced in the mid- to late 1980s suffer from visual overkill and harshly processed vacuousness. Some artists explored this tendency to directly critique and question the cultural impact of the so-called information explosion.

Jeremy Welsh (1954, UK) made a number of videotapes addressing and challenging the relationship between mediation and reality, notably *I.O.D.* (1984) and *Reflections*

16.1: Jeremy Welsh, *I.O.D.*, 1984.
Courtesy of the artist.

16.2: Jeremy Welsh, *Reflections*, 1986.
Courtesy of the artist.

16.3: Peter Callas working with the Fairlight CVI at Studio Marui, Tokyo, 1986. Courtesy of the artist.

(1986) in which he produced complex and accomplished collages of TV station logos and indents, advertisements and electronically generated captions to deliberately bombard and saturate the viewer with media imagery.

As discussed in Chapter 10, Australian artist Peter Callas explored the creative potential of the Fairlight CVI in a number of videotapes and installations produced between 1985 and 1990, including *Night's High Noon* (1988), *Karkador* (1986), *Neo Geo* (1989) and *The Fujiama Project* (1990). In this series of works, grouped by Callas under the general title 'Technology as Territory', the artist was engaged in a reworking of 'found' images, extracting them from their original context, redrawing and animating them in order to translate and recontextualize them into an 'emblem', representing these images within a new context of his own making.

> The layering or drawing techniques available to artists through computer graphics devices free them from having to use a viewfinder as a framing device … in computer devices images (as ideas) can be retrieved and recombined at a moment's notice. In this process something intangible, though incomprehensible, is made from the combination or intersection of two tangible properties.[1]

UK-based artists such as Clive Gillman and Lei Cox began to explore the potential

16.4: Clive Gillman, *NLV*, 1990. Courtesy of the artist.

of electronic processing as it crossed the digital threshold. Clive Gillman's (1960, UK) *NLV* (Non Linear Video) (1989–90) was an on-going series of visually inventive short works which featured a complex layering of analogue images using digital post-production techniques. For Gillman the *NLV* series represented a significant shift from his previous single-screen video tape work of the early 1980s towards a more non-linear and interactive approach that he developed with subsequent installation work such as *Losing* (1991) a multi-channel video installation comprising eleven monitors, a desktop computer and a video projector.

Lei Cox (1965, UK) explored the potential of electronic imaging techniques to produce hybrid images through electronic and digital collage and animation techniques, deliberately avoiding narrative sequences in favour of endlessly repeating fragments often intended to be shown alongside more traditional paintings, sculpture or photographic prints. In tapes such as *Lighthead* (1987), *Torso* (1988) and *Lei Can Fly* (1988), he created a series of disturbing and humorous short tapes that reconfigured the human form in impossible and improbable ways. In his subsequent

large-scale works such as *Magnification Maximus* (1991) and *The Sufferance* (1993) Cox continued working with digital imaging techniques to create hybridized creatures within fantastical landscape settings that the artist characterized as large-scale 'video paintings'.

FROM ANALOGUE TO DIGITAL

My own experience of this image-processing revolution can serve as an example. Working with analogue image processing and recording the output onto the U-matic (¾-inch) tape format from 1978, my use of the Videokalos Image Processor (see Chapter 7) enabled a high degree of control over the colour video image in 'real time'. Among other facilities, the Videokalos IMP provided me with 'genlock', so I could synchronize a single video tape source with a monochrome or colour video camera, mixing, keying (luminance and chrominance) composite colour control (separate R, G & B) image wipes (vertical, horizontal, circular, and elliptical). In this period I worked initially with a black-and-white (Portapak) source to produce single-screen works including *Horizontal & Vertical* (1978) and *The Distracted Driver* (1980). I set up my own studio in 1980–1 (Three-Quarter Inch Productions[2]) around a pair of Sony 2860 U-matic edit decks and from 1982 I worked with a portable U-matic recorder (Sony VO 4800) and colour camera (JVC KY1900) in conjunction with the Videokalos, to make works such as *The Room with a View* (1982) and *Time-Travelling/A True Story* (1983). With the introduction of a CEL digital frame store and access to a Gemini twin TBC in 1985–86, my effects repertoire was considerably enhanced. I was then able to mix multiple videotape sources, produce video frame grabs (providing an alternative image-sequencing effect which resembled slow motion) and perform image 'flips' (making mirror images of video sequences). New single-screen tape work in this period included the final versions of my 1985–7 work *The Stream* and *An Imaginary Landscape* (1986), both of which made considerable use of split screen effects, image flips, frame grabs and digital pixellation, and accomplished by mixing multiple video tape sources. Not only did these new image effects extend the visual complexity of my work at this time, they also opened up my ideas to embrace new themes and ideas, particularly those related to the nature of electronic imagery and its potential relationship to visual perception and the flow of thought.

This new video work and the issues it raised for me about the role of the spectator led directly to an abandoning of the single-screen video format after 1988 and the production of a series of participatory multi-monitor installation and sculptural video works during the 1990s including *Eau d'Artifice* (1989–90), *Streamline* (1991–92), *Cross-Currents* (1993), *Perpetual Motion* (1994), *Vortex* (1995), *Mind's Eye* (1997) and *Mothlight* (1998). These installation works made increasing use of digital imaging,

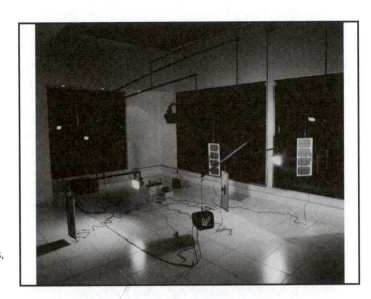

16.5: Chris Meigh-Andrews, *Mothlight*, 1998. Courtesy of the artist.

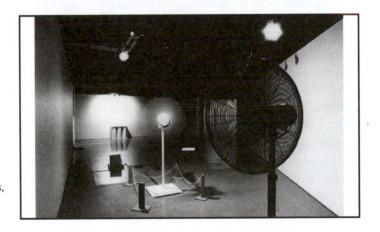

16.6: Chris Meigh-Andrews, *Perpetual Motion*, 1994. Courtesy of the artist.

and by the mid-1990s my work was completely digital at the post-production stage, using analogue videotape purely as the exhibition display format. For example, the images for *Perpetual Motion* (1994) were composed on an Apple Mac Quadra 840AV using Macromedia 'Director' software output to videotape.[3] *Vortex* (1995) featured digital slow motion video mixed with 3D texts animated via Quantel 'Paintbox' and *Mind's Eye* (1997) presented computer animated fMRI brain scans recorded onto Betacam, a broadcast video format.

COMPUTERS, NON-LINEAR EDITING AND DIGITAL VIDEO

In the period between the mid-1980s to the early 1990s a number of computer manufacturers developed machines capable of non-linear editing (NLE) of analogue video. 'Desktop video', a (now defunct) term derived from 'desktop publishing', involved using the computer to control analogue video players and recorders, and used commercially available 'genlock' cards such as the 'Radius' and 'Video Toaster' for use with computers such as the Commodore Amiga 2000, some IBM PC compatible machines (these machines were sometimes referred to as 'IBM clones' until IBM withdrew from the home computer market in 1990), and the Apple Mac Quadra AV range.

So-called 'Non-linear 'editing' (NLE) enabled direct access to any specified video frame without requiring to play, rewind or fast-forward the tape to locate the edit point. Prior to the introduction of NLE it had been necessary to laboriously assemble video images and sequences in a particular order which was then fixed, as it was necessary to electronically re-record from the original source tapes in 'real' time in order to construct a 'master' tape. Any subsequent changes to the order or the length of the sequences on the master required an editor to re-record the images from the point of the change onwards. So, for example, if it were necessary to delete, shorten, replace or move a particular sequence from the edited master, all the subsequent sequences from the source tapes would have to be re-recorded onto the master tape. Computerized non-linear editing on the other hand, allowed the editor to simply delete or modify a sequence and all the subsequent sequences would automatically 'ripple' forwards or backwards as required to accommodate the change, since all the video sequences, once digitized, could be stored on the computer's hard drive. The ordering of sequences of the source materials remained latent and the final edited version of the work was only fixed once the computer output was recorded onto tape. This was a profound change to the way that artists thought about editing and organizing their images and this technological transformation of video editing has had a major impact both to the accessibility of video editing and the kind of work that artists made.

The next stage in the technological evolution of the video medium was the introduction of full digital video. Although various elements in the video production chain, such as time-base correctors and image-processing machines for digital video effects (DVE) had been available since the mid-1970s and fully digital video had been developed for the broadcast industry during the mid-1980s with the commercial introduction of Sony D1 format, so-called consumer digital video became available in 1995 with the introduction of the DV digital tape format.

This new format, and its later higher resolution variants (DVCPRO, DVCAM and DVCPRO HD etc.), along with the rapidly diminishing costs and substantially increased processing power of desktop computers led directly to the development of digital image-processing computer software packages. Adobe 'Photoshop' (1990) and similar so-called 'digital darkroom' (and 'lightroom') techniques transformed the potential of the photographic image and in many ways provided a model for the digital editing and moving image-processing tools that followed in their wake. Video editing and imaging effects software applications such as Macromedia's 'Video Works' (1985), 'Director' (1987) and 'Final Cut Pro' (1998) and Adobe's 'Premiere' (1991) and 'After Effects' (1993), which provided video artists with so-called 'desktop video' (picture and sound editing, and image transformation techniques very similar to those familiar to film editors and TV broadcast post-production effects), but at a fraction of the cost.

16.7: Malcolm Le Grice, *Arbitrary Logic*, 1986. Courtesy of the artist.

Although this kind of non-linear manipulation provides the artist with the potential for far greater control over the ordering and construction of his or her work, it does not provide the viewer with similar enhanced possibilities. The film and video artist Malcolm Le Grice (1940, UK) has written about the issues raised by the emergence of the non-linear and its implications for film and video from ideas that have emerged from his own fine art practice including a sustained period of working with accessible digital technology. In works such as *Arbitrary Logic* (1986), *Sketches for a Sensual Philosophy* (1988) and *Digital Still Life* (1989), Le Grice worked with inexpensive home computers (initially the Sinclair Spectrum and the Atari) to explore the potential of the digital and its implications for moving image within a fine art context. In his writings Le Grice stresses his primary activity as an artist and often provides readers with what he calls a 'health warning' – pointing out that his theoretical work is based on the analysis of his own work and its relationship to others working within similar cultural and technological contexts. In his 1997 essay 'A Non-linear Tradition – Experimental Film and Digital Cinema', Le Grice identifies some of the fundamental issues and questions raised by the concept of non-linearity and its implications for artists working with the moving image. The central question relates to the relationship between non-linearity and narrative, especially with respect to the viewer's experience, which seems to be inevitably tied into a sequential unfolding of time.

THE DATABASE AND INTERACTIVITY: NEW NARRATIVE POSSIBILITIES

Le Grice identifies two potential categories of work from the history of experimental film and video which attempt to break with the narrative tradition – the abstract non-representational works of film and video makers who drew on the musical and painterly tradition in fine art discourse, which would include some, if not all the artists discussed in Chapter 7, and those who have sought to make a conscious break with the narrative tradition, even though they include images produced through photographic representation. Le Grice traces the evolution of a pure cinematic mode of discourse asserting that the viewer's experience of a moving image work is inevitably linear in nature, given the apparent continuity of consciousness and therefore it is necessary to accept the inevitability of perceptual linearity. For Le Grice the problematic issue behind narrativity is the hidden authoritarian ideological position of the dominant cultural form:

> Even if the content is transgressive or anarchic, the form locks the audience into a consequence which unifies the subject impotently with and within the narrative. It is the linear coherence of the narrative and its conclusion which represses the subject (viewer) by implicitly suppressing the complexity of the viewer's own

construction of meaning. Transmitted as a culturally validated convention, narrative subsequently becomes a model by which experience is interpreted, becomes a filter for the life experience outside the cinematic.[4]

Writer, theorist and artist Lev Manovich (1960, Russia) has written extensively on the impact of computer technology on the electronic moving image and narrativity, publishing a number of influential books and articles including 'Database as Symbolic Form' (1998) which explores the idea that the computer has introduced the database as a new cultural form to supersede the narrative form previously favoured by cinema.[5]

These ideas were extended and developed in his book *The Language of New Media* (2001) in which Manovich identified and set out five key principles underlying digital media:

1 New media 'objects', such as images and sounds exist as data.
2 The various elements of new media can exist independently.
3 New media objects can be created and modified automatically.
4 New media objects can exist in multiple versions.
5 The logical 'language' and structures of the computer affect and influence how we understand and represent ourselves and the culture.[6]

Initially practicing as a visual artist, Manovich's ideas have been formed and developed both through writing and practice, and he has produced a number of moving image works in which these ideas and principles are explored and tested out. In *Little Movies* (1994) Manovich sought to create a 'lyrical and theoretical project centred on the aesthetics of digital cinema'. *Little Movies* entirely comprises 'QuickTime' moves, an early digital video format which Manovich characterized as the earliest manifestation of a cinema yet to come. In this work, which was one of the earliest examples of an on-line video work, Manovich sought to explore QuickTime's formal properties, comparing his approach to that of the Structural filmmakers of the 1960s and early 1970s (see Chapter 4):

> As time passes, the medium becomes the message, that is, the "look", more than the content of any media technology of the past is what lingers on. "Little Movies" reads digital media of the 1990s from a hypothetical future, foregrounding its basic properties: the pixel, the computer screen, the scanlines.... An aesthetic analogy can also be made with the structural filmmaking movement of the 1960s which defined the material elements of film media as their subject matter. In "Little Movies", I thematize the material elements of digital media such as pixels, scanlines, compression artefacts, computer screen.[7]

Manovich's *Soft Cinema: Navigating the Database* (2005) (with Andreas Kratky) is a collaborative project to produce moving image works in which computer software selects and organizes the visual material in a non-linear but structured fashion, based on a set of variables which have been pre-defined. The database is programmed so that the story is almost never the same. Thus *Soft Cinema* is in essence a digital video editor that provides an interface between human editors and a database of video footage designed to 'perform' different edited versions of the footage, allowing each presentation to be unique.[8]

The Maltese artist Vince Briffa (1958, Malta) has exhibited his videotapes and installation internationally since the mid-1990s. Works include *Tabernacle for Voyeurs* (1999), *Hermes* (1999), *The Drift Between the Shores of Perception* (2000). In 2007 he exhibited *Playing God*, an interactive work that explored the potential of video loops to construct multiple meanings. Briffa was interested in the way in which looped sequences could be used to construct complex narratives:

> The work makes use of predetermined clips of edited video that respect filmic continuity as modular building blocks. Edited together, these clips become larger narratives, possibly even taking the form of loops, not following a regular path, but finishing more or less at the same point where they have started from.[9]

This work, which was specifically designed to be viewed within the environment of a church, was installed in St John's Cathedral in Valletta. Here the video image was projected upwards onto a specially constructed screen suspended from the ceiling. In discussing this work Briffa cites Lev Manovich's 2002 article 'Generation Flash', which discusses the significance of the loop as a critical device in contemporary video installation, taking up the position previously held by photography:

> The loop thus becomes the new default method to "critique" media. At the same time, it also replaces the still photograph as the new index of the real: since everybody knows that a still photograph can be digitally manipulated, a short moving sequence arranged in a loop becomes a better way to represent reality— for the time being.[10]

Many other artists have sought to explore the potential of interactivity provided by technological developments in computer hardware and software (see for example, Takahiko Iimura's *AIEUONN Six Features* (1992–9), discussed in Chapter 11). In *The Legible City* (1988–91) by Jeffrey Shaw (1944, Australia) with Dirk Groeneveld, viewers seated on a fixed bicycle were able to engage in an interactive image/text tour through the central sections of three urban centres: Manhattan (1988–9), Amsterdam (1990) and Karlsrule (1991). In all three versions of this work projected images of

16.8: Vince Briffa, drawing of ciborium screen for *Playing God*, 2008. Courtesy of the artist.

16.9: Vince Briffa, *Playing God*, 2008. Courtesy of the artist.

computer-generated texts responded to the direction of the bicycle handlebars and the speed of the cyclist-spectator, presenting them with a personalized journey through computer-generated three-dimensional textual statements and stories associated with the different cities. In each version of the installation the image-texts presented the viewer with a complex experience which fused the actual and the virtual, the physical experience of peddling and manoeuvring the bicycle and the reading of the transforming texts as she/he moves through simulated image space. The work suggested and explored the potential of non-linear interactive installation work providing new and complex perceptual experiences which extended well beyond mere spectacle:

> … the presence of writing makes it clear that a city is not only a geographical agglomeration of architecture, but also an immaterial pattern of experiences. The content of the texts, which can be perceived, only when the viewer performs the activities of cycling and reading, reveals that the inhabitant's history plays an important role in shaping the identity of a place. The effort it takes the viewer to synthesize the slowly approaching, extremely foreshortened letters into phrases whilst cycling gives evidence of the fact that, in spite of the immateriality of the virtual city, a new reality is being formed in the viewer's mind.[11]

Another Australian artist, Simon Biggs (1957, Australia), based in the UK since 1986, has also explored the potential of interactivity in a number of complex video installations. *Alchemy* (1990) a twin-channel interactive laser disk installation, is a digitally illuminated 'book of hours' comprising 24 electronic 'pages' that a viewer could explore sequentially.

16.10: Simon Biggs, *Alchemy*, 1990.
Courtesy of the artist.

16.11: Simon Biggs, *Alchemy*, 1990.
Courtesy of the artist.

The installation was physically constructed from two video monitors turned vertically and arranged to form an open book, the interactivity of the software programming allowing the visitor to 'turn' the pages with a hand gesture. The similarity with an ancient illuminated manuscript was extended to the style and visual power of the imagery but with the added dimension of animated movement. The digital pages of *Alchemy* were inhabited by a host of animated demons, angels and mythical beasts to reference a contemporary parallel with genetic and robotic research using computer-aided technologies.

Susan Collins (1964, UK), initially working with single-screen video, made *Going for Goldfish* (with Julie Meyers) (1990) and *Coming Attractions* (1991) using a Commodore Amiga computer with 'Deluxe Paint III' graphic software, soon began to explore the potential for interactivity offered by more sophisticated computer systems. Her earliest public 'site-specific' installation, *Introductory Exchanges* (1993), sited in the Woolwich foot tunnel, which runs under the River Thames in London, was aimed to 'engage viewers in an inquiry or reinterpretation of their role within specific and everyday contexts'.[12]

In subsequent commissioned installations such as *Handle with Care* (1993) and *Pedestrian Gestures* (1994) Collins developed her techniques to enable a wider array of image and sound responses to be triggered via audience interactions to create a situation in which the viewer becomes an often-unwitting collaborator/participant. Increasingly Collins has developed an approach that allows for the possibility of individual narrative routes determined by the action and direction of the viewer as s/he negotiates the work.

In the last decade of the twentieth century, artists working with video increasingly began to explore the potential relationships between electronic space and interactivity.

16.12: Susan Collins, *Pedestrian Gestures*, 1994. Courtesy of the artist.

See for example, Takahiko Iimura's interactive work *AIUEONN Six Features* (1999) which was discussed in detail in Chapter 11. In other works such as Grahame Weinbren's (1947, South Africa) *Sonata* (1993), *Passage Sets/One Pulls Pivots at the Tip of the Tongue* (1994–5) by Bill Seaman (1956, USA) and Toshio Iwai's (1962, Japan) *Piano-As Image Media* (1995), there has been an intention to open up new territories by combining aspects of earlier forms including film, literature, music and sculpture with objects and images presented within virtual space. The participatory project that has evolved from the 'Expanded Cinema' of the 1970s through the video sculpture of the 1980s has been extended via the potential interactive interplay between viewer, artist and imaging technology.

HIGH-DEFINITION VIDEO

Standard colour video resolution is either 480 horizontal lines (NTSC) or 570 (PAL), and as there is no specific agreed definition, 'high-definition' is generally accepted

16.13: Terry Flaxton, *In Re Ansel Adams*, 2008. Courtesy of the artist.

to be anything above 720 horizontal lines, which is 1280x720 pixels. Currently available standards also include a somewhat higher resolution of 1080 horizontal lines (1920x1080 pixels). There are a number of video recording formats which include HDCAM, HDCAM-SR, DVCPRO HD, XDCAM HD and AVCD.[13] HD video is now also available on-line, and it is possible to stream or download high-definition video via such services as YouTube, Vimeo and a number of other services.

The UK-based artist Terry Flaxton (1953, UK) has been working with high-definition video for a number of years, and has produced a series of works which explore the potential of this format including *Skin Deep* (1999), *Towards Aquarius* (2002). *Water Table, Un Tempo, Una Volta* and *In Other People's Skins* (all 2008).

Flaxton's *In RE Ansel Adams* (2008) begins with a close-up of the spectacular waterfall in Yosemite Valley, California, which was itself the subject of a celebrated photograph (*Clearing Winter Storm,* 1937) by American photographer Ansel Adams (1902–84) champion of the 'Zone System' and member of the f64 photography group. Flaxton's video gradually zooms back optically and then digitally to reveal a wide-angle high-definition colour image reproducing the exact framing of Adam's original composition, and in a final gesture the image sheds its colour in homage to its original photographic inspiration. Flaxton's work makes use of an ultra-high-definition video system which approaches the technical and aesthetic quality of film.

VIDEO AND THE WORLD WIDE WEB

Undoubtedly the single most significant technological development of recent times to impact personal communication is the development of the Internet. There has been an extraordinary cultural revolution since Tim Berner-Lee's development of the 'Worldwide Web' in 1990 and the subsequent declaration in 1993 that the technology would be freely available to everyone, anywhere. Video streaming became available in 1997, although the first web cam was developed as early as 1991.[14] By 2001, it has been estimated that there were over 575 million web sites, with over 1.4 billion web pages.[15] The majority, if not most artists now have their own web site, and since the launch of 'YouTube' in 2005, it became possible to upload moving image video clips, making it possible to 'post' and watch artists' video on-line. The web is one of the most commonplace and effective ways in which to view and present single-screen digital moving image work. Powerful and accurate search engines make browsing the Internet to locate information about artists and to see examples of their work a direct and primary resource.

Artists have engaged with the web cam and 'telepresence' (see Glossary) as a means of investigating issues of communication and personal relationships, developing on-line works which explore the direct 'live' engagement and face-to-face potential of

the device, or in some cases the reverse – highlighting the impossibility of achieving intimacy via mediated imagery. Annie Abrahams (1954, the Netherlands) for example has developed a number of works including *Double Blind (Love)* (2009), which was made in collaboration with artist and writer Curt Cloninger, *If Not You Not Me* (2010) and *Angry Women* (2012). In these works Abrahams draws on the ideas of American writer and academic Sherry Turkel, as developed in her book, *Alone Together: Why We Expect More from Technology and Less from Each Other* (2011), suggesting that despite illusions to the contrary, social networking technology devices can shield us from the need to find more direct and intimate relationships with each other.[16]

Computer software and the Internet have also enabled and facilitated the recent development of many significant archive projects, which allow the storage, retrieval and on-line viewing of works by video artists in many countries. Initiatives such as the Asia Art Archive (http://www.aaa.org.hk); the Australian Video Art Archive (VAVAA) (http://www.videoartchive.org.au); Video Data Bank (http://www.vdb.org) (USA); Lux on-Line (www.luxonline.org.uk/); The Rewind Project (http://www.

16.14: Annie Abrahams, *Double Blind Love*, 2009. Courtesy of the artist.

rewind.ac.uk/rewind) (UK); INA (http://www.ina.fr) (France); The Danish Video Art Archive (http://processualarts.org); The Moving Image Archive of Contemporary Art (MIACA) (http://www.miaca.org), Japan; and others have made many of the works held in their collections available to view on-line, and even in some cases to download. Additionally, visitors to these sites are able to access contextual and biographical information about the artists and their works and ideas. These archives have not only made it possible to access and view video work, but have also facilitated the retrieval of lost or little-known works and enabled them to be preserved and catalogued. Digital archiving of historically significant works by artists is perhaps one of the most important developments in recent years in the field, and has made a major contribution to the development of the research, study and understanding of this international phenomenon.

17. VIDEO ART IN THE NEW MILLENNIUM
NEW DEVELOPMENTS IN ARTISTS' VIDEO SINCE 2000

It seems that the majority of gallery visitors are still blissfully unaware of the complex history of video art, but as we have seen, back at the dawn of British video art in the early 1970s, pioneering video artist David Hall made claims for video *as* art. Hall was not interested in making work which merely used video as a medium, but strove to produce tapes which foregrounded video *as* the artwork, and in his writings he was most concerned to distinguish video art practice from broadcast television:

> Video as art seeks to explore perceptual thresholds, to expand and in part to decipher the conditioned expectations of those narrow conventions understood as television. In this context it is pertinent to recognize certain fundamental properties and characteristics that constitute the form. Notably those peculiar to the functions (and "malfunctions") of the constituent hardware – camera, recorder and monitor – and the artist's accountability to them.[1]

Against this perspective, Peter Donebauer, with perhaps a more pragmatic attitude to the technology, argued for an approach to video that focused on the primacy of the electrical signal, deliberately critiquing Hall's modernist position:

> … this rather deflates the theories of certain academics in this country who have tried to define an aesthetic based around television cameras, monitors and video tape recorders. Video can happily exist without any of them![2]

Seen from a contemporary perspective, Donebauer's view seems to have been validated. Currently artists understand video not so much as a medium to be explored and celebrated for its own sake, but as a complex carrier medium for a much broader set of cultural and contextual preoccupations. Like its sister technology, television, video can adopt a multitude of formats and like television, video has the ability to contain a diversity of other forms. In its latest digital manifestation, video embraces photography, sound, film, graphics and architecture. By extension video can contain cultural forms as diverse as narrative story-telling, documentary, theatre, dance, music, virtual reality and animation, reaching out to new and as yet undefined forms such as interactivity and non-linearity.

CONVERGENCE: RECENT ARTISTS' VIDEO AND BLURRING OF FILM AND VIDEO

Digital video has all but eradicated the boundaries between cinema and television, making the distinction irrelevant to everyone but the most devoted purist. Access to reliable inexpensive production equipment, the availability of DVD, Blu Ray Disk and large capacity computer hard drives, high-resolution recording and video projection, and the potential of video streaming and web-casting on the Internet have all had an impact on the use and popularity of video as a medium for artistic expression and as a gallery display format.

This 40-year technical revolution has had very significant implications for artists and curators. In many art galleries and museums video is ubiquitous. Artists now use the medium as a matter of course, and curators are more than willing to mount exhibitions that include or feature video work – indeed it would seem the inclusion of artists' video in mixed exhibitions is *de-rigueur*.

The UK Turner prize, internationally recognized as one of the most prestigious awards for contemporary art, provides persuasive evidence of the way in which artists' video is now not only fully integrated into the mainstream of contemporary art, but also a powerful and culturally relevant medium. Presented annually at Tate Britain since 1984, the Turner prize exhibition often features video works by its short-listed artists, and in the last fifteen years the award has been won by many artists working with video as either their primary medium, or as a key element within their repertoire.

Winners and nominees who work with video, include Willie Doherty (nominated 2000 and 2003); Isaac Julien (nominated 2000); Douglas Gordon (winner 1996); Angela Bulloch (nominee 1997); Gillian Wearing (winner 1997); Sam Taylor-Wood (nominee 1998); Steve McQueen (winner 1999); Kutlug Ataman (nominee 2004); Yinka Shonibare (nominee 2004); Jeremy Deller (winner 2004); Mark Wallanger (winner 2007); Mark Leckey (nominee 2008); Otolith Gang (Kodwo Eshun and Anjalika Sagar, nominees 2010); Hilary Lloyd (nominee 2011); and most recently Luke Fowler (nominee 2012) and Elizabeth Price (winner 2012).

Elizabeth Price (1966, UK) won the Turner prize for her video 'The Woolworth's Choir of 1979' in 2012. Her understanding of video as a medium that allows a complex blend of image sources, technological strands and cultural references is clear from her statements quoted in a recent newspaper interview:

> I use digital video to try and explore the divergent forces that are at play when
> you bring so many different technological histories together... . We can move
> between genres and forms from something that looks like a power point lecture
> to something that looks like an infomercial to something that feels like a

cinematic melodrama... . I'm interested in the medium of video as something you experience sensually as well as something you might recognise.[3]

Jeremy Deller's (1966, UK) *Memory Bucket* (2003) also reflects the way that video can be employed to shift between moving image forms and genres and demonstrates the diversity of approaches taken by contemporary artists using video. *Memory Bucket* is a blending of sophisticated home movie aesthetics with TV-style documentary. Images of the south Texan landscape were cut together with talking-head presentations and close-ups of fauna and flora. Presented on a large plasma-screen TV, this work offered a very conventional viewing strategy, the wall-mounted screen mimicking a gallery presentation of painting. *Memory Bucket* deliberately follows television conventions because for Deller, the formal concerns of video were not the main issue; the form of this work was part of a wider strategy – video being simply one element in a broader and more complex cultural canvas.

In the same Turner prize exhibition Ben Langlands (1955, UK) and Nikki Bell (1959, UK) offered several examples of a contemporary approach to video, from the twin-screen installation *NGO* (2003) which juxtaposed a multitude of acronyms of governmental and UN organizations with stark photographs of non-governmental agency signs *in situ*, to an interactive representation of Osama bin Laden's fortified hideout. This large-scale projection work offered visitors the opportunity to explore a detailed computer-modelled version of the infamous terrorist leader's abandoned mountain headquarters, via a joystick control. *The House of Osama bin Laden* (2003) was very clearly referencing the computer game format, and although stripped of any of the usual rewards or goals associated with game playing, it employed this format to deliberately juxtapose a familiar fantasy with the anxiety of the unknown.

Yinka Shonibare's (1962, UK) *Un Ballo in Maschera (A Masked Ball)* 2004 is a complex and meticulously orchestrated video work. Commissioned by Moderna Museet in Stockholm and produced by Swedish Television, this work is an excellent example of the increasingly indistinct boundaries between the cinematic and the televisual in the age of digital video. Produced in 'high-definition' digital video, *Un Ballo in Maschera* drew on the talents of a host of television industry professionals – lighting engineers, camera operators, set and costume designers, make-up artists, choreographers, video editors and sound recordists, as well as over 30 accomplished dancers. This work, clearly produced for broadcast television, is a perfect illustration of the complex and long-standing relationship between broadcast television and video art. Nam June Paik, as quoted elsewhere in this book, claimed that 'TV has been attacking us all our lives, now we can attack it back', targeting television as a worthy adversary and sparring partner.[4]

As we have seen, early video artists were often polarized in their attitude to broadcast television – some committed to video as an alternative and distinctly separate medium, whilst others fought for the right to have their works aired on TV. In many countries early video art was most often considered unsuitable for broadcast, and when shown at all, was relegated to late-night slots or ghettoized into arts programming – packaged for specialist minority audiences, chopped up and served as extracts between the instructive contextualizing of 'expert' commentary. In the UK, Channel 4 was especially active in this area, transmitting compilations of video art as part of its 'Eleventh Hour' and 'Ghosts in the Machine' series in the 1980s and 90s. Often commissioning works from major American video artists such as Gary Hill, Bill Viola and Daniel Reeves, that often only received a single airing.

Channel 4 has also sponsored the Turner prize for a number of years between 1991 and 2004, and although other sponsors have recently taken up the mantle, the Channel 4 broadcast connection continues, with John Wyver's production company 'Illuminations' providing the televised coverage. In the past Wyver has himself been an active commentator on the relationship between broadcasting and video art. In *The Necessity of Doing Away With Video Art*, written in 1991, he argued that due to the convergence of previously distinct elements of moving image culture, it was no longer necessary or desirable, to understand or treat video art as a special category. Wyver instead looked forward to a time when 'the innovative and challenging visions of artists and others integrated into each element of television's output'.[5] The main focus of Wyver's essay was a critique of the perpetuation of video art as a distinct genre, proposing a more eclectic mix of media both within the gallery context and on television. In most cases this seems to have happened in the gallery, but the broadcast industry is still keen to keep the special category alive and artists firmly in their place.

Twelve is a six-screen video projection installation by another Turner prize nominee, Kutlug Ataman (1961, Turkey). Ataman has also worked as a filmmaker, with two feature films to his credit, and his professional training was clearly evidenced by the careful framing and controlled camera work of *Twelve*. Many of his exhibited video works (such as *Kuba* (2005) are multi-screen presentations with long, minimally edited sequences running concurrently. *Twelve* presents recordings of six individuals, five men and one woman, recounting personal experiences of re-incarnation directly to camera. The video sequences, projected onto large vertical transparent screens presented viewers with life-size and very candid images, the potential intimacy of the situation deliberately contradicted by the multi-screen format of the installation. The visitor was confronted by a babble of voices from the six separate soundtracks and a juxtaposition of carefully arranged multiple projections – there is a roomful of individuals to choose from, and the images and sounds compete for attention.

(Superimposed text captions offered a simultaneous translation – the voices were all speaking in Turkish, as the subjects all lived in a region of Turkey bordering with Syria.) The electronically generated captions and the high production values initially suggested an experience reminiscent of TV news, but a closer reading provided more personal insight. Thus the work prompted an engagement by challenging the viewer's initial impressions, drawing them in and proving the opportunity to engage with a specific individual.

In 2004 Tate Modern staged 'Time Zones', the gallery's first exhibition entirely devoted to moving image work. This exhibition presented ten moving image works in a carefully choreographed exhibition. Visitors were encouraged to move through a series of darkened, interconnected spaces showcasing works by international artists from nine countries (Mexico, Turkey, Israel, China, the Netherlands, Albania, Serbia, Germany and Indonesia). These diverse works demonstrated the range and scope of moving image media and the extent to which contemporary film and video have become interchangeable and interrelated: *Liu Lan* (2003) by Yang Fudong (1971, China), and Fiona Tan's (1966, Indonesia) double-screen video installation *Saint Sebastian* (2001) were both shot on 35mm film, transferred to DVD and presented on data projectors. *Comburg* (2001) by Wolfgang Staehle (see below) was a continuous 'real-time' video projection streamed on the Internet via a web cam, whilst *Zocalo* (1999) by Francis Alys (1959, Belgium) was an unedited twelve-hour 'real-time' recording made on Mini DV (a domestic digital video format), transferred to a computer hard drive. Of the ten works on show, only *Untitled* (2001) by Jeroen de Rijke and Willem de Rooijshot (1970 and 1969, the Netherlands) was shot, edited and projected as a film.

This interchangeability of formats and presentation was echoed in the exhibition catalogue essays. Gregor Muir, describing Fiona Tan's two-monitor video installation *Rain* (2001) consciously blurred the two forms: 'On two *monitors* we view the same *film* of a downpour and a dog sat next to two buckets of water. The two *projections* are, however, out of sync, and thus the buckets are seen at various stages of fullness'.[6] Jessica Morgan compared Francis Alys' use of duration in *Zocalo* (1999) to that of Andy Warhol in his 1964 film *Empire,* as did a number of the other writers in the exhibition catalogue.[7] Arguably the art historical distinctions between these two media (and these two works) are important, even crucial – especially in relation to notions about the presentation of 'time-as-material'. Warhol's deliberate break with the dominant Romantic traditions of poetic temporality as characterized by the work of Stan Brakhage and his subjective 'camera eye', is very different from the tradition of surveillance video or the 'real-time' unedited documentation of performance by many video artists who have been discussed in this book, including Martha Rosler, William Wegman, Richard Serra, Vito Acconci, Mary Lucier, and many others. Gregor Muir,

paraphrasing P. Adams Sitney, claimed: 'We live in a world where it is possible to turn on the camera and leave it running'. This is, of course, precisely what Warhol did *not* do when shooting *Empire* – as it clearly required an active role to keep filming for 12 hours – and not simply because he had to keep changing the rolls of film!

Concurrently with 'Time Zones' Tate Modern exhibited Bruce Nauman's *Mapping the Studio II with Color Shift, Flip, Flop* and *Flip/Flop (Fat Chance John Cage)* (2001), an excellent example of the use of 'real-time' video. The installation presents nearly six hours of video and sound on seven screens. From fixed-camera positions, Nauman projects wall-sized monochromatic video images of his studio, recorded at night. The raw documentation has been electronically processed, with colour and image flipping (inverting the image) and flopping (laterally reversing) added, but the random moments of authenticity – the scurrying mouse, the flitting insects, the occasional human sound and movement impress on us that we are witnessing something real, 'authentic' and of the moment. This spatio-temporal experience is one of the most significant factors of the work. The soundtrack also plays an important, if not crucial role in *Mapping the Studio*, as it provides an immersive ambience that holds the viewer and gives depth to the flat, low-resolution images that occupy and dominate the wall space. This ambient electronic space provides a temporal continuity and references both the original space of the (audio-visual) recording and the technological space of the recording and playback apparatus. The two spaces and time frames are literally superimposed to create an experience that is neither cinematic, nor sculptural, but draws on both.

My own recent work has been concerned with the possibilities of 'real-time' and juxtaposition of time frames, particularly the simultaneous superimposition of the contemporary and the historical. In *For William Henry Fox Talbot (The Pencil of Nature)* 2002, a solar-powered live image of the famous oriel window at Lacock Abbey in Wiltshire was relayed to the Victoria and Albert Museum in London, via the Internet, transversing and connecting geographical distance, temporal space and technological history:

> The projection faded according to the light at Lacock, intense at mid-day, fading out towards evening. New technology in this instance appeared frail, the shimmering image suspended in the gallery, still dependent on the same power of light as the original photograph. But while the original photograph was the work of one man, the digital image was the result of countless men and systems working together, a reminder of the interconnectivity of new technology.[8]

I have also continued to explore the possibilities of integrating renewable energy systems with real-time video in *Interwoven Motion* (2004), an outdoor installation

located in Grizedale Forest in the English Lake District. In this work, live video images from four video cameras temporarily installed at the top of a tree overlooking one of John Ruskin's favourite views of Coniston Water were displayed on a weather-proof TV monitor at the base of the tree. In *The Monument Project (Si Monumentum Requiris Circumspice* (2009–11) a continuous stream of weather – modified panoramic time-lapse images from the top of 'The Monument' in the City of London were posted on a dedicated web site, 24 hours a day for three years.

Wolfgang Staehle's (Germany, 1950) *Comburg* (2001) projected a live web-cast to establish a relationship between notions of time and context. Staehle's real-time image of the ancient Comburg Monastery near Schwabisch Hall, Germany implies a relationship between two distinctly different approaches to 'being-in-time' – the virtually imperceptible changes from image to image, versus the distracted gaze of the gallery viewer moving from one exhibit to the next. Staehle's intention was to prompt viewers to consider their own experience of time: 'We're all running around all the time. I wanted to make people feel aware'.

Staehle has explored and extended these ideas, producing a series of works featuring on the line video streaming of images of other buildings and locations such as the Empire State Building in New York in *Empire 24/7* (1999–2004), as well as

17.1: Andrew Demirjian, *Scenes From Last Week* (Display) 2011. Courtesy of the artist.

17.2 Andrew Demirjian, *Scenes From Last Week*, 2011 (Location). Courtesy of the artist.

the Berlin Television tower, *Fernsehturm* (2001) and *Yano* (2002), from a village in the Brazilian rainforest.[9] In 1991 Staehle founded The Thing, which has developed into an international community of artists and their projects on the Internet. Initially conceived as a bulletin board system (BBS), The Thing has since developed into an on-line forum and web-based community hosting artists' websites and was the first website devoted to net art.

New York-based artist Andrew Demirjian (1966, USA) has explored the potential of the computer to store and synchronize video surveillance imagery in his 2011 site-specific installation *Scenes From Last Week*. Setting up monitors and cameras in two storefronts directly across from each other on a bustling New York thoroughfare, the work presented the current street view alongside the view from seven previous days, all digitally synchronized to the present moment. Demirjian's installation skilfully explored the relationships and conflicts inherent in video surveillance technology – creating a public artwork, which in the artists' own words, 'created a digital hall of mirrors, a perceptual trip wire into the past, reawakening our senses to randomness and ritual in our daily environment'.[10] This accessible and inventive work is an excellent example of the way in which the current generation of artists engage with the aesthetic and social implications of the technological potential of the video image and the continuing public fascination with the medium.

CONCLUSION AND SUMMARY

Over the last decade video art has come to rival the more traditional gallery-based art forms. An increasingly dominant mode of expression and representation, video seems to embody contemporary social and cultural preoccupations. Artists' video can now be presented and experienced in a diverse array of forms and formats – from galleries and museums, commercially distributed DVDs and on-line, providing the viewer with challenging spatio-temporal experiences that require constant re-negotiation from work to work. Artists employ video to provide viewers with complex socio-spatial and temporal experiences which can make use of cinematic, televisual, literary, photographic, sculptural, digital and acoustic space. The digital convergence of audio-visual technologies and the interrelationship of physical, acoustic and digital space have created new aesthetic challenges for contemporary artists, curators, critics and audiences alike.

Although video art as a genre is clearly alive and well in the contemporary visual art context, 'Artists' Video' as a separate and distinct practice within the fine art canon has been absorbed into a larger and less clearly defined moving image practice that includes filmmaking, interactive computer-controlled gaming, multi-screen projection, sculptural installation and Internet-based moving image work. Much

of this work tends to be called 'video art', but largely due to the converging power of digital image manipulation and display, the evolution of TV broadcasting and the recent technological and social revolution of the Internet, the original terms of reference have been completely transformed.

Broadcast television has also fundamentally changed in the years since the birth of video art. Many of the most radical practices in the heady early days of video art have themselves become commonplace on contemporary broadcast TV. Recuperated formal and political strategies, specialist TV and a multiplicity of terrestrial and satellite channels, as well as further convergences with the Internet and the mobile telephone networks, have contributed to a sea-change in the broadcast industry and the expectations of potential television audiences. Although artists' video is occasionally screened on broadcast TV, in most countries it is still a rare occurrence, and when shown it is most often carefully contextualized and relegated to late-night slots. However, with the increasing sophistication and reliability of the Internet and the availability of ever-faster bandwidths, so-called 'Artists' TV' is now a reality. Artists and curators are able to make video work available to specialist audiences and individuals, which in many respects renders the issue of the lack of television airtime for artists' video irrelevant.

The technological convergence of film and video (along with photography, audio, animation and other more recent technological forms) has also had an aesthetic parallel – the television industry, with its voracious appetite for new forms, has appropriated and absorbed many of the formal innovations first rehearsed in the more tentative and open-minded experimental gallery context. Similarly, contemporary artists working with video freely draw on broadcast forms – especially documentary and 'docudrama'. Indeed there is an increasingly strong argument for the case that artists' video is no longer a distinctly separate form, subsumed into moving image culture under the generic umbrella of 'film', or more often 'cinema'.

The advance in digital projection technology has been a major factor in the growth of moving image as a mainstream gallery format. Gallery visitors now routinely navigate through mixed format exhibitions in which sculpture, painting, photography film and video screens vie for attention. Gallery exhibitions often contain mini cinemas, but also include wall-mounted plasma screens mimicking traditional paintings, drawings and prints. To paraphrase the painter Barnett Newman originally talking about the more traditional gallery experience of sculpture *vs* painting: 'a painting is the thing on the gallery wall that you lean up against when watching a video'.

The history of artists' video, as is the case with the development of any genre, is complex and diverse, and it cannot and should not be seen in isolation from the

history of other distinctive art forms and genres – especially that of printmaking, photography, film, live art and performance, experimental and electronic music.

The history I have chosen to trace, explore and discuss must also be seen alongside other partial and incomplete histories of video art. The artists and works I have presented and described are simply examples to illustrate my argument and particular concerns. In my own experience of working with the medium within a fine art context, I have witnessed the emergence of the genre as a practice on the margins of fine art, and over the course of the last 40 years have observed and been engaged with video as it has taken its place alongside older, more established media.

Video art emerged during a crucial period in the cultural and technological history of the Western hemisphere and its sphere of influence. Since that initial period, the medium has been taken up by several new generations of artists and spread to Asia, the Middle East and Africa. Artists' video has been instrumental in heralding and facilitating the shift from modernism to postmodernism, enabling and empowering artists to critique the assumptions of the television broadcasters, and to challenge the notion of object-based art in the art world and the dominance of the art gallery system. Alongside other media such as photography and film, video has emerged as an ideal tool for artists previously disenfranchised, providing a new channel of communication and alternative representations.

As the technology has developed and evolved, video's distinctive characteristics have been absorbed and merged into a wider, less definable and more complex set of related media, and the rise of the digital could have rendered the terms 'video art' and 'video artist' obsolete and anachronistic, but they have remained surprisingly resilient. Artists' video has been instrumental in defining a period in late twentieth-century visual culture. The genre has made a major contribution to the acceptance and development of new and more complex forms and modes of discourse, transforming the gallery visitor's perceptions and expectations of looking at and experiencing art – opening up the rich and complex territory between perception and participation, between the actual and the virtual, between the moving and the static, between technology and art.

PART IV

REFERENCES

GLOSSARY

Technical terms and processes

ADO: Ampex Digital Optics.

Analogue Computer: A computer device with electrical circuits designed to behave analogously with the real system under study. Analogue systems are less costly and more flexible than digital systems but less accurate.

Application: Computer program.

ASCII: American Standard Code for Information Interchange. A data format for exchanging information between computers or computer programs.

Aspect Ratio: The proportional ratio of horizontal and vertical measurement in television (and film). The standard aspect ratio of video is 4:3, widescreen TV is 16:9.

Assemble Edit: An electronic edit in which a new sequence is recorded onto the end of an existing recording. A new control track is recorded at the edit point. The 'in' point of the edit is synchronous with the existing recording (see also **Control Track** and **Insert Edit**).

AVCHD: Advanced Video Coding High-Definition. A format jointly developed by Sony and Panasonic for the digital recording and playback of high-definition (HD) video.

Backup: A copy of a computer file or disk for archiving purposes.

Bandwidth: The range of frequencies contained by an electronic transmission or recording system (video or audio).

BBS: Bulletin Board System. A computer system running software that allows users to connect and log in to the system enabling them to read and exchange messages and to upload and download information.

Betacam: A professional analogue ½-inch videocassette format developed by Sony in 1982 (see also **DigiBeta** and **HDCAM**).

Bit: Binary digit. A basic unit of information that can be transmitted from one source to another within one second. The smallest unit of information that can be used by a computer (1 or zero).

Boot: The action of starting up a computer.

Burn: The permanent or temporary damage caused to a camera pick-up tube in pre-digital video cameras. The mark left by the focusing of excessively bright light from specular reflections or over-exposed areas of the video image could leave a permanent 'scar' which was evident in subsequent images recorded with the same camera.

Bus: An electronic pathway to transmit data between components in an electrical device.

Byte: A piece of computer information which is made up of eight 'bits' (see 'Bit' above).

Cable Television: The transmission of video signals to a number of subscribers via co-axial cable.

Captions: A graphic image, photograph, title etc., presented to the camera.

CCTV: Closed-circuit television. A 'live' video transmission system comprising a camera and monitor.

CD-ROM: Compact Disk Read-Only Memory.

Character Generator: An electronic device controlled by a standard 'QWERTY' keyboard for generating lettering or numbers for recording onto videotape or for display on a video monitor.

Chrominance: The colour component of a video signal.

Chroma-Key: A system of electronic mixing between multiple video sources in which a colour can be selected to be replaced by an image from an alternative image source.

Colour Bars: A video image presenting a series of coloured stripes of yellow, cyan, green, magenta, red, blue in descending order of luminance at 75 per cent and 100 per cent saturation.

Colour Temperature: The measurement in degrees Kelvin of the colour of a light source, e.g. Tungsten lamps 3,200K; Daylight; 6,500K.

Component Colour: Separate red, green and blue components that in combination provide a colour television signal.

Control Track: A continuous pre-recorded signal to enable the synchronous cutting of separate sequences during the video editing process.

CPU: Central Processing Unit.

Crabbing: The sideways movement of a camera mounted on a tripod dolly.

Crash: Computer system malfunction. When a computer system stops working and requires restarting.

CRT: Cathode Ray Tube. Large vacuum tube which formed the picture tube of a conventional television receiver or monitor.

D1: Sony/Bosch/BDS professional digital video format introduced in 1986.

D2: Apex professional digital video format, introduced in 1988.

D3: Panasonic professional digital video format, introduced in 1991.

D-9 and D-9HD: Professional digital videocassette format, developed by JVC in 1995 to compete with Sony's DigiBeta format.

Db (Decibel): A unit comparing electrical ratios. A unit of sound level.

Data: Numerical and alphabetic quantities that have been created and can be processed by digital computers.

Database: An electronic list of data information that can be searched and/or sorted.

Decoder: An electronic device that separates a coded signal into its component parts. For example a colour video decoder separates the chrominance signal into red, green and blue.

Depth of Field: The range of distance over which a recorded scene is in acceptable focus. Depth of field varies in relation to lens aperture (see **F numbers**) and the focal length of the lens. The smaller the f-number, and/or the longer the focal length, the shallower the depth of field.

DigiBeta: Digital Betacam, a digital video format developed by Sony and launched in 1993 based on the Betacam tape format (see **Betacam** and **HDCAM**).

Digital Circuit: A circuit that is limited to a specific number of stable states of being. A light switch which has only 'on' or 'off', for example, as opposed to a dimmer switch, an analogue device which has a variable number of values.

Digital Computer: An electronic machine able to process and perform mathematical operations on numerical information (see also A**nalogue Computer**).

Digitize: The process of converting analogue electronic information into digital data so that it can be processed by a computer.

Disk drive: A piece of electronic equipment to write data from a computer disk and/or to a computer disk.

Dolly: A wheeled device attached to a tripod or camera support to enable smooth camera movements during tracking and crabbing.

DOS: Disk Operating System. Used in IBM PCs.

Download: Receiving data that is being transferred from one computer to another (see also **uploading**).

Drop out: Deterioration in tape playback quality due to a drop in the RF level of the recording.

Drop Out Compensator: An electronic circuit that enables videotape flaws caused by oxide drop out in the tape coating to be temporarily corrected (see **Time-Base Corrector**).

Dub: A second-generation copy of a recording.

DV: A digital videotape format launched in 1995 by a consortium of video equipment manufacturers, including JVC, Panasonic and Sony.

DVCAM: A variant of the DV format for professional use by Sony, which improved the quality of the recordings by increasing the recording speed.

DVCPRO: A development of the DV format by Panasonic for ENG use (see **DVCAM** and **D-9**).

DVE: Digital Video Effects.

ENG: Electronic News Gathering. Location video recording of news items (as opposed to filming) using portable video equipment.

Ethernet: Protocol for fast communication and file transfer across a computer network.

Eye-line: The direction in which a person (usually an actor or principle human subject) is looking in relation to the camera.

F Numbers: A set of numbers that indicate relative apertures. (f1.8; f 2,; f 2.8; f4; f5.6,; f8; f11; f16; f22) the smaller the number, the larger the aperture, and vice-versa.

Flare: Light which is reflecting between the numerous individual lenses within a lens system.

Flying Spot Scanner (FSS): A telecine device in which a pixel-sized light beam is projected through motion picture film and then collected via a photoelectric cell converting the light into a video signal.

Focal length: The distance between a lens systems optical centre and the imaging light-sensitive surface of the camera when focused to infinity.

Freeze-Frame: Continuous playback of a single video frame (two fields).

Frequency Modulation (FM): A method of transmitting picture (or sound) information by adjusting the frequency of a carrier wave in relation to the amplitude of a low frequency signal for transmission. At the receiver the modulated carrier is demodulated to recover the original signal – the amplitude of the carrier wave is unchanged by this operation.

Gain: The amplification of an electronic (audio or video) signal.

Genlock: The synchronization of video equipment such as cameras or video recorders using an external source such as a Synch Pulse Generator (SPG).

Gigabyte: 1024 Megabytes.

HDCAM: High-Definition digital video format variant of Digital Betacam (see **Betacam**, **DigiBeta** and **DVCPRO**).

HDV: A video format for the recording of high-definition images on DV cassette tapes developed by electronics manufacturer JVC.

Head: An electromagnet used to record and playback audio and video signals that can be stored on tapes coated with magnetic material, such as iron oxide.

Headroom: The space within the frame above the top of a subject's head.

High-Definition Video: Any video system of a higher resolution than standard definition video

(SD). This most commonly involves monitor or projection display resolutions of 1280x720 pixels (720p) or 1920 x1080 pixels (1080p). There are also called 'extra high-definition' systems, such as 2K (2040x1536) (2106p) (3840x2160); 4K (4096x3072) (2540p) (4520x2540), and 4320p (7680x4320).

Insert Edit: An electronic edit in which a new video sequence is recorded between two pre-existing scenes. This technique uses the existing control track which is retained. In and out points are synchronous (see also **Assemble Edit** and **Control Track**).

Keying: Keying is a form of electronic mixing between two different synchronous video images. This is achieved via a circuit that detects a level of brightness (or colour) in the scan line of one video image and allows it to be inserted into another video image.

Kilobyte: 1024 bytes.

Laser: Light Amplification by Stimulated Emission of Radiation. An electronic device that generates a coherent (non-divergent) monochromatic light beam capable of travelling great distances without diverging.

LCD: Liquid Crystal Display

Luminance: The brightness (or black-and-white) component of a video signal, with 0 volts corresponding to black, and 1 volt corresponding to white, with the grey tones as stages in between. Usually described as '1 volt peak to peak'.

Matrix: A set or field of numbered columns or rows of information in which each part can be related to every other part.

Matte: An electronically generated mask which enables part of an image to be isolated for the insertion of another.

MB (Megabyte): 1024 Kilobytes.

MPEG: Moving Picture Experts Group. A working group of experts formed to set standards for audio and video compression and transmission. The acronym is also used for a group of standards related to digital audio and video compression such as MPEG 1, 2 and 4.

Mix: The progressive fading out of a video image source and the fading up of a second to replace it.

Moiré Patterns: Wave-like visual forms which are caused by the superimposition of multiple linear patterns.

Monitor: A high quality TV display usually without either a UHF tuner or sound amplifier which is used to check production and technical video image details.

Optical Disk: High capacity data storage medium.

OS (Operating System): Software that controls the computer.

Oscillator: A device that varies periodically over time.

Oscilloscope: An electronic test instrument with a CRT display which is used to measure electrical currents via a waveform display.

Pan: A swivel movement of the camera on a tripod or mount to the left or right.

Patch field: A system for connecting various inputs and outputs, operations or functions arranged for ease of interconnectivity.

PC (Personal Computer): IBM, or IBM clone computer.

Phosphors: Chemical compounds that, when stimulated by an electron beam produce a visible light, used in CRTs for the display of video images.

Portapak: Initially developed and introduced by Sony in 1965, the 'Portapak' was a highly portable, and relatively inexpensive ½-inch black-and-white open-reel video recorder with a dedicated camera. This machine was soon recognized by artists as an ideal tool for recording performances, events and 'happenings' in the late 1960s and early 1970s (see Chapter 1 for further details). There were several versions of the Portapak, beginning with the introduction of the low-density 405-line machine in Europe (eventually replaced by a 625 line version) and the 525-line machine (in the USA), designated EIAJ-1. These two formats were incompatible (see also **Television standards**).

P.O.V.: Point of view shot. A camera position which presents the view of a person or object within a scene.

Pull Back: To track (or dolly) back.

Pull focus: A rapid refocus from one subject to another within the same frame.

Quantizing: The process of dividing an analogue signal into levels. The more levels of quantizing the higher the sampling rate, e.g. 256 levels of sampling requires eight 'bits' (binary digits).

RAM: Random Access Memory.

Raster: The image area of the TV screen formed by the electron beam tracking the line pattern.

Registration: The electrical adjustment of a colour video camera to ensure the alignment of the red, green and blue components of the video image.

Rescan: Recording an image from a video monitor or television display by pointing a video camera at the screen.

Server: Central computer dedicated to sending and receiving data from other computers via a network.

Synch Pulse Generator: A device that generates a series of timing pulses to synchronize video equipment in a television studio or post-production facility. Signals from an SPG are fed to all equipment that produces a signal: cameras, vision mixers, video tape recorders, etc.

Telecine: A system to convert a film image into a television signal for the transmission of the film on television or to record the film onto videotape. There are various systems designed for this purpose, the simplest being a film projector presenting the film into a television camera, which is known as the 'storage type', or a 'flying spot' system (non-storage) which generates a scanned signal from the CRT (Cathode Ray Tube).

Telepresence: A set of technological devices including video cameras, microphones and video displays which enable a person to feel as if they were present, to give the appearance of being present in places other than their true location using the telephone network, or more commonly, the world wide web.

Telerobotics/Telemanipulation: It is also possible using similar systems to those discussed above to have a physical effect in a remote location using robotic control devices.

Television standards: Broadcast standards for colour television did not conform universally. There were (and still are) three main standards for the broadcast of colour television and video recording. NTSC (National Television Standards Committee) 525 lines, 30 Hz; SECAM (System Electronique Coloure Avec Memoire), 812 lines, 50 Hz, and PAL (Phase Alternation Line) 625 lines, 50 Hz). PAL and SECAM are compatible, but NTSC is not.

Tilt: Tipping the camera upwards or downwards on a tripod or camera mount.

Time-Base Corrector: A device designed to reduce or eliminate errors caused by mechanical instability present in analogue video recordings.

Transducer: An electrical device for converting one form of energy into another (e.g. a microphone transduces sounds into electrical signals).

U-matic: An industrial videocassette tape format based on ¾-inch tape developed by Sony. The tape came in two sizes – a compact twenty-minute cassette for use in a portable battery powered recorder, and a larger 60-minute cassette for use in a mains-powered studio player/recorder.

Uploading: Transferring of data or programs to a central computer.

VCR: Videocassette recorder. A video tape recorder (VTR) that records and plays back images and sounds using tape that is enclosed within a video cassette, e.g. Betacam or U-matic (see also **VTR**, **VHS**, **U-matic**).

VHS: 'Video Home System'. A domestic videocassette format based on ½-inch tape developed by JVC.

Video Feedback: The continuous looping of a video signal that is produced when a video camera is pointed at the monitor display of its own output (see Chapter 11).

Video Signal: Vision signal including synchronizing and timing pulses.

Video Tape: A continuous strip of acetate-backed magnetic recording material of various widths and compositions. Early portable recorders (e.g. the Sony Portapak, or equivalent) developed during the late 1960s used ½-inch open reel tapes. By the mid to late 1970s artists began to have access to ¾-inch tapes in cassettes such as the Sony U-matic. Broadcasters commonly used 1-inch open reel tape formats, although manufacturers developed professional quality cassette formats such as 'betacam' (Sony) and more recently D1, D2, D3, DigBeta, DV, DVCPRO, etc.

Vision Mixer: An electronic device which enables the selection of individual video picture sources (cameras, VTRs, caption generators, etc.) to be selected and/or combined for a single output for recording or live transmission (also, the person who operates such a device).

VTR: Videotape recorder – any format or standard.

Wipe: An electronic transition between two video images in which one image progressively replaces it from the top, edge or bottom of the screen.

Wipe Generator: A machine to produce electronically generated patterns used to make a transition from one video image to another. The most commonly available wipes produced horizontal or vertical transitions, but some generators produced many more, including diagonal, circular, zig-zag and curved. Often the edges of the wipe could be adjusted between a hard or 'soft' edge, which could be used to hide the threshold between the two images.

NOTES

Introduction

1. Marita Sturken, 'Paradox in the Evolution of an Art Form', in *Illuminating Video: An Essential Guide to Video Art*, Doug Hall and Sally Jo Fifer (eds), Aperture, 1990, p. 103.

Chapter 1: In the Beginning

2. Sturken, *ibid.* p. 116.

3. Stuart Marshall, 'Video from Art to Independence', *Video by Artists 2*, Art Metropole, Toronto, 1986, pp. 31–5.

4. *Ibid.*, pp. 32–3.

5. David Hall, 'British Video Art: Towards an Autonomous Practice', *Studio International* (May–June 1976), pp. 248–52.

6. David Hall, 'Video Art – the Significance of an Educational Environment', *Video Positive Catalogue*, Lisa Haskel (ed.), Liverpool, 1989, p. 47.

7. Marita Sturken, 'Paradox in the Evolution of an Art Form', in *Illuminating Video: An Essential Guide to Video Art*, Doug Hall and Sally Jo Fifer (eds), Aperture, 1990, pp. 115–16.

8. John Wyver, 'The Necessity of Doing Away With Video Art', *London Video Access Catalogue*, London, 1991.

9. Sturken, *op cit.*, p. 107.

10. Moira Roth, 'The Voice of Shigeko Kubota, A Fusion of Art, Life, Asia and America', Shigeko Kubota Video Sculpture, Mary Jane Jacob (ed.), New York, p. 80.

11. Mary Jane Jacob, 'Introduction to Shigeko Kubota', *Video Sculpture*, American Museum of the Moving Image, New York, 1991, pp. 6–7.

12. John Hanhardt, 'Dé-collage/Collage: Notes Toward a Re-examination of the Origins of Video Art' in *Illuminating Video: An Essential Guide to Video Art*, Doug Hall and Sally Jo Fifer (eds), Aperture, 1990.

13. This is a term coined by Erving Goffman in his influential book, *Frame Analysis: An Essay on the Organisation of Experience*, Harper and Row, New York, 1974.

14. Hanhardt, *op cit.*, p. 7.

15. Edith Decker-Phillips, *Paik Video*, Barrytown Ltd, New York, 1988, pp. 24–5.

16. *Ibid.*, p. 25.

17. Michael Nyman, *Experimental Music: Cage and Beyond*, Studio Vista, London, 1974, p. 74.

18. This may have become an apocryphal story, as a similar account of this event, at a different venue, with both Stockhausen and David Tudor present, has also been described elsewhere. For example, see Calvin Tomkins in 'Video Visionary', *The New Yorker Magazine*, 5 May 1975, quoted by Yongwoo Lee in an unpublished PhD Thesis, *The Origins of Video Art*, Oxford University, 1998.

19. David Revill, *The Roaring Silence: John Cage, A Life*. Bloomsbury, London, 1992, p. 193.

20. From 'Die Fluxus-Leute', an interview in *Magnum, Experimente*, No. 47 (1963), quoted in Decker-Phillips, p. 28.

21. Decker-Phillips, *op cit.*, p. 28.

22. Douglas Davis, 'Nam June Paik: The Cathode Ray Canvas', *Art and the Future: A History/Prophecy of the Collaboration Between Science, Technology and Art*, Thames and Hudson, London, 1973, pp. 147–8.

23. Yongwoo Lee, *The Origins of Video Art*, unpublished PhD thesis, Trinity College, Oxford University, 1998, p. 67.

24. One TV did not work at all, and was laid face down on the floor, the other, displaying a thin band across the centre of the screen was turned on its side and presented as *Zen for TV*.

25. Decker-Phillips, pp. 36–9.

26. *Ibid.*, p. 38.

27. This piece was still in progress, and was not completed till after 'An Imaginary Landscape No. 4'.

28. John Cage, 'Forerunners of Modern Music', *Silence*, p. 62.

29. Cage also made use of other domestic items in his musical compositions. For example, *Living Room Music* (1940), which was for four players using any household objects, furniture, etc.

30. Decker-Phillips, *op cit.*, p. 35.

31. Martha Rosler, 'Video: Shedding the Utopian Moment', in *Illuminating Video: An Essential Guide to Video Art*, pp. 45–6.

32. Woody Vasulka, in conversation with the author, 5 Septmber 2009.

33. Davis, *op cit.*, p. 149.

34. Paik's claim to having made this seminal recording has been challenged and disputed by many. For example see Tom Sherman's article 'The Premature Birth of Video Art': http://newsgrist.typepad.com/underbelly/2007/01/the_premature_b.html (accessed 3 August 2011).

35. *Ibid.* p. 148.

Chapter 2: Crossing Boundaries

1. Barbara Hess, 'No Values For Posterity: Three Films About Art', *Fersehgalerie Gerry Schum: Ready to Shoot*, Snoeck, Dusseldorf, 2005, pp. 10–11.

2. Broadcast, 24 August 1967 and 17 October 1968. *Fersehgalerie Gerry Schum: Ready to Shoot*, Snoeck, Dusseldorf, 2005, p. 316.

3. *Ibid.*, p. 19.

4. Gerry Schum, *Land Art Catalogue*, 2nd edn, Hanover, 1970. Reprinted in *Fersehgalerie Gerry Schum: Ready to Shoot*, Snoeck, Dusseldorf, 2005, pp. 109–10.

5. *Ibid.*, p. 110.

6. Keith Arnatt, 'Self Burial', *Television Interventions, 19:4:90*, Exhibition Catalogue, Third Eye Centre, Glasgow, 1990, p. 44.

7. Gerry Schum, 'Conception for Television Exhibition II of Fernsehgalerie', *Fersehgalerie Gerry Schum: Ready to Shoot*, Snoeck, Dusseldorf, 2005, pp. 149–50.

8. Karl Oskar Blasé, Interview with Gerry Schum, 'Video Documentation and Analysis', *Documenta 6* Catalogue, Kassel, 1977, pp. 37–40.

9. Michael Geissler, quoted by Wulf Herzogenrath, 'Video Art in West Germany', *Studio International* (May/June 1976), p. 221.

10. http://newmedia-arts.net/english/reperes-h/60.htm (accessed August 2011).

11. http://www.webnetmuseum.org/html/en/expo-retr-fredforest/actions/59_02_en.htm#text (accessed July 2011)

12. http://en.wikipedia.org/wiki/Fred_Forest (accessed August 2011).

13. http://195.194.24.18/~donforesta/mambo/index.php (accessed July 2011).

14. Lukasz Ronduda, 'The History of Polish Video Art from the 1970s and 80s', *Analogue: Pioneering Video from the UK, Canada and Poland (1968–88)*, Chris Meigh-Andrews and Catherine Elwes, EDAU, Preston, 2006.

15. Jozef Robakowski, quoted by Ryszard Kluszczynski in 'An Outline History of Polish Video Art', www.eyefilm.nl (accessed August 2011)

16. 'Art/Tapes/22, Florence: Videotape Production', University Art Museum, Long Beach, 2009.

17. Peggy Gale, 'Video Art in Canada: Four Worlds', *Studio International* (May/June 1976), p. 224.

18. Gutai, literally means 'concreteness'. Jiro Yoshihara proclaimed in his manifesto that: 'Gutai Art does not alter the material. Gutai Art gives life to the material. Gutai Art does not distort the material. In Gutai Art, the human spirit and the material shake hands but keep being in conflict with each other. The material never assimilates itself into the spirit. The spirit never subordinates the material. When the material exposes its characteristics remaining intact, it starts telling a story and even screaming out. To make the fullest use of the material is to make use of the spirit. To enhance the spirit is to lead the material to the high sphere of the spirit'.

19. Mono-ha ('object school') artists rejected the 'Anti-art' attitudes of the Gutai and other avant-garde movements in Japan. Instead Mono-ha artists attempted to create a new Japanese art by rejecting illusion and producing physical and material objects using natural and basic materials such as metal, wood, stone and paper, juxtaposing them to create and suggest new relationships between individual objects or between the objects and their environment. http://www.michaelblackwoodproductions.com/arts_japan.php, consulted (accessed 5 August 2011).

20. 'Video from Tokyo to Fukui and Kyoto', Barbara London, 1979, http://www.experimentaltvcenter.org (accessed 2 August 2011).

21. Takahiko Iimura, interview with the author, www.meigh-andrews.com (accessed 6 August 2010).

22. Michael Goldberg, interview with the author, 7 October 2010 and e-mail correspondence, 3 August 2011.

23. The Japanese word 'Hiroba' means public square and was selected by the group to signify the idea that video can be used as a tool of information sharing and public communication.

24. 'Japan: Video Hiroba', Fujiko Nakaya, www.vasulka.org (accessed 2 August 2011).

25. *Ibid.*

26. 'A Brief History of Video Art in Japan', www.vasulka.org (accessed 3 August 2011).

27. Alfred Birnbaum, 'Japanese Video: The Rise and Fall of Video Art'. http://www.mediamatic. net/255224/en/japan-video, (accessed 3 August 2011).

28. Arlindo Machado, 'Video Art: The Brazilian Adventure'. *Leonardo*, Vol. 29, No. 3 (1996), MIT Press, Cambridge, MA, p. 225.

29. http://www.cibercultura.org.br (accessed 26 August 2011).

30. Machado, *op cit.*, p. 228.

31. Peter Kennedy, interview with the author, 14 October 2011

32. Stephen Jones, 'Some Notes on the Early History of the Independent Video Scene in Australia', *Catalogue for the Australian Video Festival*, 1986, p. 23.

33. Brian Williams, 'Journey Though Australian Video Space 1973/76', Access Video News, 1976, (accessed 14 November 2011).

34. Stephen Jones, interview with the author, 19 October 2011.

35. Stephen Jones, 'The Electronic Art of Bush Video', www.dhub.org (accessed 4 November 2011)..

36. 'Rising Tide: Film and Video Works from the Museum of Contemporary Art's Collection', www. mca.com.au (accessed 14 November 2011).

37. Peter Callas, 'Videor Video – a History', *Globe,* Issue 9, http://www.artdes.monash.edu.au (accessed 15 November 2011).

38. Warren Burt, interview with the author, 11 October 2011.

39. *Ibid.*

40. Jones, *op cit.*, p. 27.

41. Selected Works of Mao Tse Tung, 'Introduction to Talks at the Yenan Forum on Literature and Art'. http://www.marxists.org/reference/archive/mao/selected-works/volume-3/mswv3_08.htm (accessed 9 November 2011).

42. Brittany Stanley, 'Video Art: China', http://blog.videoart.net (accessed 3 August 2012).

43. Angie Baecker, Review of, Zhang's exhibition, 'Certain Pleasures' at Minsheng Art Museum, Shanghai, China, 2011, https://www.frieze.com/issue/review/zhang-peili/ (accessed 9 November 2012).

44. Pi Li, 'Chinese Contemporary Video Art', Zooming into Focus, China Art Academy, Hangzhou, 2004, http://www.shanghartgallery.com/ (accessed 8 November 2012).

45. Stanley, Video art in China.

46. Pi Li, *op cit.*

47. Thomas J. Berghuis, *Performance Art in China*, Timezone8, Hong Kong, 2006, p. 134.

48. Pi Li, *op. cit.*

49. Berghuis, p. 140.

50. *Ibid.*, p. 141.

51. *Ibid.*, p. 141.

52. http://www.powerofculture.nl/uk/specials/synthetic_reality/exhibition.html (accessed 21 November 2012).

53. Huang Zhuan, 'Method and Attribute: History and Problems of Video Art of China', *Compound Eyes*, quoted in Berhuis, Performance Art in China, Timezone8, Hong Kong, 2006. p. 133.

54. Johan Pijnappel, 'New Media on the Indian Sub-Continent', http://www.experimenta.org/mesh/mesh17/pijnappel.htm (accessed 23 November 2012).

55. *Ibid.*

56. http://www.naturemorte.com/about/ (accessed 23 November 2012).

57. Triangle Arts Trust (TAT), set up in 1982 by Robert Loder and Anthony Caro has active centres operating in over 30 countries. Each centre within the network is independent and set up to respond to local needs. The object of the workshops is 'to counterbalance the tendency of the Western art world to put the emphasis on the object and its marketing rather than on the creative process itself'. http://en.wikipedia.org/wiki/Triangle_Arts_Trust (accessed 23 November 2012).

58. Nancy Adajania, 'New-Context Media: A Passage from Indifference to Adulation', http://www.goethe.de/ins/in/lp/prj/kus/exp/enindex.htm (accessed 23 November 2012).

59. John Hopkins, in conversation with the author, February 2005.

60. Sue Hall and John Hopkins, 'The Metasoftware of Video', *Studio International* (May/June 1976), p. 260.

61. *Ibid.*, p. 260.

62. *Ibid.*

63. Edward Lucie-Smith, 'Video in Britain', *The New Television: A Public/Private Art*, Douglas Davis and Allison Simmons (eds), MIT Press, Cambridge, MA and London, 1977, p. 187.

64. Mark Kidel, 'Video Art and British TV', *Studio International* (May/June, 1976), p. 240.

65. Mick Hartney, 'InT/Ventions: Some Instances of Confrontation with British Broadcasting', *Diverse Practices*, Julia Knight (ed.), John Libbey Media/Arts Council of England, Luton, 1996. pp. 22–3.

66. David Hall, 'Before the Concrete Sets', *London Video Access Catalogue*, 1991, p. 43.

67. They were shot on 16mm film because video was not considered suitable by the broadcasters at this stage in the development of the technology.

68. Hall, p. 248. (Hall stated here that he used the term 'media' with 'trepidation' and only as a 'convenience'.)

69. David Hall, Stephen Partridge *et al.*, '19:4:90, Television Interventions', *Fields and Frames Productions*, 1990, p. 40.

70. David Hall, in conversation with the author, 30 August 2000.

71. David Hall, 'The Video Show', *Art and Artists*, May 1975, quoted in the catalogue for 'Video – Towards Defining an Aesthetic', The Third Eye Centre, Glasgow, March 1976.

72. David Hall, 'British Video Art: Towards an Autonomous Practice', *Studio International* (May/June 1976), p. 249.

73. *Ibid.*, p. 249.

74. This draws on Peter Wollen's definition of the 'two avant-gardes' of experimental film. Wollen characterized these as an 'aesthetic' avant-garde, identified with the film Co-op movement, and a

'political' avant-garde characterized by the work of, for example, Jean-Luc Godard. See Peter Wollen, 'The Two Avant-Gardes', *Studio International*, November/December, 1975. Reprinted in *The British Avant-Garde Film: 1926–1995*, Michael O'Pray (ed.), University of Luton Press, Luton, 1996, pp. 133–43.

75. John Byrne, 'Modernism and Meaning: Reading the Intervention of British Video Art into the Gallery Space', in *Diverse Practices*, Julia Knight (ed.), pp. 239–59.

76. This image was composed of 30 vertical lines which had been created using a custom-built disc scanner similar to that devised by John Logie Baird in 1925.

77. David Hall, statement about the work from *Signs of the Times*, Chrissie Iles (ed.), Museum of Modern Art, Oxford, 1989, p. 39.

78. Sean Cubitt, *Videography: Video Media as Art and Culture*, Macmillan Education Ltd, London, 1993, pp. 89–90.

79. *Ibid.*

80. David Hall, 'Video Art – the Significance of an Educational Environment', *Video Positive* catalogue, 1989, Lisa Haskel (ed.), p. 47.

81. *Video Artists on Tour*, booklets, February 1980 and September 1984, Arts Council of Great Britain.

82. Steve Partridge, LVA Catalogue, 1978, p. 32.

83. Brian Hoey, *Studio International* (May/June, 1976), p. 255.

84. Roger Barnard, 'Video Times', *The Video Show*, Serpentine Gallery, May 1975.

85. Steve Partridge, *Studio International* (May 1976), p. 259.

86. This work has recently been re-mastered as a three-screen work.

87. Stuart Marshall, 'Video Installation in Britain – the early years. *Signs of the Times: A Decade of Video, Film, and Slide-Tape Installations, 1980–90*', Chrissie Iles (ed.), Museum of Modern Art, Oxford, 1990, p. 13.

88. David Hall, interview with the author, 30 August 2000.

89. Stuart Marshall, 'From Art to Independence', *Video by Artists 2*, Elke Town (ed.), Art Metropole, Toronto, 1986, p. 33.

90. Hartney, *op cit.*, p. 46.

91. Marshall, *op cit.*, p. 13.

Chapter 3: Technology, Access and Context

1. Tony Godfrey, *Conceptual Art*, Phaidon Press, London and New York, 1998, p. 76.

2. Guy Debord, *The Society of the Spectacle*, quoted by Tony Godfrey in *Conceptual Art*, Phaidon, London, 1998, p. 187.

3. Sue Hall and John Hopkins, interview with the author, February 2005.

4. Beryl Korot and Phyllis Gershuny (eds), 'Table of Contents', *Radical Software*, 1:1, 1970, p. 1.

5. Alongside *Wipe Cycle*, the exhibition featured works by Nam June Paik, Eric Siegal, Paul Ryan and Aldo Tambellini.

6. Frank Gillette, 'Masque in Real Time', *Video Art, an Anthology*, Ira Schneider and Beryl Korot (eds), Harcourt, Brace, Jovanovitch, New York and London, 1976.

7. Johanna Gill, Video: State of the Art, www.experimentaltvcenter.org, consulted 11/05.

8. Davidson Gogliotti, in an e-mail to the author, 11/2005

9. John Hopkins and Sue Hall, Interview with the author, February 2005.

10. *Ibid.*

11. John Hopkins and Sue Hall, Interview with the author, February 2005.

12. *Ibid.*

13. Hall and Hopkins also commissioned Monkhouse to design and build the 'procamp' – a video image-processing amplifier that enabled users to adjust the pedestal, gain, chroma-delay and luminance.

Chapter 4: Expanded Cinema

1. Fernand Leger, 'A New Realism – The Object (Its Plastic and Cinematic Graphic Value) ', *Little Review*, 1926, quoted in Malcolm Le Grice, *Abstract Film and Beyond*, Studio Vista, London, 1977, pp. 36–7.

2. P. Adams Sitney, *Visionary Film: The American Avant-Garde: 1943–1978*, Oxford University Press, Oxford, 1979, pp. 369–70.

3. Sitney, p. 374.

4. Stan Brakhage, 'Metaphors on Vision', *Film Culture*, 1963, unpaginated.

5. Sitney, op sit., p. 370.

6. Brakhage, *op cit.*

7. Annette Michelson, 'Toward Snow', *Structural Film Anthology*, Peter Gidal (ed.), BFI Publications, London, 1976. pp. 38–42.

8. Statements for the New York Film-Makers Catalogue, quoted in 'Michael Snow: A Filmography', *Afterimage11*, Sighting Snow (Winter 1982–3), p. 7.

9. Snow, *op. cit.*, p. 7.

10. Michelson, *op cit.*, p. 42.

11. *Ibid.*, p. 42.

12. Le Grice, pp. 118–20.

13. Peter Gidal, 'Theory and Definition of Structural/Materialist Film', *Structural Film Anthology*, p. 1.

14. Gidal, *ibid.*, pp. 1–15.

15. Mike O'Pray, 'Framing Snow', *Afterimage11* (Winter 1982–3), p. 60.

16. Deke Dusinberre, 'St. George in the Forest: the English Avant-Garde', *Afterimage6* (Summer 1976), p. 7.

17. Dusinberre, p. 9.

18. *Ibid.*, p. 11.

19. *Ibid.*, p. 14.

20. *Ibid.*, p. 14.

21. Chris Welsby, 'Landscape 1 & 2', *Perspectives on British Avant-Garde Film*, Hayward Gallery, London. Arts Council of Great Britain, 2 March to 24 April 1977, unpaginated.

22. Chris Welsby, *Film as Film: Formal Experiment in Film 1910–1975*, Hayward Gallery, London, 3 May to 17 June 1979, p. 150.

23. Malcom Le Grice, *Abstract Film and Beyond*, Studio Vista, London, 1977, pp. 34–5.

24. Gordon Gow, 'On Malcom Le Grice' *Structural Film Anthology*, p. 32.

25. Daniel Reeves, in conversation with the author, August 2000.

26. David Hall, in conversation with the author, August 2000.

27. This film is often confused with Len Lye's 1939 film, 'Swinging the Lambeth Walk'.

28. In discussion with the author, 5 September 2000.

29. *Ibid.*

30. *Screen* 16, No. 3, London (Autumn 1975), pp. 6–18.

31. In conversation with the author, 24 July 2000.

32. Stan Brakhage, *Essential Brakhage: Selected Writings on Film Making*, McPherson & Company, New York, 2001, p 23.

33. Jorg Zutter, 'Interview with Bill Viola', *Unseen Images*, Whitechapel Art Gallery, London, 1994, p. 105.

34. Sandra Lischi, *The Sight of Time: Films and Videos by Robert Cahen*, Edizioni Ets, Pisa, 1997, p. 24.

35. Robert Cahen, *Dibattito Videoregistrato*, Art History Dept, University of Pisa, 5 April 1990, quoted in Lischi, p. 51.

Chapter 5: Musique Concrète, Fluxus and Tape Loops

1. Michael Nyman, *Experimental Music, Cage and Beyond*, Studio Vista, London, 1974, pp. 40–1.

2. David Dunn, 'A History of Electronic Music Pioneers', *Eigenwelt der Apparatewelt, Pioneers of Electronic Art*, Ars Electronica, Linz, 1992, pp. 29–30.

3. David Revill, *The Roaring Silence: John Cage, A Life*, Bloomsbury, London, 1992, pp. 144–5.

4. Nyman, *op cit.,* p. 40.

5. Revill, *op cit.*, p.160.

6. Nyman, *op cit.,*p. 62.

7. Brecht, quoted in Nyman, *op cit.,*p 67.

8. Jackson Mac Low, 'How Maciunas Met the New York Avant Garde', *Fluxus Today and Yesterday*, Art & Design, London, 1993, p. 47.

9. Ellsworth Snyder, 'Interview with John Cage', *Fluxus Today and Yesterday*, Art & Design, London, 1993, p. 15.

10. Nyman, *op cit.,*p. 71.

11. This term was first applied by Michael Nyman in his1968 review of Cornelius Cardew's 'The Great Learning' and then extended to the music of Reich, Terry Riley and Philip Glass. See *Minimalists*, K. Robert Schwarz, Phaidon Press, London, 1996, p. 196.

12. *Ibid*, pp. 28–36.

13. *Ibid.*, p. 45.

14. Steve Reich, 'Notes on Composition 1965–73', *Steve Reich: Writings about Music*, The Press of the Nova Scotia College of Art and Design, Halifax, Nova Scotia, 1974, p. 49.

15. *Ibid.*, p. 50.

16. *Ibid.*, p. 9.

17. *Ibid.*, p. 73.

18. The Whitney Museum of American Art, 5/69, the Paula Cooper Gallery, 5/69 and at the Loeb Student Center in New York, 11/71.

Chapter 6: Theory and Practice

1. Walter Benjamin, *The Work of Art in the Age of Mechanical Reproduction*, 1936.

2. Douglas Davis, 'Prophecy: The Art of the Future', Art and the Future, Thames and Hudson, London, 1973, p. 175.

3. David Ross, 'Interview with Douglas Davis', *Video Art; An Anthology*, Ira Schneider and Beryl Korot (eds), Harcourt, Brace and Javonovitch, New York and London, 1976, p. 33.

4. Norbert Wiener, *The Human Use of Human Beings*, Sphere Books, London, 1968, p. 18.

5. George Boole published *An Investigation of the Laws of Thought, on Which are Founded the Mathematical Theories of Logic and Probabilities* in 1854. This treatise described his devising of an algebraic system of symbolic logic that was used by Shannon to link the process of human logic to the operations of machines.

6. Howard Rheingold, *Tools for Thought*, MIT Press, Cambridge and London, 2000, pp. 115–27.

7. Wiener, *op cit.*, p. 18.

8. Marshall McLuhan, *Understanding Media*, Routledge and Kegan Paul Ltd, London, 1964, p. 65.

9. *Ibid.*, p. 334.

10. *Ibid.*, pp. 355–7.

11. *Ibid.*, p. 358.

12. Frank Gillette, 'McLuhan and Recent History', from The Early Video Project, http://davidsonsfiles.org (accessed 5 March 2005).

13. Martha Rosler, 'Video: Shedding the Utopian Moment', in *Illuminating Video: An Essential Guide to Video Art*, pp. 47–8.

14. Gene Youngblood, *Expanded Cinema*, Studio Vista, London, 1970, p. 258.

15. *Ibid.*, p. 419.

16. David Antin, 'Video, the Distinctive Features of the Medium', Schnider and Korot, p. 174.

17. Susan Sontag, 'On Culture and the New Sensibility', *Against Interpretation*, Dell Publishing, New York, 1966. p. 299.

18. Hall & Hopkins, Interview with the author, February 2005.

19. http://www.scribd.com/doc/39471433/KRAUSS-a-Voyage-on-the-North-Sea (accessed 14 December 2012).

20. Jonathan Lahey Dronsfield, 'Jacques Derrida', *Art: Key Contemporary Thinkers*, Diarmuid Costello and Jonathan Vickery (eds), Berg, Oxford, 2007, p. 122.

21. *Ibid.*, p. 123.

22. http://www.iep.utm.edu/deleuze (accessed 13 December 2011).

23. *Ibid.*

24. David Macey, *Dictionary of Critical Theory*, Penguin Books, London, 2000.

25. Alice Kelsey, http://www.engl.niu.edu/wac/kristeva (accessed 15 December 2011).

26. Macey, *op cit.*, p. 219.

27. John Armitage, 'Beyond Postmodernism? Paul Virilio's Hypermodern Cultural Theory', http://www.ctheory.net (accessed 16 December 2011).

28. *Ibid.*

29. Rebecca Zorach, 'Judith Butler', *Art: Key Contemporary Thinkers*, Diarmuid Costello and Jonathan Vickery (eds), Berg, Oxford, 2007. p. 168.

30. 'Speech Acts', http://www.philosophypages.com (accessed 28 December 2011).

31. Zorach, *op cit.*, p. 169.

32. http://www.iep.utm.edu/lyotard (accessed 16 December 2011).

33. *Ibid.*

34. Macey, *op cit.*, p. 236.

Chapter 7: Beyond The Lens

1. Marshall, p. 34.

2. Peter Donebauer, 'Video Art and Technical Innovation', *Educational Broadcasting International*, September 1980, pp. 122–5.

3. Stephen Beck, 'Video Graphics', *Video Art: An Anthology*, Ira Schnider and Beryl Korot (eds), Harcourt, Brace, Jovanovitch, New York, 1976, p. 21.

4. Gene Youngblood, 'Cinema and The Code', *Leonardo*, 'Computer Art in Context', Supplemental Issue, 1989, p. 29.

5. *Ibid.*, p. 29.

6. *Ibid.*, p. 28.

7. Lucinda Furlong, 'Tracking Video Art: Image Processing as a Genre', *Art Journal* (Fall), 1985.

8. David Bienstock, programme notes for 'A Special Videotape Show', Whitney Museum of American Art, 1971, quoted in Lucinda Furlong, 'Notes Toward a History of Image-Processed Video: Woody and Steina Vasulka', *Afterimage11*, No. 5, p. 12.

9. Robert Pincus-Witten, 'Panel Remarks', *The New Television*, Douglas Davis (ed.), MIT Press, Cambridge, MA, 1977, quoted in Lucinda Furlong, 'Notes Toward a History of Image-Processed Video: Woody and Steina Vasulka', *Afterimage11*, No. 5, p. 35.

10. Bengt Modin, letter to Sherman Price, http://megamemory.homestead.com (accessed, September 2005)

11. *Ibid.*

12. Peter Bode, 'In Depth', Chris Hill, 'Attention! Production! Audience!: Performing Video in its First Decade', *Rewind: Video Art and Alternative Media in the United States, 1968–1980,* Video Data Bank, Chicago, 1998, p. 25.

13. Davis, *op cit.*, p. 150.

14. *Ibid.*, p. 151.

15. Furlong, *op cit.*, p. 234.

16. Robert Cahen, from an email to the author, 6 June 2005, translation, Aneta Kzremien.

17. *Ibid.*

18. Lucinda Furlong, 'Notes Towards a History of Image-Processed Video: Eric Siegel, Stephen Beck, Dan Sandin, Steve Rutt, Bill and Louise Etra', *Afterimage11*, Nos 1 and 2 (Summer 1983), p. 36.

19. *Ibid.*, p. 36.

20. Funded by the Rockefeller Foundation, NCET was set up in 1967 as an experimental TV workshop at the Public Broadcasting Station (PBS) at KQED in San Francisco.

21. Stephen Beck, 'Image Processing and Video Synthesis', Schnider and Korot, p. 184.

22. Peter Donebauer, 'A Personal Journey Through A New Medium', in *Diverse Practices,* Julia Knight (ed.), John Libby Media, Luton, 1996, p. 93.

23. Furlong, *op cit.,*p. 37.

24. *Ibid.*, p. 37.

25. http www.evl.uic.edu (accessed 31 October 2011).

26. As noted at the beginning of this chapter, Rutt was also aware of the work of Ture Sjölander in Sweden through one of his colleagues working with him at Rutt Electrophysics.

27. Lucinda Furlong, 'Notes Towards a History of Image-Processed Video: Eric Siegel, Stephen Beck, Dan Sandin, Steve Rutt, Bill and Louise Etra', *Afterimage11*, Nos 1 and 2 (Summer 1983), p. 37.

28. Dunn, David (ed.), *Eigenwelt Der Apparatewelt: Pionere der Elektronischen Kunst*, Vienna, 1992, pp. 136–9.

29. www.experimentaltvcenter.org (accessed 31 October 2011).

30. Jones, in conversation with the author, 19 October 2011.

31. http://www.experimentaltvcenter.org (accessed 22 November 2011).

32. *Artists' Video: An Alternative Use of the Medium*, Catalogue of the exhibition, Biddick Farm Arts Centre, Sunderland, 1976 and 1977.

33. http://www.iotacenter.org (accessed 21 November 2011).

34. http://scanimate.zfx.com (accessed 21 November 2011).

35. Peter Callas, in conversation with the author, 18 October 2011.

36. Woody Vasulka, in conversation with the author, September 2000.

37. Steina in conversation with the author, September 2000.

38. *Ibid.*

39. Vasulka, *op cit.*

40. Jeffrey Schier, 'The Rutt/Etra Scan Processor', *Eigenwelt Der Apparatewelt: Pionere der Elektronischen Kunst*, Vienna, 1992, pp. 138–9.

41. Woody Vasulka, 'Didactic Video: Organisational Models of the Electronic Image', *Afterimage13* (4 October 1974), p. 9.

42. *Ibid*, p. 9.

43. This structure had rows of five monitors stacked four high – essentially an early video wall.

44. Steina, in conversation with the author, September 2000.

45. Richard Monkhouse, in conversation with the author, 23 May 2000.

46. *Ibid.*

47. After the first three machines were built, EMS changed the name to Spectron for 'European marketing purposes'. In all, 15 Spectron video synths were built and sold (Monkhouse, 23 May 2000).

48. Richard Monkhouse, 'The Moving Art of Video Graphics – or How to Drive a Spectre', *Video and Audio-Visual Review* (December 1974), p. 22.

49. David Kirk, 'Focus', *Video Magazine*, London 1975.

50. Monkhouse, *op cit.,* 23 May 2000.

51. Robert Cahen, in an e-mail to the author, 6 June 2005.

52. Warren Burt, in conversation with the author, 11 October 2011.

53. Peter Donebauer, 'Video Art and Technical Innovation', *Educational Broadcasting International*, (September 1980), pp. 122–5.

54. Donebauer, 8 mArch 2000.

55. The commissioned tape, *Entering*, recorded on 15 April 1974, and broadcast in May 1974 was the first British video artwork to be transmitted nationally – David Hall's *TV Pieces*, transmitted by Scottish TV in 1971 as part of the Edinburgh Festival, were shot on 16 mm film, and only transmitted within the STV region.

56. Peter Donebauer, in conversation with the author, 8 March 2000.

57. Donebauer was the first and only video artist to receive funding from the BFI in 1975. This led to the production of *Circling* (1975) *Teeming* (1975) and *Dawn Creation* (1976).

58. Donebauer, 8 March 2000.

59. The VAMP group consisted of Donebauer, Monkhouse and musicians Desorgher, and Lawrence Casserley. The 1977 tour included venues at Biddick Farm, Tyne and Wear, The Arnolfini Gallery, Bristol, the ICA and Intergalactic Arts, London.

60. Donebauer, in conversation with the author, 8 March 2000.

61. Donebauer, from a statement about his video work for the British Film Institute, BFI, London, 1976.

62. *Ibid.*

63. *Merging-Emerging* (1978); *In Ernest* (1979); *Performance Pieces* (1979–80); *Moving* (1980); *Water Cycle* (1981–2); *Brewing* (1986); and *Mandala* (1991).

64. I have a good working knowledge of the functioning and capabilities of Videokalos IMP as I have used it extensively for the production of a number of my own early video tapes. See www.meigh-andrews.com

65. Gene Youngblood, 'Cinema and the Code' *Leonardo, Computer in Context Supplemental issue*, 1989, p. 28.

66. Hollis Frampton, 'The Withering Away of the State of The Art', *The New Television: A Public/Private Art*, Douglas Davis and Allison Simmons (eds), MIT Press, Cambridge and London, 1978, p. 25.

Chapter 8: In and Out of the Studio

1. 'Portapak' was the term used to describe the portable video recorder and camera equipment originally introduced by Sony, but a number of other manufacturers such as Panasonic, JVC and Shibdaen soon produced similar equipment and the name became generic among artists and other independent users.

2. Steve Partridge, *Studio International* (May/June 1976), p. 259.

3. Stuart Marshall, 'From Art to Independence', reprinted in *Diverse Practices*, Julia Knight (ed.), John Libbey Media/Arts Council of England, Luton, 1996, pp. 67–8.

4. Chris Hill (ed.), *Rewind: Video Art and Alternative Media in the United States: 1968–1980*, Video Data Bank, Chicago, 1998, p. 76.

5. It is possible that this work was at least partly inspired by Alvin Lucier's *I Am Sitting in a Room*, a sound composition which explored the acoustic properties of a performance space by the repeated re-recording of a prepared speech (see Chapter 4).

6. David Hall, from a conversation with the author.

7. Hall did not have many further opportunities to reach a broadcast television audience: his next work for television was not until the 1990s.

8. David Hall, in conversation with the author, 30 September 2000.

9. Joan Jonas, *Video Art*, Ira Schneider and Beryl Korot (eds), Harcourt, Brace and Jovanovitch, New York, 1976, p. 73.

10. Joan Jonas, 'Her Saw Her Burning', *Illuminating Video: An Essential Guide to Video Art*, Doug Hall and Sally Jo Fifer (eds), Aperture, New York, 1992, p. 367.

11. Joan Jonas, *The New Television*, Davis, Douglas and Allison Simmons (eds), MIT Press, Cambridge and London, 1978, p. 71.

12. Andre Parente, 'Hello, it is Leticia', *Leticia Parente: Arqueologia do Cotidiano: Objectos de Uso*, Colecao Arte e Technologia, Rio de Janerio, 2011, p. 28.

13. *Ibid.*, p. 36.

14. Leticia Parente, 'General Proposal of the Video Work', *Arqueologia do Cotidiano: Objectos de Uso*, Colecao Arte e Technologia, Rio de Janerio, 2011, p. 110.

15. *Ibid.*, p. 115.

16. Elena Shtromberg, 'Bodies in Peril: Enacting Censorship in Early Brazilian Video Art (1974–78)', The Aesthetics of Risk, John C. Welchman (ed.), SoCCAS Symposium, Vol. III (Zurich: JRP/Ringler, 2008), pp. 265–83.

17. *Ibid.*, p. 277.

Chapter 9: Cutting It

1. Eric Cameron, 'Sex, Lies and Lawn Grass', *Art Metropole*, Toronto, 1994, p. 1.

2. Leslie Dawn, 'Pleasures of Paradox – Works of Eric Cameron', *Desire & Dread*, Muttart Public Art Gallery, Calgary, 1998. p. 7.

3. Cameron, *op cit.,* p. 1.

4. Eric Cameron, in a letter to the author, 13 July 2005.

5. Cameron, op. cit., Art Metropole, Toronto, 1994, p. 4.

6. Eric Cameron, in an e-mail to the author, 19 July 2005.

7. Cameron, *op cit.,* p. 6.

8. Dara Birnbaum quoted in Hill, Chris (ed.), *Rewind: Video Art and Alternative Media in the United States: 1968–80*, Video Data Bank, Chicago, 1998, p. 79.

9. Norman M. Klein, 'Audience, Culture and the Video Screen', in *Illuminating Video: An Essential Guide to Video Art*, p. 391.

10. David Curtis, *Experimental Cinema: A Fifty Year Evolution*, Studio Vista, London, 1971, pp. 167–9.

11. Laura Mulvey, 'Visual Pleasure and Narrative Cinema', *Screen*, Vol. 15, 1975, pp. 6–18.

12. Catherine Elwes, *Video Loupe*, KT Press, London, 2000, p. 9.

13. Catherine Elwes, in conversation with the author, 24 July 2000.

14. Sean Cubitt, *Time Shift on Video Culture*, Routledge, London, 1992, p.132.

15. Catherine Elwes in conversation with the author, 24 July 2000.

16. Catherine Elwes, 'Through Deconstruction to Reconstruction', *Independent Video* (No. 48, November 1985), p. 21.

17. Welsh, 'One Nation Under a Will (of Iron) or: The Shiny Toys of Thatcher's Children', *Diverse Practices*, Julia Knight (ed.), Arts Council of England/University of Luton Press, Luton, 1996, pp. 129–30.

18. *Ibid.*, p. 130.

19. Klaus vom Bruch, 'Logic to the Benefit of Movement', *Video by Artists 2*, Elke Towne (ed.), Art Metropole, Toronto, 1986, pp. 38–9.

20. *Ibid.*, p. 37.

21. Chris Dercon, 'The Collages of vom Bruch', *Video By Artists 2*, Elke Town (ed.), Art Metropole, Toronto, 1986, p. 145.

22. Jozef Robakowski, 'Art is Power', http://www.robakowski.net (accessed 30 November 2011).

23. *Ibid.*

24. Lukasz Ronduda, 'Subversiuve Strategies in the Media Arts, Jozef Robakowski's Found Footage and Video Scratch', http://www.zbikow.lh.pl (accessed 30 November 2011).

25. Jozef Robakowski, 'Video Art – A Chance to Approach Reality', Film Form Workshop catalogue, Ryszard W. Kluszczydski (ed.), Warsaw, 2000.

Chapter 10: Mixing It

1. Kristian Romare, *Monument*, http.//monumentime.homestead.com (accessed 7 August 2004).

2. Peter Donebauer, in conversation with the author, 2 July 2000.

3. *Ibid.*

4. Peter Donebauer, unpublished statement about *Merging-Emerging*, 1978.

5. Bill Viola interviewed by Catherine Elwes, 'Bill Viola: Quiet Moments with Nature', *Video Loupe*, KT Press, London, 2000, p. 88.

6. Bill Viola, 'The European Scene and Other Observations', *Video Art: An Anthology*, Ira Schnider and Beryl Korot (eds), Harcourt, Brace and Janovitch, New York, 1976, pp. 274–7.

7. Bill Viola, interview with Jorg Zutter, *Bill Viola: Unseen Images*, Maria Luise Syring (ed.), London, 1994, p. 100.

8. Bill Viola, 'The European Scene and Other Observations', *Video Art: An Anthology*, Ira Schnider and Beryl Korot (eds), Harcourt, Brace and Janovitch, New York, 1976, p. 278.

9. Elwes, Viola interview, *op cit.*, p. 88.

10. Maria Luise Syring, 'The Way to Transcendence – or the Temptation of St Anthony', in *Bill Viola: Unseen Images*, Maria Luise Syring (ed.), Düsseldorf, Stockholm, Madrid, Geneva, London, 1994, p. 21.

11. Daniel Reeves, in conversation with the author, 21 November 2001.

12. *Ibid.*

13. Patricia R. Zimmermann, *States of Emergency: Documentaries, Wars, Democracies*, University of Minnesota, 2000, p. 111–12.

14. Patricia R. Zimmermann, 'Processing Trauma: The Media Art of Daniel Reeves', *Afterimage26* (2, September/October 1998), p. 12.

15. Daniel Reeves, in conversation with the author, 21 November 2001.

16. *Ibid.*

17. *Ibid.*

18. Woody Vasulka, in conversation with the author, 5 September 2000.

19. Raymond Bellour, 'The Images of the World', *Resolutions; Contemporary Video Practices*, Michael Renov and Erika Sunderburg (eds), University of Minnesota Press, Minneapolis, 1996. p. 157.

20. Sean Cubitt, *Videography: Video Media as Art and Culture*, Macmillan Education Ltd, London, 1993, p. 145.

21. Daniele Moison, 'Robert Cahen: le magicien magnetique', *Camera Video* (No. 25, February 1990), quoted in Sandra Lischi, *The Sight of Time*, p. 39.

22. Robert Cahen, from an interview with the author 6 June 2005, trans. Aneta Krzemien.

23. Lischi, *op cit.,*pp. 41–2.

24. Paul Virilio, 'Où va la Video ?',*Cahiers du Cinema*, 1986.

25. Fargier, 'Voyage au centre de la trame', quoted in Lischi, p. 39.

26. Robert Cahen, unpublished interview, 5 May 1996.

27. Peter Callas, Interviewed by the author 20 October 2011.

28. Scott McQuire, 'Electrical Storms: High Speed Historiography in the video Art of Peter Callas', *Initialising History*, dLux Media Art, Sidney, 1999. pp. 31–5.

29. Peter Callas, 'Interlaces Places: Video in Tokyo and Sidney in the Eighties', *Initialising History*, dLux Media Art, Sidney, 1999, p. 66.

Chapter 11: The Gallery Opens its Doors

1. Michael Snow, *Video Art: An Anthology*, Schneider, Ira, and Beryl Korot (eds), Harcourt, Brace Jovanovitch, New York, 1976, p. 118.

2. *Ibid.*, pp. 118–19.

3. *Ibid.*, p. 119.

4. Michael Snow, in an e-mail to the author, May 2005

5. *Ibid.*

6. Studio Azzurro, 'The Place and the People', *Studio Azzurro: Percorsi, tra video, cinema e teatro*, Electa, Milan, 1995. p. 137.

7. Valentina Valentini, 'The Spectator as Narrative Voice', *Studio Azzurro: Percorsi, tra video, cinema e teatro*, Electa, Milan, 1995. p. 138.

8. Cinzia Cremona, unpublished interview with Paolo Rosa, Milan, February 2005.

9. Judith Goddard, in conversation with the author, 7 February 2005.

10. Judith Goddard, 'Electron – Television Circle, 1987', *Signs of the Times*, Chrissie Iles (ed.), Museum of Modern Art, Oxford, 1990, p. 35.

11. *Ibid.*

12. Made in collaboration with Tony Sinden, and shown in 'Survey of the Avant-Garde', Goethe Institute, Gallery House, London.

13. David Hall, 'Structures, Paraphernalia and Television: Some Notes" in *Signs of the Times: a Decade of Video, Film and Slide-Tape Installation in Britain, 1980–1990*, Chrissie Iles (ed.), The Museum of Modern Art, Oxford, 1990, pp. 29–31.

14. George Quasha (with Charles Stein) 'Tall Acts of Seeing', Catalogue to the exhibition *Gary Hill*, Stedelijk Museum, Amsterdam, and Kunsthalle, Wien, Vienna, 1993–4, pp. 99–108.

15. *Ibid.*, p. 101.

16. Fred Anderson, Leonardo Digital Review, MIT Press, April 2002, accessed 6 November 2012.

17. Martin Anderson, 'Takhiko Iimura is a Camera', Media Mavericks (Fall 2009). http://www.takai-imura.com (accessed 6 November 2012).

18. See Chris Meigh-Andrews, 'An Interview with Takahiko Iimura', *The Moving Image Review and Journal* (MIRAJ), Vol. 1, Issue 2, Intellect Books, London. 2012.

19. This form of work was also very quickly re-appropriated by the broadcast industry, hungry for new forms.

20. *Eleventh Hour*, 'Video Two', Channel 4, October, 1985.

Chapter 12: The Ubiquity of the Video Image

1. Sherin Neshat in conversation with Heidi Zukerman Jacobson, Matrix 187.

2. Atom Egoyan, 'Turbulent', Museum catalogue essay, Musée d'art contemporain Montréal, reprinted in Filmaker Magazine (Fall 2001), http://www.filmmakermagazine.com (accessed 23 November 2011).

3. Interview with Shirin Neshat, *Bombsite*, Issue 73. http://bombsite.com (accessed 24 November 2011).

4. Tom Gunning, 'The Videos of Guy Ben-Ner: Escape from the Movies, Escape From Home', catalogue essay for the exhibition at the Israeli Pavilion, 51st Venice Biennale, 2005, p. 16.

5. Sergio Edelstein, 'Guy Ben-Ner: Self-Portrait as a Family Man', Catalogue essay for the exhibition at the Israeli Pavilion, 51st Venice Biennale, 2005, p. 66.

6. Guy Ben-Ner, interview with Stephanie Smith, http://adaptation.uchicago.edu (accessed 5 December 2011).

7. In the scene in *Wild Boy* in which the man writes 'I will be a good boy' on the child's back, Ben-Ner makes a direct visual reference to Oppenheim's *Stage Transfer Drawing (Advancing to a Future State)* (1971).

8. Guy Ben-Ner, quoted by Rachel Spence in 'The Art of Ben Guy-Ner', Jewish Quarterly, No. 198 (Summer 2005), http://www.jewishquarterly.org (accessed 6 December 2011).

9. Guy Ben-Ner, interview, http://www.sitegallery.org (accessed 5 December 2011).

10. Rebecca Weisman, 'Guy Ben-Ner: Thursday the 12th', *International Contemporary Art*, www.thefreelibrary.com (accessed 5 December 2011).

11. Bani Abidi, from an e-mail correspondence with the author, November 2012.

12. *Ibid.*

13. *Ibid.*

14. In fact, this is an important point generally, and is true of all works under consideration in this and other books in which specific works are discussed as examples or 'key' works.

15. Robin Peckham, In Search of the Alluring: The art of Zhang Peili, http://leapleapleap.com/2011/11/in-search-of-the-alluring-the-art-of-zhang-peili/ (accessed 19 November 2012).

16. *Ibid.*

17. Huang Zhuan, 'An Antithesis to Conceptualism: On Zhang Peili', *Yishi Journal of Contemporary Chinese Art* (November/December 2011, Vol. 10, No. 6).

18. Catalogue notes for Certain Pleasures, Retrospective of Zhang Peili, Minsheng Art Museum, Shanghai, China, 2011.

19. *Ibid.*

20. http://www.artthrob.co.za/04may/artbio.html (accessed 10 November 2012).

21. http://www.rest-in-space.net/basis/madikida.html (accessed 11 November 2012).

22. Colin Richards, 'Inside Out', catalogue essay, *Churchill Madikida: Standard Bank Young Artist for Visual Art 2006*, Cape Town.

23. Gabi Ngcobo, Review of Virus; http://www.artsouthafrica.com/?article=94 (accessed 12 November 2012).

24. This exhibition presented in 2004 at the Museum for African Art and the Cathedral of St John the Divine in New York, was curated by David Brodie, Laurie Ann Farrell, Sophie Perryer, Liese van der Watt and Churchill Madikida.

25. http://www.artthrob.co.za/04may/artbio.html (accessed 12 November 2012).

Chapter 13: Fields, Lines and Frames

1. Gene Youngblood 'Synathesetic Videotapes', *Expanded Cinema*, Studio Vista, London, 1970, p. 298.

2. Kathy Rae Huffman, 'What's TV Got to do With It', *Illuminating Video: An essential Guide to Video Art*, Aperture/BAVC, Doug Hall and Sally Jo Fifer, p. 82.

3. Youngblood, p. 285.

4. Kathy Rae Huffman, 'Seeing is Believing: The Arts on TV', *The Arts for Television*, The Museum of Contemporary Art, Los Angeles, 1987, p. 12.

5. John Hopkins, in conversation with the author, February 2005.

6. www.fondation-langlois.org (accessed 1 November 2011).

7. This was withdrawn in 1976.

8. Studio Azzurro in conversation with Valentina Vallentini, October 1993 and February1994, *Studio Azzurro, Percorsi tra video, cinema e teatro*, Electa, Milan, 1995, p. 156.

9. Bill Viola, 'In Response to Questions for Jorg Zutter', *Reasons for Knocking at an Empty House: Writings 1973–1994*, Thames & Hudson, London, 1995, pp. 241–2

10. Rob Perree, *Into Video Art: The Characteristics of a Medium*, Idea Books, Amsterdam, 1998, p. 46.

11. Mary Lucier, 'Light and Death', *Illuminating Video*, p. 457.

12. David Ross, 'Interview with Douglas Davis', Ira Schneider and Beryl Korot (eds), Harcourt, Brace and Jovanovitch, New York and London, 1975, pp. 32–3.

13. Jonathan Price, *Video Visions; A Medium Discovers Itself*, Plume Books, New York, 1972, p. 203.

14. Frederick Perls, *Gestalt Therapy Verbaitim*, Introduction, J. O. Stevens (ed.), Bantam books, London and Toronto, 1971, p. 4.

15. Bruce Nauman, *Avalanche* (Winter 1971), p. 29.

16. Vito Acconci, *Avalanche 6*, 1972.

17. Willoughby Sharp, 'Videoperformance', in Video Art, Schneider and Korot (eds), Harcot, Brace, Javanovitch, New York, 1975, pp. 256–9

18. http://www.medienkunstnetz.de (accessed 4 September 2009).

19. Bill Viola, 'Note on the Red Tape (1975)', *Reasons for Knocking at an Empty House: Writings 1973–1994*, Thames and Hudson, London, 1995, p. 33.

20. Viola has suggested that synaesthesia may be the natural inclination of the structure of contemporary media, see 'The Sound of One Line Scanning', *Reasons for Knocking at an Empty House: Writings 1973–1994*, Thames and Hudson, London, 1995, p. 164.

21. 'Note, Sept 30th, 1985', *Reasons for Knocking at an Empty House: Writings 1973–1994*, Thames and Hudson, London, 1995, p. 148.

22. *Ibid*, p. 159.

23. http://www.medienkunstnetz.de (accessed 6 September 2009).

24. Judith Goddard, in conversation with the author, 7 February 2005.

25. *Ibid.*

26. Pipilotti Rist, 'Innocent Collection, 1988 – Ongoing', *Pipilotti Rist*, Phaidon Press, London, 2001, p. 108.

27. http://en.wikipedia.org/wiki/Jacques_Perconte (accessed 20 October 2012).

28. James P. Crutchfield, 'Space-Time Dynamics in Video Feedback', *Eigenwelt Der Apparate-Welt*, Ars Electronica, David Dunn (ed.), Linz, 1992, p. 192.

29. David Loxton, quoted by Jonathan Price, *Video Visions: a Medium Discovers Itself*, Plume Books, New York, 1972.

Chapter 14: The Means of Production

1. Tamara Krikorian, 'Some notes on an Ephemeral Art', Exhibition Catalogue, The Third Eye Centre, Glasgow, 1979, quoted in Marshall, 1986, p. 17.

2. Catherine Elwes, *Video Art: a Guided Tour*, I. B. Taurus, London and New York, 2005, p. 41.

3. Jean Fisher, 'Reflections on Echo – Sound by Women Artists in Britain', *Signs of the Times – A decade of Video, Film and Slide-Tape installation in Britain 1980–1990*, Chrissie Iles (ed.), Oxford, 1990, p. 62.

4. DeeDee Halleck, Interview with Shirley Clarke, http://davidsonsfiles.org/shirleyclarkeinterview.html (accessed 19 November 2012).

5. http://en.wikipedia.org/wiki/Shirley_Clarke (accessed 19 November 2012).

6. Shirley Clarke: An Interview, Radical Software, New York: Gordon and Breach, Science Publishers Inc.; Vol. II, No. 4, 1973, cited in http://teepeevideospacetroupe.org/?p=243 (accessed 18 November 2012).

7. Andrew Gurian, 'Thoughts on Shirley Clarke and the Teepee Videospace Troups', http://teepeevideospacetroupe.org/?p=243 (accessed 18 November 2012).

8. http://mfj-online.org/journalPages/mfj42/gurianpage.html (accessed 18 November 2012).

9. *Ibid.*

10. Thomas F. Cohen, 'After the New American Cinema, Shirley Clarke's Video Work as Performance and Document', *Journal of Film and Video*, 64, Nos 1–2 (Spring/Summer 2012), pp. 57–64.

11. http://www.reactfeminism.org/nr1/artists/rosenbach_en.htm (accessed 10 November 2012).

12. http://clara.nmwa.org/index.php?g=entity_detail_print&entity_id=5667 (accessed 10 November 2012).

13. Syn Guerin, 'Feminist Perspective as a Component of Culture', *London Video Arts Catalogue*, London, 1991, p. 75.

14. Catherine Elwes, *Video Art, A Guided Tour*, I. B. Taurus, London and New York, 2005, p. 42.

15. Katherine Meynell, *A Dictionary of British Film and Video Artists*, p. 126.

16. Martha Gever, 'The Feminism Factor: Video and its Relation to Feminism', *Illuminating Video: An Essential Guide to Video Art*, Doug Hall and Sally Jo Fifer (eds), Aperture, San Francisco, 1992, pp. 229–30.

17. Mona Hatoum, http://bombsite.com/issues/63/articles/2130 (accessed 7 November 2012).

18. *Ibid.*

19. http://theorynow.blogspot.co.uk/2008/02/feminist-video-art-as-forerunner-to.html (accessed 8 November 2012).

20. Stuart Marshall, Artist's statement, 'The Video Show', Serpentine Gallery, May 1975.

Chapter 15: Off the Wall

1. Margaret Morse, 'Video Installation Art: The Body, the Image and the Space-in-Between', *Illuminating Video: An Essential Guide to Video Art*, Doug Hall and Sally Jo Fifer (eds), Aperture, 1990, p. 154.

2. *Ibid*, p. 155.

3. *Ibid*, p. 159.

4. Michael Archer, 'Site', *Installation Art*, Thames & Hudson, London, 1994. p. 35.

5. Frederic Jameson, *Post-Modernism & Utopia-Post Utopia: Configurations of Nature and Culture in Recent Sculpture*. MIT Press, Boston and London, 1988, p. 15.

6. Beryl Korot, 'Dachau 1974', *Video Art: An Anthology*, Ira Schneider and Beryl Korot (eds), Harcourt, Brace, Jovanovitch, New York, 1976, p. 76.

7. Jeremy Welsh 'Marty St. James and Anne Wilson', *A Directory of British Film and Video Artists, David Curtis* (ed.), Arts Council of England, John Libbey Media, Luton, 1996, p. 179.

8. Pipilotti Rist, 'Preface to Nam June Paik: Jardin Illumine', *Pipilotti Rist*, Phaidon Press, London, 2001, p. 113.

9. Peter Campus, in an e-mail to the author, 22 June 2005.

10. Rosalind Krauss, 'Video; The Aesthetics of Narcissism', in *Video Culture, a Critical Investigation*, John Hanhardt (ed.), Visual Studies Workshop Press, New York, 1990, p. 189.

11. Occasionally video artists had resorted to masking the video frame, either electronically by generating a 'wipe' or by cutting an aperture in an opaque material and putting it over the television screen, but this was awkward and often unsatisfactory compromise.

12. Tony Oursler, 'Video is Like Water', interview with Simona Lodi in *Tony Oursler*, Edizioni Charta, Milan, 1998, pp. 23–4.

13. *Ibid*, p. 25.

Chapter 16: Going Digital

1. Peter Callas, 'Images as Ideas', *London Video Access Catalogue*, 1991, p. 66.
2. Initially in partnership with Peter Livingston and Alexandra Meigh, two other artists associated with London Video Arts.
3. Made whilst I was Artist-in-Residence in Electronic Imaging at Oxford Brookes University, January to July 1995.
4. Malcom le Grice, 'A Non-Linear Tradition – Experimental Film and Digital Cinema', *Experimental Cinema in the Digital Age*, BFI Publishing, London, 2001.
5. http://transcriptions.english.ucsb.edu/archive/courses/warner/english197/Schedule_files/Manovich/Database_as_symbolic_form.htm (accessed 11 October 2012).
6. http://en.wikipedia.org/wiki/Lev_Manovich (accessed 11 October 2012).
7. http://www.manovich.net/little-movies/statement-new3.html (accessed 11 October 2012).
8. http://www.manovich.net/little-movies/statement-new3.html (accessed 11 October 2012).
9. Vince Briffa, Playing God, unpublished PhD thesis, 2008.
10. http://www.fdcw.unimaas.nl/is/generationflash.htm (accessed 7 October 2012).
11. Oliver Seifert, 'Media Scape', Guggenheim Museum, New York and ZKM, Karlsruhe, 1996, p. 48.
12. Susan Collins, *A Directory of British Film and Video Artists*, David Curtis (ed.), Arts Council of England/John Libby Media, Luton, 1996.
13. http://www.winxdvd.com/resource/hd-video.htm (accessed 16 October 2012).
14. See: http://en.wikipedia.org/wiki/Trojan_Room_coffee_pot
15. http://www.eatonhand.com/thues/wtable01.htm (accessed 16 October 2012).
16. http://en.wikipedia.org/wiki/Annie_Abrahams (accessed 17 October 2012).

Chapter 17: Video Art in the New Millennium

1. David Hall, 'British Video Art: Towards an Autonomous Practice', *Studio International* (May to June 1976), pp. 248–52.
2. Peter Donebauer, 'Video Art and Technical Innovation', *Educational Broadcasting International* (September 1980), pp. 122–5.
3. Nicky Clarke, 'Elizabeth Price takes Turner Prize 2012 for "Seductive" Video Trilogy', *The Independent*, Monday 3 December 2012.
4. Mick Hartney, 'An Incomplete and Highly Contentious Summary of the Early Chronology of Video Art (1959–76); with Tentative Steps in the Direction of a De-Definition', *London Video Arts Catalogue*, 1984, pp. 2–9.
5. John Wyver, 'The Necessity of Doing Away with Video Art', *London Video Access Catalogue*, 1991, pp. 45–8.
6. Gregor Muir, 'Chronochromie', *Time Zones: Recent Film and Video*, Tate Publishing, London, 2004, pp. 36–50.

7. Jessica Morgan, 'Time After Time', *Time Zones: Recent Film and Video*, Tate Publishing, London, 2004, pp. 14–27.

8. Paul Coldwell, 'Digital Responses: Integrating the Computer', *Pixel Raiders*, University of Sheffield, March 2003.

9. http://en.wikipedia.org/wiki/Wolfgang_Staehle (accessed 27 January 2013).

10. http://www.andrewdemirjian.com/work-installation.html#1 (accessed 28 January 2013).

BIBLIOGRAPHY

Acconci, Vito (1972) 'Body as Place-Moving in on Myself, Performing Myself', *Avalanche 6* (Fall).

Adajania, Nancy, 'New-Context Media: A Passage from Indifference to Adulation', http://www.goethe. de/ins/in/lp/prj/kus/exp/enindex.htm

Anderson, Fred (2002) 'Takahiko Iimura', Leonardo Digital Review, MIT Press (April).

Anderson, Martin (2009) 'Takahiko Iimura is a Camera', *Media Mavericks* (Fall), http://www.takaiimura. com

Archer, Michael (1994) *Installation Art*, Thames & Hudson, London.

Armitage, J, 'Beyond Postmodernism? Paul Virilio's Hypermodern Cultural Theory', http://www. ctheory.net

Arnatt, Keith (1990) 'Self Burial', Television Interventions, 19:4:90, exhibition catalogue, Third Eye Centre, Glasgow.

Baecker, Angie (2011) Review of 'Certain Pleasures' at Minsheng Art Museum, Shanghai, China, https://www.frieze.com/issue/review/zhang-peili/

Barthes, Roland (1982) *Camera Lucida: Reflections on Photography*, Jonathan Cape, London.

Beck, Stephen (1976) 'Image Processing and Video Synthesis', in Ira Schneider and Beryl Korot (eds), *Video Art: An Anthology*, Harcourt, Brace, Janovitch, New York and London, pp. 184–7.

Bellour, Raymond (1996) *'The Images of the World', Resolutions: Contemporary Video Practices*, Michael Renov and Erika Sunderburg (eds), University of Minnesota Press, Minneapolis.

Benjamin, Walter (1968 [1936]) 'The Work of Art in the Age of Mechanical Reproduction', in Hannah Arendt (trans.) *Illuminations*, Harcourt, Brace, Jovanovich, New York, pp. 253–63.

Berghuis, Thomas J (2006) *Performance Art in China*, Timezone 8, Hong Kong.

Bermingham, Alan, Michael Talbot-Smith, John Symons and Ken Angold-Stephens (1975) *The Small TV Studio*, Focal Press, London.

Birnbaum, Alfred, 'Japanese Video: The Rise and Fall of Video Art', http://www.mediamatic.net/255224/ en/japan-video

Blasé, Karl Oskar (1977) Interview with Gerry Schum, 'Video Documentation and Analysis', *Documenta 6 catalogue*, Kassel.

Brakhage, Stan (1962) 'Metaphors on Vision', Film Culture30 (Fall). unpaginated.

Brett, Guy (2000) 'The Century of Kinaesthesia', Force Fields: Phases of the Kinetic, Hayward Gallery/ Museu d'Art Contemporani de Barcelona.

Buchloh, Benjamin H. D. (1985) 'From Gadget Video to Agit Video: Some Notes on Four Recent Video Works', Art Journal (Fall).

Byrne, John (1996) 'Modernism and Meaning: Reading the Intervention of British Video Art into the Gallery Space', Diverse Practices, Julia Knight (ed.), John Libby Media, Luton.

Cage, John (1973) *Silence: Lectures and Writings*, Calder and Boyars, London.

Callas, Peter, 'Videor Video – a History', *Globe,* Issue 9, http://www.artdes.monash.edu.au

—(1999) 'Interlaced Places: Video in Tokyo and Sidney in the Eighties', *Initialising History*, dLUX Media Art, Sidney.

Cartwright, Lisa (1995) *Screening the Body: Tracing Medicine's Visual Culture*, University of Minnesota Press, London.

Cohen, Thomas F (2012) 'After the New American Cinema, Shirley Clarke's Video Work as Performance and Document', *Journal of Film and Video*, 64, Nos 1–2 (Spring/Summer), pp. 57–65.

Coldwell, Paul (2003) 'Digital Responses: Integrating the Computer', *Pixel Raiders* (March).

Crutchfield, James P. (1992) 'Space-Time Dynamics in Video Feedback', *Eigenwelt Der Apparate-Welt*, Ars Electronica, David Dunn, Linz (ed.).

Cubitt, Sean (1991) 'Visions and Transmissions: Harris Museum and Art Gallery', *Artscribe International* (April–May), pp. 67–8.

—(1992) *Time Shift on Video Culture*, Routledge, London.

—(1993) *Videography: Video Media as Art and Culture*, Macmillan Education, London.

Curtis, David (1971) *Experimental Cinema: A Fifty-year Evolution*, Studio Vista, London.

—(ed.) 'Video Artists on Tour', February 1980 and September 1984, Arts Council of Great Britain.

—(ed.) (1996) *A Directory of British Film and Video Artists*, Arts Council of England/John Libby Media, Luton.

Davis, Douglas (1973) *Art and the Future: A History/Prophecy of the Collaboration Between Science, Technology and Art*, Thames & Hudson, London.

—(ed.) (1977) *The New Television*, MIT Press, Cambridge, MA.

Decker-Phillips, Edith (1988) *Paik Video*, Barrytown, New York.

Donebauer, Peter (1975) 'Electronic Painting', *Video and Audio-Visual Review* (March) London.

—(1977) 'Video Work: Circling, Teeming, Dawn Creation', British Film Institute, London.

—(1978) 'Colour Me RGB: New Synthesiser Breaks with Tradition', *Broadcast*, 26, www.donebauer.net/ manifestations/ videokalos/press/press.htm

—(1980) 'Video Art and Technical Innovation', Educational Broadcasting International (September).

—(1996) 'A Personal Journey Through a New Medium', in Julia Knight (ed.), *Diverse Practices*, John Libby Media, Luton, pp. 87–98.

Dronsfield, Jonathan Lahey (2007) 'Jacques Derrida', in *Art: Key Contemporary Thinkers*, Diarmuid Costello and Jonathan Vickery (eds), Berg, Oxford.

Drummond, Philip (ed.) (1979) 'Film as Film: Formal Experiment in Film: 1910–1975', Hayward Gallery, London (May–June).

Dunn, David (ed.) (1992) 'Eigenwelt Der apparate-Welt: Pioniere Der Elektronischen Kunst', Ars Electronica, Vienna.

Dunn, David and Woody Vasulka, 'Digital Space: A Summary', http://www.artsclab.org/pages/digital space.html

Dusinberre, Deke (1976) 'St. George in the Forest: the English Avant-Garde', *Afterimage 6* (Summer).

Edelstein, Sergio (2005) 'Guy Ben-Ner: Self-Portrait as a Family Man', catalogue essay for the exhibition at the Israeli Pavilion, 51st Venice Biennale.

Egoyan, Atom (2001) 'Turbulent', Museum catalogue essay, Musée D'Art Contemporain Montreal (reprinted in Film-Maker Magazine, Fall).

Elwes, Catherine (1985) 'Through Deconstruction to Reconstruction', Independent Video 48 (November).

—(1992) 'Chris Meigh-Andrews: Eau d'Artifice', Performance (Spring).

—(2000) Video Loupe, KT Press, London.

—(2005) Video Art: a Guided Tour, Taurus, London and New York.

Eno, Brian (1975) Sleeve notes for 'Discreet Music', Obscure Records.

Field, Simon (ed.) (1976) 'Perspectives on English Independent Cinema', Afterimage 6 (Summer, Special Issue).

—Simon and Guy L'Eclair (eds), (1982) 'Sighting Snow', Afterimage 11 (Winter 1982–83).

Frohne, Ursula, Oliver Seifert and Annika Blunck (1996) Mediascape, Solomon R. Guggenheim Museum, New York (June–September).

Furlong, Lucinda (1983) 'Notes Toward a History of Image-Processed Video: Woody and Steina Vasulka', Afterimage 11 (5, December).

—(1983) 'Notes Towards a History of Image-Processed Video: Eric Siegel, Stephen Beck, Dan Sandin, Steve Rutt, Bill and Louise Etra, Afterimage 11 (1 and 2, Summer).

——(1985) 'Tracking Video Art: Image Processing as a Genre', Art Journal (Fall).

Gale, Peggy (1976) 'Video Art in Canada: Four Worlds', Studio International (May/June).

Gazzano, Marco Maria (1995) 'Steina and Woody Vasulka: Video, Media e Nuove Immagini Nell'arte Contemporanea', Edizioni Fahrenheit 451, Rome.

Gidal, Peter (ed.) (1976) Structural Film Anthology, British Film Institute, London.

—(1986) 'Technology and Ideology in Avant-Garde Film: An Instance', in Teresa de Lauretis and Stephen Heath (eds), The Cinematic Apparatus, Macmillan, London/St Martin's Press, New York.

Gillette, Frank, 'McLuhan and Recent History', from The Early Video Project, http://davidsonsfiles.org

Godfrey, Tony (1998) 'Conceptual Art', Phaidon Press, London and New York.

Gow, Gordon (1976) 'On Malcom Le Grice' Structural Film Anthology, British Film Institute, London.

Grayson, Sue (1975) 'Video Times' exhibition catalogue, Serpentine Gallery, May.

Groos, Ulrike, Barbara Hess and Ursula Wevers (eds), (2005) Fernsehgalerie Gerry Schum: Ready to Shoot, Kunsthalle Dusseldorf/Sneock, Dusseldorf.

Gunning, Tom (2005) 'The Videos of Guy Ben-Ner: Escape from the Movies, Escape From Home', catalogue essay for the exhibition at the Israeli Pavilion, 51st Venice Biennale.

Gurian, Andrew, 'Thoughts on Shirley Clarke and The TP Videospace Troupe', http://teepeevideospacetroupe.org/?p=243

Hall, David (1975) 'The Video Show', Art and Artists (May).

—(1976) 'British Video Art: Towards an Autonomous Practice', Studio International (May–June).

—(1976) 'Video: Towards Defining an Aesthetic', Third Eye Centre, Glasgow (March).

Hall, David and Tony Sinden (1977) '5 Films', Perspectives on British Avant-Garde Film, Hayward Gallery (2 March–24 April).

—(1978) 'Using Video and Video Art: Some Notes', Video Art '78 Catalogue, Coventry (May).

—(1991) 'Before the Concrete Sets', *London Video Access Catalogue.*

Hall, Doug and Sally Jo Fifer (eds), (1990) *Illuminating Video: An Essential Guide to Video Art*, Aperture, New York.

Hall, Sue and John Hopkins (1976) 'The Metasoftware of Video', Studio International (May/June).

Halleck, DeeDee, 'Interview with Shirley Clarke', http://davidsonsfiles.org/shirleyclarkeinterview.html

Hanhardt, John (1990) 'De-collage/Collage: Notes Towards a Re-Examination of the Origins of Video Art', in Doug Hall and Sally Jo Fifer (eds), *Illuminating Video: An Essential Guide to Video Art*, Aperture, New York.

—(ed.) (1990) Video Culture; A Critical Investigation, Peregrine Smith, New York.

—(1995) 'Film Image/Electronic Image: The Construction of Abstraction, 1960–1990', Whitney Museum of American Art, New York.

Hartney, Mick (1996) 'InT/Ventions: Some Instances of Confrontation with British Broadcasting', in Julia Knight (ed.), *Diverse Practices*, John Libby Media, Luton.

Haskell, Lisa (1989) Video Positive 1989, exhibition catalogue, Merseyside Moviola, Liverpool.

Herzogenrath, Wulf (1976) 'Video Art in West Germany', *Studio International* (May/June), pp. 217–22.

Hess, Barbara (2005) 'No Values For Posterity: Three Films About Art', *FersehgalerieGerry Schum: Ready to Shoot*, Snoeck, Dusseldorf, pp. 8–21.

Hill, Chris (ed.) (1998) *Rewind: Video Art and Alternative Media in the United States*, 1968–80, Video Data Bank, Chicago.

Hoey, Brian and Wendy Brown (eds) (1976, 1977, 1978, 1979 and 1980) *Artists' Video: An Alternative Use of the Medium*, Biddick Farm Arts Centre, Tyne and Wear.

Houghton, Nik (1991) *Video Positive 1991*, exhibition catalogue, Merseyside Moviola, Liverpool.

Huffman, Kathy Rae (1987) 'Seeing is Believing: The Arts on TV', *The Arts for Television*, Museum of Contemporary Art, Los Angeles.

Iles, Chrissie (ed.) (1990) *Signs of the Times: a Decade of Video, Film and Slide-Tape Installation in Britain, 1980–1990*, exhibition catalogue, Museum of Modern Art, Oxford.

—(ed.) (1993) *Gary Hill: In Light of the Other*, exhibition catalogue, Museum of Modern Art, Oxford.

Jacob, Mary-Jane (1991) *Shigeko Kubota: Video Sculpture*, exhibition catalogue, American Museum of the Moving Image, New York.

Jameson, Frederic (1988) *Post-Modernism and Utopia-Post Utopia: Configurations of Nature and Culture in Recent Sculpture*, MIT Press, Boston and London.

Jones, Stephen (1986) 'Some Notes on the Early History of the Independent Video Scene in Australia', *Catalogue for the Australian Video Festival.*

—'The Electronic Art of Bush Video', www.dhub.org

Kidel, Mark (1976) 'Video Art and British TV', *Studio International* (May/June).

Kirk, David (1975) 'EMS Spectron Synthesizer', *Focus*, London.

Kluszczynski, Ryszard, 'New Poland – New Video (Some Reflections on Polish Video Art Since 1989', http://An Outline History of Polish Video Art, www.eyefilm.nl

Knight, Julia (1996) *Diverse Practices: A Critical Reader on British Video Art*, John Libbey Media/Arts Council of England, Luton.

Korot, Beryl and Phyllis Gershuny (eds), (1970) 'Table of Contents', *Radical Software1,* New York.

Krikorian, Tamara (ed.) (1976) *Video: Towards Defining an Aesthetic*, Scottish Arts Council.

—(1979) 'Some notes on an Ephemeral Art', exhibition catalogue, The Third Eye Centre, Glasgow.

Lee, Yongwoo (1998) 'The Origins of Video Art', unpublished PhD Thesis, Trinity College, Oxford University.

Leger, Fernand (1926) 'A New Realism – The Object (its Plastic and Cinematic Graphic Value)', *Little Review*.

Legrice, Malcom (1977) *Abstract Film and Beyond*, Studio Vista, London.

—(1997) 'A Non-linear Tradition – Experimental Film and Digital Cinema', *Katalog 43*, Internationale Kurzfilmtage Festivale, Oberhausen, Germany.

—(2001) *Experimental Cinema in the Digital Age*, British Film Institute Publishing, London.

Li, Pi (2004) 'Chinese Contemporary Video Art', *Zooming into Focus*, China Art Academy, Hangzhou.

Lischi, Sandra (1997) *The Sight of Time: Films and Videos by Robert Cahen*, Edizioni Ets, Pisa.

Lodi, Simona (ed.) (1998) *Tony Oursler*, Edizioni Charta, Milan.

London, Barbara (ed.) (1987) *Bill Viola: Installations and Videotapes*, exhibition catalogue, The Museum of Modern Art, New York.

—(1995) *Video spaces: Eight Installations*, exhibition catalogue, Museum of Modern Art, New York.

—'Video from Tokyo to Fukui and Kyoto', 1979, http://www.experimentaltvcenter.org

London Video Arts/London Video Access Catalogues (1978, 1984, 1988, 1991).

Lucie-Smith, Edward (1977) 'Video in United Kingdom', in Douglas Davis and Allison Simmons (eds), *The New Television: A Public/Private Art*, MIT Press, Cambridge, MA and London, pp. 183–9.

Macey, David (2000) *Dictionary of Critical Theory*, Penguin Books, London.

Machado, Arlindo (1996) 'Video Art: The Brazilian Adventure', *Leonardo*, Vol. 29, No. 3, MIT Press, Cambridge, MA.

Mac Low, Jackson (1993) 'How Maciunas Met the New York Avant Garde', *Fluxus Today and Yesterday*, Art & Design, London.

MacRitchie, Lynn, Sally Potter and Caroline Tisdall (1980) *About Time: Video, Performance and Installation by 21 Women Artists*, exhibition catalogue, Institute of Contemporary Arts, London.

Marshall, Stuart (1986) 'Video from Art to Independence', in *Video by Artists 2*, Art Metropole, Toronto, pp. 31–5.

—(1990) 'Video Installation in Britain – the early years', in Chrissie Iles (ed.), *Signs of the Times: A Decade of Video, Film, and Slide-Tape Installations, 1980–90*, Museum of Modern Art, Oxford.

Mayer, Marc (1997) 'Digressions Toward an Art History of Video', *Being and Time: The Emergence of Video Projection*, Albright-Knox Gallery, Buffalo, New York.

McLuhan, Marshall (1964) *Understanding Media*, Routledge and Kegan Paul, London.

McQuire, Scott (1999) 'Electrical Storms: High Speed Historiography in the Video Art of Peter Callas', *Initialising History*, dLux Media Art, Sidney.

Meigh-Andrews, Chris (1994) 'The Visible and the Invisible', *Art Monthly* (February) London.

—(2012) 'An Interview with Takahiko Limura', *The Moving Image Review and Journal (MIRAJ)*, Vol. 1, Issue 2, Intellect Books, London, pp. 227–35.

Meigh-Andrews, Chris and Elwes, Catherine (eds), Lukasz Ronduda, 'The History of Polish Video Art from the 1970s and 80s', *Analogue: Pioneering Video from the UK, Canada and Poland (1968–88)* (2006), EDAU, Preston, pp. 73–87.

Mertins, Wim (1983) *American Minimal Music*, Kahn and Averill, London.

Michelson, Annette (1976) 'Toward Snow', in Peter Gidal (ed.), *Structural Film Anthology*, British Film Institute Publications, London.

Moison, Daniele (1990) 'Robert Cahen: le magicien magnétique', *Camera Video* 25 (February).

Morgan, Jessica (2004) 'Time After Time', *Time Zones: Recent Film and Video*, Tate Publishing, London.

Morse, Margaret (1990) 'Video Installation Art: The Body, the Image and the Space-in-Between', in Doug Hall and Sally Jo Fifer (eds), *Illuminating Video: An Essential Guide to Video Art*, Aperture, New York, pp. 153–67.

Muir, Gregor (2004) 'Chronochromie', *Time Zones: Recent Film and Video*, Tate Publishing, London.

Mulvey, Laura (1975) 'Visual Pleasure and Narrative Cinema', *Screen* 15, pp. 6–18.

Nakaya, Fujiko, 'Japan: Video Hiroba', www.vasulka.org

Ngcobo, Gabi, Review of *Virus*, http://artsouthafrica.com

Nyman, Michael (1974) *Experimental Music: Cage and Beyond*, Studio Vista, London.

O'Pray, Mike (1982) 'Framing Snow', *Afterimage 11* (Winter 1982–83), pp. 51–65.

Parente, Andre (2011) 'Hello, is it Leticia?', *Leticia Parente: Arqueologia do Cotidiano: Objectos de Uso*, Colecao Arte e Technologia, Rio de Janerio, pp. 28–40.

Parente, Leticia (2011) 'General Proposal of the Video Work', *Arqueologia do Cotidiano: Objectos de Uso*, Colecao Arte e Technologia, Rio de Janeiro.

Partridge, Stephen (ed.) (1990) *19:4:90, Television Interventions*, Fields and Frames Productions, Dundee.

Peckham, Robin 'In Search of the Alluring: The Art of Zhang Peili', http://leapleapleap.com/2011/11/in-search-of-the-alluring-the-art-of-zhang-peili/

Peili, Zhang (2011) 'Certain Pleasures – Catalogue Notes', *Retrospective of Zhang Peili*, Minsheng Art Museum, Shanghai, China.

Perree, Rob (1998) *Into Video Art: The Characteristics of a Medium*, Idea Books, Amsterdam.

Pijnappel, Johan (ed.) (1993) 'Fluxus Today and Yesterday', *Art & Design 28* (special edition), Academy Editions, London.

—'New Media on the Indian Sub-Continent', http://www.experimenta.org/mesh/mesh17/pijnappel.htm

Price, Jonathan (1972) *Video Visions: A Medium Discovers Itself*, New American Library, New York.

Quasha, George (with Charles Stein) (1993–94) 'Tall Acts of Seeing', *Gary Hill exhibition catalogue*, Stedelijk Museum, Amsterdam/Kunsthalle, Vienna.

Rees, A. L. (1999) *A History of Experimental Film and Video: from the Canonical Avant-Garde, to Contemporary British Practice*, British Film Institute, London.

Reich, Steve (1974) 'Notes on Composition 1965–1973', *Steve Reich: Writings about Music*, Nova Scotia College of Art and Design Press, Halifax, Nova Scotia.

Revill, David (1992) *The Roaring Silence: John Cage, A Life*. Bloomsbury, London.

Rheingold, Howard (2000) *Tools for Thought*, MIT Press, Cambridge/London.

Richards, Colin (2006) 'Inside Out', catalogue essay, *Churchill Madikida: Standard Bank Young Artist for Visual Art 2006*, Cape Town.

Robakowski, Jozef (2000) 'Video Art – A Chance to Approach Reality', *Film Form Workshop catalogue*, Ryszard W. KluszczydskI (ed.) Warsaw.

Robertson, George, Melinda Mash, Lisa Tickner et al. (1996) *Future Natural: Nature, Science, Culture*, Routledge, London.

Robinson, J. F. and P. H. Beard (1981) *Using Videotape*, Focal Press, London.

Ronduda, Lukasz, 'Subversive Strategies in the Media Arts, Jozef Robakowski's Found Footage and Video Scratch', http://www.zbikow.lh.pl

Rosler, Martha (1990) 'Shedding the Utopian Moment', *Illuminating Video: An Essential Guide to Video Art*, Aperture, New York, pp. 31–50.

Schneider, Ira and Beryl Korot (eds), (1976) *Video Art: An Anthology*, Harcourt, Brace, Jovanovitch, New York.

Schum, Gerry (1970) *Land Art Catalogue*, 2nd edn, Hanover.

Schwarz, K. Robert (1996) *Minimalists*, Phaidon, London.

Seifert, Oliver (1996) 'Media Scape', Guggenheim Museum, New York/ZKM, Karlsruhe.

Sherman, Tom 'Reflecting on the Future of Video', http://www.davidsonsfiles.org.

—'The Premature Birth of Video Art' http://newsgrist.typepad.com/underbelly/2007/01/the_premature_b.html

Shtromberg, Elena (2008) 'Bodies in Peril: Enacting Censorship in Early Brazilian Video Art (1974–78)', *The Aesthetics of Risk*, John C. Welchman (ed.) SoCCAS Symposium, Vol. III Zurich.

Sitney, P. Adams (1979) *Visionary Film: The American Avant-Garde: 1943–1978*, Oxford University Press, Oxford.

Smith, Stephanie, interview with Guy Ben-Ner, http://adaptation.uchicago.edu

Sontag, Susan (1966) 'On Culture and the New Sensibility', *Against Interpretation*, Dell Publishing, New York.

Spence, Rachel (2005) 'The Art of Ben Guy-Ner', *Jewish Quarterly*, Number 198 (Summer).

Stanley, Brittany, 'Video Art: China', http://blog.videoart.net

Studio Azzurro (1995) 'The Place and the People', Studio Azzurro: Percorsi, tra video, cinema e teatro, Electa, Milan, pp. 9–10.

Sturken, Marita (1984) 'TV as a Creative Medium: Howard Wise and Video Art', *Afterimage* Vol. 11, Number 10 (May).

—(1990) 'Paradox in the Evolution of an Art Form' in *Illuminating Video: An Essential Guide to Video Art*, Doug Hall and Sally Jo Fifer (eds), Aperture, New York, pp. 101–21.

—(ed.) (1996) *Woody and Steina Vasulka: Machine Media exhibition catalogue*, San Francisco Museum of Modern Art (February–March), pp. 35–48.

Syring, Marie Luise (ed.) (1994) *Bill Viola: Unseen Images*, Whitechapel Art Gallery, London.

Town, Elke (ed.) (1986) *Video by Artists 2*, Art Metropole, Toronto.

Tse Tung, Mao, Selected Works, 'Introduction to Talks at the Yenan Forum on Literature and Art', http://www.marxists.org/reference/archive/mao/selected-works/volume-3/mswv3_08.htm

Valéry, Paul (1964) 'The Conquest of Ubiquity', in Ralph Manheim (trans.) *Aesthetics*, Bollingen Series, Pantheon Books, New York, p. 225.

Vasulka, Woody and Scott Nygren (1974) 'Didactic Video: Organisational Models of the Electronic Image', *Afterimage 13* (4, October).

Viola, Bill (1995) *Reasons for Knocking at an Empty House: Writings 1973–1994*, Thames & Hudson, London.

Virilio, Paul (1986) 'Juste le Temps', *Cahiers du Cinema*, Spécial 'Où va la Video?', Paris.

Weisman, Rebecca, 'Guy Ben-Ner: Thursday the 12th', *International Contemporary Art*, www.thefreelibrary.com

Welsby, Chris (1977) 'Landscape 1 & 2', *Perspectives on British Avant-Garde Film*, Hayward Gallery, London/Arts Council of Great Britain (2 March–24 April).

—(1979) *Film as Film: Formal Experiment in Film 1910–1975*, Hayward Gallery, London (3 May–17 June).

White, Gordon (1982) *Video Techniques*, Newnes Technical Books, Butterworth, London.

Wiener, Norbert (1968) *The Human Use of Human Beings*, Sphere Books, London.

Williams, Brian (1976) 'Journey Through Australian Video Space 1973/76', *Access Video News*.

Wilson, Rodney (ed.) (1977) *Perspectives on British Avant-Garde Film*, Hayward Gallery (March–April).

Wyver, John (1991) 'The Necessity of Doing Away With Video Art', *London Video Access* Catalogue, London.

Youngblood, Gene (1970) *Expanded Cinema*, Studio Vista, London.

—(1989) 'Cinema and the Code', *Leonardo*, 'Computer Art in Context' Supplemental Issue.

Zhuan, Huang (2006) 'Method and Attribute: History and Problems of Video Art of China', *Compound Eyes*, quoted in Thomas J. Berhuis (2006), *Performance Art in China*, Timezone 8, Hong Kong.

—(2011) 'An Antithesis to Conceptualism: On Zhang Peili', *Yishi Journal of Contemporary Chinese Art* (November/December, Vol. 10, No. 6).

Zimmermann, Patricia R. (1998) 'Processing Trauma: The Media Art of Daniel Reeves', *Afterimage 26* (2, September–October).

—(2000) *States of Emergency: Documentaries, Wars, Democracies*, University of Minnesota.

Zippay, Lori (ed.) (1998) *Steina and Woody Vasulka: Video Works*, NTT InterCommunication Center (ICC) Theater, Tokyo.

Zorach, Rebecca (2007) 'Judith Butler' in *Art: Key Contemporary Thinkers*, Diarmuid Costello and Jonathan Vickery (eds), Berg, Oxford.

Zutter, Jorg (1994) 'Interview with Bill Viola', *Unseen Images*, Whitechapel Art Gallery, London.

INDEX

Pages with images are indicated in bold